No Modernism Without LESBIANS

DIANA SOUHAMI is the author of *Gluck: Her Biography*, *Gertrude and Alice*, *Greta and Cecil*, *The Trials of Radclyffe Hall* (shortlisted for the James Tait Black Prize for Biography and winner of the Lambda Literary Award), *Wild Girls*, the bestselling *Mrs Keppel and Her Daughter* (also winner of the Lambda Literary Award and a *New York Times* 'Notable Book of the Year'), *Selkirk's Island* (winner of the Whitbread Biography Award), *Coconut Chaos*, *Edith Cavell* (winner of the EDP Jarrold East Anglian Book of the Year Award), *Murder at Wrotham Hill* (shortlisted for the Crime Writers' Association Gold Dagger for Non-Fiction) and the novel *Gwendolen*. She is a Rainbow List National Treasure and she lives in London.

No Modernism Without LESBIANS

Diana Souhami

HEAD
ZEUS

An Apollo Book

To LGBTQIAPD, QUILTBAG+,
or whatever gets you to the light

'I think… if it is true that there are as many minds as there are heads, then there are as many kinds of love as there are hearts.'

LEO TOLSTOY

'As women we derive our power from ourselves not from men.'

ADRIENNE RICH

CONTENTS

THROW OVER YOUR MAN

'The world has always had lovers. And yet as near as I can observe, for thousands of years the concentrated aim of society has been to cut down on kissing. With that same amount of energy […] society could have stopped war, established liberty, given everybody a free education, free bathtubs, free music, free pianos and changed the human mind to boot.'

JANET FLANNER

I n the decades before the Second World War, many creative women who loved women fled the repressions and expectations of their home towns, such as Washington and London, and formed a like-minded community in Paris. They wrote and published what they wanted, lived as they chose and were at the vanguard of modernism, the shift into twentieth-century ways of seeing and saying.

I focus on the lives and contribution of Sylvia Beach, Bryher, Natalie Barney and Gertrude Stein – three were American, one was English. All rebelled against outworn art and attitudes. Sylvia Beach started the bookshop Shakespeare and Company and published James Joyce's *Ulysses* when no commercial publisher could or would. Bryher, born Winifred Ellerman, daughter of the richest man in England, used her inheritance to fund new

writing and film. Natalie Barney aspired to live her life as a work of art and make Paris the sapphic centre of the Western world. Gertrude Stein furthered the careers of modernist painters and writers and broke the mould of English prose. All had women lovers whom they kissed, and they changed the human mind to boot.

Within each of their stories, other women figure large: where would Sylvia Beach be without Adrienne Monnier, Bryher without the imagist poet H.D. (Hilda Doolittle), Natalie Barney without all her lovers, too many to list, or Gertrude Stein without Alice B. Toklas ('little Alice B. is the wife for me'). And then there were the women friends of the women friends, and the women they kissed too...

They gravitated to Paris and each other, turned their backs on patriarchy and created their own society. Rather than staying where they were born and struggling against censorship and outrageous denials and inequalities enforced by male legislators, they took their own power and authority and defied the stigma that conservative society tried to impose on them. Individually, each made a contribution; collectively, they were a revolutionary force in the breakaway movement of modernism, the shock of the new, the innovations in art, writing, film and lifestyle and the fracture from nineteenth-century orthodoxies.

In 1947 the novelist Truman Capote went to Romaine Brooks's studio in Paris with Natalie Barney. Natalie's relationship with Romaine lasted fifty-four years, until Romaine's death in 1970. Romaine painted many of the lesbians in their set; the portraits were large scale and lined the walls of her studio. Capote called the collection 'the all-time ultimate gallery of famous dykes'. They formed, he said, 'an international daisy-chain'.

I call them all lesbians, but the words lesbian, dyke and daisy were not much used by them. 'Friend' was the usual catch-all, though Natalie Barney nailed her colours: 'I am a lesbian. One

need not hide it nor boast of it, though being other than normal is a perilous advantage.' She drew up and signed a bespoke marriage contract with one of her partners, Lily de Gramont, duchesse de Clermont-Tonnerre. Its terms would not have been countenanced in her home town of Washington or by the French aristocracy. Gertrude Stein freely called Alice her wife, and Bryher, who chose her own gender-neutral name, viewed herself from an early age as a boy trapped in the body of a girl.

I duck the initialism of the present age: the LGBTQIA, the QUILTBAG (queer or questioning, undecided, intersex, lesbian, trans, bisexual, asexual or allied, gay or genderqueer) plus the +. Added recently are P and K: P for pansexual or polygamous and K for kink. And now there is prescriptive use of the pronoun 'they' for a person resistant to he or she. I favour H.D.'s revision: 'When is a woman not a woman? When obviously she is sleet and hail and a stuffed sea-gull.' But in French, sleet is masculine and seagull feminine, so where to draw a line?

There are but twenty-six letters in the Roman alphabet and life is short. Gertrude Stein said of her large white poodle, Basket, that of his ABCs he knew only the Bs – Basket, Bread and Ball. With canine simplicity, of my LGBs I use only the Ls – Lesbians and Love. This is not to disrespect all efforts of inclusiveness and search for identity and self-expression. I want a place in the rainbow. But I am a tyro in this language class and when writing of past times, today's language seems incongruous. I cannot talk about cisgender for Virginia Woolf, call Bryher they, or struggle with *No Modernism Without QUILTBAG+*. And all the initials in the alphabet will not help in what I hope shines through: the uniqueness, the utter singularity of each individual life. I juxtapose four women within the lesbian category. Their juxtaposition shows the inadequacy of any label. I marvel at how different, original and irreplaceable each one is, formed by their childhood, their nature and nurture, imaginative in their

contribution, unique in who they happen to be. Lining them up highlights their differences. For, of course, what matters from A to Z is not what you are, but how you are what you are, and the contribution made.

In the early decades of the twentieth century, censorship laws in Britain and America prevented lesbians from publishing anything in fiction or fact about their love lives. The subject matter was deemed obscene. Sex between consenting men was a criminal act. The 1895 trial and ruin of Oscar Wilde hung in the air of English society. Sex between consenting women was not illegal. Silence was the weapon of its repression.

In 1920, Violet Trefusis and Vita Sackville-West caused a furore when they eloped to France and their respective husbands piloted a plane to bring them back. The following year, a Conservative member of parliament, Frederick Macquisten, a minister's son, proposed that a clause 'Acts of Gross Indecency Between Female Persons' be added to the Criminal Law Amendment Act of 1885, which indicted Oscar Wilde. Lesbianism, he told the House of Commons, threatened the birth rate, debauched young girls and induced neurasthenia and insanity. His clause was agreed and went to the House of Lords to be ratified.

Their lordships speculated on the effect of breaking silence. Lord Desart, who was Director of Public Prosecutions when Oscar Wilde was indicted, said: 'You are going to tell the whole world there is such an offence, to bring it to the notice of women who have never heard of it, never thought of it, never dreamed of it. I think this is a very great mischief.'

Lord Birkenhead, the Lord Chancellor, agreed:

I am bold enough to say that of every 1,000 women, taken as a whole, 999 have never even heard a whisper of these practices. Among all these, in the homes of this country, the taint of this noxious and horrible suspicion is to be imparted.

Whispered or heard, 'these practices', Birkenhead believed, would cause contagion. In the home of his mind, a woman's place was on his arm and in his bed.

Then in 1928 came the startling trial and censorship of Radclyffe Hall's anodyne novel *The Well of Loneliness*. The only sexy bits in it were 'she kissed her full on the lips' and 'that night they were not divided', but even such mild lesbian expression was deemed obscene and the book was 'burned in the King's furnace'. Radclyffe Hall left England for Paris with her partner, Una Troubridge. Sylvia Beach sold pirated copies of *The Well* from Shakespeare and Company.

Paris

'England was consciously refusing the twentieth century', Gertrude Stein said. America enforced prohibition of alcohol as well as censorship of literature and art. Lesbians with voices to be heard, who would not collude with silence and lying about their existence, got out if they could in order to speak out. Paris was waiting: the boulevards and bars, good food, low rents. It seemed on a different planet from London. Paris was where they formed their own community, fled the repressions and expectations of their fathers, took same-sex lovers, and painted, wrote and published what they wanted.

'Paris', Gertrude said, 'was where the twentieth century was', 'the place that suited those of us that were to create the twentieth-century art and literature'. Indigenous Parisians held their traditional views but did not mind these foreigners with alternative lives. Gertrude Stein said they respected art and letters: it was not just what Paris gave, she said, 'it was all it did not take away'.

Modernism would not have taken the shape it did without the

lesbians who gravitated to Paris at that time. There had been nothing like it since Sappho and the Island of Lesbos. Many of them learned Greek to read extant Sappho fragments and wrote their own verse in her honour.

as you were when the autobus called

Freedom of choice in dress and appearance was a crucial assertion. Why should fathers dictate what their daughters could or should wear? 'As you were when the autobus called' was a party inspired and orchestrated by Elsa Maxwell, who turned party-giving into an art form and profession.

Elsa Maxwell lived for fifty years with 'Dickie', the socialite Dorothy Fellowes-Gordon. In interviews, Elsa just said she was 'not for marriage', it was 'not her thing to do' and that she belonged to the world.

Guests at her as-you-were party were picked up from their homes by bus at an unspecified time. They were to be as they were, dressed, groomed, ungroomed, when the driver sounded the horn. Cocktails were served to those waiting in the bus. For most, their 'surprise appearance' was contrived, costumes carefully unfinished: unzipped skirts, a woman with her face half made-up, a man wrapped in a towel with shaving soap on his face. But though guests were provocatively half-dressed, the implicit questions were: What is 'correct attire' and true appearance? Who is the real person, unmasked, as opposed to the presented self? Paris allowed candour, and was where pretence could be stripped, expectations confounded, identity fluid, and sexual relationships open. The autobus was a vehicle for transparency, free expression and the breaking of rules.

modernism

Modernism sent fissures through a whole bundle of myths: that a narrative must have a beginning, a middle and an end, and romance be between a hero and heroine; that art should be representative and music follow familiar notations. The modernist movement questioned orthodoxies: that God made the world in seven days, that Christ was the Son of God, parented by a virgin and a ghost, that there were tangible domains of heaven and hell, that kings were in their palaces by divine right, that man was king of all species, and that war was an acceptable way of resolving conflict between nations.

money

Virginia Woolf said a woman must have 500 guineas a year and a room of her own if she were to write fiction, plus the habit of freedom 'and the courage to write exactly what we think'. It was hard for most women to come by one of those things, let alone all. The large bank accounts of Bryher and Natalie Barney came from wealth inherited from their fathers. Both subsidized and financed friends and fellow artists; Bryher in particular was a lifelong and unstinting patron of what was new in the arts. Gertrude Stein was comfortably off, her income managed by her savvy elder brother Michael, who invested in American railroads. Her true fortune was made by indulging her passion for buying paintings to hang on the walls of her rented home. She bought works by Picasso, Matisse, Cézanne while they were still young and unknown. Her collection was soon beyond price; she could not afford insurance cover. Sylvia Beach had no private income – her father was a vicar – and her constant problem was how to glean enough to keep

her projects going. Bryher gave her money and so did Natalie Barney. More than the privilege of having wealth was how those with it used it. None of the moneyed modernist lesbians looked for profit. They used money made by men to further the modernist cause.

escape from patriarchy

Same-sex relationships have always been there, have always been diverse, complex and individual. It was always far past time for the world to recognize that truth. 'You can't censor human nature', was Sylvia Beach's view. It was always senseless to close the door on benign relationships of the heart, which will express themselves, however brutal, damaging and disheartening any penalties imposed.

The Paris lesbians had to free themselves from male authority, the controlling hand, the forbidding edict. They escaped the disapproval of fathers and the repression of censors and law-makers, defined their own terms and shaped their own lives. They did not reject all men – they were intrinsic to furthering the careers of writers, film-makers and artists whose work and ideas they admired. What shifted was the power base, the chain of command.

A community of women who called the shots was no bad idea 100 years ago, nor is it a bad idea now. Why are there still so few works by women in the art galleries, why are their symphonies and songs not filling the concert halls or their statutes defining the laws of the land?

'It is true that I only want to show off to women. Women alone stir my imagination', Virginia Woolf wrote in 1930 to the composer and suffragist Ethel Smyth, who had declared love to her. Women needed their 500 guineas, a room of their own and 'the habit of freedom and the courage to write exactly what we

think'. Three years earlier, Woolf had written to Vita Sackville-West, with whom she was, in her way, in love: 'Look here Vita – throw over your man and we'll go to Hampton Court and dine on the river together and walk in the garden in the moonlight and come home late and have a bottle of wine and get tipsy and I'll tell you all the things I have in my head… They won't stir by day, only by dark on the river. Think of that. Throw over your man, I say, and come.'

'Throw over your man' was quite a call. It might have been a way forward before the cataclysm of two world wars. War tore apart the lesbian web woven by the women in these pages. It might be a way forward now, in the dark, tipsy and in love, in the beautiful garden the world might be, before the moonlight disappears and all the things in women's heads are lost forever.

'Throw over your man, I say, and come.'

SYLVIA BEACH

'they couldn't get Ulysses *and
they couldn't get a drink'*

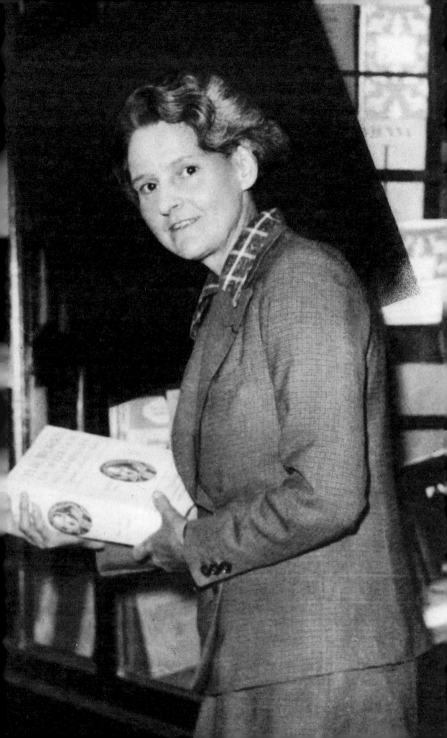

'My loves were Adrienne Monnier, James Joyce and Shakespeare and Company,' Sylvia Beach wrote in her memoirs of the woman who was her lifelong partner, of the author whose novel *Ulysses* she single-handedly published when the custodians of morality (all men) censored it as obscene in England and America, and of the bookshop she founded in 1919 in Paris, which was so much more than a bookshop and which honours her to this day.

Her appearance was sprightly but unremarkable. She was five foot two, thin, with a brisk walk, a determined chin, bobbed hair, and brown eyes behind steel-rimmed glasses. She liked comfortable clothes – mannish jackets, neckties, loose skirts and sensible shoes, and energetic outdoor pursuits like mountain hiking and horse riding. She smoked non-stop. Her conversation was humorous and open, often acerbic, but not aggressive. She spoke idiomatic French with an American accent and was fluent enough in several other languages. When she spent time in a country, she always learned something of its language.

Her determination and courage were exceptional. Born in 1887 in Princeton, New Jersey, the daughter and granddaughter of Presbyterian ministers, she gave up on church but found sanctity in books, bookshops and libraries. Books, she said, were the friends of her childhood. Books opened doors to freedom, shaped her thinking and feelings and gave her courage to rebel.

The second of three daughters, as an early assertion she dropped her birth name, Nancy, and renamed herself Sylvia. Many lesbians who contributed to the modernist revolution chose their own names: Gluck, Radclyffe Hall, Bryher, Genêt, H.D., Colette, Renée Vivien… it was an aspect of creating their own image, of breaking from patriarchy and from being the property of men.

Life as Sylvia Beach lived it might have eluded Nancy but much of her personality stayed true to her Presbyterian roots: 'Sylvia had inherited morality', Janet Flanner said of her,

and you could feel it in her and actually enjoy it too in her bookshop, which she dominated with her cheerfulness, her trust in other human beings and her own trustworthiness for good things, like generosity, sympathy, integrity, humor, kind acts, and an invariably polite démodé vocabulary.

Sylvia Beach's principles were Christian – no indulgence, concern more for others than herself, work as contribution rather than for personal profit – yet she became a champion of outspokenness and unorthodoxy in others. She actively resisted political oppression, and was at the cutting edge of what was new in writing.

She had no inherited wealth. Usually she was broke and had to appeal to relatives and wealthy friends for money. She was no businesswoman – too generous and idealistic ever to earn much.

She did not call her deep and lasting love for Adrienne Monnier lesbian, although that is what it was. Reticent about sexual reference to herself, she referred to Adrienne as her 'friend' and to the love between other lesbian couples, like Bryher and Hilda Doolittle or Gertrude Stein and Alice B. Toklas, as 'companionship'. Only about Natalie Barney was she outspoken, perhaps because Natalie was unabashed in using direct language for her own desires. Of Natalie's famed Friday afternoon salons, Sylvia wrote: 'At Miss Barney's one met lesbians; Paris ones and those only passing through town, ladies with high collars and monocles, though Miss Barney herself was so feminine.' Her words appeared to distance herself from such company, though Natalie's salon attendees were part of her social circle too.

She was always a lesbian, a feminist and a suffragist, even though she chose not to talk about her sexuality. When racism and sexism reached a zenith of viciousness with Hitler and his Third Reich, she remained in Paris as the German army marched in. She was interned in a concentration camp for having

employed and protected a Jewish assistant, for being American and for stocking James Joyce's *Finnegans Wake* in her bookshop, but not for being lesbian.

the living Paris

Paris always held magic for Sylvia Beach. She was there in 1903 with her parents and sisters, Holly and Cyprian, the same year Gertrude Stein arrived to join her brother Leo. (Cyprian, who became an actor in silent films, also chose her own name. Her birth name was Eleanor, after their mother.) Their father, the Reverend Sylvester Woodbridge Beach, was on a three-year assignment from Princeton, New Jersey, with the American Church in Paris. His vain hope was for this Paris post to placate his wife, who was always unhappy when with him but less so if in Europe, and in particular in Paris. 'Paris was paradise to Mother; an Impressionist painting', Sylvia wrote. She described her parents as Francophiles, as was she, though the Paris she experienced with them was not the vibrant city of modernist innovation she knew existed:

> I was not interested in what I could see of Paris through the bars of my family cage. I never seemed to get anywhere near the living Paris. This was not my life but Father's.

The Reverend Beach's Paris life was insulated from cultural shake-up and lesbian visibility, from the salon d'automne held at the Grand Palais, where innovative artists showed ground-breaking work, and from Gertrude Stein's 'cubico futuristic' prose. He held weekly devotional meetings 'not largely attended' at the American Church at 21 rue de Berri, close to the Champs Elysées. The Church's Ladies' Benevolent Association made garments – 600 in one year – for the Christmas fêtes. The Reverend

Beach gave pastoral help to American students in the city. 'Last night father had to get out of his bed at 2 and go to see a young architect who was dying,' Sylvia wrote to a friend. Her father laboured at learning grammatical French, which he spoke with an execrable accent. Her mother produced entertainments by the students. Sylvia escaped with Carlotta Welles, whose father had a château in Touraine, near the little town of Bourré. She stayed with her for weeks at a time. There was a walled garden by the river Cher, a private island reached by a punt. They read poetry, bird-watched, walked; 'that was the way our long, long friendship began'.

Church protocol could not conceal the horror of Sylvia's parents' relationship or ameliorate its effect on her and her sisters. The Reverend and Mrs Beach were loving towards their daughters, assiduous in helping them and encouraging of their freedom, but their own marriage was ghastly.

poor little mother

Sylvia's mother seemed like a lost soul, stifled by the church and her marriage. Her daughters referred to her as 'P.L.M.', 'Poor Little Mother'. She was born Eleanor Orbison in 1864 in the colonial city of Rawalpindi,* the fourth child of Presbyterian missionaries. Her father became ill when she was four and the family moved back to America, to Bellefonte, a small town in Pennsylvania. Eleanor's father died and her mother, anxious about bringing up four children alone and without money, sent her, the youngest, to live with wealthy relatives at Greenhill Farms in Overbrook, 200 miles away. Eleanor remembered that as a glorious time. Her cousin Holly was the same age, there were ponies to ride, woodland picnics, painting and music lessons.

* Taken from the Sikhs by the British in 1849 and now in Pakistan.

Pastoral joy ended when her mother abruptly took her back home, to a regime of Christian piety. 'Granny taught us to knit', Sylvia later wrote of her mother's mother, 'and taught herself Greek so as to be able to read the Greek Testament at 6 a.m. before rising. Granny planned to go to Heaven when she died, and was determined to get all her relatives and friends past the gate of it.'

Eleanor was sent to Bellefonte Academy, a church school. Aged sixteen, she became engaged to the Latin teacher, Sylvester Woodbridge Beach. He was twenty-eight, a graduate of Princeton Theological Seminary. What precipitated this engagement is not on record, but it was not, on her part, from love or desire. They married as soon as she was eighteen, and by the time she was in her twenties she had three daughters: Mary Hollingsworth – Holly, born June 1884; Nancy (Sylvia), born March 1887; then Eleanor (Cyprian), born April 1893. After that, Mrs Beach slept in a separate room from her husband and for months at a time travelled in Europe so as to be away from him. 'Never let a man touch you' was her advice when Sylvia was in her early teens.

about my education

Sylvia saw her parents' unhappy marriage as a lesson in what to avoid. As a child she was at home a lot, ill with migraines and eczema, so she missed out on school. 'About my education', she wrote as an adult, with Gertrudian disregard for the conventions of grammar, 'the less said the better: I ain't had none: never went to school and wouldn't have learned anything if I had went.' She spent long hours in the back parlour on a divan beside a bookcase, which had a set of Shakespeare's works 'excepting the volume containing *Hamlet* in which Granny had come across a passage that "wasn't nice" so she had burnt the book. What would Granny have thought of *Ulysses*?'

Sylvia's only formal schooling was a stint in her teens at an academy in Lausanne for 'a lot of weak maidens'. She spent hateful months as a boarder, was uninterested in the curriculum and was scolded if she talked or looked out of the window at Lake Geneva. Her migraines troubled her and she felt she learned nothing. 'I was miserable and soon Mother brought me home.' What she did learn was to resist authority, travel independently and think for herself. Many lesbian shapers of modernism had makeshift schooling. They learned in their own ways.

a very bad example

In 1906, the Reverend Beach's Paris assignment ended and the family returned to Princeton, where he was minister of the First Presbyterian Church. Sylvia worked as a research assistant for a professor of English at the university, and campaigned for suffrage and women's rights, but she wanted to be back in Europe, away from the claustration of home.

She travelled often to France – sometimes to meet with her friend Carlotta, sometimes with her sisters or mother. 'We had a veritable passion for France,' she wrote. She also spent time in Italy with the family of another girlfriend, Marion Mason, acquired another language, absorbed another European culture. But lack of money limited where she could study or stay. And in 1915, on an extended visit to Spain with her mother, gossip spread about the Beaches' broken home life. A New York scandal sheet, *Town Topics: The Journal of Society*, ran a piece about the Reverend Beach's neglect of his wife and family and how:

> his open attentions to a fair fat and fifty member of his
> congregation is causing no little comment and setting a very
> bad example. The sudden departure of his wife and daughter
> to Europe a few months ago, despite the danger of sea

voyaging under the present uncertain war conditions, together
with the almost immediate ensconcement of himself at the
woman's Summer house in New Jersey, where he still remains,
indulging in numerous gay automobile trips, sometimes with,
more often without, a chaperon, has and is causing much
comment in the exclusive little Summer colony, as well as
New York and Princeton.

The Reverend Beach, summoned before the Church Board,
said in defence that because he could not give his children money,
he encouraged them to travel and seek experience to fit them for
whatever careers they chose. He wrote to Sylvia that he wished
people 'would understand that and LET US ALONE'.

He could not say his wife hated being in the same country
with him, let alone the same house. Divorce was not a possibility.
To allay this damaging gossip and give a semblance of Christian
respectability, Eleanor Beach went back to Princeton to her un-
satisfactory husband and 'the new black cook and white poodle'.
Sylvia went to Paris to meet up with Cyprian.

I worked as a *volontaire agricole*

In August 1916, Sylvia's passport stamp read *journaliste littéraire*.
Perhaps to acquire student status, she had amended her date of
birth from 1887 to 1896 to make herself seem nine years younger
than she was. Cyprian, under her stage name Cyprian Gilles, was
playing the heroine in a twelve-part silent movie serial, *Judex*,
about 'a masked fighter for justice'. She was 'so beautiful she
couldn't walk down the street without being followed by hopeful
men', Sylvia said. She had rented a studio in rue de Beaujolais
in the 1st arrondissement. Sylvia booked in at the Palais Royal
hotel in the same 'fairly respectable' street. It was close to the
Palais Royal theatre 'where the naughtiest plays in Paris were put
on', and to bookshops 'dealing in erotica'. A conjoining balcony

ran around the hotel and her room looked out over gardens, a fountain, a statue by Rodin of Victor Hugo.

For a year she studied French literature, particularly poetry, in the nearby Bibliothèque nationale, and gave English lessons. But by 1917 the war and German attacks on Paris had intensified. By day, the streets were raked by 'Big Bertha' howitzers. At night, she and Cyprian watched bombing raids from the hotel balcony. That summer, to help in the war effort and escape the bombs, she joined the *Volontaires Agricoles*. All male farmhands were at the front. For two months, in the Loire Valley near Tours, she picked grapes, bundled wheat and pruned trees, alongside wounded French soldiers and German prisoners of war. She stayed first in a cheap hotel in Tours – 'oh là-là, how moyen âge', she wrote about the hole-in-the-ground toilet – and then on a farm owned by M and Mme Heurtault, with their seven-year-old son and their cows, chickens, geese and horses.

> I'm treated like a member of the family. They are so nice.
> Such good-natured, such sloppy people… They press wine
> on me, fine old vintages of all soils and are disappointed
> that I can't use but a glass a meal.

She said the inside of their big house was like a barnyard. She wore a khaki blouson and plus fours and delighted in the sense of liberation these mannish clothes brought her and the curiosity they provoked: 'My Khaki suit is gaped at something awful,' she wrote in August to Cyprian. She had her hair cut short, felt liberated at not having to ride side-saddle in a skirt, liked the twelve-hour days of hard physical work and, though she missed urban culture, enjoyed defying assumptions of how women should dress. Local land-working women wore skirts and had long hair and put her appearance down to the eccentricity of Americans rather than an expression of sexual identity. Picasso, too, interpreted lesbian dress code as an American phenomenon. '*Ils sont pas des hommes, ils*

sont pas des femmes, ils sont des Américains,'* he said. But it was not just because Sylvia was American and working on the land that she felt freed. Many women, and lesbians in particular, described the liberation of short hair, comfortable shoes and escape from constraining clothes and the behaviour they dictated.

It was a relief, Sylvia said, to 'have escaped the expectation of proper young ladies'. When Vita Sackville-West put on 'land girl' dungarees in 1918, she felt an emotional key turn. 'In the unaccustomed freedom of breeches and gaiters I went into wild spirits', she wrote. Spurred with courage, she then seduced Violet Trefusis.

In letters home, Sylvia reported that her migraine attacks had abated and her health had never been better.

the little gray bookshop of Adrienne Monnier

In October 1917, when the season for farm work ended, Sylvia rejoined Cyprian in Paris, resumed her literary studies at the Bibliothèque nationale and again gave English lessons for money. She was thirty, fluent in the French language, versed in its literature and assimilated into European culture. She had distanced herself from the theological constraints and emotional anxieties of home. But she had not decided what to do with her life.

One day in the library she noted that a journal she wanted to see, *Vers et Prose*, which published work by Paul Valéry, Guillaume Apollinaire and Stéphane Mallarmé, could be found at the bookshop of Adrienne Monnier, 7 rue de l'Odéon, Paris VI. She was unfamiliar with the area. Wearing a wide Spanish hat and a dark cloak, she crossed the Seine at the pont des Arts and found the

* 'They are not men, they are not women, they are Americans.'

street. It ran from the back of the Théâtre de l'Odéon down to boulevard Saint-Germain. Its architecture reminded her of the colonial houses in Princeton. She passed an antique shop, a carpet shop, a music store, a printer. Halfway down she found the little bookshop with A. Monnier painted above the door. She peered through the window at shelves of books, portraits of authors, and a stoutish woman with fair hair sitting at a table, dressed in a grey ankle-length skirt and a velvet waistcoat over a white silk blouse. 'She seemed gray and white like her bookshop.' Seeing Sylvia's interest and hesitation, Adrienne Monnier came to the door to welcome her. A gust of wind blew off Sylvia's hat, which bowled down the road. Adrienne rushed after it, pounced on it, brushed it off and returned it to her.

This mise en scène etched itself into Sylvia's memory. It was the event that marked the separation of her old life from the new, the moment her heart found its wings. For Gertrude Stein, the epiphany came when she hung Cézanne's portrait of his wife, Hortense, above her work table. For Bryher, it was when H.D., Hilda Doolittle, opened the door of a cottage in Cornwall to greet her. For Natalie Barney, it was when she defied her father and published her *Portraits-Sonnets de Femmes*.

Sylvia followed Adrienne into the shop. They sat and talked about books. 'That was the beginning of much laughter and love. And of a lifetime together.' To this love they brought the elision of their cultures, the elision of their lands: 'Sylvia, so American and so French at the same time,' Adrienne said of her.

> American by her nature 'young, friendly, fresh, heroic…
> electric' (I borrow the adjectives from Whitman speaking of his
> fellow citizens). French through her passionate attachment to
> our country, through her desire to embrace its slightest nuances.

In a love poem to her, published in her collection *La Figure*, Adrienne wrote: *Je te salue, ma Sœur née par-delà les mers / Voici*

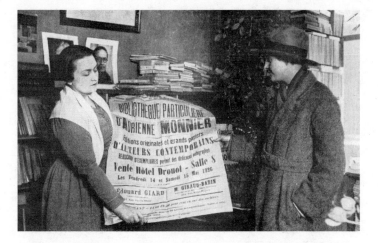

que mon étoile a retrouvé la tienne. 'I greet you my sister, born from across the seas / See how my star has found yours.'

Sylvia felt on visiting Adrienne that she had been drawn 'irresistibly' to the spot where important things in her life were going to happen. She entered The House of the Friends of Books and departed The House of her Father's God and Mother's Grief. She began to dream of a bookshop of her own. Here was evidence of where and how such a dream might find fulfilment.

Adrienne became her mentor, lover and life partner. She was twenty-five, five years younger than Sylvia. Adrienne, too, scraped together such funds as she could. In 1915, her father, Clovis Monnier, had given her the money to open La Maison des Amies des Livres. He was a *postier ambulant* – a postal worker on night trains; he sorted mail in transit for delivery and had been paid ten thousand francs' compensation after a train crash left him with a permanent limp. He loved and was proud of his daughter. Paris rents were low, because of the war, and his insurance money was enough to set up her bookshop, which quickly became a special place. All who loved books were welcome. France's finest poets and writers became Adrienne's customers and friends – Paul Valéry

and Guillaume Apollinaire, André Gide and Jules Romains...
Her books were in French but she commissioned translations,
stocked the avant-garde journals, championed women writers,
loaned books, held discussions and authors' readings.

these two extraordinary women

Sylvia said of herself that she was the only American to discover
La Maison des Amies at that time. She described herself as 'a
beginner, but a good beginner' in modern French writing. 'While
the guns of war boomed' she joined Adrienne's subscription
library and spent many hours in 'the little gray bookshop', smok-
ing and talking with Adrienne and the French authors who called
in – some of them from the front and in uniform. At the Biblio-
thèque nationale, she had studied their work. At Adrienne's,
André Gide gave readings of Paul Valéry's poems; Jules Romains,
in uniform, read 'Europe', his poem about longing for peace in a
continent that was being destroyed by war. At musical evenings
at the shop, Sylvia heard new music by Erik Satie and Francis
Poulenc. She absorbed the creative magic of being bookseller,
librarian, impresario all under one roof and with the personal
stamp of the owner. And she saw, what she had long felt, how
here was the Paris not of her father, but the city of new ideas
where she could be herself and nurture her aspirations and hopes
both for love and a 'book plan' of her own.

Adrienne said Americans appreciated in Europe in general,
and in France in particular, what they did not have at home,
'what is calm, old, graceful and made by hand'. At the same time
they brought, she said, 'without spoiling the decor', new ways
of seeing, and the technology and innovations of the twentieth
century. As a French woman she was drawn, through Sylvia, to
read contemporary American writers not then known in France.
Americans 'have democracy in their blood', she said, 'it is their

tradition, their reason for being'. In literature, this love of democracy allowed strictures and boundaries to break and new ideas and thinking to come in.

In appearance, they were opposites: Adrienne wore full ankle-length skirts that made her look stouter than she was – and she was stout, 'all curves and placidity'. Sylvia was thin and nervous. Both were strong, independent, intelligent and imaginative. Both effused the same warm humanity. They were open-minded and neither was answerable to a man or to men.

Janet Flanner, who moved to Paris in 1922 with her lover, Solita Solano, and as Genêt began her fortnightly 'Letter from Paris' for *The New Yorker* three years later, viewed them as a couple. She wrote with affection and admiration of 'these two extraordinary women—

> Mlle. Monnier, buxom as an abbess, placidly picturesque in the costume she had permanently adopted, consisting of a long, full gray skirt, a bright velveteen waistcoat, and a white blouse, and slim, jacketed Sylvia, with her schoolgirl white collar and big colored bowknot, in the style of Colette's *Claudine à l'École*.'

among the valiant Serbs

The war festered on and put Sylvia's 'book plan' on hold. Only when Germany surrendered in November 1918 could she consider how to earn, save, and forward the project. She had no capital, knew nothing about business and all she knew about books was that she loved them. She and Adrienne discussed possibilities. Initial thinking was for Sylvia to open a branch of La Maison des Amies in London or Greenwich Village. Adrienne favoured New York. 'She doesn't like English things,' Sylvia said. Sylvia's mother, too, encouraged the New York idea and was willing to put her savings into it, but her capital was insufficient to make it viable.

From January to July 1919, to earn money and help with post-war reconstruction, Sylvia and Holly worked for the American Red Cross in Belgrade. Ten million fighting men had died in the war. Eight million horses. Nor did the dying end with the cessation of fighting. The influenza pandemic after the war killed more than thirty million people worldwide. Sylvia's unit 'distributed pyjamas and bath towels among the valiant Serbs'. She scorned the male hierarchy of the Red Cross: men getting the managerial jobs and higher wages, women taking orders and doing the menial work.

In Serbia, at the military hospital where she worked at Palanka, sixty miles from Belgrade, she saw the reality of war: 'destruction, deprivation, skeletons of horses by the roadside, I don't know if the war killed them or just hunger.' In an epidemic of typhoid,

> 20 to 30 patients died every day – the bodies piled in a room and left till someone had a spare moment to put them away for ever in the ground. They were mostly Bulgarian prisoners so no one bothered much about it.
>
> The water supply came from a well containing a German prisoner who had fallen in some time ago and had not as yet been removed. There were 30 beds for 250 men and the patients were crowded together in layers on the floor, absolutely no nursing provided for them, their uniforms rotting on them. The dying men had their pockets looted by the prisoner attendants, who never attended to them except to perform this last little service for them.

London was not the town to start my shop in

The Treaty of Versailles, signed on 28 June 1919, marked the official end to the killing. Sylvia wrote to Cyprian that she had more or less decided to open her bookshop in London:

> I really don't know where I shall find the capital, and they say
> the town is crammed at present – no rooms whatsoever.

She crossed the Channel to look for premises to rent and voiced hope that Cyprian, Holly and their mother would all meet with her in September to help get the venture launched.

Within weeks she was back in Paris. 'One look was enough to show me that London was not the town to start my shop in.' Adrienne thought a better idea would be a little American bookshop stocked with contemporary English writing, on the Left Bank, close to her – the English equivalent of Maison des Amis des Livres. She was optimistic such a project would succeed. There was nothing like it in Paris. Wealthy Anglo-American Paris residents, who neither lived in nor particularly frequented the Latin quarter, were served by Brentano's, the American booksellers at 37 avenue de l'Opéra, and by Galignani and W.H. Smith in rue de Rivoli, but those sellers did not specialize in books by new writers or sell the experimental literary journals.

Adrienne had kept her own bookshop going throughout the war; she would help at every stage, and guide Sylvia through the bureaucratic difficulties of not being a French citizen. She knew of prospective customers and was certain others would follow.

Buoyed by such assurances, Sylvia began the project that shaped her life and became central to the modernist revolution. Adrienne's support and experience was a key incentive. Their mutual love and trust parented the project. Paris was affordable. That was important. Sylvia's savings and her mother's capital would go much further than in either New York or London.

Making money was not a prime consideration. Neither of them was much good at that. Both loved books and their authors. Books were essential to civilized living. Both saw their work as contribution rather than commerce. They were agents between writers and readers, guardians and disseminators of ideas that

suggested how lessons might be learned and a better world come about, how human nature might be understood more deeply and language taken to the edges of meaning.

Adrienne earned enough to pay the bills, buy stock and live simply and freely. Sylvia hoped to do the same. Neither foresaw quite how famous and enduring their 'book plan' would turn out to be.

boutique à louer

Adrienne found premises for Sylvia at 8 rue Dupuytren, a street away from her own shop in rue de l'Odéon. One day she saw what had been a laundry, with the shutters closed and a sign outside advertising '*Boutique à Louer*'. The concierge, an elderly woman in a black lace cap, 'la mère Garrouste' everyone called her, showed them round. Sylvia knew at once the space would work for her: two rooms divided by a glass door, a fireplace in the front room, a kitchenette with a gas stove out the back.

setting up shop

'It was great fun getting my little shop ready for the book business,' she said. In late August her mother wired her 3,000 dollars without expectation of reimbursement. Poor Little Mother briefly became Dear Little Mother. 'O mother dear, you never never have failed your undeserving children at a critical moment!!!' Sylvia wrote, 'and how can I tell you in a letter what a D.L.M. you are but there are hugs and kisses…'

Adrienne suggested Sylvia paint the walls of the new shop the same battleship grey as in her place. 'Never a-bit, say I!' was Sylvia's response. She chose beige and yellow and what she considered a sunny look. An upholsterer, whom she described as 'humpbacked', covered the damp laundry walls with hessian.

A carpenter made shelves, magazine racks and display cases for the windows. Sylvia and Adrienne picked up furniture in the Paris flea market – 'you really found bargains in those days': one table for displaying books, another for tea and conversation, comfortable chairs, library steps and ladders, a desk, brass scales, lamps, vases for flowers. Sylvia put down two black and white woollen rugs she had bought cheaply in Serbia. In time, on every available bit of wall, she hung photographs and portraits of writers past and present, the faces of the voices that inhabited the shelves.

Her intention was to specialize in modern innovative writing. But such books in English were expensive to buy and ship from abroad. Their purchase had to be in pounds and dollars. When that price was converted into francs, with a margin of profit added, they became luxuries few Left Bankers could afford.

Sylvia gave Cyprian a list of titles to send from the States. To stock her shelves despite limited funds, and to create a lending library, she scoured the second-hand Paris bookshops. In one frequently visited treasure house near the Bourse, the owner, Monsieur Chevillet, led her by candlelight down to the cellar and left her to rummage. She took the train and ferry to London and talked to booksellers whom she admired and hoped to emulate.

London shops and their owners

Harold Monro, with his Poetry Bookshop at 35 Devonshire Street in Bloomsbury, was a mentor and inspiration. In 1913 he had turned an eighteenth-century house into a shop, publishing house and meeting place for poets and readers. At his own expense he published poetry and edited *The Poetry Review*. The shop was on the ground floor. The poet Amy Lowell called it a room rather than a shop. There was a coal fire, comfortable chairs, a cat and a couple of dogs. Offices were on the first floor, poetry readings

were held on the second, and at the top were two attic rooms for poets and artists who needed cheap lodgings. Weekly terms were 3s 6d for rent and 3s 6d for breakfasts. The sculptor Jacob Epstein stayed some months, as did the poets Robert Frost and Wilfrid Wilson Gibson. There was no space for Wilfred Owen so he rented rooms above the coffee shop opposite.

Sylvia observed the welcoming atmosphere, how visitors were made to feel at home, how ambience created identity. She gleaned information about the English language poetry publications in circulation, many of them of fleeting life span, 'the little presses that died to make verse free' as Gertrude Stein put it. Such magazines survived for a while on a shoestring, for the most part went unnoticed by the censors and were the preferred outlet for writers who took risks. 'If a manuscript was sold to an established publisher its author was regarded as a black sheep,' Bryher wrote. 'We were permitted to appear without loss of prestige in *Contact*, *Broom*, *transition*, the *Transatlantic* and *This Quarter*.' Most of all, Sylvia saw in Monro's bookshop another individual enterprise like Adrienne's, a place for the expression and dissemination of ideas, hope for civilization, hope for imagination and sensibility beyond the scourge of war.

On her way back to the boat train, she stopped in Cork Street at the premises of the publisher and bookseller Charles Elkin Mathews, co-founder of The Bodley Head. She found him 'sitting in a sort of gallery with books surging around and creeping up almost to his feet'. She gleaned from him more contacts and ideas about rule breaking and experiment. From 1894 to 1897, in partnership with John Lane, Mathews published the periodical *The Yellow Book*. Aubrey Beardsley was its art editor and it was associated in people's minds with banned and illicit fiction and alternative lifestyles: the decadence of J.K. Huysman's *À rebours*, translated into English as *Against Nature*, and the homosexuality of Oscar Wilde.

W.B. Yeats, James Joyce, Ezra Pound and the poet laureate Robert Bridges were all published by Mathews. Sylvia ordered their titles. As she was leaving, she admired some framed drawings on the walls by William Blake. Mathews got out two 'beautiful original drawings' by him and sold them to her for what she thought an 'absurdly small sum'. She went home to Paris with two trunks full of treasures.

lending library and book-hop

The shop's name came to her one morning as she lay in bed. A specialist signwriter did the lettering SHAKESPEARE AND COMPANY over the door. Down one side column by the window he painted 'Lending Library' and down the other 'Book-hop'. Sylvia left it like that for a while, then had 'hop' painted over with 'Sellers'. Charles Winzer, a half-Polish, half-English artist friend of Adrienne's, painted a signboard of an egg-headed Shakespeare, wearing a gold medallion chain, to hang outside above the entrance door. On a night when Sylvia forgot to take this sign in, someone stole it. Winzer painted another and that was stolen too. Adrienne's younger sister Marie, an embroiderer and illustrator, painted the third, 'a rather French-looking Shakespeare' Sylvia thought, which no one stole.

The setting was personal and welcoming: a place to visit even for those with little money, the sort of shop that creates the identity of a city. The erstwhile laundry at rue Dupuytren became Shakespeare and Company's location for two years.

Sylvia moved in with Adrienne in her fourth-floor apartment in rue de l'Odéon. Adrienne was the homemaker and cook. Bryher thought her the best cook she knew and wrote about her roast chicken dinners, the smell of beeswax and herbs, the murmur of civilized conversation.

By 1919, two of Sylvia's three declared great loves had elided:

Adrienne Monnier and Shakespeare and Company. Her destiny was sealed by a visit on a windy day to the proprietor of the House of the Friends of Books. She and Adrienne saw life from the same point of view. Their imaginations and open minds shaped their enthusiasm for the modernist voices that so shocked those with conservative views: the patriarchs and censors, the architects and implementers of repressive rules and laws.

Shakespeare and Company opens its doors

Shakespeare and Company opened on Tuesday 19 November 1919. Preparing for the day had taken Sylvia four months. Displayed in the window were works by Shakespeare, Chaucer, T.S. Eliot, James Joyce and Adrienne's favourite English-language book, Jerome K. Jerome's *Three Men in a Boat*. Inside, the stock was eclectic, with the contemporary and experimental shelved alongside the literary canon. There was Tagore, Tolstoy, Schopenhauer, Henry James and Gertrude Stein. On review racks were copies of *Atlantic Monthly*, *The Dial*, *Chapbook*, *The Egoist*, *Broom*, *New English Review*, *Little Review*.

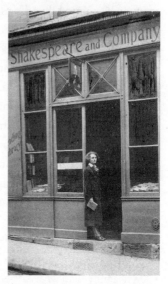

Framed on the walls, and declaring allegiance to civil and sexual liberty, were two photographs of Oscar Wilde in velvet breeches and cloak, and letters of his to Bosie – Lord Alfred Douglas. Also displayed were the Blake drawings sold so cheaply to Sylvia by Elkin Mathews, and manuscript writings and scribblings of

Walt Whitman, which Agnes Orbison, Sylvia's maternal aunt, had retrieved from his wastepaper basket when, as a student at Bryn Mawr,* she had gone with a friend to visit him.† Walt Whitman's *Leaves of Grass* poetry collection, with his message of integrity to self and resistance to suppression, inspired and gave courage to Sylvia, Bryher and Natalie Barney. Mostly the photographs and books that lined the walls and shelves were of and by men. Sylvia was a feminist but not a zealous promoter of women's writing. She was a navigator, steering away from the old order and into the new.

The shutters were hardly off the windows before the shop filled with people, Sylvia said. And so it stayed. 'From that moment on, for over twenty years, they never gave me time to meditate.' Customers did not want only to buy books – she might have made some money if they had. Shakespeare and Company quickly evolved into a bookshop, library, book club, bank, post office, hotel, referral agency and a place to meet and talk about books and life and to have tea. Sylvia was soon effecting introductions and suggesting contacts for young American writers, finding them places to live, finding them paid work, advising on any and every subject.

Many, or probably most, of her clients were short of cash. For students from the University of Paris, borrowing books was affordable, buying them was not. So her shop, like Adrienne's, became a subscription library too.

early bunnies

Sylvia was not a strict librarian. She called her subscribers 'bunnies', from the French *abonné*. Each bunny had a card with

* A women's college in Pennsylvania.
† Using these manuscripts as a base, Sylvia arranged a Walt Whitman exhibition in the late 1920s.

her or his name and address, date of initial subscription and record of payments made and due. The idea was to produce this card when books were borrowed, 'or when he or she was broke'. Sylvia recorded the title and date of the book or books taken out. The allowance for each bunny was two volumes for a fortnight. But she had no catalogue of books in circulation, nor was she assiduous at updating cards, recalling overdue books or imposing fines. Some members, such as James Joyce, took out multiple volumes, kept them for years and paid no fees or fines.

Her early customers were French and came via Adrienne. André Gide's was the first subscription. Adrienne brought him round from rue de l'Odéon on the opening morning. Sylvia said he was tall, handsome and wearing a broad-brimmed Stetson and a cape. 'Rather overwhelmed by the honor', she wrote out his card: 'André Gide: 1 Villa Montmorency, Paris XIV; 1 year, 1 volume.' Gide was 47. His, friendship with Oscar Wilde, defence of homosexuality, failed marriage and sexual relationship with his teenage student Marc Allégret made the uncensorious friendship of Adrienne and Sylvia important to him. He went to Adrienne's on Thursdays and to Sylvia's on Mondays to read the latest issues of the French, American and British literary journals.

The poets Jules Romains – he was a proponent of 'Unanimism', collective consciousness, as opposed to individualism – and Valery Larbaud, who wrote poems about love and desire, were subscribers. Larbaud gave Sylvia a little cracked china ornament of Shakespeare's birthplace which he had had since he was a child. Sylvia called him the godfather of her shop. The symbolist poet Léon-Paul Fargue, the biographer and novelist André Maurois, the poet Paul Valéry – all were customers too. Louis Aragon used come and recite his surrealist poems. Sylvia said one called 'La Table' had nothing in it but la table: 'the table the table the table the table…' Another poem, 'Suicide', just had all the letters of the alphabet: 'a b c d e f g h i j k l m n o p q r s t u v w x y z'.

At first, French writers went to Sylvia out of respect and affection for Adrienne, but they soon became part of the wider enterprise both women created. Of Paul Valéry, Sylvia wrote, 'As a young student under the spell of *La Jeune Parque* I would never have believed that one day Valéry himself would be inscribing my copy and that he would be coming to bring me each of his books as they appeared.' Léon-Paul Fargue did a drawing for her of her stove, left over from when the shop was a laundry.

suppressions across the sea

As for her English-speaking compatriots, Sylvia said she could not have foreseen, when she opened her bookshop in 1919, the extent to which her fortunes would be shaped by what she called 'suppressions across the sea'. The Director of Public Prosecutions in England and the Society for the Suppression of Vice in America were the moral arbiters of what could or could not be published in their countries. They kept vigilant watch for sexually explicit prose, expletives and all they considered indecent, heretical or injurious to the mind of a maiden. These lawmakers and guardians had fixed ideas of what women were and where they belonged, and a horror of lesbians, anarchists and freethinkers. They viewed homosexuality as a wilful aberration, a corrosive perversion, and kept a long list of words deemed dirty enough, whatever their context, to contaminate society. They held inordinate allegiance to an unreconstructed government of patriarchs, the story of the Christian Trinity, and the national flag.

they couldn't get *Ulysses* and they couldn't get a drink

In America, frustration at censorship of free expression was compounded by Prohibition. The Temperance Movement succeeded

in getting the Eighteenth Amendment to the Constitution ratified in 1919 and from 1920 to 1933 the drinking, sale or importing of alcohol was banned. Sylvia said the reasons for the exodus from America of almost every freethinking writer after the First World War were that they couldn't get *Ulysses* and couldn't get a drink.

Fear of censorship in Britain and America made both printers and publishers of books and journals averse to risk. Held equally responsible if a publication was deemed obscene, they faced proofs, plates and finished copies being seized and destroyed, court costs, fines, adverse publicity and even prison. In Britain, D.H. Lawrence, James Joyce and Radclyffe Hall were among those whose work was censored. All moved abroad, as did any aspiring writer who wanted to speak out about unconventional desire. The Bloomsbury Group played safe. Whatever their sexual orientation, their references were too oblique, their allegiance too strong to the rose garden and croquet on the lawn for them to threaten the fabric of English society. E.M. Forster burned most of what he called his 'indecent writings'. He kept his novel *Maurice*, his fantasy of a fulfilled homosexual relationship written in 1914, locked in a drawer; it was published posthumously in 1971. Vita Sackville-West kept her account of her passionate affair with Violet Trefusis locked in a Gladstone bag. Not until after Violet's death in 1973 did Vita's son, Nigel Nicolson, publish it as *Portrait of a Marriage*, not the portrait of a lesbian affair, which was how Vita had written it. Nigel Nicolson portrayed his father, Harold, Vita's husband, as the hero of the saga, the man whose love and tolerance saved the marriage from Violet, the evil temptress. No mention was made that Harold Nicolson was himself homosexual or that Vita was dedicated to lesbian love.

Both Harold and Vita were delighted for Virginia Woolf's *Orlando* to be published in 1928, the same year Radclyffe Hall's *The Well of Loneliness* was censored and destroyed, and to

acknowledge Vita as its androgynous hero. Virginia Woolf's sapphism was oblique, touched with genius, and bleached of scandal. Hers was the acceptable voice of gender diversity: discreet, nuanced and literary. Only Vita's mother, Lady Sackville, dissented, called Virginia 'that Virgin Woolf', pasted a photograph of her in her copy of *Orlando* and captioned it:

> The awful face of a mad woman whose successful mad desire is
> to separate people who care for each other. I loathe this woman
> for having changed my Vita and taken her away from me.

two customers from rue de Fleurus

Gertrude Stein, already ensconced in Paris and hailed as one of its monuments, was the first American writer to visit Shakespeare and Company. Alice B. Toklas was with her:

> Not long after I had opened my bookshop two women came
> walking down the rue Dupuytren. One of them with a very
> fine face was stout, wore a long robe and on her head a most
> becoming top of a basket. She was accompanied by a slim dark
> whimsical woman: she reminded me of a gypsy. They were
> Gertrude Stein and Alice B. Toklas…
>
> Her remarks and those of Alice who rounded them off were
> inseparable. Obviously they saw things from the same point of
> view as people do when they are perfectly congenial. Their two
> characters however seemed to me quite independent of each
> other. Alice had a great deal more finesse than Gertrude.
> And she was grown up. Gertrude was a child, something of an
> infant prodigy.

Gertrude subscribed to Sylvia's lending library but complained that there were no amusing books in it. Despite her often unfathomable prose, she liked to read popular fiction. Where, she wanted to know, was that American masterpiece *The Trail of the Lonesome Pine* by John Fox Junior? That was a bestselling

1908 western romance set in the Appalachian Mountains, about two feuding families, a beautiful country girl and a handsome foreigner... In 1913 it inspired a song – Gertrude's favourite – with the same title. Where too, Gertrude asked, was *A Girl of the Limberlost* by Gene Stratton-Porter, a sequel to her earlier novel *Freckles*? Sylvia apologized but wondered if Gertrude could mention another library in Paris with two copies of *Tender Buttons* circulating. *Tender Buttons* was one of Gertrude's exceedingly modernist prose pieces, which few could manage to read.

Gertrude donated her own books to the shop. She gave Sylvia a first edition of 'Melanctha', the first story in her tripartite novel *Three Lives* (someone then stole it from the bookshop). She also gave her a copy of what Sylvia called 'that thing with the terrifying title', *Have They Attacked Mary. He giggled: A Political Caricature*, and her *Portrait of Mabel Dodge at the Villa Curonia*, in which a random paragraph read:

> It is a gnarled division that which is not any obstruction and
> the forgotten swelling is certainly attracting, it is attracting
> the whiter division, it is not sinking to be growing, it is not
> darkening to be disappearing, it is not aged to be annoying.
> There can not be sighing. This is this bliss.

And she donated the August 1912 issue of *Camera Work*, published by Alfred Stieglitz, with pieces by her on Picasso and Matisse. Stieglitz brought out fifty issues of *Camera Work* between 1903 and 1917 in rebellion against 'the philistines, the exhibition authorities and institutions that clung to Victorian conventional style'. *Camera Work* championed modernism and modern art, with writings by Friedrich Nietzsche, Maurice Maeterlinck and, most importantly to Gertrude, Gertrude Stein. Sylvia called Gertrude's subscription a friendly gesture. She said she took scant interest in any books but her own:

But she did write a poem about my bookshop which she brought to me one day in 1920. It was entitled 'Rich and Poor in English' and bore the subtitle 'to subscribe in French and other Latin Tongues'. You can find it in *Painted Lace* volume V of the Yale edition of her work.

Gertrude offered the poem as a publicity incentive for subscribers to the Shakespeare and Company library. It read:

A curry comb
Or
A matter of dogs
It is this I please
Please
Seals go a long way
Or better.

Alice said it persuaded many readers to subscribe.

Gertrude tolerated Sylvia's equivocation about her writing, until Sylvia championed James Joyce's *Ulysses* as a modernist masterpiece above her own work. Up until then, she and Alice did not pass the shop without calling in. And Sylvia visited 27 rue de Fleurus, admired the paintings by Picasso and Matisse, ate Alice's cakes, went on jaunts in their model T Ford, Godiva, or Gody for short. She marvelled at the 'latest technological acquisitions': headlights that could be turned off and on inside the car, an electric cigarette lighter. Gertrude drove, Alice map-read.

Adrienne avoided Gertrude. She found her rude. On a visit with Sylvia to rue de Fleurus, Gertrude told her:

You French have no Alps in literature, no Shakespeare; all your genius is in those speeches of the generals: fanfare. Such as 'On ne passera pas!'

Adrienne chose not to visit again. Sylvia thought Gertrude lived in Paris unaware of the French. She never heard French spoken at 27 rue de Fleurus.

new voices

Sylvia had a leaflet printed with a map on the back so literary Americans in Paris could find their way to her. Ernest Hemingway, Robert McAlmon, F. Scott Fitzgerald, Paul Bowles – a roll call of modernists headed for the bookshop. She called herself 'the mother hen of the '20s'. 'Fitting people with books is about as difficult as fitting them with shoes,' she said with pride. Often it was hard for her to get any work done because visitors congregated in her shop, not spending money, but reading reviews, talking and making friends. Adrienne's shop was peaceful, she said; hers was boisterous. Eugène Jolas, publisher of the literary magazine *transition*, called her 'probably the best known woman in Paris'. Her fame lasted for the whole tenure of Shakespeare and Company, right up until Hitler's Nazi army closed it down and interned her in 1942.

It became a pattern for hopeful young American writers to arrive at the quayside, go to a cheap hotel, unpack their suitcases, go to Le Dôme, known as the Anglo-American café, at 108 Montparnasse, move on at closing time to The Dingo at 10 rue Delambre, because it stayed open all night, then next afternoon cross the Luxembourg gardens to meet the legendary Sylvia Beach, browse the magazines and book titles in her shop and talk to the 'brilliant new people' who wrote them.

Ernest Hemingway

'These young writers seemed to come to me about everything,' Sylvia said. Hemingway was a favourite. 'I have found a wonderful place', he wrote to his new wife, Hadley, on 28 December 1921.

It's full of all the good books and it is warm and cheerful and Miss Beach is a fine person. She trusted me to take these books and bring the money later.

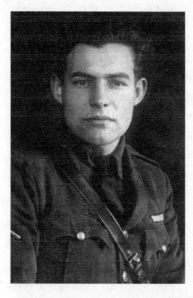

The books were by Turgenev, D.H. Lawrence, Tolstoy and Dostoyevsky.

Hemingway was twenty-two and had married Hadley, who was thirty, three months earlier. He wanted to prove himself in Paris as a novelist. Meantime, for money he was sports correspondent for the *Toronto Star*. His French was fluent. He and Hadley moved into the Hôtel d'Angleterre at 44 rue Jacob. It was clean and cheap, he told Sylvia, and they could get a high grade dinner with wine for twelve francs at the restaurant on the corner.

He sat by the fire in Shakespeare and Company and talked to Sylvia about his life. He spoke 'rather bitterly', she thought, about his childhood. He showed her his war wounds, caused by Austrian mortar fire in June 1918 when he worked as an ambulance driver with the American Red Cross in Italy: 'there was a flash, as when a blast-furnace door is swung open, and a roar that started white and went red', he wrote in a letter home. Self-effacing about his bravery and pain, despite his injuries and though still under attack, he had dragged a wounded Italian soldier to safety. Scott Fitzgerald heard from a man in the same unit that Hemingway 'crawled some hellish distance', pulling the wounded man with him, and doctors wondered why he was still alive 'with so many perforations'. He was awarded a silver medal by the Italian government.

Hemingway said of Sylvia in his memoirs, 'No one that I ever knew was nicer to me.' He thought her ignorant about sport

and suggested taking her and Adrienne to boxing matches and cycling events.

In gatherings at both Sylvia's and Adrienne's, Hemingway read his first short stories. Jonathan Cape, visiting Sylvia in Paris in 1926, asked her what new American writers he should publish: 'Here, read Hemingway,' she said. 'And that is how Mr Cape became Hemingway's English publisher.' Jonathan Cape, one of the courageous mainstream publishers of the twenties, was thwarted and punished in London by the censors for trying to publish Radclyffe Hall's *Well of Loneliness* in 1928.

the crowd...

Ezra Pound was an early visitor to Shakespeare and Company. Sylvia admired his defiance of censorship, his championing of James Joyce's work, and attempts to serialize *Ulysses* in little magazines in London and New York. 'I found the acknowledged leader of the modernist movement not bumptious,' she wrote of him. He was a fair carpenter and did handy jobs for her in the shop; he mended a cigarette box and a chair. She used to visit him for tea at his studio at 70 rue Notre-Dame-des-Champs.

Contact Editions

Robert McAlmon, American, impoverished and openly homo-sexual, became an innovative publisher by marrying Bryher, the daughter of Sir John and Lady Ellerman. By the marriage, Bryher secured her inheritance and secretly from her parents continued her relationship with the poet H.D., Hilda Doolittle. With his share of her money, McAlmon started up Contact Editions and published, often for the first time, Ernest Hemingway, Gertrude Stein, Ezra Pound, H.D., James Joyce, Ford Madox Ford, Bryher and himself.

He called at Sylvia's shop most days after his arrival in Paris in 1921. Sylvia was enamoured of him. Like her, he was the child of a pastor. He had bright blue eyes, a nasal drawl, was irredeemably social and searched out customers for her in his drinking haunts in Montparnasse. In an unpublished draft of her memoir, Sylvia said she once felt attracted to him and told him so but her 'thirteen generations of clergymen meant, to his relief, they talked only of the weather'.

McAlmon was always meaning to write the definitive book of the 1920s, and always looking for a quiet place away from people to achieve this, but when he found such places he went straight to the bars. 'The drinks were always on him', Sylvia said, 'and, alas! often in him.' Abstemious herself, she said she shared him with the Dome and the Dingo. After a while, he was permanently in his cups.

In May 1929 he wrote to her from Théoule, a resort on the Côte d'Azur, telling her he had found the perfect place, marvellous and wild, and was writing 'My Susceptible Friend, Adrian', a shocking novel, the best thing he had ever done. But then he got distracted by the sun, the wine, the 'siesta phase that comes on me unconquerably every afternoon' and the way the pension keeper could almost compete with Adrienne with her roast chicken.

Bryher called Sylvia 'an ambassador of the arts' who always knew the exact book a person needed. Bryher's main home was in Vaud in Switzerland, but she stayed with Sylvia on visits to Paris. Sylvia always gave up her bedroom to her. Sylvia disliked Switzerland, perhaps because of her unhappy time at boarding school there, so only occasionally did she visit Bryher.

The star of the 'crowd', as Sylvia called these writers whose works were on her shelves and whose friendships were in her heart, was James Joyce. Her service to him was extraordinary.

Ulysses in Paris

Sylvia first met Joyce in July 1920 at a lunch given by the poet André Spire. Ezra Pound took Joyce and his partner, Nora, to

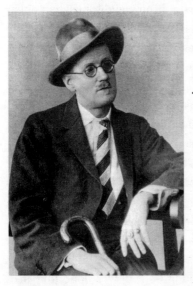

the lunch. He called him 'a damn fine writer' and wanted to help him get *Ulysses* published. He had enticed Joyce to Paris from Trieste, where he and his family were living. Joyce agreed to visit for a few days. He stayed twenty years. He completed Sylvia's triumvirate of loves. She thought him a genius and though she did not, as when Alice B. Toklas first set eyes on Gertrude Stein, hear bells in her head at such a significant encounter, she wrote about their meeting with the same sense of thrall.

Joyce had been working on *Ulysses* for seven years. In it, with Aristotelian unity, he compressed into twenty-four hours the whole existence of one man, Leopold Bloom. The chosen day, 16 June 1904, the day Joyce met his wife, Nora Barnacle, became the canvas for *Ulysses*. On that day, no thought, act, or happening was too intimate, visceral or secret to record. For societies embarrassed to mention bodily functions and where much that was thought and done must not be said, here was a book doomed to be condemned and denied by the guardians of propriety.

Joyce divided *Ulysses* into eighteen 'Episodes'. He took the theme of Homer's *Odyssey* about Odysseus's journey home from

the Trojan War to his wife, Penelope, in Ithaca. Joyce thought the Odyssey 'all-embracing... greater and more human, than Hamlet, Don Quixote, Dante, Faust'. In his version, Ulysses – Odysseus in Latin – became Leopold Bloom, an anti-hero, a pacifist, father, traveller and artist. His voyage home was from in and around Dublin. The wine-dark sea of Homer's day was the snot-green Irish sea, the monster Cyclops was a bigoted drunk who goaded and bullied Bloom; the winds that blew Odysseus and his men off course were the 'hot air' of the newspaper men. Once home, rather than slaying his rival suitors, Bloom mournfully observed the impression his wife Molly's lover had left in their bed, told her of his day, kissed her bottom and fell asleep with his head the wrong way down the bed.

James Joyce looked to Homer for inspiration for his modernist masterpiece. Lesbian modernist poets looked to Sappho and the sixth century BC.

Adamant that all his book must be printed or none of it, Joyce would not accede to censors or accept publication of a bowdlerized version. Readers in search of obscenity, profanity or accessible dirt had to dig for it. 'There's less than ten per cent of that in my book', he maintained. Nonetheless, there was enough to startle and offend those programmed to take offence. Buried not so deep were the words fuck, cunt, gleet (a discharge caused by gonorrhoea), figging (inserting a piece of ginger into the anus or vagina to produce a burning sensation); there was Bloom masturbating while listening to a Catholic choir and watching an Irish virgin show her legs; or sitting contentedly on the lavatory above his own rising smell; there was Molly Bloom's menstruation and sexual appetite... But such happenings were embedded in page on page of classical reference, enigma, puzzle, stream of consciousness, foreign phrase and obscure tangent. *Ulysses* never was or could be an easy pornographic read.

Miss Harriet Weaver fought and lost her battle of *Ulysses*

Sylvia knew of Joyce's discouraging endeavours to get *Ulysses* past the censors. Literary lesbian friends in London and New York – Harriet Weaver and Margaret Anderson – had already done their best, risked much, spent much, endured insult from critics and been thoroughly thwarted in their efforts to shepherd this 'most dangerous book' to publication.

In London, Harriet Weaver and Dora Marsden tried to serialize it in 1919 in their literary magazine *The Egoist*, which they launched in 1914. *The Egoist* evolved from *The New Freewoman*. Both were radical feminist papers, funded by Harriet, who inherited a fortune from her mother.

Harriet's prim demeanour belied her progressive views. 'I had a narrow upbringing in a small English provincial town,' she said of herself. Her father, a doctor, was an evangelical Christian with 'a deep sense of sin'. Her mother, when she found Harriet in her teens reading *Adam Bede*, a book by a woman who lived with a man who was not her husband, took the book from her and summoned the vicar. Such suppression fuelled Harriet's passion for freedom, justice and women's rights, qualities she found in Dora Marsden: 'a remarkable person, a genius and also very beautiful to look upon', she said of her.

The Egoist, subtitled 'an individualist review', quickly became England's most important modernist periodical. The poet

Richard Aldington was assistant editor; Joyce, Ezra Pound, T.S. Eliot, Amy Lowell, H.D., Lucie Delarue-Mardrus, Remy de Gourmont – all were contributors. Harriet's declared aim was:

> to probe to the depths of human nature… to regard nothing in
> human nature as foreign to it, but to hold itself ready to bring
> to the surface what may be found…

In her enthusiasm and support for James Joyce, Harriet moved far from narrow English provincialism. It was her ambition and intention to publish everything he wrote. She sent him money to enable him to keep writing and she supported him and his difficult family. The writer Rebecca West said that without Harriet Weaver, it was 'doubtful whether Stephen Dedalus and Leopold Bloom would have found their way into the world's mind'. Before *Ulysses*, from February 1914 to September 1915 Harriet had tried to serialize Joyce's *Portrait of the Artist as a Young Man*. When her printer, Ballantyne Hanson and Co., baulked in one instalment at printing fart and ballocks,* she sacked them. The next printer, without consulting her, excised from chapter 5 a description of a girl standing by the sea's edge:

> Her thighs, fuller and soft hued as ivory, were bared almost
> to the hips where the white fringes of her drawers were like
> featherings of soft white down.

Harriet sacked them too. 'I can but apologise to you', she wrote to Joyce on 28 July 1915, 'for this stupid censoring of your novel… I hope you will not have this annoyance when the novel comes to be printed in book form.'

the Egoist Press

To achieve book form, she funded her own publishing company,

* A variation on bollocks.

the Egoist Press. Thirteen printers refused to set the *Portrait* unexpurgated, so she had the sheets sent over from Joyce's New York publisher, Benjamin Huebsch, then issued the book in February 1917 under the Egoist imprint. H.G. Wells, in *The Nation*, called the *Portrait* 'memorable' and 'great writing'; *Everyman* said it was 'garbage' and John Quinn, legal defender of freedom of expression, in a review in *Vanity Fair* in New York praised Harriet for her publishing initiative and enterprise.

As for serializing *Ulysses* in *The Egoist*, she got as far as five instalments. Readers cancelled subscriptions and complained of its unsuitability for family reading. So Harriet again abandoned serialization attempts and tried to bring *Ulysses* too out in book form. No printer would touch it. She even approached Virginia and Leonard Woolf, at T.S. Eliot's suggestion, in the hope they would set it on their Hogarth press. She went to tea on Sunday 14 April 1918 but got short shrift. Virginia Woolf wrote in her diary:

> I did my best to make her reveal herself in spite of her
> appearance, all that the editress of the Egoist ought to be,
> but she remained unalterably modest, judicious and decorous.
> Her neat mauve suit fitted both soul and body; her grey gloves
> laid straight by her plate symbolized domestic rectitude; her
> table manners were those of a well bred hen. We could get
> no talk to go. Possibly the poor woman was impeded by her
> sense that what she had in the brown paper parcel was quite
> out of keeping with her own contents. But then how did she
> ever come in contact with Joyce and the rest? Why did their
> filth exit from her mouth? Heaven knows. She is incompetent
> from the business point of view and was uncertain what
> arrangements to make… And so she went.

It was a high-handed dismissal of a courageous woman who bucked the establishment in defence of women's rights and freedom of speech. The 'poor woman' had travelled far from

domestic rectitude. She challenged the prudery of the Establishment and the censorship of the judiciary and did much to 'bring to the surface what may be found'.

Ulysses wandered overseas... and was again in trouble

In New York in 1918, Margaret Anderson, with her partner Jane Heap, wanted to serialize *Ulysses* in their magazine *The Little Review*. Born in 1886 in Indianapolis, one of three daughters with a mother from hell, Margaret's principles for living were: first, not to do what you don't want to do, and, second, to do what you do want to do. She started the *Review* in 1914, when she was twenty-eight. She intended it to be the most interesting magazine ever launched and her byline was 'A Magazine of the Arts making no compromise with the public taste'.

In the March 1915 issue, she declared her lesbian identity and her championing of homosexual rights. 'With us', she wrote, 'love is just as punishable as murder or robbery...' She voiced outrage at those 'tortured and crucified every day for their love –

because it is not expressed according to conventional morality'. People went up to her in the street to congratulate her.

Like Harriet Weaver, Margaret Anderson saw patriarchal government as coercive and violent. 'Applied Anarchism' was *The Little Review*'s credo. She went to lectures by the anarchist Emma Goldman, smoked cigarettes, wore trousers and was quoted in the *Washington Post* for saying:

> Why shouldn't women do anything they want to do? [...] We are
> all in bondage to social convention and only by rebellion may
> we break those bonds. I have been in revolt since I was eight.

She met Jane Heap in 1916, described her as 'the world's best talker' and thought her ideas more interesting than anyone else's. 'We formed a consolidation that was to make us much loved and even more loathed.'

They lived together, spoke out through their magazine and published contributions from Sherwood Anderson, Mina Loy, Dorothy Richardson, Ernest Hemingway, Hope Mirrlees, Gertrude Stein, W.B. Yeats, Djuna Barnes. None of their contributors got paid.

> I don't remember ever having explained to anyone that the
> Little Review couldn't pay for contributions. It was quite taken
> for granted that since there was no money there would be no
> talk of remuneration.

The September 1916 issue had thirteen blank pages. Margaret Anderson said there was not enough good stuff to fill them. She called these empty pages a 'Want Ad'. Jane Heap filled some of the other pages with drawings of Margaret playing the piano, and the two of them horse-riding and attending anarchist meetings.

Mustir

Only two unsolicited pieces were ever accepted for *The Little*

Review. One, a poem called 'Mustir', was from Baroness Elsa von Freytag-Loringhoven. She dedicated it to Marcel Duchamp and his painting *Nude Descending a Staircase*. A bit of it read:

> The sweet corners of thine tired mouth Mustir
> So world-old tired tired to nobility
> To more to shame to hatred of thineself
> So noble soul so weak a body
> Thine body is the prey of mice.

It went on like that. The baroness lived in two rooms in New York with three dogs, and made art out of tinfoil, garbage and beads. Her husband had shot himself in Germany at the beginning of the war, which she said was the bravest act of his life. She wore a kilt and white spats and

> hanging from her bust were two tea-balls from which the
> nickel had worn away. On her head was a black velvet tam
> o'shanter with a feather and several spoons – long ice-cream
> soda spoons. She had enormous earrings of tarnished silver
> and on her hands were many rings, on the little finger were
> rings filled with shot which rang like bells when she waved her
> hands. Her hair was the colour of a bay horse. She clanked
> when she walked because of all her bracelets.

Ezra Pound became the magazine's foreign editor in May 1917. He had co-founded the short-lived journal *BLAST* in June 1914, just before the First World War, at the same time as *The Little Review* was launched. One passage in the first issue read: 'Blast France, Blast England, Blast Humour, Blast the years 1837 to 1900.' Pound sent Margaret and Jane writings for the *Review* by T.S. Eliot, Wyndham Lewis, W.B. Yeats, Ford Madox Ford and above all himself: 'I must have a steady place for my best stuff,' he told them.

Then in February 1918, with his high recommendation, he sent them the first chapter of a manuscript, which he said he

had no idea if they would publish because it would probably get them into difficulties with the censors. Margaret began reading *Ulysses* and said to Jane it was the most beautiful thing they would ever get. 'We'll print it if it's the last effort of our lives.'

the literary masterpiece of our generation

Margaret Anderson called *Ulysses* 'the literary masterpiece of our generation'. She and Jane Heap serialized the first episode in March and from then to 1920 published twenty-three instalments. They kept the text intact as written and persuaded the printer, paper suppliers and binders to push ahead without guarantee of payment. Four times, issues containing 'Episodes' were burned by order of the United States Post Office because of alleged obscenity. Few seemed to like this 'most beautiful thing'. *The New York Times* called Margaret and Jane 'purveyors of lascivious literature'.

The road to serialization was steeper than uphill. Neologisms like 'the scrotumtighteningsea' and irreverent reference to the British royal family and Roman Catholic Church were seen as gauntlets thrown for combat with the Society for the Suppression of Vice. Margaret's Serbo-Croatian printer was perhaps oblivious to what was deemed obscene, but raids and seizures of the magazine by the United States Post Office became commonplace.

episodes 4, 8, 9 and 12

Episode 4 was seized in June 1918. Ezra Pound had told Joyce, 'I suppose we'll be damn well suppressed if we print the text as it stands. BUT it is damn well worth it.' He went some way to editing out what might be perceived as obscenities, profanities

and offensivenesses, but the vice squad had only to see the name James Joyce to want to seize and censor, ban and burn.

Ezra had made an editorial effort to sanitize the account of Leopold Bloom reading his newspaper on the lavatory:

> he allowed his bowels to ease themselves quietly as he read …
> that slight constipation of yesterday quite gone. Hope it's not
> too big bring on piles again. No, just right…

And he changed Joyce's allusion to 'the grey sunken cunt of the world' to 'the grey sunken belly of the world' out of concession to mentionable body parts. Nonetheless, the magazine was confiscated by the Post Office.

So too was episode 8, 'Lestrygonians', in the January 1919 issue, in which Bloom recalled an early sexual experience with his wife, Molly:

> High on Ben Howth rhododendrons a nannygoat walking
> surefooted, dropping currants. Screened under ferns she
> laughed warmfolded. Wildly I lay on her, kissed her; eyes, her
> lips, her stretched neck, beating, woman's breasts full in her
> blouse of nun's veiling, fat nipples upright. Hot I tongued her.
> She kissed me. I was kissed. All yielding she tossed my hair.
> Kissed, she kissed me.

Off that went to the bonfire, as did the May 1919 issue, which included the second half of episode 9, 'Scylla and Charybdis', and the January 1920 issue containing the third instalment of episode 12, 'Cyclops'.

episode 13 'Nausicaa'

Worse than confiscation came with episode 13, 'Nausicaa', where Leopold Bloom surreptitiously masturbates at the sight of Gerty MacDowell's leg, while inside the church the choir sings *Laudate Dominum omnes gentes* and in the distance is a firework display:

And she saw a long Roman candle going up over the trees up, up, and, in the tense hush, they were all breathless with excitement as it went higher and higher and she had to lean back more and more to look up after it, high, high, almost out of sight, and her face was suffused with a divine, an entrancing blush from straining back and he could see her other things too, nainsook knickers, the fabric that caresses the skin, better than those other pettiwidth, the green, four and eleven, on account of being white and she let him and she saw that he saw and then it went so high it went out of sight a moment and she was trembling in every limb from being bent so far back he had a full view high up above her knee no-one ever not even on the swing or wading and she wasn't ashamed and he wasn't either to look in that immodest way like that because he couldn't resist the sight of the wondrous revealment half offered like those skirt-dancers behaving so immodest before gentlemen looking and he kept on looking, looking. She would fain have cried to him chokingly, held out her snowy slender arms to him to come, to feel his lips laid on her white brow the cry of a young girl's love, a little strangled cry, wrung from her, that cry that has rung through the ages. And then a rocket sprang and bang shot blind and O! then the Roman candle burst and it was like a sigh of O! and everyone cried O! O! in raptures and it gushed out of it a stream of rain gold hair threads and they shed and ah! they were all greeny dewy stars falling with golden, O so lively! O so soft, sweet, soft!

the lesbian business

John Sumner, Secretary of the New York Society for the Suppression of Vice, was a conscientious suppressor. He ordered proprietors to remove indecent window displays, he arrested cross-dressers, watched plays and movies deemed dubious,

sought out questionable books and magazines and personally supervised the burning of those labelled obscene by the courts. In the Washington Square Book Shop, he bought his 'Nausicaa' edition of *The Little Review*. Two weeks later, Josephine Bell, the shop's proprietor, was arrested and charged for selling it to him. She had previously been indicted for writing a poem in praise of Emma Goldman and anarchism.

John Quinn was a lawyer, friend and patron to Ezra Pound and a supporter of Joyce's work. He fought key legal battles to defend modernist writers and artists against censorship laws. A big burly man, an Irish American loyal to his roots, his grandfather, a blacksmith, had emigrated to Ohio from Limerick. Quinn was also an art collector and in 1913 in New York he staged the first large-scale exhibition of modern art in America.

He gave financial backing to *The Little Review*, arranged the transfer of court charges from the Washington Square Book Shop to Margaret and Jane and took on their legal defence pro bono. But he castigated them for getting into this fix: 'You're damn fools trying to get away with such a thing as *Ulysses* in this puritan-ridden country,' he told them. He said it was their job to exercise editorial judgement.

> An artist might paint a picture of two women doing the Lesbian business, but the owner of a gallery would be an idiot if he hung it.

But Margaret Anderson and Jane Heap were unapologetic. They wanted a picture of two women 'doing the Lesbian business' judged on artistic merit, not by prejudice against its content. They wanted publication of *Ulysses* and for the Society for the Suppression of Vice to be demolished. They were fed up with the antics of men like John Sumner.

The trial for the publication of obscenity was held in October 1920 before the Court of Special Sessions. Sumner knew all about

Margaret Anderson and Jane Heap. They were radical feminists, who supported anarchism and homosexual rights. They were lesbians. They wore trousers. They lived together. Margaret personally confronted him in Eighth Street and

> engaged in such a passionate exchange of ideas that we had to go into the Washington Square Bookshop to finish. He was full of quotations from Victor Hugo and other second rate minds…

eat the stars

There was a judge and two prosecutors. Quinn told Margaret and Jane to behave themselves and stand up when these elderly men entered. 'Why must I stand up as a tribute to three men who wouldn't understand my simplest remark?' was Margaret's response. She said two of the men slept through most of the proceedings. Which did not go well. Joyce was an artist on a par with Shakespeare, Dante and Blake, Quinn told the court. As a witness he called Philip Moeller, co-founder of the New York Theatre Guild. Moeller tried to explain the Freudian subconscious mind so as to help the court realize the intellectual underpinning of *Ulysses*. The judge asked him to speak in a language the court could understand. One of the prosecutors wanted the obscene bits read out. The judge said that should not happen in Margaret Anderson's hearing. Quinn explained she was the publisher. The judge replied:

> I am sure she didn't know the significance of what she was publishing. I myself do not understand *Ulysses*… It sounds to me like the ravings of a disordered mind. I can't see why anyone would want to publish it.

Though the ostensible aim of these sleepy white-haired old men was to protect the sensibilities of women, of the sort they supposed their wives and daughters to be, in fact theirs

was an exertion of male authority and power over women. It had been Joyce's partner, Nora, who inspired the book, Harriet Weaver who funded it, Margaret Anderson and Jane Heap who serialized it. Had the all-male court known that most of the women involved, past and future, in this fraught publishing enterprise were lesbian, it would have further fuelled their intent to suppress publication of the ravings of a disordered mind.

Margaret and Jane were sentenced to either ten days in prison or a fine of $100. They had no money and payment was made by Joanna Fortune, a wealthy customer from Chicago. The two editors were then felons with a criminal record. When their fingerprints were taken, Margaret made a fuss about dipping her fingers into the sticky gum, said she could not use the court soap, insisted on more towels and a nail brush, and told them she would sue if her hands were disfigured.

No New York newspaper came to their defence or spoke out for Joyce. 'The position of the great artist is impregnable,' Margaret wrote in the *Review*'s next edition.

> You can no more limit his expression, patronizingly suggest
> that his genius present itself in channels personally pleasing to
> you, than you can eat the stars.

She had aspired to make *The Little Review* the most interesting magazine ever launched. She felt she was done. 'Ten years of one's life is enough to devote to one idea – unless one has no other ideas,' she said. She suffered a depressive breakdown, felt disaffected with America and voiced dislike of intellectuals who learned about life from books rather than experiencing it. She said she knew the difference between life and death in everything and that was all she needed to know.

Then in New York she met the opera singer and actor Georgette Leblanc, who for many years had been the playwright Maurice Maeterlinck's lover. They fell in love, left for France and lived

there together for twenty years. It was as if Margaret Anderson gave up fighting for modernism and lived it. Like Natalie Barney, she wanted her work of art to be her life. She, Georgette, Jane Heap and Solita Solano became followers of the philosopher Gurdjieff at his 'Institute for the Harmonious Development of Man' in Fontainebleau. She talked of existing in relation to the mystery of the universe.

In 1930 she published her autobiography, *My Thirty Years' War*. In it, she described herself as happy and her perceived hardships as illusions: 'I have never been too hungry or too tired, too ill or too cold, too ugly or too wrong...' She spoke of her passion for music, nature and ideas and said her true happiness was founded on her love for Georgette Leblanc. This idyll lasted until June 1939 when, in rue Casimir Périer in Paris, Georgette said to her: 'Look at this curious little swelling. I wonder what it is.' Margaret then felt she faced two wars: Hitler and Georgette's inoperable breast cancer.

the greatest writer of my times

When Sylvia Beach first met James Joyce at André Spire's lunch in July 1920, she had read in both *The Egoist* and *The Little Review* such episodes of *Ulysses* as had escaped the bonfires of puritanism. She was thrilled to meet him in person. Neither of them had been invited to the lunch. Sylvia went with Adrienne, Joyce was taken there by Ezra Pound. Spire, a Zionist activist as well as a poet, was founder in 1912 of the Association des Jeunes Juifs, and at the time of the Dreyfus affair (in which a Jewish artillery captain in the French army was falsely convicted of passing military secrets to the Germans), he had been shot in the arm while fighting a duel with an anti-Semitic columnist for *La Libre Parole*.

Sylvia talked first to Joyce's partner, Nora. Tall, with Celtic golden hair and bright eyes, Nora was grateful for conversation in English. She told Sylvia she could not understand a word of what the others were talking about in French but would have been fine were the conversation in Italian. She said she never read what Joyce wrote and wished she had married a farmer, a banker, a ragpicker... anyone but a writer. She complained that he never stopped scribbling, reached for paper and pencil first thing in the morning then went out when lunch was on the table. None the less, Sylvia thought the relationship worked:

> What a good thing for Joyce, I thought, that she had chosen
> him. What would he have done without Nora? And what
> would his work have done without her?

She thought Nora kept Joyce sane. At Spire's lunch, Joyce turned his wine glasses upside down to show he was not drinking alcohol. Ezra kept trying to persuade him. Joyce insisted he never drank until the evening – then he usually got through a couple of bottles of Vouvray. At the end of the lunch, he went into Spire's small library. Sylvia found him there, 'drooping', as she put it. 'We shook hands; that is, he put his limp, boneless hand in my tough little paw.' She described him as of medium height, thin, slightly stooped, his eyes deep blue. His right eye looked wonky, with the lens of his spectacles thicker than the left. (He had glaucoma and constant and progressive trouble with his sight.) His hair was thick and sandy coloured, his skin fair, his beard 'a sort of goatee', his voice 'pitched like a tenor's'. He wore bejewelled chunky rings on the middle and third fingers of his left hand. He asked Sylvia what she did for a living, seemed amused by her name, and that of her shop, wrote them down in a little notebook and said he would come the next day to visit her.

Sylvia Beach had found her third great love.

She felt at ease in this initial encounter, 'overcome though I

was in the presence of the greatest writer of my times'. Outside in the street, a dog barked. Joyce went pale, trembled and asked: 'Is it coming in? Is it fierce?' Sylvia assured him it was only chasing a ball. He told her he had been afraid of dogs since one bit him on the chin when he was five. His beard was to hide the scar. He was afraid of many things: thunder, heights, the sea, infections. Two nuns in the street would bring bad luck, so would walking under a ladder, a hat left on a bed, an umbrella opened indoors. Black cats were lucky.

He had quaint ideas of propriety and of what could or could not be said in front of women. Formal and prudish in conversation, he never swore and was overly courteous. At home, he liked playing the piano and making up songs – musical hall numbers about a Mr Dooley. His son, Georgio, trained as an opera singer and his daughter, Lucia, as a professional dancer.

Shakespeare and Company to the rescue

Joyce called at Shakespeare and Company the day after the lunch. He sat twirling an ash-plant cane. Sylvia shooed her friendly little dog, Teddy, 'an intellectual', into the back room. Lucky, the black cat, stayed. (Lucky chewed customers' gloves and Hemingway's hat.) Joyce joined the library and Sylvia wrote out a card: 'James Joyce: 5 rue de l'Assomption, Paris; subscription for one month; seven francs.' He borrowed a copy of the Irish play *Riders to the Sea* by John Millington Synge, which he had once translated into German. Set on the Aran Islands in Ireland, it was about a woman whose husband and five sons drown.

Joyce lamented his problems in getting his work published. Obscenity had been the cry, censorship the reality, from as far back as 1905 when he first tried to get *Dubliners* published. Twenty-two publishers and printers turned that down. Then it took a decade before *A Portrait of the Artist as a Young Man* was

published. And now *Ulysses*... He had used up his entire savings getting to Paris. He had come here in an effort to finish his book. He had been working on it for seven years. He had to write at night, which was straining his eyes. He needed to find somewhere to live for himself, his wife and children. He would have to work as a language teacher to provide for them all. Could Sylvia help him find students? He could teach five languages: Italian, French, German, Greek, English; six perhaps – he had learned Norwegian in order to read Ibsen; seven maybe – he spoke Yiddish, knew Hebrew...

Joyce began to frequent Shakespeare and Company like other young writers, though Sylvia put him in a class of his own: 'I didn't imagine a James Joyce going in and out the door.' One day in the winter of 1920, he brought in the copy of *The Little Review* with episode 13, 'Nausicaa'. He lamented the charges against the editors and the court verdict in New York. 'My book will never come out now', he said, and sat with his head in his hands. Sylvia found it intolerable to see him so abject and to hear how his masterpiece was pilloried by heathens. 'Would you like me to publish *Ulysses*?' she asked. Joyce said: 'I would.'

She thought he seemed relieved, though it concerned her that he was putting a book it had taken him seven years to write, and which in her view ought to have been the crown of a great publishing house, into the hands of someone young, inexperienced, and not a publisher. But there was no hope of an established publisher taking it on in the English-speaking countries.

the diligent editor and the exigent author

'Undeterred by lack of capital, experience and all the requisites of a publisher I went right ahead with *Ulysses*,' Sylvia wrote. She called Shakespeare and Company 'my literary welfare work' and publishing *Ulysses* 'my missionary endeavour'. Adrienne approved the plan and was her adviser.

Joyce took over Sylvia's life. He arrived at the bookshop at noon each day and returned again in the early evenings. Sylvia attended to his correspondence and became his banker, agent and publicist. She rivalled Alice B. Toklas's dedication to Gertrude Stein. Joyce worked all hours on *Ulysses*, reworking the same passages, but it was not a book he would ever declare finished.

Sylvia unwaveringly thought *Ulysses* a masterpiece. She saw its integrity as a work of art. Transparency was allied to mentioning what some might deem unmentionable. Joyce, prudish in person as in many ways was she, dismissed the idea that in literature there were words or thoughts that were off limits. Sylvia agreed. She deplored censorship and the entrenchment into law of what could or could not be said. 'You cannot legislate against human nature' was her view of laws that criminalized free expression.

By offering to publish the book, she took on far more than she

could reasonably manage. Joyce was obsessively painstaking and worse than demanding. He could not get on with fountain pens or typewriters, wrote with black pencils bought from W.H. Smith, and his handwriting and directions were hard to read. He created a complicated schema of different passages, marked in coloured pencils and peppered with annotations. He put all sorts of cross references on a card index, then pieced passages together. Typists went haywire. Cyprian Beach and Robert McAlmon helped – both were reasonably good at deciphering illegible handwriting. McAlmon was cavalier and made stuff up when manuscript marks were too complicated. Joyce noticed.

He haunted the bookshop in gloom about his book's prospects. Sylvia and Adrienne called him Melancholy Jesus. He thought if a dozen copies were printed, there would be some left over.

one man's day and life

Joyce explained his book as the epic story of two races – Israel and Ireland – as well as an account of both one man's day and life, and of the cycle of the human body. His reader was not invited to distinguish between an external and internal voice. Joyce said Job, not he, invented the interior monologue. Gertrude Stein thought it was neither Job nor Joyce but herself with her magnum opus, *The Making of Americans*. The 'continuous present', she called her efforts. She viewed Sylvia's proposed publishing of *Ulysses* as betrayal, cancelled her subscription to Shakespeare and Company and joined the American Library in Paris. Joyce was her rival and undeserving of accolade. *She* was the genius, the architect of modernism. *She* created twentieth-century style.

Sylvia, who took a grown-up view of such rivalry, described her and Gertrude's relationship as 'friendly protagonists'. Nor, of course, did she think Joyce a lone modernist. Dorothy Richardson was another woman writer who changed the landscape of fiction.

She published episodes of her long semi-autobiographical work *Pilgrimage* from 1915 up until her death in 1957. *Pilgrimage* was about a Londoner, Miriam Henderson, who rejects nineteenth-century ideas of femininity and evolves a new gender identity somewhere between masculine and feminine. With publication of the first episode, 'Pointed Roofs', Virginia Woolf said Dorothy Richardson had:

> invented, or, if she has not invented, developed and applied to her own uses, a sentence which we might call the psychological sentence of the feminine gender.

May Sinclair, in a review of 'Pointed Roofs', used the term 'stream of consciousness'. Dorothy Richardson disliked the term and did not think she was writing a novel. She told Sylvia that Proust, James Joyce, Virginia Woolf and herself were all simultaneously using the 'new method' in writing style, though very differently. Proust's first volume of *À la Recherche du temps perdu* was published in 1913 while she was finishing 'Pointed Roofs'. James Joyce had begun *Ulysses* and Virginia Woolf had written her first novel, *The Voyage Out*.

he spends money like a drunken sailor

Money, or lack of it, was from the start a big problem with Sylvia's publishing enterprise. Bryher helped by shifting money into Sylvia's account. Sylvia regularly gave small amounts of this to Joyce. At first he repaid her, but then he did not. Harriet Weaver then made Joyce a bequest to provide him with sufficient monthly income for life. 'Saint Harriet', Sylvia called her.

> It was a tremendous relief to feel that I could now go ahead and publish *Ulysses*, and also that Shakespeare and Company was free of encumbrance, so to speak.

The allowance was sufficient for a reasonable person to live on, but not Joyce. He was a spendthrift.

> It wasn't long before he was again hard up and Miss Weaver came again to his help. Adrienne and I just managed to make ends meet by living in the simplest style, but Joyce liked to live among the well-to-do.

That was Sylvia's polite way of reproaching him. Joyce liked to travel first class. When he visited Harriet Weaver in London, he booked his whole family into the Strand Palace Hotel. In Paris, he and his family dined most nights at Le Petit Trianon at the corner of boulevard Montparnasse and rue de Rennes. The proprietor and staff greeted him from his taxi, took him to his special table, the head waiter read the items from the menu. Joyce cared little for food but he urged his guests to choose the best on the menu and the finest wines. The waiter kept his glass filled.

> Joyce would have sat there with family and friends and his white wine till all hours if at a certain moment Nora hadn't decided it was time to go. He ended by obeying her...

His tips were famous – to the waiters, the attendant who took his coat, the doorman who fetched him a taxi. 'I never grudged tips', Sylvia wrote, 'but knowing the circumstances, it seemed to me that Joyce overtipped.' She said he enjoyed spending the way other people might enjoy hoarding. A publisher, visiting her shop after dining out with Joyce, said: 'He spends money like a drunken sailor.' His parties were elaborate – food supplied by the best caterers, the best wines, though for himself he preferred large quantities of an ordinary white, a waiter hired to serve. He assiduously remembered birthdays and sent huge bouquets of flowers – all of which showed his generosity and largesse – except that the money came from women friends, not employers.

Darantiere of Dijon

Adrienne's printer, Maurice Darantiere in Dijon, agreed to take on the typesetting and printing. He and his father before him were master printers. They had printed J.K. Huysman's *À rebours* and other contentious writers. Darantiere shared his house with his young assistant, liked good food and was unfazed by colourful relationship or supposedly dirty words. He did not know, though, what he was letting himself in for with *Ulysses*. He did not use linotype machines. He cast Joyce's 600-page novel, one letter at a time, from tiny metal blocks. The process would have been laborious and costly even with minimal corrections. Joyce viewed proofs as manuscript drafts to be revised; there was no point at which he considered his book finished and Sylvia told Darantiere to give him all the galleys he wanted.

Sylvia had no capital so Darantiere agreed to wait to be paid until her subscriptions came in. He printed a prospectus advertising the publishing by Shakespeare and Company of *Ulysses* by James Joyce, 'complete as written'. The edition would be limited to 1,000 copies, 100 on Hollande paper and signed by Joyce for sale at 350 francs, 150 on Arches paper with special binding at 250 francs and 750 on ordinary paper at 150 francs. There was a photograph of Joyce and excerpts from reviews of the episodes serialized in *The Little Review*.

Prepaid orders came in fast, though Sylvia did not want to bank this money before delivery. Gide, 'always sure to give his support to the cause of freedom of expression', subscribed, as did W.B. Yeats. Ernest Hemingway wanted several copies. Robert McAlmon 'combed the nightclubs for subscribers'. T.E. Lawrence ordered two of the expensive editions. George Bernard Shaw was antipathetic and complained to Sylvia of the book's 'foulmouthed, foul-minded derision and obscenity'.

Sylvia wrote to Holly on 23 April 1921: 'I am about to publish Ulysses – of James Joyce. It will appear in October.' She voiced hopes that this might put her shop into profit. Both projections were optimistic.

grey bare hairy buttocks

Printing was held up because no typist could transcribe the 'Circe' episode. Seven typists failed to make sense of it, the eighth threatened to throw herself out of the window, the ninth rang the bell of Shakespeare and Company, flung the pages she had attempted to transcribe through the door, then dashed off down the road. Cyprian did her best then handed over to her friend Raymonde Linossier, one of the few women barristers in Paris. Raymonde often helped Sylvia in the shop but had to conceal her lesbian, feminist and freethinking interests from her father. Francis Poulenc hoped for a lavender cover-up marriage with her to hide his homosexuality but she declined. Raymonde struggled with forty-five pages then passed the manuscript to a Mrs Harrison, whose husband worked at the British Embassy. He found pages on his wife's desk describing Father Malachi O'Flynn celebrating a black mass. He read:

> 'I'll do him in, so help me fucking Christ! I'll wring the bastard
> fucker's bleeding blasted fucking windpipe!'
> (The Reverend Mr Love raises high behind the celebrant's
> petticoats revealing his grey bare hairy buttocks between which
> a carrot is stuck.)

Mr Harrison raged, threw the manuscript pages on the fire and chased his wife into the street. John Quinn in America had the only other manuscript copy. Sylvia, Joyce and Darantiere had to wait for him to send photographed copies of the destroyed pages.

Sylvia's father was a minister, Harriet Weaver's a doctor and

an evangelical Christian. Both Sylvia and Harriet seemed prim in aspect. Virginia Woolf had said Harriet symbolized 'domestic rectitude'. Carrots up clergymen's bottoms were not the customary narrative for daughters of the pious.

By allowing Joyce to go into proof after proof, the cost to Sylvia in time and expense was huge. His alterations alone added 4,000 francs to the quoted printing price. She took on an assistant to help with all the extra administration: a Greek subscriber, Myrsine Moschos, who was with her for nine years.

> Joyce was delighted to hear of my Greek assistant. He thought it a good omen for his Ulysses. Omen or no omen, I was delighted to have someone to help me now, and someone who was a wonderful helper.

Stratford on Odéon

In the middle of this fraught publication process, Sylvia moved shop. Adrienne, as ever, was the enabler. The antique dealer opposite her in rue de l'Odéon wanted someone to take over her lease. Though the timing was inconvenient for Sylvia, it was an opportunity too good to miss: she and Adrienne could be closer and their events cross-cultural. Adrienne's customers were interested in the young American and English writers flocking to Paris. Adrienne was working to publish a French translation of *Ulysses*. At the end of the street in boulevard Saint-Germain were the literary cafés – the Flore, the Deux Magots. There was more floor space in the new premises, there was a room at the back with a fireplace, and two small upstairs rooms that Sylvia could rent out, as Harold Monro did in London. The composer George Antheil was to live up there for several years. His *Ballet Mécanique*, first performed in 1926, was played with pianos, drums, xylophones, aeroplane propellers, pieces of tin and amplifiers. Sylvia described him as a 'fellow with bangs, a

squished nose and a big mouth with a grin in it. A regular high school boy.'

In the summer of 1921, Sylvia, Holly, Myrsine and Myrsine's sister Hélène carted everything to the new shop: baskets of unanswered correspondence marked Urgent, furniture, books, magazines, the portraits, Whitman manuscripts, Blake drawings and Lucky the black cat and Teddy the dog. Adrienne called their new set-up 'Odéonia' because the glass windows of their shops reflected each other. Joyce called it Stratford on Odéon. The two bookshops defined the street.

Moving and adapting the new premises involved more expense. On 22 September 1921, Sylvia asked Holly to lend her 1,000 francs:

My carpentry bill will be handed in any day now, and mother, who was going to lend me all the money for my moving expenses, had to stop off in the midst having… had a great deal of expense getting Cyprian equipped as a rising star. My business is going well and I could tackle the carpenter bill if I didn't have to put every single centime aside to pay the printer of Ulysses five thousand francs on the 1st of December. He requires it and naturally the cheques from subscribers will not arrive in time for that first payment. I am making an average of 100 a day in the shop but I have to keep paying pounds to London publishers out of that and my living expenses which I try to make as low as possible. If you could lend me a thousand I would start to pay you back each month after January all the fortune I owe you. I shall be sure to take in about 4000 a month this winter. My business has increased since I moved and it was a good move in every way. But I've had to pay a good many of the moving expenses. Holly dear you must not hesitate to refuse if you can't afford to loan me anything. You have a right to turn with the 'poorest sort of worm'. 'Hell's Bells' as Uncle Tom would explain.

Holly sent the money: 'Holly dear', Sylvia wrote on 24 October,

I shan't forget you sending me all that money and some day you are going to get an awful shock when you see me un-lending it again to its owner. ha ha...

Sylvia's constant requests for money might seem like importuning, but the service she gave needed subsidy. Janet Flanner called her:

the great amateur woman publisher... She exerted an enormous transatlantic influence without recognizing it... she had a vigorous clear mind, an excellent memory, a tremendous respect for books as civilizing objects and was a really remarkable librarian.

In Janet Flanner's view, no man would have given James Joyce a comparable publishing service: 'The patience she gave to him was female', she said, 'was even quasi maternal in relation to his book.' She called Sylvia 'the intrepid, unselfish, totally inexperienced and little moneyed young lady publisher of *Ulysses* in Paris in 1922'.

the first reading

On 7 December 1921, two months before publication, Sylvia arranged for the first reading of *Ulysses* at Adrienne's bookshop. Advanced warning was sent to Les Amis that the language was bold. The bookshop was packed; 250 people crowded in. The lights failed at one point but the event was a success. Readings at Shakespeare and Company followed and people began to view the place as a Joycean workshop. Joyce went on making corrections, alterations and additions to proofs, and then corrections, alterations and additions to the corrections, alterations and additions. And then corrections... At least a third of his novel was added at proof stage. No mainstream publisher would have countenanced such expense and madness. There was no

way Joyce would ever, could ever, consider his book finished. It moved to final proof only when Sylvia and Darantiere in despair could take no more changes. Joyce's prose blossomed and blossomed because Sylvia allowed and financed this, but the unceasing proofreading and changes were a nightmare. Her own eyesight worsened and so did her headaches.

2 February 1922

The autumn of 1921 came and went. No *Ulysses*. Sylvia and Darantiere vexed over production detail – like getting the right blue of the Greek flag for the binding. Darantiere's search took him to Germany but the blue was on flimsy paper so he lithographed the colour on to white card.

Sylvia had promised the book would be out for Joyce's birthday on 2 February 1922. He did not send back final corrected proofs until 31 January. Darantiere worked through the night. On the morning of Joyce's fortieth birthday, a Wednesday, Sylvia went to Gare de Lyons to collect two advance copies from the Dijon train. She took one to Joyce as his birthday present and put the other in the window of Shakespeare and Company. Within hours there was a queue of people wanting to order a copy. There was an average of one to six errors per page. Attempts to correct these mistakes in subsequent printings led to the creation of new errors. To stir the confusion, Joyce added deliberate mistakes to challenge his readers and delight his critics.

Copies arrived at the shop through February and March. Joyce signed the deluxe editions and helped Sylvia and Myrsine send out others. The average selling price in Paris was 136 francs. In England and Ireland it was around £40. Though no publisher had risked their imprint for it, and bookshops were chary of stocking it, this was a notable literary event. Reviewers and critics responded. John Middleton Murry in *The Nation*

and Athenaeum called it 'a remarkable book of inspissated obscurities' and Joyce 'a half-demented man of genius who tore away inhibitions and limitations'. Arnold Bennett called Joyce an 'astonishing phenomenon in letters'. The *Observer*'s reviewer said: '… the very obscenity of *Ulysses* is somehow beautiful and wrings the soul to pity.' Virginia Woolf said it was the work of 'a self-taught working man… egotistic, insistent, raw, striking, & ultimately nauseating'. And George Bernard Shaw called the book obscene, foul-mouthed and foul-minded: 'I am an elderly Irish gentleman and if you imagine that any Irishman much less an elderly one would pay 150 francs for such a book you know little of my countrymen.' In fact, some Irishmen paid 350 francs for the deluxe edition.

Whatever this book was or was not, it was a literary happening. More than the thousand copies were needed. Harriet Weaver compiled extracts of reviews for publicity. Fan mail and comment came from far-off parts of the globe. By the end of 1922, *Ulysses* was Shakespeare and Company's bestselling book. That year also, in England, T.S. Eliot published *The Waste Land* and Virginia Woolf brought out *Jacob's Room*; in New York, F. Scott Fitzgerald published *The Beautiful and Damned* and *The Diamond as Big as the Ritz*; in Paris, Marcel Proust published the *Sodome et Gomorrhe* sequence of his epic *À la Recherche du temps perdu*; and at the Gare de Lyon, a briefcase with the entire year of Ernest Hemingway's writing was stolen and not retrieved.

Nora wants to leave

In March 1922, Harriet, responding to yet another request by Joyce for money, sent him £1,500. Which totalled £8,500 she had gifted him.* Her original intention was to give him the

* Equivalent to about £500,000 in 2020.

means to write, but this stretched to help with living and medical expenses, Nora's clothes, care for Lucia, the hotels where the family took holidays. Harriet agreed with Joyce that after his efforts with *Ulysses* he needed to take a holiday. Nora saw a different opportunity. She had had enough. Joyce had published his unreadable book, she was homesick for Ireland, she had not been back for ten years, she would take Harriet's money and go home to her mother, Annie Barnacle, in Galway.

It was not a realistic escape. There was no place for Nora with her mother. Nora was born in Galway workhouse on 21 March 1884. Her father, a baker, was illiterate and an alcoholic. She had been left with her maternal grandmother, Catherine Healy, when she was two. She worked as a laundress when she was twelve and was a chambermaid in a Dublin hotel when she met Joyce.

Joyce begged her not to leave him. Ireland, he warned, was in turmoil, she would not be safe, he could not manage without her, the worry affected his eyes. Nora set off with Lucia and Giorgio at the end of March. Joyce collapsed in Shakespeare and Company, beseeched McAlmon to help him and in April wrote imploring letters to Nora:

'My darling, my love, my queen: I jump out of bed to send you this. Your wire is postmarked 18 hours later than your letter which I have just received. A cheque for your fur will follow in a few hours and also money for yourself. If you wish to live there (as you ask me to send two pounds a week) I will send that amount (£8 and £4 rent) on the first of every month… Evidently it is impossible to describe to you the despair I have been in since you left. Yesterday I got a fainting fit in Miss Beach's shop and she had to run and get me some kind of drug. Your image is always in my heart. How glad I am to hear you are looking younger! O my dearest, if you would only turn to me even now and read that terrible book which has now broken the heart in my breast and take me to yourself alone to do what you will! I have

only 10 minutes to write this so forgive me. Will write again before noon and also wire. These few words for the moment and my undying unhappy love. Jim'

Ireland was a war zone. Annie Barnacle's house was small. Nora's children were unhappy there and within weeks the family was reunited in Paris to continue their chaotic life.

I have read pages 690 to 732

James Douglas, editor of London's *Sunday Express*, did his worst for *Ulysses* on 28 May 1922. 'Beauty and the Beast', he headlined his swipe. This, he said, was 'the most infamously obscene book in ancient or modern literature':

> All the secret sewers of vice are canalised in this book's flood
> of unimaginable thoughts, images, and pornographic words.
> And its unclean lunacies are larded with appalling and revolting
> blasphemies directed against the Christian religion and against
> the holy name of Christ...

The law enforcers got involved on 12 December. In accordance with an act of 1876, a customs officer at Croydon airport intercepted and confiscated a posted copy of *Ulysses*. The importer 'protested the seizure' and called the book 'a noteworthy work of art by an author of considerable repute which is being seriously discussed in the highest literary circles'.

The customs official sent the contentious noteworthy work of art to Sir Archibald Bodkin, Director of Public Prosecutions, with a request for his early opinion. Within days, Sir Archibald sent his report to the Home Office. He had not got on well with *Ulysses*:

> As might be supposed I have not had the time, nor may I add
> the inclination to read through this book. I have however
> read pages 690 to 732. I am entirely unable to appreciate how
> those pages are relevant to the rest of the book or indeed what

the book itself is about. I can discover no story. There is no introduction which gives a key to its purpose and the pages above mentioned, written as they are as if composed by a more or less illiterate vulgar woman, form an entirely detached part of the production. In my opinion there is more, and a great deal more than mere vulgarity or coarseness, there is a great deal of unmitigated filth and obscenity.

The book appears to have been printed as a limited edition in Paris where I notice the author, perhaps prudently, resides. Its price no doubt ensures a limited distribution. It is not only deplorable but at the same time astonishing that publications such as *The Quarterly Review*, the *Observer* and *The Nation* should have devoted any space to a critique upon *Ulysses*. It is in the pages mentioned above that the glaring obscenity and filth appears. In my opinion the book is obscene and indecent and on that ground the Customs authorities would be justified in refusing to part with it.

It is conceivable that there will be criticism of this attitude towards this publication of a well-known writer; the answer will be that it is filthy and filthy books are not allowed to be imported into this country. Let those who desire to possess or champion a book of this description do so.

This guardian of the nation's morals did not have a clue what the book was about. He had skipped to the final soliloquy by Molly Bloom – who was a woman, and moreover an uneducated Irish woman. Another ardent moral crusader, the Home Secretary Sir William Joynson-Hicks – he raged a relentless war against the work of D.H. Lawrence – agreed with Sir Archibald, whom he knew from the Garrick Club:

Fortunately the book is too expensive to command a wide circle of readers. The fear is that other writers with the love of notoriety will attempt to write in the same vein.

Joynson-Hicks signed interception warrants instructing postal

confiscation. Any chance of orderly sales of *Ulysses* ended. The grand old men of England were clear about what 'their' women should be allowed to hear, say, read or be. The lesbian publishers of *Ulysses* were equally clear in their resistance to male tyranny and stupidity.

In 1926, the critic F.R. Leavis asked that Galloway and Porter, a respected Cambridge bookshop in Sidney Street, founded in 1902, be allowed to import copies of *Ulysses* for his lectures and for the university library. Sir Archibald quashed the idea:

> It was hardly credited that this book shall be proposed as the subject of lectures in any circumstances but above all that it should be the subject of discussion and be available for the use of a mixed body of students.

Silence was the way to preserve the status quo. Women must be kept in their place, protected by and answerable to men like Sir Archibald.

a copy stuffed down his trousers

For Sylvia, struggle and chaos defined the distribution of *Ulysses* from writer to reader. Getting subscribed copies to American readers was a problem. The United States Post Office confiscated and destroyed any sent through the mail. Ernest Hemingway helped devise a distribution plan, which involved a Canadian painter friend of his, Bernard Braverman. *Ulysses* was not banned in Canada. Sylvia shipped forty copies to Braverman at his Ontario address. Each day he then took the ferry to the States with a copy stuffed down his trousers. After a few weeks he got a friend to help until all subscribed copies were smuggled through. They were then sent to private addresses via American Express.

The whole procedure was fraught, slow and costly. Sylvia had edited and published what came to be judged a modernist

masterpiece, a turning point in the history of the novel. She and her shop were at the centre of this evolution. Her efforts brought fame, infamy and financial loss. Looking after Joyce took up swathes of her time and energy. She seemed to capitulate to his every need. 'He is such a terribly nervous, sensitive man', she wrote to Harriet Weaver on 8 June 1922. To keep going, she depended increasingly on gifts of money – from John Quinn, Harriet Weaver, Bryher, Bryher's mother, Holly, Cyprian, Mary Morris, who was her mother's wealthy cousin, Mary Morris's granddaughter Marguerite McCoy in Overbrook, Pennsylvania...

As recompense for all her efforts, production expenses and 'several hundred francs postage', Joyce gave her the manuscripts of *Dubliners*, *Stephen Hero*, which was part of the first draft of *A Portrait of The Artist As a Young Man*, and 'A Sketch for a Portrait of the Artist', written in his sister Mabel's copybook, which Sylvia called the 'most precious to me of all his manuscripts'.

getting away

Looking after Joyce distracted her from managing the shop and strained her relationship with Adrienne. She was, she said, prepared:

> to do everything I could for Joyce, but I insisted on going away weekends and every Saturday there was a tussle with Joyce over my departure for the country. If it hadn't been for Adrienne pulling on my side I could never have got loose. Joyce as Saturday approached always thought up so many extra chores for me...

He wanted her undivided attention, but the two women, out of habit and need, went at weekends to Adrienne's parents' home at Rocfoin in Eure-et-Loir, not far from Chartres. Sylvia said

you could see the cathedral across the wheat fields. They escaped to rural tranquillity. The house, three miles from a station, had a thatched roof, no bathroom, an elm tree in the garden. Water was from an outside pump, there was an orchard of pear and peach trees, flowers, hens, cats and Mousse the sheepdog. Joyce pursued Sylvia if he could, always wanting replies by return of post or by express. However great her efforts for him, he pushed for more. He seemed respectful of his wife's dissatisfaction but not of Sylvia's generosity.

He behaved the same way over her summer holiday. Each August, she and Adrienne went to a little chalet in La Féclaz, a remote Alpine village, far from the concerns of modernism and cultural trend. In the summer's heat, local farmers took their cattle to graze on the cool upland pastures there. Conversations with villagers were in patois. Sylvia and Adrienne led a primitive life, chopped wood, walked in the pine forests and ate simple food: soup, eggs and home-made cheese.

When Sylvia was away, Joyce wheedled money from Myrsine: 'As she well knew whether anything was left in his account or not, we had to look after the author of Ulysses,' Sylvia wrote caustically in her memoir. Constant scavenging for money wore her down. Funds to keep the bookshop going became an insurmountable problem. Help from her family dried up. For years her mother's cousin, Mary Morris, had sent fifty dollars a month, but in May 1923 the Reverend Beach retired as pastor of the First Presbyterian Church in Princeton, and 'P.L.M.', poor little mother, not wanting to be in the house with him, sailed for Italy. Sylvia transferred the monthly payment to her, thinking she needed it more. And she quarrelled with Cyprian who said she felt miserable in Sylvia's company. Opportunities in French cinema ended for Cyprian and she left for Pasadena and a shared life with her girlfriend, Jerry – Helen Jerome Eddy, also an actress. She and Sylvia only met once after she left –

in Pasadena in 1936, to celebrate their father's eighty-fourth birthday.

a question of rights

Sylvia's publishing enterprise, unprotected by a binding legal agreement, slipped irretrievably out of her control. Joyce showed her no loyalty. He had turned to her with *Ulysses* only because no bona fide publishing house would risk taking the book on. He would have much preferred any offer from Jonathan Cape or Random House. Sylvia's pioneering effort was his last resort. She served a purpose.

She and Joyce were dealing in illicit goods. They depended on honour among felons. Without legal protection, Sylvia took her chance like any self-respecting bootlegger. The book was banned in England and America. She, Harriet Weaver, Margaret Anderson and Jane Heap were all in defiance of the law. Sylvia was generous and courageous but careless of self-protection. Marianne Moore said of her 'she never allowed logic to persuade her to regret over-charity to a beneficiary'. Joyce did nothing to safeguard her interests. He was an extraordinary wordsmith but a self-serving man.

In Paris, the Shakespeare and Company edition, under her direction, went through many small run-ons on a supply and demand basis: 'We sent copies to India, China and Japan, had customers in the Straits settlements and, I daresay, among the headhunters of Sarawak,' Sylvia wrote. In the shop, copies sold directly to customers were disguised in jackets offering 'Shakespeare's Works Complete in One Volume' or 'Merry Tales for Little Folks'. Other Paris bookshops sold copies for around 150 francs. Joyce received regular small payments.

Keen for wider sales, Joyce, without discussion with Sylvia, asked Harriet Weaver to oversee an edition for sale in England.

This was printed by Darantiere as a run-on of 2,000 copies from Sylvia's edition, and identical except for a changed imprint: 'Published by John Rodker for the Egoist Press.' John Rodker was an English poet.

These copies were then sold under the counter in English bookshops. One bookseller managed to ship 800 of them to America. Some turned up in Paris, where booksellers complained of the availability of a cheaper, seemingly identical version before they had shifted all copies of the first.

Joyce then, again without consulting Sylvia, arranged with Harriet for a third edition of 500 copies and went independently to Darantiere to discuss corrections. All these copies were seized at Folkestone under Sections 207 and 208 of the 1876 Customs Consolidation Act. They were forfeit unless claimed. Harriet did not want adverse publicity and a battle with the 'authorities' she knew she would lose. The consignment was 'burned in the King's chimney'.

Sylvia, anxious about her precarious hold over the book and its openness to piracy, wrote to John Quinn in America asking if, by sending copies to the Library of Congress, she might safeguard her copyright. He thought the bigger threat was from confiscation and he warned her about John Sumner and the Society for the Suppression of Vice. 'This isn't an easy game you are up against,' he said.

the pirates move in

The pirates moved in, took their chance, printed a version however they chose and used the Shakespeare and Company imprint and Darantiere's name as printer. Bootleggers hawked copies in London, Paris and New York, called on shopkeepers, asked how many copies of *Ulysses*, or *Lady Chatterley's Lover* or *The Well of Loneliness* or *Two Flappers in Paris* or *Five Smackings*

of Suzette were wanted – ten or more at $5 then to be sold at double or triple the price. 'The driver dumped his books and was gone.' Shakespeare and Company was the ostensible publisher of all these pirated editions of *Ulysses*, though Sylvia had no tally of what was printed and sold, where or by whom. Nor did she have legal claim to be the legitimate publisher of this illegitimate book.

got any spicy books

She developed an unwanted reputation as a publisher and vendor of pornography. An Irish priest who called at her shop to buy a copy asked if she had any other spicy books. *Ulysses* was listed in catalogues of erotica along with *Fanny Hill*, *The Perfumed Garden* and *Raped on the Railway*.

Accomplished writers of books censored as obscene hoped she would publish their efforts too. Richard Aldington and Aldous Huxley tried to persuade her to publish D.H. Lawrence's *Lady Chatterley's Lover*. Sylvia explained her reasons for refusal: it was enough for her to be a one-book publisher; she lacked capital, staff, space and time to do more; she did not want a reputation as a publisher of erotic books; she needed to concentrate on her bookshop. 'You couldn't persuade anyone that Shakespeare and Company hadn't made a fortune,' she said. It was not her way to complain of just how exhausting, problematic and draining of energy all aspects of publication had been.

When Aldington and Huxley's exhortations failed, Lawrence and his wife, Frieda, came to the shop to try to persuade her. She found him a man of great personal charm. He was ill with tuberculosis, feverish and coughing, and she hated having to explain her reasons for turning him away. She did not tell him that she did not like the book and found it the least interesting of his novels.

Most days one writer or another called, hoping she would publish their racy writings. 'They brought me their most erotic efforts,' she said. Aleister Crowley, author of *Diary of a Drug Fiend*, asked her to publish his memoirs. She found him repulsive:

> His clay-coloured head was bald except for a single strand of black hair stretching from his forehead over the top of his head and down to the nape of his neck. The strand seemed glued to the skin so that it was not likely to blow up in the wind.

The head waiter of Maxim's promised his memoirs would out-raunch *Ulysses*. Frank Harris tried to entice her with *My Life and Loves* by reading aloud to her the sauciest bits. She did not like the book any more than she liked him. When leaving Paris to catch a train to Nice, he stopped by and asked her to recommend something hot for him to read on the journey. She sold him Louisa May Alcott's *Little Women* in two volumes.

Tallulah Bankhead's agent asked if she would publish Tallulah's memoirs. Sylvia doubted she would have turned that down, but no manuscript arrived. Tallulah's name, like Greta Garbo's, was another link in the daisy-chain of famous lesbians.

> Henry Miller and that lovely Japanese-looking friend of his, Miss Anaïs Nin, came to see if I would publish an interesting novel he had been working on: *Tropic of Cancer* and *Tropic of Capricorn*.

Sylvia turned down both Tropics. She could have become a publisher like Virginia and Leonard Woolf with their Hogarth Press; she just did not want to. She did, though, meet with Havelock Ellis and agree to stock his censored book *Studies in the Psychology of Sex*. At lunch, 'Dr Ellis said he would like vegetables, and no wine, thank you, just water.' And Sylvia stocked Radclyffe Hall's banned *Well of Loneliness*.

Adrienne's Silver Ship

Influenced by Sylvia, Adrienne took modernist English writing to French readers. In June 1925 she started a literary magazine, *Le Navire d'Argent* – The Silver Ship, named after the ship in the Paris coat of arms: 'Tossed by the waves but never sunk', read the heraldic legend. 'French in language but international in spirit' was Adrienne's creed. In the magazine, she was the first to publish Hemingway in translation. And T.S. Eliot, when she published his 'Love Song of J. Alfred Prufrock', wrote: 'To Adrienne Monnier, with *Navire d'Argent*, I owe the introduction of my verse to French readers.' In the October 1925 issue she included in English an excerpt from Joyce's 'Work in Progress'. Joyce had intended the piece for an English magazine but took it away when the editor asked him to cut a paragraph the printer thought obscene. In gratitude, he sent Adrienne a magnificently dressed gigantic cold salmon from Potel et Chabot, the most exclusive caterers in Paris.

Le Navire d'Argent was one more of the innovative magazines in service to literature and freedom of thought that could not survive. Adrienne published it monthly until May 1926. After twelve issues, she was in financial straits. To pay debts, she sold her personal collection of 400 books, many inscribed to her from their authors.

a petition of protest

By the late 1920s, Shakespeare and Company had become one of the sights of Paris, written up in magazines, a must for book lovers, a place for pilgrimage. Sylvia was assumed to be rich from the notoriety of *Ulysses* but most of any money received went to Joyce. By 1927 the bulk of her time was taken up fighting

pirates. Bryher sent a quantity of files to the shop to house the huge volume of paperwork this generated.

In America, a peddler of raunchy prose and pornography, Samuel Roth, published instalments of *Ulysses* in his magazine *Two Worlds Monthly* without consultation, permission or payment. Sylvia and Joyce organized a petition of protest; 167 people signed it, among them Sherwood Anderson, Richard Aldington, E.M. Forster, Bryher, Mary Butts, H.D., Albert Einstein, T.S. Eliot, Havelock Ellis, Gaston Gallimard, André Gide, Ernest Hemingway, Bravig Imbs, Storm Jameson, D.H. Lawrence, Wyndham Lewis, Mina Loy, Maurice Maeterlinck, André Maurois, W. Somerset Maugham, Middleton Murry, Bertrand Russell, Virgil Thomson, Paul Valéry, Hugh Walpole, H.G. Wells, Rebecca West, Thornton Wilder, Virginia Woolf, W.B. Yeats… Sylvia invited Gertrude to sign, but she did not do so. An injunction was obtained against Roth in December 1928. He became a pariah in literary circles but continued his pirating under a different name.

P.L.M.

Mother became an increasing problem throughout this publishing saga. Sylvia was alarmed at the quantity of prescription drugs she took, ostensibly for a heart condition. Eleanor Beach made regular visits to her chicks, as she called her three daughters, in whatever country they happened to be. In Paris, she bought clothes for Sylvia – and lamented her lack of interest in them. Then she moved on to Italy to stay with Holly. Sylvia tried to be dutiful and sometimes went with her, but told Holly she would go mad if she spent too long in her mother's company.

Eleanor wrote to Sylvia of the pain of her 'terrible marriage', and of how Sylvester's temper was like 'a spiked band into my head' so she felt her 'brain will give way'. She said she was nearly crazy and having a breakdown. Sylvia called it a 'wretched business'

that their mother had to keep the pretence of a marriage and go back to America to the husband she feared and despised. As the years passed, Eleanor travelled with varying women friends and acquaintances to Paris, Rome, Florence, Algiers, Naples. She seemed lost.

In 1924, in Paris, she was charged with shoplifting jewellery from the Galeries Lafayette department store in boulevard Haussmann in the 9th arrondissement – trinket items of no particular value. Maybe from fear and confusion, or because she was at her wits' end, she told no one of the charge or the ensuing court summonses. In June 1927, the police arrested her. Sylvia hired a lawyer, who elicited a character reference from the pastor of the American Church in Paris, got a doctor's report testifying to Eleanor's mental strain and confusion brought on by her medication, and secured her release without charge.

Eleanor, consumed with shame, wrote a long protestation of her innocence, drew up a will dividing her possessions among her three daughters and on 22 June, a Wednesday, overdosed on prescription drugs. An ambulance took her to the American Hospital at Neuilly-sur-Seine. She died at 5 p.m. She was sixty-three. Sylvia telegraphed her father and sisters, saying the death was from heart failure. She somehow averted an inquest, arranged her mother's cremation and for her ashes to be buried at Père-Lachaise cemetery, settled her bills and, with her instinct to downplay drama, kept to herself the true circumstances of how her mother had died.

Joyce's eyes and family

Joyce looked to Sylvia to sort out his unending problems of health, finances and family. He feared he was going blind. Sylvia found specialist help, but treatment for glaucoma was crude. Operations caused great pain and were of dubious success.

Leeches were stuck round his eyes to drain them of blood.

Money and its lack was the never-ending vexation. Any amount Sylvia scavenged for him was gone the next day. She asked Harriet Weaver to help get Joyce's son, Georgio, a job: 'that would be a relief to Joyce', she wrote. 'George is a fine big fellow, but he has nothing to do all the time but loaf (He teaches Italian one hour a week).'

Joyce's family seemed dysfunctional. Whatever genetic vulnerability his two children, Georgio and Lucia, had was made worse by their rackety upbringing: constant shifts of language, insecure abode in different countries, an obsessive artist for a father, a dissatisfied mother. Both children had talent: Giorgio as a classical singer, Lucia as a dancer, but they were overshadowed by their father. Giorgio became alcoholic, as indeed was Joyce. He married an American heiress and divorcee ten years his senior – Helen Fleischmann, a friend of the art collector Peggy Guggenheim. They had a son, Stephen. She had a breakdown and went back to the States without Giorgio.

And as for Lucia… Joyce referred to her '*King Lear* scenes': 'Whatever spark or gift I possess has been transmitted to Lucia,' he said, 'and it has kindled a fire in her brain.' This fire consumed her. Joyce's gift with words and ideas expressed itself in Lucia as madness. In conversation they shared a make-believe language. Carl Jung diagnosed her as schizophrenic. He described them as 'two people going to the bottom of the river, one diving and the other falling'.

Nora favoured Giorgio and disliked Lucia. Tension between her and her daughter was intense. Lucia's earliest memories were of her mother's scoldings. Her anxiety and insecurity was exacerbated by never staying anywhere long enough to forge other relationships. By the age of thirteen she had lived at numerous different addresses in Trieste, Zurich and Paris. More than once the family was evicted from apartments for not paying the rent. Lucia learned Italian, German, French, but no language allowed her to understand or control what was wrong with her. Home life made her anxious and she became violent towards her mother. Joyce loved Lucia and believed she had some special insight, but he was unable to help her. 'She behaves like a fool very often but her mind is as clear and as unsparing as the lightning,' he wrote to Harriet Weaver.

Lucia wanted her own identity and success. She went to nine dance schools in seven years, but left every group she joined. Among her teachers was Raymond Duncan, Isadora's brother, at the Dalcroze Institute in Paris.

In 1927, when she was twenty-one, she became besotted with Samuel Beckett. He was twenty-three and had moved to Paris to work as Joyce's secretary. Sylvia championed Beckett's work and stocked his books. She particularly liked the title of ten interconnected stories set in Dublin, *More Pricks Than Kicks*.

'My love was Samuel Beckett,' Lucia wrote. 'I wasn't able to marry him.' Other unsatisfactory affairs were with her drawing teacher, the sculptor Alexander Calder: 'We were in love but I think he went away.' Then there was the artist Albert Hubbell, who did cover illustrations for *The New Yorker*. Already married, he ended his involvement with Lucia by 'just sliding out of her life'.

In 1929 she was a finalist in the first international festival of dance in Paris, held at the Bal Bullier, a dance hall on boulevard

Saint-Michel.* Mortified at not winning, Lucia gave up dancing, a decision, Joyce wrote to a friend, that caused her 'a month of tears'. Her life disintegrated. She had an unsuccessful operation to try to correct the cast in her left eye. She picked up men, said she was lesbian. Joyce encouraged her to take up book illustration. She drew lettrines – ornamental capitals – and he paid various publishers to pay her for this work. He called Lucia 'that poor proud soul, whom the storm has so harshly assailed but not conquered'.

carrying on for Joyce

Sylvia continued to serve Joyce. His hope was for her to publish all his work at prices readers could afford. She did her best, but she had had enough. She financed a recording of him reading *Ulysses* but, with understatement, admitted 'this was not a commercial venture'.

> I handed over most of the thirty copies to Joyce for distribution among his family and friends, and sold none until, years later when I was hard up, I did sell and get a stiff price for one or two I had left.

She published a little volume, *Pomes Penyeach*, of thirteen of his poems, each decorated with Lucia's lettrines, but again shifted few copies.

Joyce wanted her to arrange production of *Exiles*, an early play of his about a husband and wife relationship. Sylvia was not a theatre producer and lack of money, contacts or commercial viability were obstacles. Nor was she eager to be the publisher of his next literary masterpiece, *Finnegans Wake*, which he called 'Work in Progress' until it was finished.

* Sonia Delaunay, a pioneer of the Orphism movement in art, did a painting of the Bal Bullier in 1913.

Sylvia's last publishing effort for Joyce in 1929 was of twelve essays by twelve of his friends, including McAlmon and Beckett, about *Finnegans Wake*. It was called *Our Exagmination Round his Factification for Incamination of Work in Progress*. Sylvia designed the cover, but it was not a 'can't wait to read it' affair. An explanatory sentence read:

> Imagine the twelve deaferended dumbbawls of the whowl abovebeugled to be the contonuation through regeneration of the urutteration of the word in pregross.

Sales were thin.

Sylvia was exhausted by her 'Joycean-Shakespeare and Company labours... It was a great relief to think that Miss Weaver and Mr Eliot were going to take care of Finnegans Wake.' But Harriet Weaver's interest in *Finnegans Wake* was also lukewarm. On 4 February 1927 she wrote to Joyce:

> I do not care much for the darknesses and unintelligibilities of your deliberately-entangled language system. It seems to me you are wasting your genius.

Joyce was so upset he took to his bed. Nora asked him why he did not write ordinary books people could understand.

betrayal

Sylvia and her shop were badly affected by the Depression. The devalued dollar slashed the spending power of expatriate Americans, and tourists stopped coming to the city. Hemingway and writers living on fixed or erratic incomes went home. In 1930 Sylvia gave Joyce 13,000 francs in overdraft from Shakespeare and Company, became ill with migraines and pneumonia, and learned that yet another pirated edition of *Ulysses* was being distributed in Cleveland, Ohio.

By the end of 1931 both she and Joyce agreed the only way to stop this ungovernable piracy was to sell *Ulysses* to a mainstream American publisher large enough to negotiate its legality, control distribution and own the rights to all sales.

This Joyce then did with total disregard for Sylvia. The book, in his view, was his property. In February 1932, Random House New York offered him an advance of $2,500 for world rights to *Ulysses* with a 15 per cent royalty on sales – Bodley Head was their London imprint. They agreed to take on all risks of the court battle and then to publish the book unexpurgated. Joyce accepted the offer and signed the rights of *Ulysses* over to them. He did not tell Sylvia of the deal. He treated her as his representative in Paris, not his publisher. Sylvia, entirely excluded from the arrangement, learned of it on 2 April from Joyce's lawyer, Paul Léon, a friend of Giorgio's wife, Helen. Léon showed Sylvia a letter Joyce had written to his Random House editor, which he used in the preface to the legitimized edition:

> My friend Mr Ezra Pound and good luck brought me into
> contact with a very clever and energetic person Miss Sylvia
> Beach… This brave woman risked what professional
> publishers did not wish to, she took the manuscript and
> handed it to the printers.

Joyce was a man whose trade was words. Miss Sylvia Beach had taken his manuscript and handed it to the printers. She was a clever and energetic messenger who had delivered a parcel.

By 1932, Ezra Pound was condemning Jews as usurers and supporting fascism. He supported Mussolini, whom he met in Italy on 30 January 1933. Sylvia wrote to Holly that Joyce:

> has written a preface to the new edition connecting me up with
> Ezra Pound in the first publishing of Ulysses. So as you might
> say he has not only robbed me but taken away my character.

She lost all trust in him. She wrote to Holly, 'He thinks, like

Napoleon, that his fellow beings are only made to serve his ends. He'd grind their bones to make his bread.'

Only when offended to the core would Sylvia criticize her hero so roundly. Adrienne wrote to Joyce, telling him he asked too much of Sylvia and of herself and they could do no more for him. Sylvia transferred taxi-loads of paperwork about him to Paul Léon, who managed Joyce's affairs thereafter. No longer able to afford to pay for an assistant, she parted with Myrsine, who went to the Joyces to help care for Lucia – they briefly became lovers. Sylvia painted the shop, bought additional shelving and tried to regenerate her 'book plan' and look to the future despite this massive betrayal and a backdrop of darkness from encroaching war. She had done all she could and more for James Joyce. When he had an opportunity to repay her, he did not do so.

hard times

For Joyce, there was a terrible nemesis. Positive news about *Ulysses* was pushed into the shadows by Lucia's troubles. At his fiftieth birthday party, on 2 February 1932, she had a psychotic breakdown. Beckett's presence at the party contributed to her distress. She threw a chair at her mother and Giorgio had her committed to hospital. Crude and terrifying treatments were sprung on her. She was kept in bed in solitary confinement for seven weeks and injected with 'bovine serum'. She threw things out of the window of her locked room. She was put in a strait-jacket. Her return home was unmanageable.

In 1933, Hitler and his National Socialist party in Germany began setting up extermination camps for Jews, gypsies, homo-sexuals and all people they viewed as tainted. In America, Prohibition ended and Judge John Woolsey of the United States District Court in New York revoked censorship of *Ulysses*.

Random House's defence case for publication was successful. Their lawyer, Morris Ernst, who had successfully protected Radclyffe Hall's *Well of Loneliness* in America in 1929, spoke out convincingly for the book. He gathered support from writers, educators, clergymen, librarians. The judge, who had actually read *Ulysses*, in his verdict in December 1933 called the book sincere, honest and a 'tragic but very powerful commentary on the inner lives of men and women... Ulysses may therefore be admitted into the United States.'

In Paris, Joyce's phone rang non-stop with congratulatory calls. Lucia said 'I'm the artist' and cut the wires. They were mended and she cut them again. Random House New York and Bodley Head in London rushed into production. With huge advance free publicity, they sold 35,000 copies of *Ulysses* in the first three months. Joyce received 45,000 dollars in royalties. Sylvia got nothing. 'As for my personal feelings well, one is not at all proud of them,' she said.

what to do with Lucia

Doctors thought Lucia would benefit if separated from her parents. In spring 1935 she was sent to stay with cousins in Bray, a seaside town near Dublin. She made a peat fire on the living room carpet, turned on the gas tap in the middle of the night, tried to unbutton the trousers of her cousin's boyfriend, then left without saying where she was going. She went to Dublin, gave away her clothes and possessions and slept rough. 'She lived like a gypsy in squalor,' Joyce said. When found, she herself asked to be admitted to hospital. Harriet Weaver paid for her to be treated at St Andrew's hospital in Northampton, where a Dr Macdonald gave her 'glandular injections'. She then convalesced in a cottage in Tadworth in Surrey with Harriet, who hired a trained nurse to look after her.

When she returned home, the Joyces had her admitted to an asylum in Ivry, 5 kilometres south of Paris. She was twenty-eight. She never again lived outside of an institution. For forty-seven years, until her death, she stayed incarcerated in sanatoria in France, Switzerland and England. Joyce wanted to bring her home but Nora could not accept this.

something must be done

By 1935, Sylvia was fearful of bankruptcy and the closing down of Shakespeare and Company. To raise money, she sold her rare books and some of Joyce's manuscripts. Friends donated and took out additional subscriptions. Bryher gave her $1,400 and bought one of the Blake drawings acquired by Sylvia in 1919 from Charles Elkin Mathews but insisted it stay in the shop. Anxiety made Sylvia ill. 'Attacks of migraine stopped her in her tracks', her friend, the writer Katherine Anne Porter said.

'Something must be done' was André Gide's view. He had been the first customer at Shakespeare and Company and he could not contemplate the shop closing. Writers could not do without it or Sylvia. With André Malraux, under the banner of the International Association of Writers for the Defence of Culture, he organized a rally and presented a petition to the government appealing for help. This request was declined because Sylvia was not a French citizen. With Paul Valéry and Jules Romains, Gide then created The Friends of Shakespeare and Company. Two hundred members paid a subscription of 200 francs a year or more to support the shop and attend readings there by French and American writers. Simone de Beauvoir joined on 4 September 1935 and borrowed scores of titles. The largest donations came from Sylvia's childhood friend, Carlotta Welles, and, as ever, from Bryher.

Mussolini invaded Ethiopia in the summer of 1936. The tone of the little magazines grew dark, concerned more with the evil

of fascism and the conflagration of war than with innovations of style. Shakespeare and Company stocked *New Masses*, *New Statesman* and *Die Rote Front* ('The Red Front') alongside the literary journals.

a visit to America

For Sylvia, the joy of her book plan was ended. Nor was she well. In August 1936 she made her first visit back to America in twenty-two years to meet with her father and sisters in Altadena, California, to celebrate his eighty-fourth birthday. He paid for her flight. She also wanted medical treatment in New York. She closed the shop for two months, leaving a temporary assistant, Margaret Newitt, to act as a casual caretaker. Adrienne took a holiday in Venice with the photographer Gisèle Freund.

In California, Sylvia stayed with Cyprian, whom she had not seen for thirteen years, and her partner, Jerry. Holly was with her husband, Frederic Dennis, and their three-year-old son. After the family reunion, Sylvia moved on to New York. She had a hysterectomy and radium treatment but did not record details of what was wrong. While in the city she met with the publisher Alfred Knopf, who voiced interest in her memoirs. Ten years went by before she wrote her slim classic *Shakespeare and Company*. At Bryher's insistence she also met up with the poet Marianne Moore, with whom she had corresponded for years. Sylvia said of her: 'She looks like a little old maid school marm but only at first. When you take a good look at her and hear her talk she is unique and fascinating.' Marianne Moore gave Sylvia a photograph of herself inscribed: 'To courageous generous unselfish wilful Sylvia Beach.' She was working on an article for *The Nation* on Gertrude Stein, and she took Sylvia to a performance of *Macbeth* in Brooklyn with an all-black cast.

After two months away, and weakened by hospital treatment,

Sylvia returned to Paris in October 1936, to what she called her 'problematic little business'. The franc was devalued, Hemingway was fighting in the Spanish civil war, Bryher was using her money to finance the escape of Jewish psychiatrists and intellectuals from Austria and Germany, the talk was of a European war and Gisèle had moved in with Adrienne.

Gisèle Freund

Sylvia found her relationship of fifteen years downgraded. She moved out immediately from Adrienne's apartment to the

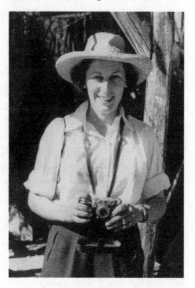

rooms above Shakespeare and Company. It was not her way to make a display of hurt, or a fuss about jealousy or betrayal, but she could not live under the same roof as Adrienne and her new lover. She ate dinner with them most days and maintained a loving friendship and work partnership with Adrienne but the physical intimacy and commitment of being all in all to each other was broken.

Sylvia was nearing fifty and Adrienne was forty-four. Gisèle, who was twenty-eight, was a refugee, a German Jew. As a member of a student socialist group in Frankfurt, one of her first pieces of photojournalism in May 1932 had been of a march of anti-fascist students attacked by Nazi groups. Among the marchers were her friends Walter Benjamin and Bertolt Brecht. She saw photography as evidence, a revelatory way to

shape ideas, influence behaviour and define society. 'When you do not like human beings you cannot make good portraits,' she said.

She knew of the lesbian network in Paris and, when Hitler became Chancellor, she fled there, with her negatives strapped to her body to get past the border guards. Adrienne became her protector and arranged a cover-up marriage for her with Pierre Blum, a French national, to get her a visa to stay. (They divorced some years later.) She enrolled at the Sorbonne and wrote a doctoral thesis on photography in France in the nineteenth century. Adrienne published this under the *Maison des Amis des Livres* imprint, and in 1939 mounted an exhibition of her photographs.

Gisèle – a Jew, a German, a lesbian, a socialist, a spokesperson for Free France, a subversive – did not have a safe country. She documented social issues and took portraits of writers and artists, among them colour photographs of Virginia Woolf and of Vita Sackville-West at Sissinghurst.

For Sylvia, Adrienne's love affair with Gisèle followed Joyce's betrayal with *Ulysses*. She was not, like Natalie Barney, outspoken about desire or jealousy. Candid expression in *Ulysses* was one thing, her own feelings another. She responded to humiliation with a headache rather than confrontation. Hurt, she walked away without fuss.

'Adrienne used to call me Fleur de Presbytère – "Flower of the Parsonage"', she wrote.

> Whether from my puritan ancestry or puritanical upbringing – once when I was in my early teens my mother told me 'never to let a man touch me' – I was always physically afraid of men. That is probably why I lived happily so many years with Adrienne.

It was a disconcerting comment on her parents' relationship

and her own sexual identity. It called for a scrutiny it did not receive. To the world she declared her love for Adrienne, who was more earthy and appetitive, more at ease than was she. But the devotion between them went beyond Sylvia's puritanical reserve or other lovers. It was a lifelong lien.

hunkering down

Sylvia was awarded the Légion d'honneur in 1937 by the French government for her contribution to literature. She was characteristically self-effacing about her 'little ribbon gibbon given me by the French'. All around her, honour was under threat. Enterprises like hers could not rise above the engulfing spectre of war. She increased the cost of library subscriptions and continued to host readings, but there were fewer people in Paris and even fewer who still bought books.

In July she hosted the launch of Bryher's *Paris 1900*. Adrienne gave a reading of Bryher's description of her visit, aged five, to the 1900 Exposition and after the launch Bryher hosted a dinner for Sylvia, Adrienne and friends at the Tour d'Argent, one of Paris's finest restaurants. But the glory days of Shakespeare and Company were done. Its demise marked the end of the exuberance and freedom of modernist innovation. Old-style masculine domination steamrollered in with murder, repression, punishment and with winning defined by who best killed and destroyed. Sylvia talked of the 'insanity' of war. Samuel Beckett said she had a permanent worried look. 'Everyone in Paris wants to flee to America away from wars and dictators,' Sylvia wrote to her father. Bryher assured her that whatever happened to Shakespeare and Company, she would look after her. 'I tried always to do what I could for the real artists and especially for the woman artist,' she said. These women artists were lesbian. She set up a fund of monthly payments to cover Sylvia's living

expenses through the next seven years. And Carlotta Welles, who had married a banker, James Briggs, paid $120 a month so Sylvia could at least employ another assistant. But it was not possible to see a way forward. In the summer of 1937 she closed the shop and went to Jersey for six weeks. She seemed uprooted. Uncertain.

the occupying force

In May 1940, Germany declared war on Belgium, France, Luxembourg and the Netherlands. Winston Churchill vowed to 'wage war against a monstrous tyranny never surpassed in the dark and lamentable catalogue of human crime'.

Days before the German army invaded Paris, citizens left or tried to leave. Sylvia enquired at the American embassy but then decided to stay. Neither she nor Adrienne capitulated to intimidation. By June, when France surrendered to the Nazis, only about 25,000 people remained in the city. In boulevard de Sébastopol, Sylvia and Adrienne watched the stream of refugees trudge through the city from the north and north-east and from Belgium:

cattle drawn carts piled with household goods; on top of
them children, old people and sick people, pregnant women
and women with babies, poultry in coups and dogs and cats.
Sometimes they stopped at the Luxembourg Gardens to let
the cows graze there.

The refugees did not know where they could go. Abandoned dogs roamed the streets. On 14 June, Sylvia and Adrienne watched in tears as the German army marched in. 'It was an awful experience. Horrible.' German forces seized parliament buildings: the Chamber of Deputies, the Senate, the Ministry of Foreign Affairs, the Naval Ministry. Signs in German declared these buildings under the 'protection' of the German army. Cannon and machine guns were set up at the Arc de Triomphe.

Swastikas replaced French flags on government buildings, monuments, shopping arcades, the main hotels. At the Place de l'Étoile, helmeted Wehrmacht troops marched to a Nazi band while Parisians wept. 'In the evening, great depression,' Adrienne wrote in her diary.

Paris was violated. The only people with cars were the invaders. Sylvia told friends and family she could manage on Bryher's allowance. 'You know I can take care of myself and am a prudent person.' Each day she and Adrienne foraged for food – fruit, meat and butter. She still had fifty-nine library members. She welcomed students and refugees at the bookshop and took on a Jewish assistant, Françoise Bernheim, who was obliged by the Nazis to wear a large yellow star and was forbidden to enter theatres, cinemas, cafés, concert halls, or to sit on park benches or even those in the street.

Sylvia and Adrienne came under Nazi scrutiny. Sylvia was warned of the imminent confiscation of her books. Adrienne was suspect for having written a condemnation of Nazism and anti-Semitism. She helped Gisèle Freund get to Buenos Aires as the guest of Victoria Ocampo, the feminist Argentine writer who founded the literary journal *Sur*, and in May 1940 she hid Walter Benjamin and Arthur Koestler in her apartment. Koestler, who had been imprisoned in Spain for airing anti-fascist views, was writing *Darkness at Noon*.

the death of Joyce

James Joyce, Nora and Giorgio fled to Vaud in Switzerland. Lucia was left in a clinic in Pornichet run by a Dr Delmas. Joyce found a sanatorium prepared to take her in Switzerland but he could not get a resident's permit for her. He was devastated at leaving her in occupied France – and at the lukewarm reception of his *Finnegans Wake*.

Sylvia's father died in November 1940 in Princeton at the age of eighty-eight, unaware of the engulfing war. Two months later, Joyce died in Switzerland on 13 January 1941 of peritonitis from a duodenal ulcer. Giorgio wrote to Maria Jolas, co-editor with her husband, Eugène, of *transition*, 'I hope Dr Delmas has not put Lucia in the street as needless to say I cannot pay him nor can I communicate with him.' After that, neither he nor Nora wrote to or visited Lucia or paid for her care. Joyce had appointed Harriet Weaver his literary executor. She paid Lucia's medical fees and living expenses, visited her and was her contact with the outside world. The Delmas clinic was bombed during the war, which left it run down and ill-equipped. Lucia remained there as a patient until 1951.

the enemy alien

America formally joined the Allies in the war against Germany after the Japanese bombed Pearl Harbor on 7 December 1941. Sylvia was then officially declared an enemy alien. 'My nationality, added to my Jewish affiliations, finished Shakespeare and Company in Nazi eyes,' she wrote.

> We Americans had to declare ourselves at the Kommandatur and register once a week at the Commissary in the section of Paris where we lived. (Jews had to sign every day.) There were so few Americans that our names were in a sort of scrapbook that was always getting mislaid. I used to find it for the Commissaire. Opposite my name and antecedents was the notation 'has no horse'. I could never find out why.

Shakespeare and Company was watched by the Nazis. It housed an American, a Jew and subversive literature. One day in December 1941 a uniformed SS officer called, ostensibly wanting to buy *Finnegans Wake*. Sylvia, sensing a trap, told him apologetically she could not help him. He called again. At the end of

the month she was informed her books were to be confiscated and her shop closed. The concierge of 12 rue l'Odéon offered her the unoccupied top floor apartment in the building free of charge. Within hours Sylvia, Adrienne, the concierge and Françoise moved everything up there: books, photographs, furniture, memorabilia, letters and magazines, the freedom and daring, the fun and the hopes. A handyman took down the shelves, painted out the name Shakespeare and Company and put up the outside shutters.

Twenty-two years of magical thought, imagination, new voices and history were boxed into hiding, away from the jackboots and swastikas. For fascists, burning of books was an item of agenda. So was the imprisonment and murder of 'enemies of the people', of whom Sylvia was now one. She was American, she was lesbian, she befriended Jews, published *Ulysses*, traded in 'Noxious and Unwanted Literature' and opposed and derided this army of men.

internment

Late in August 1942, at nine in the morning, they came for her. Sylvia hastily packed woollens and a copy of the Bible and Shakespeare and was herded on to a truck. Adrienne saw her off. The concierge cried. On the truck with her was a friend, Katherine Dudley, 'dressed as though for a vernissage', and other American and British women. The German soldiers stopped at addresses where American or 'alien' women might be. If they came out without anyone, the other prisoners cheered.

They were put in a former zoo in the Bois de Boulogne: 'the monkey house as we called it.' German soldiers counted them repeatedly but never agreed on the same number. After ten days they were taken to a remote railway station and, in sealed cattle trucks, transported to an internment camp at Vittel in the Vosges mountains near the German border.

Vittel, a 'showcase' concentration camp, had been a spa resort

of hotels grouped around parkland before being commandeered by the Nazis. Barbed-wire fencing, patrolling guards and Nazi flags signalled its transformation from resort to prison. It was populated mainly with British and American women who had been residing in France. Most of the hotels had heating and running water; prisoners did their own cooking, had monthly visitors and received mail and Red Cross food parcels. There was no killing or beating of inmates, no forced labour.

Sylvia, because of her migraines, had a medical certificate from her doctor, Thérèse Bertrand-Fontaine. She was first treated at the makeshift hospital then interned in one of the hotels with American nuns, teachers, prostitutes, a poet or two, and a woman who had been living at the Paris Ritz and had brought all her jewels with her. Sylvia fastened her pearl necklace for her in the mornings. When Adrienne visited, Sylvia gave her some of the Red Cross luxuries: condensed milk, sugar, coffee, prunes, chocolate, cigarettes.

She thought of little but release. After four months, on Christmas Eve 1942, she and some other American women were moved to a run-down hotel in the camp. She said she was put in the sort of room where you slit your wrists. There was a rat hole in it, the bath tub was coated with mud and there was no running water.

Adrienne petitioned an American art collector, Tudor Wilkinson, who had secured the release of his cross-dressing wife by giving Hermann Göring a painting. Wilkinson gave Adrienne hope he could secure Sylvia's release too. When this did not happen, she appealed to Jacques Benoist-Méchin, who had translated excerpts of *Ulysses* into French for the edition she published in 1929. He had welcomed the German occupation, was a collaborator, a fascist, an SS general and an ambassador in Paris for the enemy. Like Gertrude Stein, in perverse times Adrienne cosied up to the enemy for life-saving favours. Benoist-Méchin secured Sylvia's release on health grounds.

After six months' internment, in March 1943 announcement of Sylvia's sudden release from the Vittel camp was made over the loudspeaker. She stuffed clothing and food supplies saved from Red Cross parcels into her rucksack and borrowed money for her train fare back to Paris. The camp officials issued a document saying she could be reconvicted at any time. She suffered survivors' guilt: 'What if my dear dear friends left behind in the camp were not released? This thought spoiled all the pleasure of release for me.'

Her experience was different from Jewish internees who could not appeal to collaborators in high places. After she left, Jews originally from Poland but with American passports were interned at Vittel. A poet, Yitzhak Katznelson, taken there two months after Sylvia was released, wrote in his diary: 'There is not a single Jew here who believes that he will be allowed to remain alive.' He buried a copy of a poem he had written, *The Song of the Murdered Jewish People*, in the camp's gardens. He died in Auschwitz in 1944. Sylvia's Paris assistant, Françoise Bernheim, was murdered in Auschwitz after a round-up of Paris Jews. Paul Léon, who took over Joyce's affairs from Sylvia, was also murdered in a concentration camp in 1942. Katznelson's poem was exhumed after the war and published in Paris in 1945.

a twilit life

'I came back to Paris and hid, for fear they'd think I was well enough to go back,' Sylvia said after her return to the city. She 'disappeared' from the streets; she kept the apartment above the shop at 12 rue l'Odéon as her legal address, but did not go there. She led a twilit existence, hidden by Sarah Watson and her partner, Marcelle Fournier, who ran the students' hostel at 93 boulevard Saint-Michel. 'I lived happily in the little kitchen at the top of their house', Sylvia said. She visited Benoist-Méchin

and thanked him for freeing her. He assured her that if she was again interned, he would again secure her release.

She registered weekly with the police. In the evenings she ate with Adrienne and they worked to edit and circulate, secretly, from person to person, clandestine copies of Les Éditions de Minuit, an underground publishing enterprise of texts unacceptable to the Nazis. Friends in the Resistance wrote for the series under pen names. 'François La Colère' was Louis Aragon. 'Forez' was François Mauriac. 'Mortagne' was Claude Morgan, editor of the underground paper *Libération*. Gide and Paul Éluard contributed. Adrienne made the first French translation of John Steinbeck's *The Moon is Down*. Each copy of the Éditions was inscribed in French: 'This book, published with the aid of literary patriots, has been printed under the oppression in Paris.' Penalties for them all, if detected, were more devastating than any inflicted by the Society for the Suppression of Vice or the Director of Public Prosecutions. If apprehended, they risked imprisonment and death.

waved lavatory brushes

The Occupation ended on 24 August 1944. Sylvia and Adrienne went to boulevard Saint-Michel to watch the Liberation of Paris. Hitler had given orders for the city to be reduced to rubble if it could not be held. French Resistance fighters attacked the departing army. Onlookers cheered and waved lavatory brushes as the Germans retreated. Enraged, Nazi soldiers set fire to buildings and shot indiscriminately at Parisians. Sylvia and Adrienne lay on their stomachs. They saw blood on the pavements and Red Cross stretchers picking up casualties when the shooting stopped.

Two days later they again joined the crowds to cheer the triumphal march of General de Gaulle, leader of the Free French, down the Champs-Elysées. Jacques Benoist-Méchin was arrested

with other collaborators. His death sentence was later commuted on appeal to life imprisonment. He was freed after ten years.

Sylvia dismissed what others described as her courage in staying in occupied Paris. In her self-deprecating way, she said she did not have the energy to flee and that 'nothing happened to us or the other monuments'.

after the war

Much had happened to Sylvia, to Adrienne, to the world and its monuments, to integrity, lightness of heart and freedom of spirit. Paris was a different place and Sylvia a different woman. War snuffed out the dreams, questioning and playful imaginations of the modernists. Friends urged Sylvia to reopen Shakespeare and Company but there was no going back. She was fifty-eight. The world could not again be as it once was. There was a reckoning to be had: two world wars of astonishing impiety, a hundred million deaths… Civilization had turned out to be a carapace and peace on Earth an illusion. Art was a luxury. The focus was on how to acquire food, how to survive.

Bryher, as ever, gave Sylvia money and sent parcels. Janet Flanner sold her numbered uncut first edition of *Ulysses* to the Pierpont Morgan Library in New York and gave Sylvia the $100 she got for it. Sylvia gave 5,000 books and journals from Shakespeare and Company, stored in boxes in her flat above the shop, to the American Library, her former rival. She did charity work at a hospital, worked on translations, wrote her memoirs.

Lucia

Lucia stayed imprisoned by her own psyche. Dr Delmas died in 1951, his clinic at Pornichet closed and Harriet Weaver, staunch as ever, arranged Lucia's move to St Andrew's Hospital in

Northampton, where she had been treated in 1935. Harriet made all payments. Lucia remained there until her death in December 1982, thirty years later. Treatment with phenothiazines subdued most of her symptoms except torpor. Nonetheless, she spoke of her longing to leave: to go to Paris, to Switzerland, to Galway, to London.

Gisèle

Gisèle Freund fell foul of the authorities in Argentina. In 1950 *Life* magazine ran photos by her of a bejewelled and pampered Eva Perón; images that showed up the hypocrisy of the party line of austerity. Their publication caused a rift between America and Argentina. *Life* was blacklisted in Argentina. Gisèle fled again with her negatives, this time to Mexico, where Frida Kahlo befriended her. She photographed her and Diego Rivera. Not until 1953 did she make Paris her permanent home. She was then the only woman to work for Magnum, the photo agency founded by Henri Cartier-Bresson and Robert Capa. In 1954 she was refused entry to America because her name was on Senator Joseph McCarthy's blacklist. Magnum then fired her, fearful her socialist views would damage the agency's reputation. Gisèle continued as a photojournalist, alone and uncompromised – another courageous lesbian chronicler not silenced by men of power.

the swooping down of death

Cyprian died of cancer of the bladder in 1951. She was fifty-eight. Unbeknown to Sylvia, she had been seriously ill for a year. Jerry, Cyprian's partner of twenty-four years, gave Sylvia the news. That year, too, Adrienne became ill with rheumatism and

fainting spells. Unable to manage, she sold La Maison des Amis des Livres, her little grey bookshop that so inspired Sylvia and was at the spiritual heart of Paris for three decades. In autumn 1954 she was diagnosed with Ménière's disease. The following May, she wrote:

I am putting an end to my days. I am no longer able to tolerate the noises that have martyred me for eight months or the tiredness and suffering I have endured these recent years. I go to my death without fear. I found a mother on being born here. I shall likewise find a mother in the other life.

On 18 June she left this note on top of her personal papers, then overdosed on sleeping pills. Sylvia found her in a coma the following morning. Adrienne died at 11 p.m. in hospital. 'She died last night. I'm glad she hasn't got to go on suffering any more,' Sylvia told Bryher.

Of her own suffering at such a loss, Sylvia wrote:

Can see no remedy at all for the swooping down of death on someone you love… the realization that the person is gone for good… The feeling of incompleteness is one of death's worst cruelties. Sometimes you wish you had left with her as she suggested, she knew what living without her was going to be like. She knew everything.

Adrienne

Katherine Anne Porter wrote to Sylvia of how she thought of her and Adrienne together as one 'beautiful living being', and of 'that pathetic fallacy of thinking of us all as immortal… we could never hear of each other's death!' She recalled Adrienne:

with her firmness and calmness and humorous wit, in her long grey beguine's dress and her clear eyes that could undoubtedly see through millstones… a whole space of life comes back to me: that little pavilion and garden at 70 bis

rue Notre-Dame des Champs, with you and Adrienne at
dinner there and such good talk! And your flat above 12 rue
de l'Odéon, the parties there, the sparkle of life in *everybody*
present, which you two could always bring out. And your
wonderful books that I loved to roam around among, the
best place I knew in Paris...

Sylvia carried on. Her circumspect, brief memoir, *Shakespeare
and Company*, was published in 1959. That same year, sponsored
by the Cultural Center of the American Embassy in Paris, she
researched and staged a ten-week exhibition, 'The Twenties:
American Writers and Their Friends in Paris'. The age of post-
war reconstruction looked back at the pre-war years. As a front
of house exhibit, Sylvia and Gertrude Stein's widow, Alice B.
Toklas, sat at a café table in front of a mural photo of the Dingo
bar while a pianola played George Antheil's *Ballet Mécanique*.

Sylvia gave radio talks, lectures and interviews as asked. She
sold what was left of her Joyce archive, her 'Joyce collection' as she
called it, to the University of Buffalo for $55,510. The payment
gave her financial ease, though too late in the day. The university
awarded her an honorary doctorate. In June 1962, dressed in
Irish tweeds and conveyed there in a horse-drawn carriage, she
opened the James Joyce Tower & Museum in Sandycove near
Dublin – the setting of the first scenes in *Ulysses*.

Sylvia's death

Four months later, on 5 October, she died of a heart attack alone
in her Paris apartment at 12 rue de l'Odéon. A friend, the writer
Maurice Saillet, who had worked with Adrienne at La Maison
des Amis des Livres, found her two days later.

In the homage that followed Sylvia's death, Bryher wrote of
her that 'no citizen has ever done more to spread knowledge of

America abroad'. T.S. Eliot said only a scattering of people knew how important a part Sylvia and Adrienne played in the artistic and intellectual life of those interwar years.

Holly arranged with Princeton University for their associate librarian for special collections, Howard C. Rice, to sort all the books, business papers, correspondence, photographs, paintings and memorabilia still in Sylvia's apartment. Thirty-one shipping cases were sent to Princeton filled with more than two thousand books, hundreds of photographs, thousands of papers, as well as artefacts. Some four thousand other books, the core lending library of Shakespeare and Company – not the avant-garde Company, but Shakespeare, the Elizabethan poets, eighteenth-century novelists, Romantics and Victorians – went to the University of Paris English department.

'I was not interested in what I could see of Paris through the bars of my family cage,' Sylvia had said as early as 1903. Her Paris was created by her fearless, bright and open mind, her courage and passion for new writing. Publishing *Ulysses*, a book that changed the concept of fiction, was her great act of generosity and defiance. Her 'book plan', Shakespeare and Company, 'so much more than a bookshop', was for twenty-two years the hub for the dissemination of new ways of seeing and saying. Books were civilizing objects, of that she was sure. She was 'the avenging angel' of the small bookstore, the lover of authors and ideas, of the challenging magazines that lasted only a few issues, the poems that earned no money, and of a raw unpublished manuscript no commercial publisher dared touch.

BRYHER

*'When is a woman not a woman?
When obviously she is sleet and
hail and a stuffed sea-gull.'*

H.D.

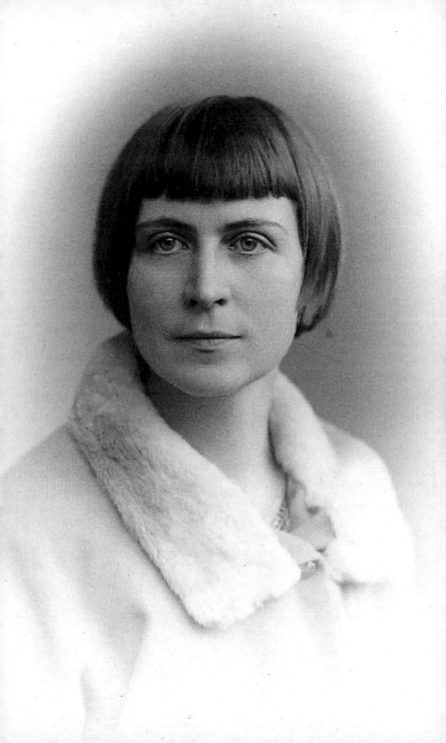

Bryher felt trapped in the wrong body. Even as a child she viewed her birth gender as a trick, a mistake. She saw herself as a boy who needed to escape from the physical cage of a girl. She was tormented by pressure to have curls, wear frocks, be called by her birth names, Annie Winifred, or her nickname, Dolly.

Adrienne Monnier said it was impossible to speak about Bryher's style of dress: 'it is distinguished by absolutely nothing; everything about it is neutral to an extreme. When I see her I simply want to brush her beret...'

Bryher did not want the patronymic of her father, the matronymic of her mother, or the name of any husband of convenience. Bryher is one of the Isles of Scilly off the Cornish coast, a part of the world she came particularly to love. She chose to be defined by the sea, the cliffs and by a landscape beyond gender. Nothing pleased her more, she said, than getting her hair cut short. Short hair and her chosen name distanced Bryher from the daughter she could not and would not be.

Barbered hair and a changed name declared resistance. Radclyffe Hall was Dear John to her partner Una Troubridge, and she had the curls painted out from a portrait of her made when she was a child named Marguerite. The society painter Gluck, whose birth name was Hannah Gluckstein, insisted on 'Gluck, no prefix, no suffix, no quotes' in the art world, and had her hair cut at Truefitt gentlemen's hairdresser in Bond Street; Alice B. Toklas cropped Gertrude Stein's hair with the kitchen scissors.

Money shaped Bryher's life and work – she was born into a vault of it. Access to great wealth meant the power to do good as she saw it. 'I have rushed to the penniless young, not with bowls of soup but with typewriters,' she wrote. She became a patron of modernism. She was the rock and saviour of her partner, the poet H.D. – Hilda Doolittle. She funded the Contact Publishing Company in Paris, supported James Joyce and his family with a

monthly allowance, gave money to Sylvia Beach and subsidized Margaret Anderson's *Little Review* in New York. She started the film company POOL Productions in Switzerland, financed its experimental films, and founded *Close Up*, the first film magazine in English. She built a Bauhaus-style home in Switzerland. She supported the emerging psychoanalytical movement in Vienna, and funded Freud and other Jewish intellectuals hounded by the Nazis to help them get out of Germany and Austria.

Bryher's allegiance was to new ways of saying and seeing, civil liberties, gender equality. 'I was completely a child of my age,' she said, by which she meant the age of modernism, of new ways of seeing and saying.

Bryher's life was long, her interests wide. Subversive in the causes she supported and in her revisionist ideas of gender and relationship, she made two lavender marriages with gay men, one to secure her inheritance and pacify her parents, the other to secure adoption rights for H.D.'s child. She accepted the open sexual relationships of those with whom she was involved and was vocal and dedicated in her opposition to fascism. And yet there was something neutral 'to the extreme' about Bryher's demeanour. She did not drink, smoke or party. She liked unfussy food (toast and Yorkshire pudding), seemed humourless, stayed quiet when others were talking and was overlooked in a group. No one fell in love with her, though numerous people were hugely grateful for her help and the way she realized their dreams. Among her writings were a number of novels in which the hero was a twelve-year-old boy and it was as if this boy were an identity trapped within herself.

Bryher was Sylvia Beach's trusted friend for forty years. They confided, corresponded and looked out for each other even when living in different countries. Bryher discreetly helped Sylvia and Adrienne Monnier keep their bookshops going. In her memoirs, she wrote:

There was only one street in Paris for me, the rue de l'Odéon. It is association I suppose, but I have always considered it one of the most beautiful streets in the world. It meant naturally Sylvia and Adrienne and the happy hours that I spent in their libraries. Has there ever been another bookshop like Shakespeare and Company? It was not just the crowded shelves, the little bust of Shakespeare nor the many informal photographs of her friends, it was Sylvia herself, standing like a passenger from the *Mayflower* with the wind still blowing through her hair and a thorough command of French slang, waiting to help us and be our guide. She found us printers, translators and rooms… she was the perfect Ambassador and I doubt if a citizen has ever done more to spread knowledge of America abroad.

name of the father

Bryher was born Annie Winifred Glover on 2 September 1894 in the English seaside town of Margate; on her birth certificate was a dash in the space headed Name of Father. Officially she was illegitimate, for though her parents lived together, they were not married. Her father, John Reeves Ellerman, did not marry Hannah Glover, her mother, until Bryher was fifteen. There was the impediment of an existing husband. Only when Hannah Glover belatedly gave birth to a son did Sir John, as he had then become, marry her to accord legitimacy to his son and heir and, as a secondary consideration, to his teenage daughter.

John Ellerman, a self-made man

Bryher's father was a self-made man. When he died in 1933 aged seventy-one, he left an estate of more than £36 million, the

largest recorded fortune in Britain.* He was born in Hull in 1862, the only child of an English mother and German father. Bryher said she searched the family tree in vain, hoping for Jewish ancestry. His own father died when he was nine. He left home aged fourteen, was articled to a Birmingham chartered accountant, and when he was twenty-four he started his own accountancy firm, John Ellerman & Co., in Moorgate, London.

By scrutiny of their accounts, he identified ailing shipping companies that commanded South African, Atlantic and Indian routes, took them over as the sole stakeholder, and combined them all into what quickly became the giant Ellerman Lines. His first competitive purchase of a shipping line was for Leyland & Company. He bid for this after Frederick Leyland collapsed and died of a heart attack in 1892, aged sixty, at Blackfriars Station in London. Ellerman then bought up other lines, like Thomas Wilson's of Hull, the largest privately owned shipping line in the world. In 1905 he was created a baronet for lending ships to the British government in the Boer War, and by 1917 he owned not only as many ships as were in the entire French merchant navy, but also swathes of prime London property and most of the shares in the *Financial Times*, *The Times*, *The Illustrated London News*, *The Sphere*, *Tatler* and *The Sketch*. He was also a major shareholder in twenty-two collieries and seventy breweries.

He had a mind like a latter-day computer, with a kind of Euclidean power of prediction. At any given time he knew which of his ships was where, what it carried, where it would unload, how many passengers would embark and disembark and what each journey was worth. Apparently he predicted, even to the months, the dates of both world wars.

As a parent, he was remote. The Mayfair house at 1 South Audley Street where Bryher was brought up was huge, the

* Equivalent to £2.5 billion in 2020.

chauffeurs liveried, the servants numerous. Sir John worked long hours, amassing money by the lax rules of Victorian enterprise culture. He was portly, immaculate, his hands laced across his middle when he sat, 'his beard so neat it could have been applied with spirit gum', his eyes ice-blue, as were Bryher's. He watched steadily, was soft-spoken and never discourteous. His eyes did not seem mirthful when he laughed.

He had no particular vision of what he wanted to do with his colossal wealth beyond creating more of it and bequeathing his empire to a son. Though as rich as Henry Ford and John D. Rockefeller, little was known of him, for he shunned publicity and society. His personal habits were abstemious: an early supper, a single whisky and to bed at ten. Hannah Glover, Bryher's mother, was deaf, selectively so, a side effect of scarlet fever. She did what he required of her. To the first of Bryher's gay ersatz husbands, she said of Sir John: 'He keeps me in a glass case but I keep human.'

Bryher's childhood

Sir John was fond of his daughter, whom he called Winifred or Dolly, but he had fixed ideas of a woman's place. An empty atmosphere pervaded 1 South Audley Street. Despite the size and opulence of the house, there was little or no conversation or emotional exchange between its three occupants. Bryher, the only child for fifteen years, never played with and seldom saw a child of her own age.

She suffered her restrictive clothes, the sense she could not be the appropriate daughter, a succession of nannies and governesses. She wished she were her father's son so as to pass his test of approval. She learned horse riding and fencing: 'I found the French fleuret too formal and switched to the duelling sword dreaming of challenges.' She had a sense of imprisonment, of identity denied:

In the early nineteen hundreds so many harmless things were forbidden us. We might not feel water nor sand nor earth when two kinds of drawers and two kinds of petticoats, a pinafore and serge frock imposed, as I can still remember, a very real strain on one's vitality. Prohibitions were imposed for whose reason we might not ask. We were pruned of every form of self-expression, like the single flower on an exhibition stem, until everything in us went into a single desire, freedom, which we saw only in wind or in the breaking waves and as we could not hold these, into what was nearest to them, poetry.

She ran away several times but got no further than the end of the street. As with Sylvia Beach, books were her childhood refuge and she identified with heroic fictional figures. Sir John's library, with its leather armchairs and stoked fires, was shelved with leather-bound editions of the classics. The titles of the complete works of Charles Dickens were tooled in gold on red bindings. On the walls were landscapes in oil – a precipice on Capri with fig trees in the foreground, a mid-period Corot of the Loire on a grey day.

For Bryher, from the age of five, escape from the oppression of South Audley Street was to sail with her parents on her father's ships: 'I watched the seamen enviously because the thing I wanted most was a boy's sailor suit.' In a memoir, *The Heart to Artemis*, she wrote of journeys in the decade before the First World War, to Egypt, Turkey, Italy, Spain, North Africa. She described the streets of Cairo, learning Arabic, taking a steamship down the Nile, trekking through the desert on donkey back, walking in Capri, climbing the Alps, nights in tents and palaces. She loved these travels. They created in her a restless international view, a disregard for the notion of home as a fixed place. Travel became natural to her as a lifestyle. When adult, she crossed the globe with the same nonchalance as others might go to the shops.

"'What do you expect me to do for you?" my analyst asked many years later. "As a child you have been in paradise."'

a brother

When Bryher was fifteen, in 1909, her brother, John, was born. A son was the apotheosis of family for Sir John Ellerman. To legitimize his son's birth and inheritance rights, he married Hannah Glover under a little-known Scottish law, *per verba de praesenti*, by which a couple could be legally married without witness if they lived together in Scotland for twenty-one successive days. Sir John's son might not easily have succeeded to his baronetcy or business were he identified as illegitimate.

All that Bryher, as Winifred or Dolly, had been denied was heaped on her brother. He was his father's heir and would inherit the Ellerman empire. His path was not easy and his childhood was lonely. His father forbade him ordinary pleasures – like going to see a Charlie Chaplin film. He was not allowed outside without a hat, and almost predictably had little interest in finance or business as an adult. His life's work and passion became the study of rodents. He lectured and published scholarly articles and a three-volume, 1,500-page monograph, *The Families and Genera of Living Rodents*, with a list of named forms (1758–1936).*

Bryher hated him from the off. It was bad enough, after fifteen years of being the only child, to be usurped by a sibling, but the unfairness of the blatant privilege bestowed on this boy compounded the insult of her illegitimacy and sense of gender incongruence. It also honed her feminism and guided her subversion and rebellion. A core element of her embrace of new

* Sir John Ellerman, 2nd Baronet, had no children and died leaving half the amount he had inherited.

writing and thinking was the sense that the values of the past were patriarchal, stifling, and inordinately unfair.

To her conservative father, she was his daughter, his Dolly. He was bewildered by her. Her path was to be a wife and mother, ergo she must wear frocks, be debarred from working in his or in any business, and by laws of primogeniture, enforced by men of power like himself, after the birth of his son, be excluded from inheriting his estate.

boarding school

In what to Bryher was a literal act of rejection, immediately after her brother's birth she was packed off to Queenswood Ladies' College in Eastbourne. There were eighty boarders aged nine to seventeen and a few day girls:

> I was flung into a crowded boarding school to sink or swim alone… Nobody gave any explanations; it was a perfect preparation for Freud. The experience could have driven me to insanity or suicide and it was as crippling for a time as a paralytic stroke. I did not recover from it until long after psychoanalysis and I survived only because I was tough.

School highlighted her sense of dislocation. 'I had the emotional development of a boy of nine,' she said of herself. She did not know who or where she was or how to communicate in this bewildering, unfamiliar environment. She said she did not understand the vernacular of 'bags I this seat' or 'funny old fish'. She hated the discipline but liked the food. Her marks were average.

'Nobody gave any explanations' was Bryher's protest about her strange childhood. Her mother described the home environment as like being in a glass case. For Bryher, cut off from herself and others by wealth, emotional inarticulacy and assumptions about

gender, it was like being marooned. If she could not be Winifred Glover or Winifred Ellerman, then who was she?

a friend

At school she made her first friend. Doris Banfield was half Scillonian, half Cornish, and her father too was a shipowner. In 1911 Bryher was allowed to go for a summer holiday with the Banfield family to their house in the Scillies: 'It was an instantaneous falling in love... the sea, islands and boats.' With Doris, she swam in the sea, collected shells ('cowries were the great prize'), went out in small fishing boats, landed on uninhabited islets – 'even to see a puffin on the rocks near where we were sitting seemed an intrusion'. Doris had a fox terrier called Sampie with a black spot above his tail. Bryher was happy, free, and away from school and South Audley Street. Her attachment to Cornwall and her friendship and support of Doris became lifelong:

> There was something about Cornwall that made us forget the difficulties of getting there. It was older, less tolerant of the human race, yet offering some sudden moments of illumination such as I have never felt in any other land. Once there, I never wanted to leave it, yet I also knew that I should do no work, moment would succeed moment of hibernation and dream.

When adult, and in command of her own affairs, Bryher bought Doris a daffodil farm in Trenoweth Valley in St Keverne in Cornwall. She took holidays at this farm and stayed there when London was being bombed in the Second World War.

complete frustration

On leaving school, Bryher asked her father to let her work in the family business. He refused. 'Women will never be accepted

at conferences,' he said. In 1914 she applied to work as a land girl. She was twenty. Her father's signed permission was needed and he would not give it. Sylvia Beach's parents encouraged her freedom of choice; Bryher's sought her conformity. Only by subterfuge could she be free. Her father allowed her request to study Arabic at the University of London but her sense of being blocked and thwarted was acute: 'I waste in a raw world, dumb, unendurable and old,' she wrote. She became suicidal:

> Complete frustration leads to a preoccupation with death.
> I could think of nothing else. There was plenty of vitality in
> me but this only made the situation worse. I found a bottle
> of rat poison in a cupboard and the only thing that prevented
> me from swallowing it was that I did not want to hurt my
> parents. For myself death seemed infinitely preferable to the
> subexistence we had to endure. The rat poison became my
> talisman. I could struggle on as long as I knew that it was mine
> for the taking... Under such circumstances I am always amazed
> now that I survived.

She did not correlate her brother's later absorption in the behaviour of rodents with her own preoccupation with rat poison in a cupboard. She said her one overmastering passion was to be free, to get out of South Audley Street, open herself to new experience, live her own life.

To express the humiliation of being trapped as a woman in a world claimed by men, she began writing *Development*, about her traumatic school days, 'at the rate of about a phrase a day, written almost with blood'. In it, she advocated educational reform for women:

> I have always been a feminist if that word means fighting for
> women's rights and I glory in it... Equality means equality
> with no special privileges or advantages on either side, but
> why should men have all the interesting jobs?

She identified as a feminist even while feeling she was at heart a man.

Like Sylvia Beach and Natalie Barney, Bryher read the symbolist poetry of Stéphane Mallarmé – poems of dreams of an ideal world: 'for the next twenty years my principles of conduct were founded upon his ideas', she said. She called him 'my master'. Mallarmé's ideas were to purify speech, use contemporary language, avoid the hackneyed and 'paint not the object but the effect it produces'. Poetry and art were about evocation and suggestion: 'between the lines and above the glance communication is achieved'. Mallarmé, for Bryher, hinted at the buried life, identity unexpressed, the mind liberated from purely conscious thought. She resolved to be a writer. She published a poetry collection, *Region of Lutany*, in 1914 – poems of longing for distant places and of yearning for freedom. She learned by heart all the poems in H.D.'s collection *Sea Garden*. This, she said, was the one book above all others that made her self-aware: 'The rhythms were new, it evoked for me both the Scillies and the South. It touched Mallarmé's vision.' Here were poems that reimagined the world:

> to blot out this garden
> to forget, to find a new beauty
> in some terrible
> wind-tortured place.

She did not know that H.D. was Hilda Doolittle, an American woman who had women lovers. *Sea Garden*, published in 1916, had been financed and edited by Amy Lowell, another American lesbian poet whom Bryher admired from an early age. Amy Lowell was a large woman with dark hair, a deep voice and a masterful manner. Margaret Anderson said she was so vast she had difficulty getting through the door.

Bryher meets H.D.

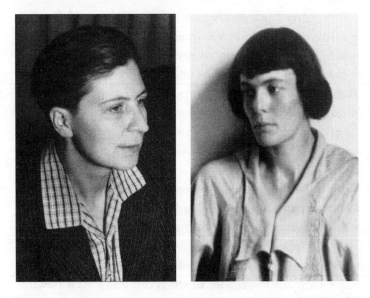

Bryher wanted to meet H.D. In the summer of 1918, she asked the editor of *The Sphere*, a journal owned by her father, to find her address. She learned she was staying in Cornwall, near St Ives. Bryher wrote a fan letter, went to Zennor with Doris Banfield, and asked H.D. if she and a friend might visit. H.D. thought her letter was from an elderly schoolmistress. She invited Bryher to tea on 17 July. She told her to look below the ruins of Bosigran Castle for a square house, close to the road, with two tall red chimneys. Bryher was full of anticipation:

> Was something going to happen to her at last? If she had a
> friend, something would burst and she would shoot ahead, be
> the thing she wanted and disgrace them by her knowledge.
> Because she would care for no laws, only for happiness. If she
> found a friend, an answer, the past years would vanish utterly
> from her mind.

Her words sounded as if written by a gauche schoolgirl rather than an elderly schoolmistress. She wrote them five years after first meeting H.D., by which time more than friendship had happened. The bursting thing she wanted, the shooting ahead, was intimacy and a woman lover. Friend was a catch-all word. There was nothing explosive about her friendship with Doris Banfield. The disgrace, the flouting of laws, the knowledge, the answer, was to live out her desire for sexual and emotional relationship with a woman. H.D. was her quest. Of that she was sure.

The door opened and I started in surprise. I had seen the face before, on a Greek statue or in some indefinable territory of the mind. We were meeting again after a long absence but not for the first time. 'Won't you come in?' the voice had a birdlike quality that was nearer to song than speech. There was a bowl of wild flowers on the table, a pile of books on the chair. We sat down and looked at each other or, more correctly, I stared. I was waiting for a question to prove my integrity and the extent of my knowledge. 'I wonder if you could tell me something' H.D. began, 'have you ever seen a puffin and what is it like?'

'They call them sea parrots and there are dozens of them in the Scillies. I go there almost every summer. You must join me next year.'

So Love began. Bryher's equivalent of Sylvia Beach's hat bowling in the wind down rue de l'Odéon with Adrienne Monnier in pursuit. H.D. said Bryher loved her 'so madly it is terrible. No man has ever cared for me like that.'

Bryher was twenty-four and H.D. thirty-two at the time of this first meeting. Bryher, naive and cut off by the strangeness of her childhood, had had no sexual relationships. Her romantic expectations were lofty, her commitment certain. She was in love with H.D. before she met her. H.D.'s emotional life was more than muddled, her mental health fragile. D.H. Lawrence said of her: 'She is like a person walking a tightrope. You wonder

if she'll get across.' There was a thin line between the imagery of her poetry and her bouts of psychosis.

The Bosigran Castle address sounded grand but was in fact a tin miner's stone cottage at the foot of the castle ruins. H.D. had lived there since March with Cecil Gray, a Scottish musicologist. Richard Aldington, her husband, was conscripted and fighting at the Western Front. Gray, who was in London on the day of Bryher's visit, was twenty-three and had rented the Cornish cottage as a love nest for their affair. H.D. was not in love with him. She was missing Aldington. She was also enamoured of D.H. Lawrence and believed him to be in love with her. She had joined Gray to escape the Zeppelin bombing raids on London and her emotional confusion. She found the Cornish landscape inspirational. She was translating the choruses from Euripides' *Hippolytus* – Harriet Weaver published this in her Egoist Press. Gray kept being cautioned for contravening blackout regulations; visible lights were a guide to hostile submarines, he was told.

Frances, Ezra, Richard, Cecil

H.D.'s relationships overlapped, merged, were never exclusive and seemed incidental to the true experience of her life, which was her writing. She slipped into affairs and was vague about shaping her life. She seemed to say 'yes' to all overtures. In her early twenties she had expressed deep love for a poet, Frances Gregg. 'No one will ever love you as I love you,' she wrote to her in 1911. She described this love in an autobiographical novel, *HERmione*, not published until 1981, twenty years after her death. 'I don't want to be (as they say crudely) a boy', H.D. told Frances, 'nor do I want to be a girl. What is all this trash of Sappho? None of that seems real. I feel you. My pulse runs swiftly.'

For H.D., love was transcendent, the currency of poetry, and same-sex love as valid as any other: 'We are legitimate children', she wrote.

We are children of the Rossettis, of Burne Jones, of Swinburne...
We were in the thoughts of Wilde when he spoke late at night
of carts rumbling past the window, fresh with farm produce
on the way to Covent Garden. He was talking to a young man
called Gilbert.

Before Frances Gregg – and while with her – she had been 'engaged' to Ezra Pound, whom she first met at a Halloween party in Pennsylvania when she was fifteen and he was sixteen. She vowed to dedicate her life to him; he gave her a pearl ring, wrote poems to and about her and called her Saint Hilda. But he too was dating Frances Gregg, who wrote in her journal: 'Two girls in love with each other and each in love with the same man.'

H.D. was five foot eleven – taller than most men. She stooped to compensate. Like Bryher, Natalie Barney, Gertrude Stein and most creative lesbians of the time, she felt she was not the daughter her parents wanted. In Pennsylvania her father was a distinguished astronomer and her three brothers and two half-brothers were academically successful. There was expectation of achievement in the Doolittle household but H.D. dropped out of Bryn Mawr without qualifications. 'She was a disappointment to her father, an odd duckling to her mother, an importunate overgrown unincarnated entity that had no place here' was how she described herself in *HERmione*. When Ezra Pound asked Professor Doolittle's permission to marry Hilda, he was dismissed as 'nothing but a nomad'.

In July 1911 H.D. travelled to London with Frances Gregg and Frances's mother. They all met up with Pound. The Greggs returned home in the autumn but H.D. stayed on. She asked Pound if they were engaged. 'Gawd forbid' was his reply, but he

helped her find a place in London's literary world. Her poems were published in Harriet Weaver's *The Egoist* along with work by Pound, T.S. Eliot, Ford Madox Ford, Richard Aldington and James Joyce. Harriet described H.D. as 'tall, thin, pale, rather handsome, dreamy-eyed, pleasant mannered'. With the publication of *Sea Garden*, which so inspired Bryher, the novelist May Sinclair called H.D. 'the best of the Imagists'. H.D. wove images from the coasts of Cornwall, and Maine in New England, into emotional moments in time.

She met Richard Aldington at a party in London in 1911 when she was twenty and he was twenty-six. He thought her the finest of poets and had no problem with her love for Frances Gregg. They rented rooms together in a house in Kensington – 6 Church Walk. Ezra Pound was a neighbour. They all wanted to free poetry from past constraints, use only essential words, discard rules about rhyme. They wanted too to discard rules in their personal lives. H.D. said that 'to deny love entrance is to crush and break beauty. Let love crush & break you but never break love by denial and conscience.'

She believed the hurt she suffered 'freed my song – this is most precious to me'.

She and Aldington travelled together to Paris, Italy, Capri. Ezra Pound, jealous, wrote a poem, 'The Faun'. It began:

Ha! sir, I have seen you sniffing and snoozling
 about my flowers.
And what, pray, do you know about
horticulture, you capriped?

In Venice, Aldington met H.D.'s parents, who did not approve of him any more than of Ezra Pound. Nonetheless, on 18 October 1913 Aldington and H.D. married at Kensington Registry Office in London with Professor Doolittle and Ezra Pound as witnesses. They rented a house in Hampstead, next door to

D.H. Lawrence and his wife, Frieda. The following August, war
was declared. H.D. was pregnant. She became seriously ill in the
last months of pregnancy and the baby was stillborn. 'Why is it
always the girl who dies' was her lament – for her own mother
had given birth to two stillborn baby girls. After the trauma, she
no longer wanted sex with Aldington, although she wanted his
love and support. She was unfazed or even encouraging of his
affairs with other women, in particular his affair with Dorothy
'Arabella' Yorke.

Aldington was conscripted in 1916. After he left, H.D. had
auditory hallucinations and from outside of her head heard his
voice calling her. D.H. and Frieda Lawrence were sympathetic to
her mental fragility. 'Hilda gets very low at times,' Frieda wrote
to Amy Lowell. 'It isn't good for her to be alone and Richard
away, she feels it very much...'

By 1918 H.D. was alone in temporary lodgings in Mecklen-
burgh Square in London's King's Cross. Through the Lawrences
she met Cecil Gray, who had until then avoided conscription
because of 'a heart tic'. He told her he loved her. In his Cornwall
cottage, he was working on a musical interpretation of Flaubert's
The Temptation of St Anthony. In March he pleaded with H.D.
to join him. Lawrence was unhappy at her going. H.D. seemed
unclear about what she was doing or with whom. Aldington
wrote to her almost every day; he admitted they had grown
apart, but was jealous of her being with Gray. Then in May he
was sent with the British Expeditionary Force to the Western
Front and the hell of front-line battle. He wrote to H.D. of
'them bloody, bleedin' fuckin' trenches... I wish I wasn't a
soldier.' He told her in a way he cared most terribly for her and
in a way he cared for Arabella, 'but there are too many dead
men, too much misery... But you are silly to think that our love
would ever be broken.'

a devilish mess

The First World War threw H.D.'s life into turmoil. She called it 'the stillborn generation'. Her crises of identity and bouts of insanity were recurring and painful. She wrote: 'I feel my work is beautiful. I have a deep faith in it, an absolute faith. But sometimes I have no faith in myself.'

For Bryher, meeting H.D., whom she felt she knew through her work, was love before first sight. For herself, she was insulated from the war and from life. She described H.D. as 'the most beautiful figure that I had ever seen with a face that came directly from a Greek statue, and the body of an athlete'. She did not know, when she went to tea on 17 July, that H.D. was pregnant with Cecil Gray's child.

Initially, the two women corresponded but did not often meet. Bryher returned to the confines of South Audley Street. She self-published a eulogistic essay, *Amy Lowell: A Critical Appreciation*. In gratitude, Amy Lowell arranged for Harriet Monroe, editor of the magazine *Poetry*, to publish three of Bryher's poems, 'Waste', 'Rejection' and 'Wakefulness'.

Two weeks after meeting Bryher, H.D. wrote to tell Aldington she was pregnant, that the father was Cecil Gray and conception had been in early July. The following month,

Gray was conscripted. He did not know H.D. was pregnant with his child.

'You seem to be in rather a devilish mess,' Aldington wrote to H.D. on 3 August.

> I will accept this child as mine if you wish, or follow any other
> course which seems desirable to you. I enclose five pounds,
> I will send you as much of my pay as I can. Try & keep it by
> for doctors &c. You will need it.

He added he hoped she was mistaken about this pregnancy and that he loved her but desired Arabella.

The next day he felt differently:

> Damn it Dooley, I am fed up to have lost you. I was an idiot to
> let you go away with Grey… I never really thought you would
> have a child with him. And Dooley, I can't ever really love this
> little one – there's our own sweet dead baby I'll never forget.
> I should always hate this one for being alive…I love you & I
> want you to be happy & have lovers & girl lovers if you want,
> but I don't want to lose you as I should if this happened….

H.D. *was* in a devilish mess. Neither or none of the men in her life was willing to be father to this child. When she finally told Gray of her pregnancy, he was silent. On leave, he did not visit her. Aldington shifted between anger and rejection. H.D. did not want an illegal abortion. She had no money and wondered about having the baby adopted.

In September, her brother Gilbert, fighting with the American Expeditionary Force in north-eastern France, was killed by machine-gun fire in the Battle of Saint-Mihiel near the town of Thiaucourt. He was thirty-two. Their father, in Pennsylvania, had a massive heart attack when he heard the news.

The backdrop for them all was the carnage of war, described by Virginia Woolf as 'this preposterous masculine fiction'. Except it was preposterous fact.

H.D. did not tell Bryher of her pregnancy until December 1918, five months after their first meeting and a month after the war's end. Aldington, jubilant at having survived, picked up with Dorothy Yorke, and hardened himself against responsibility for his wife: 'No more than Cain am I my brother's keeper', he wrote to H.D. 'Get from Gray what you can; and call on me in any emergency. I shall not fail you.'

Aldington met Bryher in London and thought her of a fine temperament but crushed by her parents and their immense wealth. 'I don't see how she can do anything until she gets away from her people,' he said. Gray vanished from the scene. He was well off with inherited money from wealthy parents but after hearing of H.D.'s pregnancy he wanted nothing to do with her or the child he had fathered.

H.D. was isolated and vulnerable. Her baby was due in March 1919. 'Her nerves are very shaken, perhaps the child will soothe and settle her,' D.H. Lawrence wrote to Amy Lowell. In the final weeks of her pregnancy H.D.'s father died, devastated by the death of his son Gilbert in France the previous September. H.D. became ill, mentally and physically. She had visual and auditory hallucinations of a gigantic river god and a doctor with wings on his sleeves. She caught influenza, which led to pneumonia.

Bryher to the rescue

Bryher found her close to death in rented rooms in Ealing. She became her saviour, arranged medical and nursing care, booked her in to St Faith's Nursing Home, financed everything needed for the birth, visited daily, brought 'wonderful bunches of anemones', promised support and spoke of taking her to Cornwall and the Scillies, to Greece, to America as soon as she was strong. Her commitment and management were unwavering. It was hard for H.D. to distrust her or to resist her.

Frances Perdita Aldington was born at noon on 31 March 1919. She was given her first name after Frances Gregg but was known as Perdita. Bryher visited that day and most days thereafter, always bringing flowers, assurances of help and anything that was needed. H.D. wanted Richard Aldington named as the father on Perdita's birth certificate. She wanted to avoid the stigma of illegitimacy and to conceal the 'devilish mess'. Aldington threatened legal action if she did this. She named him as father anyway, without telling him.

Aldington was conflicted about H.D. He asked her to return to him, but when she did, in London, he ordered her to leave. 'Hilda must get out of here at once,' he wrote to Bryher. The yo-yo of his devotion and hostility destabilized H.D., who talked of her psychic death.

As for Gray, three years after Perdita's birth the writer Brigit Patmore, who had introduced H.D. to Aldington, confronted him about his behaviour towards H.D. and his daughter. He said he had much on his conscience, that inaction was almost a madness with him and 'You must think me the greatest cad on earth, but everything was so awful...' Brigit Patmore told him H.D. would have died had it not been for Bryher. He 'went green' and claimed he would always look after Perdita, but his family had suffered financial loss and money was now scarce. Brigit Patmore did not believe him: 'He seems divided between hatred & disgust with his own part in it & a consequent weak determination to shut it out completely, & a sort of equally weak desire to make it all right,' she wrote to Bryher.

Perdita, who looked like her father, only met him once – by chance on Capri in 1947. A few years after her birth, Gray apparently fathered another girl by an unspecified young married woman. He wrote in one of his notebooks: 'The world is full of my daughters. It pullulates with them. You can't escape them. They are all over the place.'

He married three times. His addiction to alcohol and cocaine got out of hand and he died aged fifty-six of cirrhosis of the liver.

Saint Bryher

Bryher saved H.D.'s life and H.D. became her life. Both were outsiders. Bryher never doubted H.D.'s creative talent was greater than her own. The core of their relationship was H.D.'s need and Bryher's unfaltering wish to protect her and to champion her work. Three weeks after Perdita's birth, Bryher took H.D. to Eastbourne to recuperate. Perdita was left in the Norland Nursery in Holland Park, which became her main home throughout her infancy. Bryher paid all fees.

A pattern of dependency and provision formed. In June and July 1919, Bryher took H.D. to Mullion Cove in south Cornwall and to the Scilly Isle from which she had taken her name. H.D. had a psychotic episode, which years later she described to Freud as the 'sense of being in a bell jar' immersed in a watery globe. Bryher encouraged such episodes and called them the most wonderful thing. But they alarmed H.D. and caused her mental and physical torment, even while she cherished them as a creative source.

Bryher did not shrink from the demands H.D.'s mental breakdowns brought. She gave H.D. wealth, love, admiration, loyalty and psychiatric help. In a poem dedicating her 1926 novel *Palimpsest* to Bryher, H.D. wrote;

stars turn in purple, glorious to the sight;
yours is not gracious as the Pleiads are
nor as Orion's sapphires, luminous
yet disenchanted, cold imperious face,

when all the others, blighted, reel and fall,
your star, steel-set, keeps lone and frigid tryst
to freighted ships baffled in wind and blast.

H.D. was, throughout her life, 'baffled in wind and blast'. Bryher was her North Star. Other stars, more bright and alluring, reeled and fell from sight when the going got stormy. As a provider, Bryher was more of a man than Aldington or Gray. Aldington proffered a fiver but said he would always hate his wife's baby for being alive. Gray ran from the scene and would not face responsibility for having fathered a child.

Bryher offered herself as more than a partner to H.D., more than a 'girl lover' or friend. She was the resolution to this devilish mess. H.D. would have the best accommodation, travel anywhere in the world, buy what she wanted and have provision for her child. She could be free to write. Bryher's devotion would be steel-set. She would be her steadfast partner, her wise guardian. That year she financed the publishing of H.D.'s volume of verse *Hymen* with Harriet Weaver's Egoist Press and subsidized the Poets' Translation Series where H.D.'s Greek translations appeared.

that odd commanding look

So H.D. chose to make her life's voyage under Bryher's lone and frigid tryst. But there was a barrier to her affection. She found Bryher controlling; 'cold and imperious'. She described her eyes as 'bluer than blue, bluer than gentian, than convolvulus, than forget-me-not, than the blue of pansies. They were a child's eyes, gone wild and fair with gladness.'

But she was not drawn to the personality behind this blueness:

that odd commanding look and that certainty and that lack
of understanding and that utter understanding that goes
with certain types of people… people who were simple and
domineering never having known anything of scraping, of
terror at the wrong thing, of the wrong people. Hard face,
child face, how can you be so hard? The smile froze across

the white large teeth and the white perfect teeth showed the lips as hard, coral red, clear, beautifully cut and yet the child was not beautiful.

There was something out of reach in Bryher: a kinship with her father's computing mind and her brother's remorseless interest in rodents. She wanted to be part of H.D.'s creative world with her own gender identity understood. But H.D. was not particularly sympathetic to Bryher's problems, the strange obstinacy of the solitary child, the girl who was privileged but undermined and with a sense of encasement in the wrong body. H.D. declared love and affection for Bryher, but never passion. She said she had a brain where her heart ought to be, though she came to trust this brain and not once did Bryher fail her. 'When I met Bryher first', H.D. wrote,

> a little thing – all tense, dressed like a princess, buns over her ears – she said to me 'you're the first person who treats me like a human being. Everyone else looks at me as though they saw just over my head a funnel out of which pours gold coins.'

But H.D. quickly became dependent on the gold coins that poured from the Ellerman funnel. Bryher's father was not just the richest man in Britain, he was the richest by a factor of four, the largest taxpayer in the country. Bryher neither wanted nor expected acknowledgement or thanks. H.D. was neither calculating nor mercenary, but she knew the measure of the gift: rescue from a devilish mess and absolute creative freedom of the sort most writers dare not dream.

In return, H.D. gave Bryher the avenue of escape from South Audley Street, a path for creative endeavour and a revisionist lifestyle. They talked of living together. Bryher said she would be glad to be with her 'almost entirely' and promised to provide for Perdita.

They needed each other, though the road was not easy. H.D. needed Bryher's wealth and strength, her generosity and care. She was not in love with her and often said she would leave her. She described herself as at times very lonely with Bryher. But, she confided to Ezra Pound, Bryher looked after Perdita and 'that seemed to be the only thing I was hanging on for':

> I put down a lot of myself after Perdita's birth. I loved
> Richard very much and you know he threatened to use
> Perdita to divorce me and to have me locked up if I
> registered her as legitimate.

Hilda's circle did not like me at all

Bryher, when she returned with H.D. from Cornwall in the summer of 1919, rented a London flat for them both in Kensington Church Street, 16 Bullingham Mansions, an Edwardian block near the nursery where Perdita was almost permanently ensconced. 'Hilda's circle did not like me at all', Bryher said of her cool reception into H.D.'s world. Ezra Pound and Richard Aldington called at the flat. Both felt redundant. Ezra Pound thought Bryher impossible. She seemed guarded, self-assured, dominating even through her silence. In August, when Aldington was hard up, H.D. gave him £10. It was Bryher's money.

Bryher seemed an unlikely proponent of modernism. She did not look or behave like a poet or an artist. She was emphatic, and businesslike. She wrote unflowery prose and wooed with precision:

> 'It meant everything to talk that day of Mallarmé.'
> 'It meant so much to see you yesterday.'
> 'I'll send the car over to fetch you.'

Many cars were sent.

H.D. and South Audley Street

H.D., when introduced to Sir John and Lady Ellerman, could not communicate with them nor they with her. She was presented as a quasi chaperone for Bryher, a role she struggled to perform. After the first encounter she always took a tranquillizer before visiting. The Ellermans were disconcerted. Why was their daughter spending so much time with this woman, this poet who was separated from her husband and who had a newborn daughter whom the father did not acknowledge? This was not an arrangement they wished to understand. They suspected Winifred's private life was irregular and they feared for her reputation and the Ellerman name. They wanted her married. Sir John did not threaten to withdraw the investments, shares and assured income in place for her, but he did not wish to bankroll unorthodoxy. Bryher cared about incurring his disapproval. Also, her allowance as a married woman would be far greater, though it would not compare to the inheritance reserved for her brother.

For Bryher, taking on H.D., her emotional fragility, baby daughter and devilish mess, was a challenge. She was herself young, naive, battling with her own gender incongruity and her parents' expectations of Victorian conformity. She had courage and determination, but was also in thrall to her parents and their status. And so she was divided; she must be both man and woman, both modernist and Victorian. She went 'back and forth from Audley Street, strange and uneven but always staunch and loyal'.

Havelock Ellis

H.D. introduced Bryher to Havelock Ellis. 'Nobody could have been kinder to me,' Bryher said of him. She and H.D. began analysis with him. She read his *Studies in the Psychology of Sex*,

they talked about women's rights, he gave her a paper on Freud, and she became one of the first subscribers to the *Journal of Psychoanalysis*. The boundaries between the roles of therapist, analysand and friend were blurred. He called to see them at their Kensington flat and joined them there on Christmas Day 1919. There was a tree and presents. Perdita was brought over from the Norland Nursery.

Havelock Ellis was at home with sexual diversity. His wife, Edith, was lesbian; he was a virgin when he married her in 1891 and was impotent until he was sixty. His 1897 medical textbook on same-sex relationship, *Sexual Inversion*, had been censored as obscene. Bryher told him of her conviction that she was a boy trapped in a female body. He assured her this was a not uncommon phenomenon and gave her *Psychopathia Sexualis* by Richard von Krafft-Ebing to read.

H.D.'s relationship with him was colourful. In *Fountain of Life*, a collection of impressions and comments, he wrote of his interest in urolagnia and described in embellished prose how H.D. urinated on him:

> her tall form languidly rose and stood erect, taut and massive
> it seemed now with the length of those straight adolescent legs
> still more ravishing in their unyielding pride, and the form
> before me seemed to be some adorable Olympian vase, and a
> large stream gushed afar in the glistering liquid arch, endlessly,
> it seemed to my wondering eyes, as I contemplated with
> enthralled gaze this prototypal statue of the Fountain of Life.

The therapeutic value of this to H.D. was unclear, but when, years later, she recounted the incident to Freud, she said he 'bust his cat-whiskers with joy'.

Ellis's overmind

Havelock Ellis's theories and writings about sex were banned by

the censors. His attempts to classify and understand gender and sexual behaviour were disallowed. His ideas seemed of questionable help to H.D. He talked of her mind taking on a physical character in the creation of her work:

> When a creative scientist, artist or philosopher has been for some hours or days intent on his work, his mind often takes on an almost physical character. That is, the mind becomes his real body. His overmind becomes his brain... In place of the 'real' material body, the creative artist has a fantasmatic body, a body of the mind. It is this insubstantial body and ethereal overmind which produce man's highest cultural achievements.

In 1919, in *Notes on Thought and Vision*, H.D. described how her 'overmind' went beyond her body and normal thinking to a state of visionary awareness. In thirty-two pages she wrote of the 'super feelers of the super mind' and how 'Christ was the grapes that hung against the sunlit walls of Nazareth'.

H.D.'s hold on reality was uncertain and such flights were scary. She had much to cope with and talk of fantasmatic bodies and super feelers did not make her well. She slipped into depression. Bryher hoped a journey to Greece would help and held this out as a prize. They would visit the temples and sites of the gods who inspired H.D. Such a journey would take her away from the confusion of Gray, Aldington and the baby daughter whose needs she could not answer. As soon as H.D. was strong enough, they would leave:

> We had made a pact; if I got well she would take me to Greece. I got well. But something was lacking. Something had gone. I was convalescent you might say psychically, I had taken up my bed and walked. But where had I walked?

Havelock Ellis was both analyst and friend. Bryher made plans for him to accompany them on the Greek visit.

to Greece with H.D. and Havelock Ellis

Early in February 1920, the three of them sailed on the SS *Borodino*, one of Ellerman's passenger ships. Perdita, eleven months old, was left in the Norland Nursery. H.D. found the journey difficult. Terrified of the sea, she anticipated shipwreck and the engulfing ocean. The trio arrived at Piraeus at the end of the month. In Athens, she and Bryher stayed at the Hotel Grande Bretagne. 'They were comfortably ensconced in the most luxurious hotel in the city,' Ellis wrote. He was uncomfortably ensconced in a modest pension.

They explored the streets of Athens, heard Greek spoken, visited the Acropolis and the Archaeological Museum and sensed, like Oscar Wilde before them, 'the spirit of the gods that dwelt within the marble'. Bryher's hope was to transport H.D. to the classical past. They climbed the slopes of Mount Hymettus, 'found early hyacinths and great rose-coloured anemones among the rocks' and reached the eleventh-century monastery of Kaisariani where there was once a shrine to Aphrodite. They had tea with Evalina Palmer, who had been Natalie Barney's lover and who extolled Sappho and her community of women on Lesbos. They climbed Mount Lykabettos, visited Eleusis, the birthplace of Aeschylus...

Here were the columns and statues of Greece bathed in authentic light. But H.D. was ill. She felt trapped. The war, the death of her brother and father, her broken marriage, separation from America, failed relationships with men, severance from her year-old baby, anxiety over motherhood, and pressure from the weight of Bryher's full-on love and indulgent wealth all affected her. 'They are both very peculiar,' Havelock Ellis wrote in a letter home. As if he wasn't.

He left them and made his own way home alone. At the end of March, Bryher and H.D. then cruised to Corfu on the SS

Hélène, stopping at little islands on the way. In Corfu town, they stayed five weeks in a suite at the Belle Venise Hotel, the 'jewel in the crown' of nineteenth-century Corfu. They walked among olive groves, drove to the town of Potamós, visited the Byzantine monastery at Paleokastritsa, went to the hilltop village of Pelekas, saw the Temple of Artemis at Kanoni. At times H.D. felt elated and liberated, as if, for many years, she had been 'crawling about existing under mist and fog'. The whirlwind of impressions, she said, 'will flood over me when I leave'. But before she left she suffered hallucinations and saw helmeted faces and tiny black people climbing up a wall of their rooms in the Belle Venise:

> They are not important but it would be a calamity if one of
> them got stuck on one's eye. There was that sort of feeling
> people, people, why did they annoy me so? Would they
> eventually cloud my vision, or worse still would one of
> them get stuck in my eye?

Bryher interpreted these hallucinations not as symptoms of illness but as imaginative inspiration. Here was the mind of the creative genius. She encouraged H.D. to probe into the meaning of these images. Which sent H.D. crazier. Years later, in *Tribute to Freud*, H.D. wrote about this breakdown:

> this writing on the wall before me, could not be shared
> with anyone except the girl who stood so bravely beside me.
> This girl said without hesitation, 'Go on.' It was she really
> who had the detachment and the integrity of the Pythoness
> of Delphi. But it was I, battered and disassociated from my
> American family and my English friends, who was seeing the
> pictures, who was reading the writing or who was granted
> the inner vision.

That was thirty-six years later, in 1956. At the time, for Bryher, twenty-five years old and cocooned from experience of other people, the situation took some managing. Their resident

psychoanalyst had fled. Havelock Ellis wrote: 'Hilda went right out of her mind and Bryher had to bring her back overland.'

H.D. would not face travelling back by sea. She feared collision with icebergs, as with the *Titanic*. Bryher made other arrangements to get her lover home. At the end of April they made the short boat trip on the SS *Arcadia* through the Gulf of Corinth to the Italian port of Brindisi, rested up at the Hotel Europe, took the train to Rome, stayed at the Grand Hotel, and within weeks were back at the Mullion Cove Hotel in the reassuring landscape of Cornwall. From there they returned to their flat at Bullingham Mansions in Kensington.

where to live

Once back from Greece, Bryher spent little time at South Audley Street. To her parents' concern, she was mostly at the Kensington flat with H.D. Bryher felt unsettled by their disapproval and unable to navigate her double life.

H.D. was homesick for America. She missed friends and family, and wanted to find a home for her child, and leave behind her failed marriage and the depressed aftermath of European war. She hinted to Amy Lowell at her close relationship with Bryher; she praised Bryher's work and said they would all meet when they came to America in the autumn. She also wrote to Marianne Moore of plans to winter in California with Bryher, Perdita and her nurse, so as to escape the fog and rain of England and with thoughts and plans of settling there.

America

Both H.D. and Bryher hoped relocating to America would answer their problems. Bryher wanted to please H.D. and be her partner. America was H.D.'s country and Bryher wanted to

see her acclaimed there. For herself, she needed to escape South Audley Street and her parents' wishes. In her autobiographical novel *Two Selves*, which she published in 1923, she wrote:

> If people got between one and one's vision one had to cut them out...
>
> 'I want to be free....It's not that I'm not grateful for all you've done for me but I can't help wanting to use my brain. If I don't go away I can't develop. I don't want to hurt your feelings. Surely you must see that I don't want to hurt your feelings. But I want to live by myself.'
>
> 'But how are you not free?' She knew that would be the astonished answer. 'What have you ever been forbidden to do?'
>
> 'It's the thousand things too unimportant to mention. But that make a barrier... Not cutting my hair short... I want to write. I have never been my real self to you. I have been silent about the things I care about. Because I knew you hated me to be rough and independent.
>
> She could not say this. Could not hurt people's feelings. Things had gone on too long.

But how to partner H.D. was also a problem for Bryher. Her commitment was total, she thought H.D. a genius, but finding a context was not going to be easy. To H.D., on some level other people were like trees blowing in the wind. And Bryher had her own bouts of confusion and temper loss. H.D. observed her distress but was not a person to protect or console. In later life, Bryher reflected that she did not understand her own motivation until she had undergone years of psychoanalysis with Hanns Sachs, a colleague of Freud's.

Bryher, H.D., Perdita and a nurse set off for America in late August 1920 on the SS *Adriatic*, the fastest ocean liner and the first to have an indoor swimming pool. Bryher was in search of a brave new world where she could be who she was, but there was

a kind of unreality in their journeying – as if at heart they could never be a family or find a destination. There was little sense of parenting Perdita, of enjoying her personality or little ways. The plan was to meet with editors and publishers in New York, then visit H.D.'s mother in Orange city in California and leave Perdita with her until they found somewhere peaceful to settle in the Californian countryside, a house where they could live and work.

They arrived in New York on 10 September 1920, H.D.'s thirty-fourth birthday. Amy Lowell and her partner, the actress Ada Dwyer Russell, met them, took them to the Belmont hotel and drove them around the city. H.D. met with friends and peers: Marianne Moore, the editors of the literary magazines – Harriet Monroe from *Poetry*, Margaret Anderson from *The Little Review*.

Bryher's book *Development* had been published earlier that year in New York. In it, she declared her gender disorientation:

Her one regret was that she was a girl. Never having played with any boys she imagined them wonderful creatures, welded of her favourite heroes and her own fancy, ever seeking adventures, and of course, wiser than any grown-up people. She tried to forget, to escape any reference to being a girl, her knowledge of them being confined to one book read by accident, an impression they liked clothes and were afraid of getting dirty. She was sure if she hoped enough she would turn into a boy.

Amy Lowell wrote a preface. The book received good reviews and sold well. Bryher's father warned her not to draw attention to the Ellerman name and forbade her to make any revelations about him, his family life or business empire. He insisted that on return to England she should live again at South Audley Street.

In New York, H.D. and Bryher assembled and published a collection of Marianne Moore's poetry. They called the volume *Poems* and Bryher financed it. She also made Marianne Moore

the first beneficiary from the Bryher Foundation Fund, which she later set up to help hard-up artists. Marianne Moore's parents had separated before she was born and she lived with her mother, who called her 'he' and 'Uncle Fangs'. They were devoted to each other and slept in the same bed.

William Carlos Williams was a friend of H.D.'s from her college days in Philadelphia. She invited him to the hotel and he brought with him Robert McAlmon, a young impoverished writer. McAlmon was the eighth child of a Presbyterian minister in a small provincial mid-western town. His childhood was miserable; his father beat him and despised his homosexuality. He left home, enrolled at the University of Southern California, dropped out, made his way to Greenwich Village, mixed with writers and artists and lived hand to mouth. When Bryher met him, he was earning a dollar an hour as a life model at The Cooper Union for the Advancement of Science and Art.

Bryher thought him authentic. He told her he had 'the energy of a yearling stallion... we can't be too careful livers', he said, 'or we just won't live at all.' He admired her mind and spirit, had read a review of *Development* in *The New Republic* and said he too hated school, conformity and 'timid stepping'. He was disappointed in the New York literary scene. He had written a novel, but knew it would not get past the censors. He longed to join the exodus of American writers, go to Paris, write freely, meet James Joyce, be open about his homosexuality. That was his dream, but he did not have the money for his fare.

McAlmon thought H.D. the best of the Imagists, although he did not rate Imagism and thought it escapist. Bryher, he said, was better than any imagist. She told him of her yearning to be a boy. He said a boy's life was difficult: beatings, no money, not enough to eat. As for himself, he aspired 'to sing with my own voice and dance on my own legs and blaspheme and fight – express impulses rather than trying to squeeze them into writing'.

He advised her to 'see the lightness of wit and clarity of perception of your Greeks'. He intended to get on a freighter, head for Europe and test his luck. Such expressions of freedom resonated with Bryher. She told him not to leave until she got back to New York.

disaffection

Bryher corresponded with McAlmon while she travelled with H.D., H.D.'s widowed mother, Helen Wolle Doolittle, Perdita and the nurse to Los Angeles, Monrovia, Santa Barbara, Carmel. It quickly became clear to Bryher that America was not going to be the answer to the question of where to live and how, with her unorthodox identity and new-found family. She and they were rootless, and she was disaffected with all she saw. H.D., disappointed by Bryher's aversion to America, felt discouraged and could not work. Her daughter had no home. But Bryher was also fearful of returning to London. 'I did not want to live in England because I knew I shocked my family with my advanced ideas.'

Bryher published 'An Impression of America' in *The Sphere*. She wrote that she had imagined Santa Barbara to be a quiet sunlit Californian town straggling down from the mountains to the sea, but what she found was a resort:

> it is everything I am trying to escape from – a civilisation
> without life, when I want America, the America that had the
> energy to lay the miles of railroad we came across, the America
> that planted the corn, the America that built New York.

She worked on a roman à clef, *West*, about her disappointment:

> I thought America was going to be new, different. And it's like
> Victorian England grafted on to the cheap end of Nice. Dust,
> formality and no end to spending money… Greece was cheap
> and you had Hymettus. New York was New York, arrogant and

barbaric. But here you weighed out gold and silver for suburbia gone reckless, for the grind of wheels and an indefinable sense of restraint.

My friends were all Americans. I wanted to know the country that they came from… I doubt if the books which brought me over could have been written if their authors had not escaped to Europe from the environment of their adolescence. There's a passion of beauty in them. A whole new world created. I thought that they were writing of what was about them. They were getting away from it. It's a great joke.

America bewildered Bryher. She was shaped by Victorian England, its class structures and entitlements. Her acquired tastes, sensibilities and sense of history were English and European. She was at ease in Europe. Her disaffection with America equalled McAlmon's. Like him, she wanted to get on a freighter, head for Europe and test her luck – albeit a freighter with first-class accommodation.

if we married

After six months, in February 1921, Bryher and her dependants were back in New York. They stayed at the Hotel Brevoort on Fifth Avenue. She met again with McAlmon and over tea there proposed to him:

> I put my problem before him and suggested that if we married, my family would leave me alone. I would give him part of my allowance, he would join me for occasional visits to my parents, but otherwise we would live strictly separate lives… we neither of us felt the slightest attraction towards each other but remained perfectly friendly. We were divorced in 1927…

This was a way out from her parents' insistence that when she returned to England, she should live with them and not with H.D.

I was desperately afraid of hurting their feelings. I knew equally
well that after a period of comparative freedom, I could not
adjust to a conventional routine. I admit that I was foolish but
I took the course I did in good faith.

McAlmon readily agreed. They married next day, Valentine's
Day, a Monday, at New York City Hall. H.D.'s view was that
Bryher 'knows what she wants and how much & how little she
wants'. Bryher, under the terms of her father's trust fund, would
receive more money if married, but her prime motivation was to
have an acceptable reason for leaving her parents' home.

On the afternoon of her marriage, Bryher went with H.D.,
but not McAlmon, to tea with Marianne Moore and her mother
at 14 St Luke's Place, Greenwich Village. The ostensible reason
was to meet with Scofield Thayer, who owned *The Dial*, to talk
about publishing H.D.'s latest poetry. Marianne Moore was
shocked by the marriage. Her view was 'marriage is a Crusade,
there is always tragedy in it. There is no such thing as a prudent
marriage.' But she was appalled by this version; she felt McAlmon
was taking advantage of Bryher. He later explained to her 'it's an
unromantic arrangement between us', but she wrote a satirical
poem, 'Marriage', which was seen as a reproach to him. It might
also have been a reproach to Scofield Thayer, who asked her to
marry him even though he was already married to someone else.
Marianne Moore viewed herself as both a confirmed bachelor
and wedded to her mother. In Mrs Moore's view, McAlmon had
dishonoured Bryher and insulted the Ellermans and England.
She referred to him as the 'scoundrel bridegroom'.

The press was equally confused. Winifred Ellerman did not
show up in Burke's Peerage. Sir John had not married until 1908,
Bryher was born in 1894 and there was no advertised record of
her birth, only that of her brother John, now eleven. *The New York
Times* suggested the whole thing was a scam: '"Heiress" Writer
Weds Village Poet', it reported. 'Greenwich Circles Stirred

by the Romance of Robert Menzies McAlmon.' 'The girl' was thought to have proposed to and 'exploited' him by claiming to be the daughter of Sir John Ellerman, to whom Burke's Peerage credited only a son.

The truth about what was going on was not surmised.

the Ellermans' son-in-law

Bryher cabled her news to her parents. For a time her cables went unanswered. Eventually, Sir John asked them both to come over. They booked to sail on the Ellerman White Star liner SS *Celtic* from Pier 43 on Sunday 20 February. 'We are in a terrible confusion of packing & unpacking and repacking,' H.D. wrote.

On the Thursday before the newlyweds left, a celebratory dinner was held in a private room at the Brevoort. Among the guests were Robert McAlmon's sister Grace, Marianne Moore and her mother, Scofield Thayer, and Florence and William Carlos Williams, who gave Bryher and McAlmon a box of orchids. On the voyage back to England everyone had the sulks, H.D. said. McAlmon was 'very good' with Perdita. He had no clear idea of the extent of the Ellerman fortune or what his role as a husband would be.

In London, the married couple moved in to South Audley Street, H.D. was installed in an apartment nearby in a regal part of town, St James' Court, Buckingham Gate, and Perdita was delivered back to the Norland Nursery but brought out to join her revisionist family on her second birthday. H.D. wrote to Amy Lowell that when the Ellermans recovered from the shock, they

> were very, very pleased with 'Dolly's' choice and rather over-
> did things. They forced upon the couple a whirl of parties and
> a cascade of gifts and other unimaginable bridal atrocities.

No need for them to know that McAlmon was homosexual,

penniless, posed nude as an artists' model, was overfond of drink and had not a hint of desire for their daughter, who had set up the whole charade. He was a man. She was a woman. He was her husband and their son-in-law. Their daughter was married. She was Mrs McAlmon. She had a good friend who was a poet. The whole set-up could be explained away in more or less socially acceptable terms. No need to have conversations about same-sex love, the role of women, gender dysphoria or primogeniture. No need to upset the apple cart or to tell the truth.

Bryher pretended, up to a point, to be the daughter her parents insisted she was. They would not, in their house, allow her to be anything else. In the front drawing room, on a gold easel, behind a stand of cut flowers, was a life-size portrait of 'Dolly' in a lady's chair, wearing white tulle with a blue sash to match her blue eyes. It was by Sir Luke Fildes, who had painted King Edward VII in his coronation robes. Lady Ellerman claimed that the sash was sent back twice to Paris to be redyed before it matched exactly the true blue of her daughter's blue blue eyes.

McAlmon felt trapped. He would get through dinner, smoke an after-dinner cigar with Sir John in the library, then, in collusion with Payton the butler, sneak out to the clubs. He tried to make literary connections but found London culture respectable and prim. Sir John offered to find him an editorial post on one of his journals: *Tatler*, *The Sketch*, *The Sphere*. McAlmon had different

publishing plans in mind. He had tea with T.S. Eliot and met Wyndham Lewis but failed to persuade Sir John to buy Lewis's paintings. He was appalled at the repression of Bryher's brother, who had to wear a bowler hat when he went out, had been sent away to Malvern College, which he hated, and who had no friends. Of Sir John Ellerman, McAlmon wrote in his memoir:

> moneymakers on the grand scale are monomaniacs and fanatics and self-willed. As regards finance Sir John had that thing which need not be looked upon with awe, genius, but in many other respects he was a perfect case of arrested development.

Pretence of togetherness by the newlyweds at South Audley Street was a dinnertime affair. London was a stopgap. Bryher and McAlmon were both writing novels. H.D. worked on an autobiographical prose-poem, 'Paint it Today', and a book of poems, *Heliodora*. She wrote to Marianne Moore that Bryher was 'wonderful, so good, intense & radiant, a baby Maecenas I call her'. Maecenas was an ancient Roman patron of poets, including of Horace and Virgil. McAlmon was impatient to head for Paris and to get away from them all. Bryher intended to make a base for herself and H.D. in Switzerland as soon as she could convincingly do so.

writers on the move

By the summer of 1921, McAlmon was in Paris and Bryher and H.D. were at the Riant Chateau in Territet in Montreux, Switzerland. This became their base until 1930. Switzerland was a tax haven for Bryher's inheritance. Their apartment looked out over Lake Geneva, the Alps towered behind them, the climate was agreeable. Perdita was brought out for visits and holidays by a Mrs Dixie from the Norland Nursery. Towards the end of the year, H.D.'s mother joined them. She stayed as part of the

family for four years and travelled with Bryher and H.D. to Italy, Greece and Constantinople. On Perdita's visits, she looked after her. When in London without Bryher, H.D. stayed at the Hotel Washington in Curzon Street.

Bryher and H.D. were writers on the move. While Bryher travelled with H.D., her parents thought she was with McAlmon in Paris. Sylvia Beach acted as go-between, posted on Bryher's letters to Lady Ellerman so they would have the Paris postmark and forwarded mail to Bryher from her parents. 'It may have been wrong but it saved my parents from a lot of anxiety and I cannot think it did any harm,' Bryher said.

She and H.D. travelled by train through Egypt. They survived sandstorms, visited the tomb of Tutankhamun, stayed at Luxor, cruised up the Nile, visited the Temple of Edfu, walked in the gardens of the Winter Palace Hotel, visited mosques and Coptic churches and bought fly whisks and turquoise cats and giant scarabs from bazaars, drove in a sand cart to the tombs in the Valley of the Kings, admired Karnak by moonlight... On Capri they stayed at the Hotel Quisisana with Nancy Cunard and Norman Douglas, who was 'wildly, gloriously drunk'.

Paris and Contact Editions

In Paris, with Bryher's money and editorial input, McAlmon set up Contact Editions. He ran the enterprise from his room at the Foyot hotel in rue de Tournon; its restaurant was considered one of the best in the city. Contact's publishing legend ran:

> Contact Editions are not concerned with what the 'public' wants. There are commercial publishers who know the public and its tastes. If books seem to us to have something of individuality, intelligence, talent, a live sense of literature, and a quality which has the odour and timbre of authenticity we publish them. We admit that eccentricities exist.

> We will bring out books by various writers who seem not
> likely to be published by other publishers for commercial or
> legislative reasons.

That was an invitation to a host of expatriate writers at odds with the censors and mainstream thought. Between 1922 and 1930, Contact published, often for the first time, the work of Gertrude Stein, Djuna Barnes, H.D., Gertrude Beasley, Mary Butts, Mina Loy, as well as Ernest Hemingway, Ezra Pound, William Carlos Williams, Ford Madox Ford, Nathanael West, and of course McAlmon himself. All were paid with Bryher's money. Bryher's *Two Selves*, which included the account of her meeting with H.D., was published by Contact in 1923.

With McAlmon as commissioning editor, Contact published Hemingway's first work, *Three Stories and Ten Poems*, and took on the mammoth task of publishing Gertrude Stein's 500,000-word *The Making of Americans*. He also published his own short stories, set in the American Midwest, his *Grim Fairy Tales*, about the homosexual subculture of Berlin, and his novel *Village*, a fictionalized account of the South Dakota town where he grew up and found his first love – Gene Vidal, the novelist Gore Vidal's father, all of which mainstream publishers rejected as obscene. Seventy years later, in 1995, in a memoir, *Palimpsest*, Gore Vidal wrote of McAlmon's book: 'It is curious – to say the least – to encounter one's father as a boy of fifteen as seen through the eyes of a boy of fourteen who is in love with him.' H.D. used the same title – *Palimpsest* – in 1926 for three connected short stories, published first by Contact, then by Houghton Mifflin in New York.

McAlmon called his stable of writers 'the Bunch'. No more than five hundred copies of a book were printed. American reviewers spoke disparagingly of 'expatriate' writers and 'Paris publications', though most of Contact's authors were later picked up by commercial publishers. In his memoir *Being Geniuses Together*, McAlmon was caustic about 'The Bunch': 'They are as

they are as they are and were as they were as they were and they wasn't roses,' he wrote.

Mary Butts was grateful for Bryher's patronage. Bryher wrote of her: 'Mary was one of the few who matter, a builder of English, and I have never doubted since I read her first short story that she belonged to the immortals...' Marianne Moore also recommended her with high praise. Like Bryher, Mary Butts was inspired by Cornwall and she had a small house at Sennen Cove. She had studied Greek and said her classical education started as a small child when her father told her Greek myths and they acted them out together. 'Only in Homer', she wrote, 'have I found impersonal consolation, a life where I am unsexed or bisexed, or completely myself.' Of 'ecstasies transcended' with her lover, Eleanor Rogers, she wrote in her journal in September 1916: 'there will have to be a secret manuscript seeing that no one can write openly about these things.' Contact Editions published her short stories and her first novel, *Ashe of Rings*.

Bryher's lasting impression was of Mary Butts's hair, 'flaming and red... the torque-gold of windy islands'.

Dorothy Richardson was another modernist whom Bryher funded. She was twenty-one years older than Bryher, who gave her books, clothes, flowers and encouragement and £100 a year. In 1933 she set up a trust fund for her.

Dorothy Richardson's 2,000-page semi-autobiographical prose work *Pilgrimage* was published in chapter volumes between 1915 and her death in 1957. Her narrator, Miriam Henderson, was on an unending search for a room, a life and voice of her own. Through her, Dorothy Richardson conveyed thoughts on gender, feminism, socialism and animal rights.

In Paris, Bryher was accepted as both married to McAlmon and H.D.'s partner. There was no need to dissemble. With McAlmon she went to Gertrude's salons, to Sylvia and Adrienne's literary evenings and to Jean Cocteau's cabarets at Le Bœuf sur le

Toit. Man Ray photographed her. McAlmon introduced her to James Joyce, who was his drinking partner, and took her, Harriet Weaver, Thelma Wood, Djuna Barnes and Ezra Pound to Chez Bricktop in Montparnasse.* After the cabaret, Bryher took them all to dinner at l'Avenue restaurant in avenue Montaigne.

Only occasionally, though, did Bryher accompany McAlmon to the clubs and cafés. She 'found the places he visited intolerably dull'. She did not drink or want to pick up women, take drugs, or even go to bed late.

McAlmon, a tireless social networker and partygoer, spent much of his allowance from Bryher in the bars. Marianne Moore said of him that his work was 'all riot and no construction'. H.D. agreed. His drinking got him into trouble: he pranced about naked at the Quat'z Arts costume ball in 1925.†

H.D. shunned the Paris lights. She preferred London, and found it easier to love Bryher when away from her. Often they were not just in separate living quarters but in separate countries. H.D. could not exist financially or emotionally without Bryher, but nor could she cope with Bryher's control. Separated, she wrote often and anxiously: 'Just to prove my darling', she wrote in 1922, from the Hotel Washington in Curzon Street,

> that I think of HE all the time. I bought some pink roses to put before the Man Ray portrait – my little altar…
>
> This is just to say I love and love and love you. I missed not hearing this morning horribly, not a note came last night no doubt one will arrive ce soir. Dear Heart, 1001 kisses.

She used whimsical gender-laced nicknames: Bryher was Fido.

* Cole Porter wrote the song 'Miss Otis Regrets' especially for Bricktop, who was born Ada Beatrice Queen Victoria Louise Virginia Smith, in West Virginia, to an Irish father and African-American mother.
† A Parisian annual ball started by Henri Guillaume, the first one held in 1892.

'I am very eager for news of Fido-He', 'Dear He, do be good', or 'Fido, mon cher, as Adrienne says'. Bryher signed herself 'love and barks' and did little drawings of a terrier. 'The little sketches of Fido-He are very comforting and lifelike. See that his bow is fresh and pretty every day.'

Such whimsy was a barrier. Bryher was the generous bene-factor, the courageous publisher for new and compelling writing, but she could not capture H.D.'s creative heart. Fondness was perhaps as much as H.D. could feel for Bryher – as well as grati-tude, dependence, respect and recoil.

Most of Bryher's friends lived in Paris, and she visited often – usually she stayed with Sylvia and Adrienne. But she did not want to live there. Nor did she want to spend much time in London, where South Audley Street loomed. She preferred the neutrality of Switzerland and the habit of frequent travel.

parents for Perdita

The challenge for Bryher, with her alternative family, was how to make it work. H.D. said her 'heart contracted' when, on Valentine's Day in 1923, D.H. Lawrence sent her red roses and a book of his poems, some of which had been written to her. She had no such residual feeling for Ezra Pound, whom she called 'blustering and really stupid. He is adolescent. He seems almost "arrested" in development.'

As for H.D.'s husband, by 1925 Richard Aldington was living in Paris with Brigit Patmore. H.D. confided to Brigit her fear that Aldington might seek divorce on the grounds of desertion and that, because she had registered him as the father, she would lose custody of Perdita, who was six. She wondered, if Bryher and Robert McAlmon were to adopt Perdita, whether Aldington would oppose this.

Bryher was willing to go ahead with adoption but had provisos:

her parents must not hear of it; Perdita should retain British nationality, which H.D. had through her marriage to Aldington but which Bryher forfeited through her marriage to McAlmon; and Aldington must cooperate. On 4 March, Bryher wrote to Brigit Patmore:

> I personally don't trust R.A. a scrap. Now I suggest, and Robert is very kind and helpful and says that I may, that Robert and I adopt, legally and fully, Perdita. She will take our name, have an immediate settlement on her as regards money, and her education and everything provided for. I have no wish to take her from Hilda's care, in fact that is the only stipulation that Robert makes, that it does not mean that I drag an infant round with me.
>
> My hands are tied unless she is mine, because there is no fun in providing an expensive education and either having a fight with R.A. in the middle of it, or else having some beastly struggle in the courts of justice.
>
> Please do not mention this matter to anybody as if the thing is carried through it must be done as secretly and quietly as possible. I should prefer that the whole thing was kept silent, that only the parties interested know about it, and that as she was born in England she still stayed on her mother's passport. It is simply a question that I am not prepared to pay down money for an expensive education and have R.A. making a mess of things in the middle… If H. could get a legal separation with custody of child, things would be different. But I will not spend a lot of money on the infant's education and have R.A. stick his nose in, in the middle.

Thus the struggle and subterfuge when the law would not allow same-sex marriage. Had fairness ruled, Sylvia Beach might have married Adrienne Monnier, Gertrude Stein would have married Alice B. Toklas,* Bryher could have married H.D. and

* Marriage to Alice would have protected Gertrude's art collection from avaricious relatives.

Perdita would have had two bona fide mothers. The adoption by Bryher and McAlmon did not happen. Adoption was for a later date with a different husband. But there was a sense of Perdita as an encumbrance, a problem to be negotiated.

Bryher's stark letter revealed how much Perdita was at the mercy of complex adult relationships and marital law. Her strange unavailable mother could not concentrate on her work if she was in the same apartment with her. She met her biological father on one occasion only and he wanted nothing to do with her. Bryher would 'throw money' at her education and care, if conditions were acceptable, but did not want 'to drag an infant around' with her.

Perdita could not be sure of her name or address. She bore the name of a man she never saw and who had not wanted her birth registered in his name. She might become Perdita McAlmon, the name of a man who once played with her on a ship. She had been housed at Norland Nursery, shunted from London to Switzerland, sent to a girls' boarding school. From time to time, her mother's partner's deaf mother took her out in a Daimler to view London. Her mother's mother was a devout Moravian Christian, who lived in Pennsylvania and looked after her on holidays. There was not one special adult to make her feel safe.

That year, 1925, Jonathan Cape published *West* by Bryher – her impressions of early twentieth-century America – and *Heliodora and Other Poems* by H.D. The contrast in style and vision was strong, Bryher's solemn naivety, H.D.'s inspired complexity. In *West*, Bryher dismissed American landscape:

> One could be one's self in Europe. Because the grass, the trees were familiar. Here not even the air was the same… One was a piece of a puzzle upset in the wrong box.

H.D.'s connection was to an interior terrain:

> We strove for a name,
> while the light of the lamps burnt thin

and the outer dawn came in,
a ghost, the last at the feast
or the first,
to sit within
with the two that remained
to quibble in flowers and verse
over a girl's name.

He said, 'the rain loving'
I said, 'the narcissus, drunk,
drunk with the rain.'

Yet I had lost
for he said,
'the rose, the lover's gift,
is loved of love,'
he said it,
'loved of love,'
I waited, even as he spoke,
to see the room filled with a light,
as when in winter
the embers catch in a wind
when a room is dank:
so it would be filled, I thought,
our room with a light
when he said
(and he said it first)
'the rose, the lover's delight,
is loved of love,'
but the light was the same.

Then he caught,
seeing the fire in my eyes,
my fire, my fever, perhaps,
for he leaned
with the purple wine
stained in his sleeve,

and said this:
'Did you ever think
a girl's mouth
caught in a kiss
is a lily that laughs?'

In August, Bryher rented two Knightsbridge flats, one with a seven-year lease at 26 Sloane Street for H.D. and another for McAlmon at 45 Parkside. Bryher, when in London, stayed at South Audley Street or in one or other of the flats. This was a family that needed space.

another lover, another husband

In late 1926, H.D.'s first lesbian love, Frances Gregg, was operated on for cancer in St George's Hospital, London. She recovered well. In December she introduced H.D. to a friend, Kenneth Macpherson, a film-maker and photographer. He was twenty-four, H.D. was forty. His father was an artist; his mother, like Kenneth, had affairs with young men.*

Macpherson and H.D. began an affair. She said she loved him. He said he needed her but,

> Please if you can stay near me. I see now how exactly that is what I need. I would do anything for you... Some desperate hurt looks out of your eyes... As things are now, all that you were to me yesterday is all that I want or ask – all that anyone could want or ask – it came so swiftly after you had spoken of gods upon earth, and I knew that I had seen god or goddess in you then. God but you have in you that swift, impetuous, sudden divinity. Love me if you can. Hilda I need you. But be free!

* Macpherson's longest relationship was in the 1930s with the cabaret singer Jimmy Daniels, who focused on songs by George Gershwin, Rodgers and Hart and Cole Porter.

He wanted her, but not too much of her. Near, but not too near. Not nearer than yesterday.

Like McAlmon, Macpherson lacked money of his own and had career ambitions but no prospects. He was apprenticed to a commercial artist but wanted to make films. Photography and film-making were expensive and needed financial backing. Bryher liked Macpherson's roughness, embrace of new ideas, youth and energy, in much the same way as she had once liked McAlmon's, and she was interested in the emerging art of cinema. Also, by 1926, she was tired of McAlmon: tired of his drinking, squandering of funds and diminished creative influence. She accused him of being alcoholic and a dope fiend. He was neither compliant nor reliable. But he did not want to divorce her.

She accepted Macpherson's sexual relationship with H.D. and his homosexuality. He could be a new member of her unconventional family, a recipient of her enabling patronage. She also wanted to help H.D. find a legal family context for Perdita so as to pay for her 'expensive education' without 'beastly struggle in the courts of justice'. If Bryher married Macpherson, who was Scottish, and as husband and wife they adopted Perdita, British citizenship would be acquired all round. H.D. would still be Perdita's legal British birth mother and Aldington would no longer be a threat.

H.D. said of Macpherson that he was 'very untravelled'. He had not been as far as Paris. Bryher proposed marriage to him and offered to finance his film-making. Her money would fuel all plans. All he need do was accept her as head of the household and at the centre of arrangements. Marriage to Bryher was as appealing to Macpherson as it had been to McAlmon. Such a marriage and free love with H.D. did not preclude his having sex with men. H.D. had no acquaintance with or insistence on monogamy.

They all travelled to Territet via Paris, where Bryher bought Macpherson his first movie camera.

In June 1927 Bryher divorced Robert McAlmon, who then became known in Paris as Robert McAlimony. His revenge was to write a scathing roman à clef, *A Scarlet Pansy*, under the pseudonym Robert Scully. McAlmon was the Pansy or Fay Étrange from Kuntsville, Pennsylvania, who worked as a nude model. Bryher was Marjorie Bull-Dike. Sylvia Beach, Gertrude Stein and Alice B. Toklas were among the lesbians cast as Fuchs, Pickup, Butsch, Godown and Kuntz. Like McAlmon's memoir *Being Geniuses Together*, which he published in 1938, his *Scarlet Pansy* was too vitriolic and not funny enough and as a memoir did not compare in style with Djuna Barnes's *Ladies Almanack* or Hemingway's *A Moveable Feast* or Gertrude Stein's *The Autobiography of Alice B. Toklas*.

On 1 September, Bryher and Kenneth Macpherson married in Chelsea Registry Office in London with H.D. and Bryher's brother, John, as witnesses. The following March, Mr and Mrs Macpherson formally adopted Perdita.

And so, dressed in evening clothes from Savile Row and with cufflinks from Cartier, husband number two, Kenneth Macpherson, smoked after-dinner cigars with Sir John Ellerman in the deep leather armchairs of the library at 1 South Audley Street.

> Hoping to be a man of the world and with requisite subaltern respect, I would nod sagely and knit my brow. One was really trying to communicate with the Ice Cap… I decided he was a sort of Eternomatic precision instrument, a full-time solitary chess-game. … I accepted that John thought little of me and in his way he was right.

Bryher, back in the parental home, regressed to a version of Winifred or Dolly, drawn into behaviour that intellectually she despised. The Ellermans belonged to the world of Empire

and money, power and privilege, low pay for miners and formal landscape paintings. Bryher, though a rebel, was inextricably linked to this world.

Macpherson could not sit in Sir John's library and speak of his own revisionist views: of les Fauves, Dada, Cubism, Surrealism, experimental film; of his marriage of convenience from which no progeny would follow because he, the groom, felt not a whiff of desire for his wife, nor she for him. The truth could not be spoken. It could not be said that Sir John's daughter saw herself as a biological mistake, a he trapped in the body of a she, and that her essentially homosexual husband was having an affair with her bisexual partner. Pretence was needed, because Ellerman's money funded such modernist revision.

Bryher and her husband went with Sir John and Lady Ellerman to the opening night of *Show Boat* at Drury Lane. Ivor Novello's mother, a friend of Lady Ellerman, was in their party, smothered in diamonds and pale blue ostrich feathers. 'It's easy to see Dolly married him for his looks,' she said of Macpherson in his white tie and tails. They were in the Royal Box, which was wreathed with carnations and roses. There was applause as they entered. Bryher wore floral chiffon. Macpherson said of her:

> She looked a fright… This evening dress had been acquired
> for her by her mother, to turn her back into Dolly. What was
> meant to be a draped cape behind, hung down in front as if
> to conceal pregnancy. You could see crisscross stitching down
> the seams.

Bryher was wearing the dress inside out and back to front. 'How is one to know?' she asked. In the interval, in an anteroom, they were served caviare and champagne by peruked lackeys in white satin tails and red velvet breeches. Macpherson downed too many brandies.

family affairs

In Switzerland, the family lived at Riant Chateau. Perdita began her expensive education. H.D. found life in Switzerland 'too self contained and insulated', and though she loathed the air and fog in London, she needed escape to 26 Sloane Street. Kenneth Macpherson decorated the apartment with camp opulence: a gold Buddha beside a brocaded divan bed, damask curtains, Lalique glass wall brackets. H.D. had 'a little Swiss maid named Sophie who does not speak English'. There was another flat at 169 Sloane Street for Macpherson or Bryher or guests.

In 1927, H.D. wrote her roman à clef *HERmione*, based on her life from 1905 to 1911, and 'Halcyon', a poem about her relationship with Bryher, was published in *Poetry*. 'I am full of work and trying to keep "young" – have friends near this winter, who insist on my dancing and dancing AND dancing', she wrote to a friend.

This oddball family had its tensions. Macpherson disparaged his wife to H.D. He warned her not to:

> get caught up into the Bryher blunderbuss manner… I don't want you to feel lost, harassed, browbeaten, separated from us, from yourself from Bryher…. Don't be vulnerable… because she has a fort, has to have a fort, in some ways BE a fort, so must you be armed and able to fall back on simple strength reserved for protection.

Whether or not Bryher's manner was blunderbuss, her patronage and imagination allowed them all to take a new creative direction, another break from Victorian norms and certainties, a new way of communicating.

POOL productions

The year 1927 was a transforming one for Bryher. At Territet, with Macpherson, she changed direction. Both thought film the new medium of communication. With her money and his technological expertise they started POOL Productions, a film company. Bryher explained the name, which was based on the analogy of a stone being dropped into a pool:

> as the stone will cause a spread of ripples to the water's edge, so ideas once started will go to their unknown boundary... these concentric expansions are exemplified in POOL which is the source simply – the stone – the idea... The expanding ripples from a stone dropped in a pool have become more a symbol for the growth of an idea than a simple matter of hydraulics.

With POOL Productions, Bryher's focus turned from literary innovation in Paris to Berlin and Russia, the psychoanalytical writings of Freud, and the new realism of films about social conditions. Berlin was the film capital of Europe. Bryher was the only member of the group to speak much German. She said she 'saw a dozen of these films in small projection rooms without music at nine o'clock in the morning and they were art and they were truth'.

In Berlin, she and Macpherson met in the Hotel Adlon with the Austrian film-maker G.W. Pabst, who was at the forefront of the German movement for 'new realism' in film. Macpherson wrote to H.D. about this meeting and of looking at photos 'one of Pabst himself, young, very very very very Lesbian, and he is Deeeeelllllighted to mit you'.

Bryher was affected by Pabst's film *Joyless Street*, about inflation in Vienna and poverty in the middle class. She saw the film as an indictment of the treatment of women and of the soulless Weimar era. It starred Greta Garbo before Hollywood consumed

her. H.D. called the film her 'never to be forgotten premiere to the whole art of the screen'.

Switzerland, set in the heart of Europe, was the perfect place for POOL's headquarters. Bryher rented a studio near Lausanne, spent $4,000 on the best cameras, Klieg carbon-arc close lamps, a projector and other equipment. She was the producer, Macpherson the director and they, H.D. and friends scripted, acted in and improvised the films they made. The company became a vehicle to explore afresh in another medium the modernist ideas and lifestyle that guided them all.

In February they made the first of their films, *Wing Beat*, inspired, Bryher said, by the play of light on Lake Geneva. The wild dancing figure of H.D. elided with shifting light, the flight of a bird and the movement of water. Their advertisement for it read:

> Free verse poem. Telepathy and attraction, the reaching out,
> the very edge of dimensions, the chemistry of actual attraction,
> of will, shivering and quavering on a frail, too high, too
> inaccessible brink.

They aspired to change the direction of British film, to make film magical. Macpherson was 'scornful of the obvious lighting in most American films'. Bryher said he achieved wonderful effects with shadow and half-lights. Pabst, impressed with *Wing Beat*, said H.D.'s performance 'showed up the utter futility of the Hollywood tradition and that beauty was something quite different'.

Bryher delighted in 'the glory of escape through another medium'. She loved the innovations of technology. She acquired a car, a Buick 'with special hill-climbing devices'. Flying exhilarated her and in May 1927, when in Venice with Macpherson, she saw a return flight to Vienna advertised. She booked them on it and took with her a letter of introduction to Freud from

Havelock Ellis. There were six other passengers on the plane and they flew into a storm. They had two days in Vienna and she sent her letter round by messenger to Freud's house at Berggasse 19:

> We were invited to call the next afternoon... We were taken
> into the famous room with the statuettes and the chow.
> The dog approved of Kenneth, another element in our
> favour. Freud sat behind his desk, I recognised him from the
> photographs but what they and reports about him had lacked
> was his gaiety. He asked us several questions about Ellis whose
> courage as an investigator he admired, but then an amazing life
> came into his eyes as he questioned us about flying: Why had
> we chosen to come by air, what did it feel like, how high had
> the pilot taken us, what did a landscape look like from above?
> We told him about the storm and the strange impression that
> we had had of seeing lightning sideways and I knew that he
> wished that he had been with us.

Close Up

Bryher also rented an office space near the film studio in Lausanne. There, she, Macpherson and H.D. started a subscription magazine, *Close Up*, 'to meet the need of those interested in the artistic and educational development of the cinema'. It ran from July 1927 to December 1933, at first monthly, then quarterly, with 500 copies for each printing. It was the first journal in English devoted exclusively to film and that treated film as an art form. Subscriptions were through booksellers or direct from a London office in the Charing Cross Road.

Its international focus gave Sergei Eisenstein and other Soviet and eastern film-makers a voice in the west and it became a forum for discussion of film technique. Its originality was on a

par with the innovative literary magazines. There were articles on the educational use of film and on technical innovation, there were reviews of films and of books dealing with cinema. Forty or fifty photographs were included in each issue. 'We do not issue "gossip articles"', subscribers were told.

The first issue sold out in a month and was enthusiastically reviewed. *Close Up* reflected the excitement of new ways of seeing, and of how film as a medium could be used. Bryher and Macpherson encouraged experimental cinema. The intention was for each issue to deal with a different theme: 'the Negro attitude and problem', 'the Far East and its relation to cinema'.

Topics ranged wide: the hazards of film-making, social injustice, gender, problems of light and sound, the insularity of England, repressive methods of education, the nascent art or science of psychoanalysis. Macpherson hoped for public show-ings of experimental films in Paris and London and that 'people making films and experimenting in all sorts of ways shall be able to see what others are doing in the same way'.

Friends contributed. H.D., in the first issue, had an article on 'Cinema and the Classics' and a poem, 'Projector', in which she praised the art of cinema as a 'redemptive light' and criticized the overuse of spectacle. Over the magazine's six-year life span, she wrote eleven reviews.

Bryher wrote about *Joyless Street*, and how Pabst, through the interlocking lives of the inhabitants of a single street, reflected the economic depression and brutality of Vienna after the First World War. She told of how he made the film in thirty-four days, how on one occasion the crew worked for thirty-six hours without anyone leaving the set, how in Germany censors tried to ban it, and Pabst could not get Greta Garbo work in Europe after it, so she went reluctantly to Hollywood.

Sergei Eisenstein, in a piece called 'A Statement on Sound',

warned of 'the silent thing that has learned to talk' and how sound, as a new montage element working with visual images, might destroy the purity of those images.

Upton Sinclair wrote of the film *Thunder Over Mexico*, based on Eisenstein's *¡Que Viva México!*. Eisenstein had shot 285,000 feet of film in Mexico and this was shipped to Hollywood, but he was then banished from the United States so could not edit the film himself and no film studio would take it on. Sinclair was said to have massacred Eisenstein's work by using only 2 per cent of his footage.

Nancy Cunard, who was in a relationship with Henry Crowder, the African-American jazz musician, wrote about the Scottsboro Trial of nine black boys, the youngest thirteen, falsely accused in Alabama of gang-raping two white American women on a train in 1931. Through her Hours Press, which she set up in her Normandy farmhouse, she presented a petition to the Governor, demanding their 'unconditional and immediate release'.

Hanns Sachs wrote of how witch hunts had evolved to demonize women who failed to be docile and subservient housewives.

Marianne Moore wrote enthusiastically about a twenty-seven-minute film, *Lot in Sodom*, which premiered at the Little Carnegie Theatre in New York on Christmas Day 1933:

a chill passed over me as the blood wandered down the torso of the prostrate body, and I thought the use of slow motion and distortion, the Blake designs in the fire, and the Pascin, Giotto and El Greco effects, wonderful.

Though familiar names contributed, Bryher was emphatic that her new venture should not be linked in any way with Contact Editions or Robert McAlmon. She turned down a contribution from William Carlos Williams because he remained a friend of McAlmon's and had worked with him.

Graham Greene, as a cinema reviewer in the 1920s, read *Close*

Up with much enthusiasm. He saw in film a new art, with images as formal in design as in painting, but where this design moved. He too initially thought the introduction of sound a reduction, a dilution. Film, when he came to write novels, influenced his imagination and perception.

Bryher invited Dorothy Richardson to contribute. She thought her name, as an experimental writer, would indicate to *Close Up*'s readership the kind of artistic endeavour the magazine wanted to promote. Dorothy Richardson, at first reluctant, suggested other writers who might know more about film but then capitulated and wrote a piece on how sound spoiled movies.

Gertrude Stein wrote a 'phylo-scenic aria' rather akin to the poem she wrote to promote interest in Sylvia Beach's bookshop.

Foothills and Berlin

In 1928, POOL Productions made their second film, *Foothills*. Bryher, H.D. and Kenneth acted in it. H.D. described, or half-described, the plot as:

> a dame from the city [Jess played by H.D.] comes to the
> country village for rest… There are all the complications of
> village life and gossip and a sort of idealistic encounter with
> the young intelligent lout [Jean played by Kenneth] in Vaudois
> farm clothes.

More formally, Kenneth Macpherson said of the film and himself:

> This is a four-reel film experimentally made in a small studio
> arranged and equipped by the author of the scenario, who also
> directed, part-photographed and part-played in the production.
> Unlike most of the One-Man films made to date, it does not
> attempt abstractions, freak effects or incoherency, but is a
> simple story simply told of life in a small Swiss village.

The locations are genuine beauty spots of Switzerland, none of the artistes are professionals, one of the roles is actually played by a Swiss peasant. The season is Spring when the hills are covered knee-high with wild flowers and the trees are all in blossom against snow capped mountains.

They all had fun. Making an experimental film seemed as free and spontaneous as children at play.

There were problems over taxes and distribution in English-speaking countries so Bryher and Macpherson showed *Foothills* in Berlin. Pabst liked it. Through her friendship with Pabst, Bryher met Jewish artists and intellectuals imperilled by anti-Semitism and the rise of fascism. Pabst introduced her to Lotte Reiniger, the pioneer in animated film. Bryher wrote to H.D. that Reiniger made her films herself, in a room the size of their dining room at Territet, with a piece of glass, a movie camera 'and an electric apparatus'. Bryher gave her money to finance her work and together they explored Berlin.

Hanns Sachs and analysis

Also through Pabst, Bryher met the psychoanalyst Hanns Sachs. He was adviser for Pabst's 1926 silent film *Secrets of a Soul*, subtitled 'A psychoanalytic film'. It explored the cause of neurosis and the psychopathology of jealousy and guilt. Its explanatory legend ran:

Inside every person there are desires and passions which remain unknown to 'consciousness'. In the dark hours of psychological conflict, these 'unconscious' drives attempt to assert themselves. Mysterious illnesses arise from such struggles, the resolution and cure of which form the field of psychoanalysis.

Freud was asked to contribute but would not:

> I do not believe in the possibility of anything good and useful
> coming of the project and therefore for the time being cannot
> give my authorization... I do not deny that I should prefer my
> name not to come into it at all.

Bryher began analysis with Hanns Sachs. Mainly she saw him in Berlin but during the summer they met in Switzerland. Her daily hour-long sessions with him first thing in the morning took place from 1928 to 1932. He lived in a small apartment at 7 Mommsenstrasse near the Kurfürstendamm – the most famous avenue in Berlin. His English was fluent. He charged his foreign analysands twenty marks, his German ones ten. 'Analysis must have no morals only mirrors', he told Bryher. She saw her analysis as liberation, a discovery of self, the uncovering of the repressions of her formative years:

> The object of my search since I had been a child was absolute
> truth. Not to be believed was what I found hardest to bear.
> I could not have burst through the barriers that were holding
> me up without help. We tried to dig down to the bones of the
> past and to excavate memories in the process.

private ripples

A spread of ripples from stones in pools happened not just with POOL Productions but in the private lives of Bryher's family too. Macpherson and H.D. had begun their affair in 1926, Bryher divorced McAlmon in 1927 and married Macpherson and adopted Perdita in the same year. They worked together on films and the magazine, but family connections were tenuous. Perdita had no choice about Bryher and Kenneth Macpherson becoming her adoptive parents; she stayed at different apartments, was sent to various schools, taken on trips

to different countries. Bryher was conscientious and generous with money, but no one seemed to bother to find out who Perdita was.

Monkeys' Moon and an abortion

In 1929, POOL Productions made the third of their short experimental films, *Monkeys' Moon*. It lasted six minutes. Macpherson shot it in the grounds of Territet. H.D. and Bryher acted in it and it featured two of their pet monkeys, Lady and Tsme, a beetle, a watering can, the moon, a trombone, Bryher's feet, stones and flower pots. The idea was to use dramatic lighting, montage and double or triple exposure to evoke psychological states, impressions, inner experience and tension. The moon cut through the sky, the monkeys were agitated, the beetle was on its back, water dripped from the can, there were shadows, feet walking... The intention was for film to interact with poetry and painting.*

Also in 1929, POOL published *Film Problems of Soviet Russia* by Bryher. Macpherson chose the illustrations. In it, Bryher condemned censorship, political intervention in the arts, and militarism. Of Eisenstein's film *Battleship Potemkin*, she wrote: 'Personally, as long as there is an army I should use *Potemkin* as an educational and propaganda film at Sandhurst and at Woolwich.'†

With Kenneth Macpherson and the writer and poet Robert Herring, she went to Iceland to shoot film for a new project, *Borderline*, but her consuming interest was psychoanalysis. Berlin

* The film was thought lost until the Beinecke Rare Book & Manuscript Library acquired a copy in 2008 and restored and digitized it.
† Sandhurst is the Royal Military Academy where British Army officers are trained. Woolwich was the location of the Royal Arsenal.

was the city where, through extensive psychoanalysis, she delved into the wellspring of her personality. Homosexuality was visible in the cabarets and culture, in Pabst's film *Pandora's Box* and William Dieterle's *Sex in Chains*. Magnus Hirschfeld's Institute for Sexology defended homosexual rights. Bryher became a patron of the International Psychoanalytical Press, gave money to the cause and trained to become an analyst. She might have been one of the first lesbian psychoanalysts had the war not brought such plans to an end.

H.D. had no particular enthusiasm for film or Berlin. In London that year she published new poems in *Imagist Anthology* but she felt blocked in her work. She became absorbed in astrology and tarot card readings, which did not help her mental health. From Territet she wrote to tell Macpherson she had cut her hair even shorter – 'I think it is so much more comfortable and nice' – and that she was pregnant with his child. He panicked, told her she must come to Berlin, and that Hanns Sachs would arrange an abortion:

> Brave, handsome, beautiful, sad, noble, furry dignified kitten, hurry up and come and have that star or starfish or star maiden or whatever it is removed. Just get on that train and tell itself its troubles are almost over and tell itself it myst bye a NAICE woman from now on.

Macpherson's alarm was total. 'No more "Normal" for Rover', he said of himself. He needed little prompting to give up normal with H.D. or any woman. His preferred company and sex life was with homosexual men. He referred to H.D. 'throwing three schizophrenic phits per day when asked to go anywhere but always going'. Nor was he convinced the child was his. H.D. had been 'seeing' other men when in London. Abortion was illegal in Germany, as in England and America. H.D. went to Berlin; Sachs found a doctor, who ended the pregnancy.

Borderline

In 1930, POOL Productions made *Borderline*, their only full-length feature film. Pabst called it 'the only real avant-garde film'. Macpherson was director. Paul Robeson starred in it. It focused on race, class, sexuality and gender and was set in an unspecified border town in some mid-European mountain area. The characters were people 'not out of life, not in life', H.D. said. Her borderline was between creativity and madness. The symbolism of her poetry was given parallel expression in filmed images: a stuffed bird, a witch-like doll, a rose.

Paul Robeson was an activist for black civil rights as well as an actor and singer. In the late 1920s and early 30s, black, Jewish and homosexual identities were all targeted by fascist power. In mainstream entertainment, white actors 'blacked up' to avoid giving acting roles to people of colour. If black actors were included, they reinforced the idea of white superiority. They were servants, slaves, doormen, villains. In *Showboat*, Paul Robeson was the simple-minded 'darky'. Skin pigmentation was used to reflect gradations of moral worth. The blacker the skin, the worse the character; the whiter and blonder, the purer. This prejudice snaked through society, language and popular culture.

Artists who wanted a better world tried to address issues of race. H.D., in February 1927, said she had been 'reading a good

deal on the "darky" problem lately'. In August 1929, *Close Up* ran an issue on black cinema. Robert Herring argued for a pure Afro-American cinema: 'Not black films passing for white and not please white passing for black.'

Janet Flanner, Genêt of *The New Yorker*, in her 'Letter from Paris' in 1925, wrote of Afro-American jazz in Paris and Josephine Baker's star performance, aged nineteen, in *La Revue Nègre* at the Théâtre des Champs Élysées. Sidney Bechet played the clarinet. Josephine Baker:

> made her entry entirely nude except for a pink flamingo feather between her limbs; she was being carried upside down and doing the split on the shoulder of a black giant. Mid stage he paused, and with his long fingers holding her basket-wise around the waist, swung her in a slow cartwheel to the stage floor, where she stood, like his magnificent discarded burden, in an instant of complete silence... A scream of salutation spread through the theatre. Whatever happened next was unimportant. The two specific elements had been established and were unforgettable: her magnificent dark body, a new model that to the French proved for the first time that black was beautiful, and the acute response of the white masculine public in the capital of hedonism of all Europe – Paris.

This was a breakthrough. Black was beautiful, naked and free. Paris was at the vanguard of liberation. Josephine Baker, born in the slums of St Louis, Missouri, to a single mother, worked her way from dresser to chorus girl in an all-black show, *The Chocolate Dandies*. In Broadway auditions, she was rejected for being 'too black'. In Paris, by 1935 she was singing Offenbach's *La Créole* at the Marigny, a role created in 1875 for Anna Judic, who 'blacked up' with liquorice for the part.

Gender and colour were at the heart of modernist revision. Barbette starred with a trapeze act at the Cirque Médrano in Paris;

his given name was Vander Clyde but 'he was only himself when dressed as a woman'. He performed to the music of *Scheherazade* wearing diaphanous white skirts and white ostrich plumes. The audience gasped when he removed his wig and revealed himself to be a man.

In *Borderline*, Bryher wanted Macpherson to explore conscious and unconscious mental processes in relation to colour. She wanted visual expression of Freud's ideas. Macpherson used light and shadow to focus in close-up on tense expression, the veins in hands, the sweat on a brow.

Paul Robeson was on his way to Berlin to perform in a stage version of Eugene O'Neill's *The Emperor Jones*. He was travelling with his wife, Eslanda, who was also his manager and herself an actor and activist. She acted in *Borderline* too. Robert Herring, who was homosexual both in and out of *Borderline*, brought the Robesons into the film. He played the part of the pianist. A friend of his, Gavin Arthur, also homosexual and a grandson of the twenty-first American president, Chester A. Arthur, was the violent husband. Kenneth Macpherson's father was the film's lighting manager.

For the Robesons, the whole thing was a lark and a diversion 'time out from the hectic pace of touring'. Filming took nine days, they stayed for ten. Macpherson's fascination with Robeson's body was plain in the shooting. H.D. wrote of her sexual feelings towards Robeson in various poems like 'Red Roses for Bronze', where Robeson was the bronze god.

The film's plot was secondary to its social purpose and experimental themes: Pete (Robeson) works in a cheap café in this border town. The café's gay pianist (Herring) lusts after him. The café manager (Bryher) lusts after the barmaid. Pete's estranged wife, Adah (Eslanda), is in the same town, though neither is aware of the presence of the other. Adah is staying in rooms with a married couple, Thorne (Gavin Arthur) and Astrid (H.D.).

Thorne and Adah become lovers. In a quarrel, Thorne stabs Astrid, his wife. Adah is blamed and Thorne acquitted. The mayor, acting for the townsfolk, orders Pete out of town – he goes, a scapegoat for the crimes and neuroses of the whites.

Robeson was depicted as the hero, not the victim. Racist words rebounded on who spoke them: 'Nigger lover.' 'You brought him here.' 'If I had my way not one negro would be allowed in the country.' Robeson was accorded the beauty of the femme fatale. Blackness was co-opted. Pete had no character beyond his beauty. Eslanda Robeson wrote in her diary that she and Paul 'ruined our make up with tears of laughter' over Macpherson and H.D.'s 'naive ideas of negroes'. 'We never once felt we were colored with them.'

No one was paid and the total cost to Bryher of making the film was $2,000. In location shots in the village of Lutry, crowds followed the crew. H.D. said of the finished film: 'It is without question a work of art.' She thought it posed existential questions and was dramatically thrilling:

> When is an African not an African? When obviously he is an earth-god. When is a woman not a woman? When obviously she is sleet and hail and a stuffed sea-gull. When is white not white and when is black white and when is white black? You may or may not like this sort of cinematography.

Pabst declared himself 'very enthusiastic' about it. Eslanda said, 'It's a dreadful highbrow but beautifully done.' In October 1930 it was screened at the Academy cinema in London; the previous year, the Robesons had been refused service at the Savoy Grill. Interest in it came from many countries, including Japan. *Borderline* called for the right to be other, be that lesbian, queer, black, white.

The encroaching Nazi presence haunted the film. *Close Up* and POOL Productions came to an end with Hitler's rise to power.

Kenwin

Bryher's next modernist project was the building in 1930 of a Bauhaus villa in the foothills above Lake Geneva at Burier-La-Tour near Montreux.

> It was the time of the Bauhaus… I loved the new functional furniture, the horizontal windows and the abolition of what I thought of as messy decoration.

The aesthetic of the Bauhaus School, founded by Walter Gropius, was space, light and holistic living, a unity of life and art. Berlin was the birthplace of the Bauhaus movement. Kenneth Macpherson worked on the project with Bryher. They named the building Kenwin, a naff merging of syllables of his first name and hers. It was the only modern house in the area. Bryher's father encouraged the investment.

Bryher intended Kenwin to be a place of work and creativity for all who lived there. The villa's first architect was the Hungarian film set designer and architect Alexander Ferenczy, a pupil of Adolf Loos, whose minimalist views were reflected in the works of Le Corbusier, Mies van der Rohe and other modernists. Ferenczy had designed sets for the film producers Alexander Korda and Friedrich Zelnik. His design for Kenwin reflected his cinematographic interest and awareness of the uses of light. There was a film studio and a library on the ground floor, there were bedrooms above facing the mountains and lake, there were decks and balconies.

Bryher moved in in September 1931. She gave the full address as Villa Kenwin, Chemin de Vallon, 1814 Burier-La-Tour, Vaud, Switzerland. There was creative space for them all. She added to her menagerie: more monkeys (Sister, Bill and Gibb), two tiger cubs, dogs and cats. But her dream of the place as a centre of creativity was never realized. Kenwin became her home,

not Kenneth's or H.D.'s. They visited, but no more films were made. *Close Up* came to an end. Macpherson and H.D. took separate paths.

no more normal

Macpherson kept easily to 'No more Normal'. The writer Norman Douglas, who drank, became his permanent companion. They travelled to Tunisia and Capri, frequented the bars, picked up young men. Macpherson made no more films. H.D., after the abortion and Macpherson's rebuttal, lost direction in her work and came close to breakdown.

Freud

In the summer of 1932, Bryher went to Berlin for the last of her sessions with Sachs. One afternoon they were threatened in the

street by gangs of brown-shirted youths. Sachs told Bryher he was leaving for Boston. She had arranged funds, to be managed by Freud's son Martin, to help analysts threatened by anti-Semitism and the collapse of the Viennese economy. She urged Sachs, before he left, to write to Freud in Vienna to ask him to take on H.D. as an analysand. Havelock Ellis also recommended H.D. to Freud at Bryher's request.

So Freud wrote to Bryher about analysis for her 'cousin', the poet. He suggested a fee of $15 an hour for daily sessions for three months, the account to be settled at the end of each month.* He wanted to read H.D.'s poetry so as to better understand her. He hoped she would not be living alone in Vienna, because the nature of his analysis precluded her from socializing with his family.

Bryher and Kenneth Macpherson saw H.D. off for Vienna in February 1933. She stayed at the Hotel Regina, built as a palace in 1877 at the Ringstrasse, and walked to Freud's home at 19 Berggasse for her daily five o'clock sessions. These began on 1 March 1933, a month after Hitler became Chancellor in Germany. She hoped Freud would help her start writing again. She had lost direction and only by writing did she feel she could cope with her dread of mental breakdown and fear of the impending war.

H.D. was forty-six, Freud seventy-seven and frail after operations for throat cancer. Unmodernist in his tastes, he collected antiques and his practice room was filled, H.D. said, with the 'stares' of animal-shaped gods and idols. She thought it like an opium dive. She resisted lying on the couch, but 'he said he would prefer me to recline'. All day, from breakfast until he went to sleep, he smoked. His usual quantity was twenty cigars a day – Trabucos, which were the tobacco monopoly of the Austrian

* The equivalent of $255 an hour in 2020.

government. Often on Sundays he went to art museums and archaeological collections.

For H.D., familial transference to Freud worked fast. She referred to him as Papa, as the oracle of Vienna, a mother-bull 'filled with potent love' and as 'Jesus Christ after the resurrection'. On his birthday, his study was filled with flowers from friends. H.D. had wanted to buy him a statue of a goddess to go with his collection of antiques, but could not find anything suitable.

During their sessions, Yofi, his chow dog, whom he called his Protector, slept by H.D.'s couch and snored. When Yofi got into a fight with another of his dogs, Freud lay on the floor between them, coins falling out of his pockets. He gave Bryher two of Yofi's puppies – to Bryher's dismay.

H.D. told Freud about Havelock Ellis's urolagnia habits, about which he 'bust his cat-whiskers with joy'. She also told him Ellis's wife was lesbian, which he did not already know. Freud seemed smitten with H.D. According to Bryher, he said of H.D. 'that seldom if ever had he come into contact with a mind so fine, a spirit so pure' as hers. He hoped she would have analysis 'of months of weeks of even years if she so desired and she would have preference over all others'.

In one session Freud talked half the time, in another he beat his hand on the pillow of his famous analysands' couch where H.D. lay and said: 'I am an old man, you do not think it worth your while to love me.' He asked her to stand beside him to see who was taller: she was, though she had hoped he would be, so that she could feel herself to be a child. H.D. felt special because of Freud's interest in her. To Bryher she wrote that 'anyone who gets within ten miles of Freud is a sort of minor god-in-the-machine', and she told Havelock Ellis that Freud 'cannot take on people who have nothing to offer in return any more'.

After the sessions, H.D. wrote *Tribute to Freud*. She called him 'a discoverer of new life'. According to him, H.D. was 'the

perfect example of the bisexual'. He explained her bisexuality, she told Bryher, in terms of parental loss:

> usually a child decides for or against one or another parent, or identifies himself with one. But to me, it was simply the loss of both parents, and a sort of perfect bisexual attitude arises, loss and independence. I have tried to be man, or woman, but I have to be both. But it will work out, papa says and I said, now in writing.

At the root of H.D.'s lesbian loves, Freud surmised, was her search for union with her mother, or a mother. To Bryher, H.D. boasted of the size of her 'mother-fix':

> F says mine is absolutely FIRST layer, I got stuck at the earliest pre-OE stage and 'back to the womb' seems to be my only solution. Hence islands, sea, Greek primitives and so on. It's all too wonder-making.

Freud told her he did not like being the mother in transference: 'I feel so very, very very MASCULINE.' Nor did he have time for her horoscopy and what he called her 'star fish stuff'. She characterized his dismissal of what he viewed as superstition and pseudoscience as a racial trait:

> These Jews, I think, hold that any dealings with 'lore' and that sort of craft is wrong. I think so too, when it IS WRONG!!!! But it isn't always. And I want to write my vol. to prove it.

To Bryher, H.D. voiced gratitude for making psychotherapy with Freud possible – and for much else too:

> You evidently in some way are food, help, support, mother, though of course it mixes over into father too.

And it was true. Whenever Bryher could make life better for the people in her orbit, she did so – and for the wider world. She expected little in return and did not count the cost.

J'accuse!

Freud's work was publicly burned by the National Socialists in Berlin in May 1933. Bryher offered to pay for the Freud family to move from Vienna. She sent him emergency funds, in case he needed to escape, and a copy of *J'accuse!*, published by the World Alliance for Combating Anti-Semitism. It exposed Nazi atrocities and included the letter written by Émile Zola in 1898 to the President of France about the unlawful jailing of Alfred Dreyfus.

In *Close Up* in 1933, Bryher published a long article, 'What Shall You Do In the War?' She wanted to galvanize outrage and action against the pogroms of German Jews, the tide of refugees and exiles, censorship, book burnings, the aggressive militarism of the Nazi regime. 'I cannot understand how any person anywhere who professed to the slightest belief in ethics could stand aside at such a moment.'

She viewed the situation as too grave for 'a pacifism of theories and pamphlets' when an attempt was underway:

> to exterminate a whole section of the population no matter
> whether their characters were good or bad… It is useless for us
> to talk about disarmament when children are being trained in
> military drill and where every leader of intellectual thought in
> Germany is exiled or silenced.

Freud got H.D. writing again. Bryher went often to Vienna to visit her, sometimes with Macpherson and Norman Douglas. After a break in London, H.D. resumed the sessions in autumn 1934. One evening she strayed into closed-off streets and was interrogated by the military police. Jews were regularly attacked by Nazi gangs. On a day of violence when swastikas and anti-Semitic slogans were chalked on pavements, she turned up for her session with Freud, though all his other patients had cancelled. Bryher sent her instructions on how to get out of

Vienna. H.D. replied that as her heart was 'here with this old saint', she would stay and risk death.

Freud was accepting of the relationship between the two women. He respected them both. Bryher said of him:

> Freud in himself was not what his admirers wanted him to be, a silent sage or hermit sitting on a rock and staring at the horizon. He reminded me rather of a doctor of the nineties, full of advice and kindness, who would have gone out in all weathers to help his patients and turned no one away from his door... nobody this last century has helped humanity so much.

Pursuit of psychoanalysis was in defiance of the meaningless evil of the times. Freud was pessimistic about the present, the future and this cancer of brutality:

> He says 'many many people will be murdered' [he meant Jews] I said I didn't think massacre was possible, there was still the open sympathy of the world... he gave a flea shake to his shoulders and said 'well we better go on with your analysis. It is the only thing now.'

'Die Bergner'

In Berlin, through her friendships with Pabst and Hanns Sachs, Bryher met the actress Elisabeth Bergner. She declared herself in love with her. 'Die Bergner', as she was known, was Viennese, Jewish and a left-wing activist. She was married to the film-maker Paul Czinner, who was Jewish and homosexual. Both were hounded by the Nazi regime. The 'Bergner Phenomenon' came from her androgynous looks and complex performances. She was a femme fatale and, like Greta Garbo, Marlene Dietrich and Katharine Hepburn, the new gender-questioning ideal of a heroine. Her acting career had been meteoric. In Berlin in the early 1920s she gave 566 consecutive performances in the

trouser role of Rosalind in *As You Like It*. After a screening in Berlin in 1934 of Paul Czinner's film *The Rise of Catherine the Great*, in which she starred, she, Czinner and all their films were banned by the Nazis.

While H.D. was in Vienna, Elisabeth Bergner was a frequent guest at Kenwin. Bryher compiled a scrapbook about her, took her to tea at South Audley Street in London, gave money for her film productions. She recounted all their encounters to H.D. and asked her to search second-hand shops in Vienna for photographs of Bergner and to post them to her.

Bryher's courtship consisted of her pursuit and Bergner's retreat. On 25 July 1933 Bryher reported to H.D.:

> such a scene with Elizabeth. She called me a 'crude taxi
> driver' and kicked me out. She said any question of zoo [sex]
> was piggish and never to be spoken of in her presence and
> that she had never been with anyone, male or female, or
> inanimate except C [Paul Czinner her husband] for a week
> which she would always remember but never repeat... She
> said her one emotion was jealousy... That she spent half her
> time thinking of your great beauty as you moved across the
> Kenwin grass and the other half wondering how you could
> delicately be poisoned!!!!!!!! that she wanted someone who
> would never speak to someone else and that I was unbearably
> crude. That I was wicked.

Bergner and Czinner left Germany in late 1933. They went first to London, then to America. Bryher travelled to see her performances. At the Apollo Theatre in London, Bergner was praised for her stage performance as an unmarried mother in *Escape Me Never*, adapted from a novel by Margaret Kennedy. The play went to Broadway. Czinner directed the film version in 1935 and Bergner was nominated for a best actress Oscar. Other nominees included Katharine Hepburn for *Alice Adams* and Bette Davis for *Dangerous* (Bette Davis won). Bryher saw all

three films in New York. 'If you saw Hepburn you would never leave New York', she wrote to H.D., 'so I think it is just as well you are NOT here.'

Bryher considered leaving Europe for America but had no attachment to American lifestyle. She went to the first night in February 1934 in Connecticut of Virgil Thomson and Gertrude Stein's opera *Four Saints in Three Acts*, a theatrical spectacle that was a valediction to the gaiety and freedom modernist lesbians had sought.

death of Sir John Ellerman

Bryher's father had a stroke in the Hotel Royal in Dieppe on 16 July 1933. Bryher, in Kenwin, was contacted by her mother from the hotel. No train was scheduled before evening, so she telephoned Geneva airport and chartered a single-engine two-seater passenger plane, a Gipsy Moth; the pilot had been trained by the Swiss Air Force. The day was stormy, the flight turbulent. When she reached the hotel, her father was dead.

One of his ships took his body back to England. His coffin was draped with a Union Jack. At South Audley Street, Bryher fought off reporters who tried to question her mother. 'I had the great satisfaction myself of kicking one cameraman hard in the stomach,' she said.

Sir John was buried at Putney Vale Cemetery near Wimbledon Common on a grey, rainy July day. An officer from his ships, Lady Ellerman and Bryher's brother, John, followed the hearse in the family's Rolls-Royce. Bryher called it the Crystal Palace because it was designed with headroom for her mother's elaborate hats. Macpherson called it 'a Hilton on wheels, towering over everything on the roads except the tops of buses'. He and Bryher followed in 'the Lanchester'. Press photographers shoved and pushed in their efforts to photograph the coffin as it was lowered

into the ground. Lady Ellerman wrote to *The Times* about their hooliganism.

Bryher's father had died at the height of the Depression. His estate, valued for probate at £36,685,000,* represented 30 per cent of the nation's wealth passed by probate that year, a fortune accrued by a man who showed little interest in what money could buy. 'I believe that my father could have become a religious leader as easily as a financier, he had such an extraordinary inner detachment,' Bryher said.

Her brother, aged twenty-three, heir to their father's business, became the second Sir John. Bryher suspected that a 'Letter of Directions' about the inheritance had been taken from her father's safe. She inferred her brother knew of this; he 'said unpardonable things', threw a chair at her head and they had no further contact. A month later, he married his girlfriend, Esther de Sola, who was from an orthodox Sephardic Jewish family – the elder Sir John had disapproved of her. They had no children. He was a private man who shunned all publicity, and he divided his time between a house in Buckinghamshire, a suite he permanently hired at the Dorchester Hotel in London and frequent trips to South Africa for his rodent work. He was made a fellow of the Royal Society there.

By the terms of her father's will, Bryher received £600,000 outright and a further £600,000 in trust.† Her brother received £600,000 outright and £2,000,000 in trust. Extravagant though it was, the settlement insulted her. In *Development*, she had written of herself:

> To possess the intellect, the hopes, the ambitions of a man, unsoftened by any feminine attribute, to have these sheathed in convention, impossible to break, without hurt to those she had

* The equivalent of £2.5 billion in 2020.
† The equivalent of £30 million in 2020.

no wish to hurt, to feel so thoroughly unlike a girl—this was the tragedy.

Hurt was all around Bryher when it came to family matters. Freud wrote to her from Vienna three days after her father's death:

> I read the news in our newspapers with great sympathy for you, not without a certain envy towards him. I suspect you will have a turbulent time ahead of you, during which a lot will depend on your mother's health and behaviour. My son Ernst's address is: Mascot Hotel, York Street, Baker Street, W.1. I don't know for how long he'll be staying in London still. Fa and Tattoun are fine and ask to be remembered to you.
>
> Warmly yours
> Freud

Fa and Tattoun were Freud's chow puppies from Yofi, which Bryher had not felt able to house at Kenwin. Freud foresaw that Bryher would be tested by her father's will. By the distribution of the wealth her father had accumulated, Bryher was made to feel of less value than her brother. Her inheritance was huge, she already benefited from substantial investments from her father, but her younger brother was to receive three times more. Money was a metaphor for worth. Whatever the size of the fortune, she was perceived as less deserving of it. The insult was compounded because she felt herself to have 'the intellect, hopes and ambitions of a man, unsoftened by any feminine attribute'. Bryher was as clever and courageous as any man, so why an insistence on gender that she did not apply to herself?

a fractured world

H.D.'s intense delving with Freud helped her recover her poetic voice and accept her dependency on Bryher. But analysis

inevitably made clear that the price for this dependency was her autonomy. H.D. tried to distance herself from Bryher. In November 1934, as the sessions were coming to an end, she wrote to her:

> PLEASE Fido, if you love me, and love my work, leave that to work its own will in its own way... Please for six months or a year do NOT probe me about my writing.

It seemed H.D. related her writer's block to the control Bryher exerted over her. It was hard for Bryher to be told to keep away. She did love H.D. and she did love her work and had done everything to serve H.D.'s poetic gift. Despite her authoritative temperament, she tried to keep this boundary too.

Back at Kenwin after her father's death, Bryher's main pre-occupation was the impact of fascism in Europe. With her additional wealth, she renegotiated trust funds for H.D. and Dorothy Richardson and for herself hired a new housekeeper, Elsie Volkart, whom she called 'the dragon'.

There were no more shared projects with Macpherson. *Close Up* folded. Fascism meant film-makers like Eisenstein and Fritz Lang left for America. Any film with Jewish backing or involvement was forbidden distribution in Germany. Janet Flanner wrote in her *New Yorker* 'Letter from Paris' in 1934:

> from now on there will apparently be no more of those excellent modern films coming out of Germany, except maybe some featuring Friedrich der Grosse with a little up-to-date swastika moustache.

Switzerland opened its borders to Jewish refugees, though in Zurich they were not allowed to seek work because of existing unemployment.

Macpherson was only intermittently at Kenwin. He began a relationship with David Wickham, a young man from Barbados, and he travelled with him and Norman Douglas. He had no

wish to be with H.D. or Bryher, but nor did he want formally to separate or divorce. The marriage suited him financially and made no demands. Bryher suggested he have analysis to find out if he genuinely wanted any sort of life with her. He complained that she tried to control him and change him from what he really was. In August 1934 she wrote him a frosty letter:

> I don't want to change you from what you really are but since I have known you you have been two completely different people. Between 1926 and 1930 you wrote two books, you made four films, you did a lot of work on *Close Up*, both from the photographic and the editorial side, and you spent practically the whole year with me, entirely happily to judge from your letters which I have. From 1930 to 1934 you dropped your film work entirely, you did less and less for *Close Up*, some issues not even the photographs and you have written, I think, one book. Almost all this time you have lived at least half the year with other people.
>
> Now the solution once I know which you are is absolutely easy. If you are as you are now, why then we have not an interest in common, I do not like the way you live, and you dislike equally the way I live. Therefore the sooner we are separated or divorced the better. It would be stupid to continue like this.
>
> If you are as you were 1926–30, we had then a great deal in common and there would be a reasonable chance of continuing happily on that basis. I suggested analysis as the way to show which person you wanted to be. But I don't want to stop you from being the person you want to be. If we are living together, not for a few separated weeks, but for at least two thirds of the year and if we have a community of interests, that is one thing. If you wish of yourself to try analysis, to discover what it is that you really want to be, I'll wait certainly while you try it but I cannot continue with you if you wish to go on with the same conditions that you have lived with since last January.

Macpherson did not try analysis, nor did he try to rekindle a community of interests with Bryher, or to live with her again.

H.D. in London

In London, H.D. continued analysis with an Austrian friend of Freud's, Walter Schmideberg, who shared his consulting room with his mother-in-law, Melanie Klein. Schmideberg helped H.D. with the stress caused when Aldington finally divorced her in 1938 to marry Brigit Patmore's former daughter-in-law, Netta, who was pregnant with his child. He wanted the child to be legitimate.

H.D. visited Kenwin but did not view it as home. Though afraid of the prospect of war, she did not share Bryher's efforts to help European Jews escape Nazi tyranny, nor did she travel with her. She took Perdita to Greece in March and April 1932, they visited Athens and Delphi, but her base was London and a flat at 49 Lowndes Square in Knightsbridge.

In February 1935, Silvia Dobson, a primary school teacher and aspiring writer, wrote H.D. a fan letter. H.D. invited her to tea and she visited on Valentine's Day. She was twenty-six, H.D. was forty-nine. They became lovers under H.D.'s rules of free love and not much proximity. They travelled to Venice together and indulged a great deal in what Freud called H.D.'s 'star fish stuff'. They drew up astrological charts, H.D. experienced 'intense states' of perception, and when Silvia sent her flowers she said one of the lilies would protect her, for it had 'five buds and flowers and five is the pentacle to keep off witches. Five is Mercury and Mercury is the Messenger or Gabriel of the Zodiac. Isn't he too Virgo.'

Silvia Dobson also began analysis, paid for and arranged by Bryher.

the road to war

From the early 1930s, Bryher felt she tried and failed to get people to face the eventuality of another war. Any brave publishing enterprise in Berlin became impossible. Determined to keep cultural innovation alive, in 1935 Bryher bought the London-based magazine *Life and Letters*, renamed it *Life and Letters Today* and installed Robert Herring as editor. She wanted an outlet for H.D.'s writing and for the work of friends and contemporaries, to keep an international scope and to ensure contributors got paid. The first issue featured work from H.D., Mary Butts, Havelock Ellis, Kenneth Macpherson, Lotte Reiniger and Gertrude Stein.

The magazine ran from 1935 until 1950. With her usual foresight, Bryher stockpiled paper so publication continued throughout the war years when other magazines folded through paper shortages. *Life and Letters Today* published poetry, opinion pieces, articles, short stories and theatre, cinema and book reviews. Dorothy Richardson, the Sitwells, Marianne Moore, Sartre, André Gide, Paul Valéry, Elizabeth Bishop and T.S. Eliot all contributed, as did Perdita, who was now sixteen. H.D. published serially her impressions of Freud.

Until the outbreak of war, Bryher maintained her habit of travel. She took Perdita to America in the spring of 1935, she stayed with Sylvia Beach in Paris, visited Gertrude Stein and Alice B. Toklas in their summer house at Bilignin near Aix-les-Bains, and there was a stream of guests at Kenwin. But her urgent task was to help Jewish doctors, lawyers, psychologists and intellectuals escape Nazi-controlled areas and ensure their safe havens in other countries. By 1940, when she herself had to flee Switzerland, she had helped, with money, contacts and sponsorship, 105 such people, 60 of them Jews, escape the Nazis. She established a fund in America for psychoanalytical

training, financed the smuggling of documents, helped Walter Benjamin get to Paris and Freud, his wife Martha and daughter Anna, to London. Of Freud's other children, she helped Oliver, an engineer, get to Paris and his daughter Mathilde to the south of France.

Freud reached London on 6 June 1938. On 16 November, he wrote to the editor of *Time and Tide*:

> I came to Vienna as a small child of 4 years from a small town in Moravia. After 78 years of assiduous work I had to leave my home, saw the Scientific Society I had founded, dissolved, our institutions destroyed, our printing Press 'Verlag' taken over by the invaders, the books I had published, confiscated or reduced to pulp, my children expelled from their professions…

Such was the work of dictators, censors and racists. Janet Flanner in her letter for *The New Yorker* wrote of how Brussels was packed with refugees and of how, at Verviers near the Belgian/German frontier, customs officers stayed up half the night to search out and detain refugees who, with packs on their backs and no visas on their passports, tried to sneak through the fields and over the border in darkness.

In February 1940 Bryher wrote:

> I blame the English government intensely for not having stopped Hitler before German rearmament became serious. As it is there is nothing now but to fight it out for were the Germans to triumph there would be no more liberty, art or thought in Europe.

more war

Bryher's mother died in September 1939 in a hospital in Truro, Cornwall. The South Audley Street house then passed to Bryher's brother. 'I had no idea where he was', Bryher wrote. 'The few

necessary business arrangements were made through our law-yers.' Sigmund Freud died in London the same month of throat cancer. He was eighty-three.

In Switzerland, there was not enough fuel to heat Kenwin, and Elsie Volkart, Bryher's housekeeper, moved to a little house near Lausanne. Bryher listened on the radio to the invasion of France on 10 May 1940. By September, with the threat of Germany invading England, she needed to get to London and H.D., though she hated the thought of leaving Kenwin and Switzerland. 'Ask me to die for England but do not ask me to live in the British climate' was her view.

Because of her refugee work, she was on the German authori-ties' blacklist. She learned, like Sylvia Beach and Gertrude Stein, that 'when people are fighting for their own lives and for those whom they love, the words "law" and "justice" become empty words'. She burned all papers that might incriminate herself and others and looked for help, from whatever source, to get out of the country. She could not leave by a regular route or take funds with her. 'I plundered the black market for passports,' she said.

A favour came from a Swiss man in a travel agency for whose son she had once found a textbook. He told Bryher of seats on a coach, with a collective visa for the business people on it, going from Geneva to Barcelona. Bryher wanted to take a young English student, Grace, the daughter of a friend, with her. She travelled with a suitcase and a rucksack containing enough food for three days. A gruelling journey followed. They journeyed via Grenoble, Sète, Perpignan. It took twenty-one hours to get to Barcelona, her suitcase was searched, she had no money, the British Institute was closed. She cabled relatives in America and 'oiled the wheels' with dollars. Not for the first or last time were Bryher's wheels oiled with banknotes.

After four days they flew to Madrid, then Lisbon, where they remained stuck for three weeks. Bryher took over the sorting of

tickets and exit permits. They were put on a waiting list for spare places on 'the Clipper', a plane from America to Portugal then London. Each day they checked at the airport, and at dawn one morning they got seats. The flight was turbulent and there was a shortage of paper bags in which to be sick. They landed in rain and darkness in a south of England airport – 'It may have been Poole' – then were put on a bus, and finally sent by train to London.

the guns began

H.D., returning from lunch on a day in late October, found Bryher sitting on her suitcase in the entrance to 49 Lowndes Square. Bryher wrote:

> Here I was, aged forty-six, forced back into the cage and
> misery of the first war and I had no illusions that the second
> one would soon be over. I felt a little better when Hilda came
> up the staircase a few minutes afterwards to look at me in
> astonishment. She took me immediately to show me the pile of
> sand kept ready to throw on incendiaries. Many of my friends,
> I found, were scattered about England but at least I was with
> the people I loved... as the sirens started, the guns began and
> we went with our blankets to the shelter downstairs.

For Bryher and her circle, the élan, shared endeavours, flamboyant freedom, mischief and optimism of artistic experiment were over. War came down like a shutter on free expression. And for its duration, she and H.D. stayed almost continuously together – which tested their tempers.

Bryher edited *Life and Letters Today* with Robert Herring, and worked on a memoir of the war years, *The Days of Mars*, and on a novel, *Beowulf*, based on the Blitz on London. She learned Persian and in the long evenings of the blackout felt she was going crazy. She yearned for pre-war Paris, 'that blue, smoky atmosphere where everyone was sipping bitter coffee and arguing about

metaphysics', and missed the 'snowy mountain crests above the placid lake' of her home in Switzerland. She hoped the United States would enter the war with the Allies, given their military strength, and bring it to an end.

Friends dispersed. Sylvia Beach was forced to close Shakespeare and Company then was interned by the Nazis. Gertrude Stein and Alice B. Toklas were in Vichy-occupied France. Robert McAlmon and Kenneth Macpherson were in America. Perdita, who was twenty, was driving an ambulance for the Red Cross. Ezra Pound became overtly anti-Semitic and regularly and publicly said 'something vile against Jews'. On 21 April 1941, Plymouth was bombed. Frances Gregg was killed in her house, along with her daughter and mother. She was fifty-six.

Bryher felt trapped in London. She and H.D. were visited by a government official because of all the black-market packets of cigarettes and the amount of chocolate they acquired above their ration coupons. The only journeys she made were to Barra in the Outer Hebrides to stay with Compton Mackenzie and his wife, Faith, and to Cornwall to stay with Doris Banfield.

As ever, Bryher saw it as imperative to help with acts of generosity. She gave money to Osbert and Edith Sitwell – she bought Edith Sitwell a house. When a woman in a bread queue told her she had broken her dentures on wartime bread and to replace them would cost more than her Christmas bonus, Bryher paid her dentist's bills: 'we were firm friends until she died shortly after the war', she wrote. A firefighter complained to her about his ill-fitting Wellington boots, so she bought him better ones. She helped clean up when the London Library was bombed and flooded. She paid for clippings of camel hair from the zoo to be made into coats for distribution as needed.

H.D., though destabilized by the war, during those years wrote three novels, three volumes of poetry, a memoir, short stories and a collection of poetry and prose. But the death of Freud, the

killing of Frances Gregg, air raids, danger, unalleviated proximity to Bryher and constant news of destruction caused her to break down.

'I could visualise the very worst terrors,' she said. Preoccupations with spiritualism and the occult, with Bryher, psychoanalysis, her Moravian heritage, and terror of bombardment filled her writing. She wrote in *The Gift*:

> I could see myself caught in the fall of bricks and I would be
> pinned down under a great beam, helpless. Many had been.
> I would be burned to death.

The Gift, she said, 'was a Gift of Vision, it was the Gift of Wisdom, the Gift of the Holy Spirit, the Sanctus Spiritus'.

In the summer of 1944, with Paris and Belgium liberated and the blackout reduced to a 'dim out', Bryher and H.D. went to Cornwall for two months. Bryher received her first letter in five years from Sylvia Beach and immediately sent money to her. In February 1945, she reported buying ice cream at Harrods and on VE day – Victory in Europe – on 8 May, she and H.D. hung Allied flags in the windows of Lowndes Square. That Christmas, they had turkey and a decorated tree.

H.D.'s breakdown

Neither Bryher nor H.D. wanted to remain in post-war Britain. They talked of going to America. But H.D. was not well. She was paranoid. She delved into spiritualism, held seances and thought she heard urgent messages warning of an imminent third world war. In the spring of 1946 she tore the bookplates out of her books, moved furniture into the hall and climbed on to the roof of 49 Lowndes Square, intending to throw herself to the street. Instead, she threw down a fur coat Bryher had recently given her.

Bryher wrote: 'I am not frightened of mental illness and because

of this I am able to understand and handle certain cases during the difficult hours between their treatments.' Twenty-eight years of partnership with H.D. had taught her about psychosis. She chartered a plane and flew her to a clinic in Switzerland: Dr Brunner's Nervenklinik in Küsnacht, by Lake Zurich.

She was advised by H.D.'s doctors not to visit or write to her. The medical opinion was that because H.D. had seemed distressed by Bryher in London, separation would help her restore. But not seeing Bryher or hearing from her terrified H.D. even more. She feared she was dead like Frances Gregg, or in mortal danger. For herself, she wrote to friends that she had meningitis and was staying in a romantic eighteenth-century manor house with roses brought from Versailles. To Bryher, she wrote that she was frightened of being charged with insanity. She asked her to come with armed men to rescue her but feared that then they would both be entrapped. She lost forty pounds in weight.

Bryher was criticized for being controlling, but at the root of all her intervention was the desire to do what was best. Without her, H.D. would probably be dead. She employed Walter Schmideberg as a psychiatrist for her and as a companion for herself.

H.D.'s letters from the clinic showed her need for Bryher. 'My frenzy was due entirely to the separation and anxiety', she told her. She thought her room at the clinic had been wired and her telephone line cut. She imagined all the apparatus of war directed at her: gun shots, police dogs and whistles and gas fumes. Never once did her paranoia direct itself towards Bryher. She wrote to her:

> I had a sort of 'shock-treatment.' They locked me in the
> bed-room, with window & shutters barred. There were
> 5 of us, 3 hefty men and a nurse. One of the men left with

the nurse, when I refused an injection. I thought they were trying to kill me. I suppose this is 'dementia praecox.'
I begged for a few minutes. An enormous prize-fighter, weighing a ton, ordered me to lie down on the bed. I refused & tried to dodge them. I have been severely shocked: if that is what they wanted to do, they succeeded. It was worse or 'better' than the most lurid film. They spotted my sheets with some sort of real or chemical 'urine'. I did not find this until long after mid-night, when I opened the bed. The stench was frightful—'bed-wetting' child memories, I presume! I must leave here. They did not kill me. I refused food, as I was heart-broken about you & pup, so then, I suppose they wrote me up as 'paranoia' or 'schiz.' and for a time I lived on your coffee and cigarettes. I do not know why I am here. There is T.B. on the towels. I am also apparently mad. However, we will laugh soon & I feel, dear Fido, I can now discuss with you intelligently, the Tibetan Book of the dead.

By October, H.D. was calm enough for Bryher to explain to her why she had kept away:

When you were so very ill in London you seemed to worry whenever I was there, so Dr Carroll said I must not be with you then or write, but all the time I was in touch with Dr Brunner to see how you were. I wrote the moment it was felt you were well enough for letters.

Bryher visited with Walter Schmideberg, whom H.D. called The Bear. It was a relief to Bryher that H.D. was in a safe and peaceful place and that she did not have to take on the impossible burden of caring for her alone. She visited her most days for lunch or tea or to do a bit of shopping. She gave her an additional settlement of £70,000 and an annual allowance of £2,500, though H.D. spent little or nothing beyond the fees for the clinic.

Bryher was unsettled too and, apart from Schmideberg, no one looked out for her. She could not return immediately to Kenwin. Refurbishment was needed and the heating pipes had rusted. Her parents were dead, she was not on speaking terms with her brother, H.D. was gripped by psychosis and Bryher saw very little of Kenneth Macpherson who did not visit H.D.

Bryher flew to America in January 1947 to discuss divorce details with him. He was sharing a house with Peggy Guggenheim and Bryher found him 'very sad, disillusioned and more mature'. He seemed to have given up all artistic ambition. When the divorce was finalized in February, he moved with the photographer Islay Lyons, who became his long-term partner, and 'that old roué' Norman Douglas to the Villa Tuoro in Capri. Bryher financed their ménage. She also gave him an apartment in Rome, near the Coliseum.

She moved back to the Villa Kenwin in the spring of 1947. Elsie Volkart resumed as her housekeeper. For ten years, Schmideberg was Bryher's paid companion there. It was as if Bryher felt obliged to pay for all relationships. Like McAlmon and Macpherson, Schmideberg drank; he was also treated for drug addiction.

She resumed her passion for travel. She flew to the Caribbean with Robert Herring and Walter Schmideberg, to India with Macpherson and Islay Lyons, to New York via the Azores and Canada with Perdita. 'It was almost my ideal of life, flipping up and down all over continents.' She loved the sunsets and mountains, the markets and street life, the excitement of unknown places and of moving on.

Perdita marries

Perdita went to New York when the war ended; she needed to distance herself from her mother and Bryher. She married in Maine in June 1950. Her husband, John Valentine Schaffner,

was the New York literary agent for whom she had been working. The writer and academic Norman Holmes Pearson wrote to H.D. of the day. Perdita looked lovely, he said, in a soft blue dress with a wide blue hat to match and a bouquet of white and yellow flowers. The following February, her eldest son, Valentine Schaffner, was born. With her subsequent children, Perdita told her mother they were due a month later than in reality to spare them both anxiety. She visited Bryher and her mother with her husband and new baby in 1951 and stayed two weeks at Kenwin.

Perdita opted for a more conventional model of family than the variety she had experienced in her formative years. She took her husband's name, reclaimed her American citizenship, wrote for literary magazines, had four children, cats called Petunia, Magnolia and Dr Hugh de P. Van Brugh PhD. The homey, easy things Perdita was denied as a child, she created for herself and those whom she found to love. She lived to be eighty.

One of her sons, Nicholas, a rock star and biographer of The Beatles, died of AIDS when he was thirty-eight. John Schaffner, her husband, died aged seventy, also of AIDS.

Kenwin alone

When H.D. was well enough to leave the clinic, she did not return to Kenwin. She went first to the Alexandra Hotel, half an hour's walk away from Bryher. They saw each other almost every day – met in a bakery 'for chocolate and an inch of whipped cream and ambrosia croissants'. H.D.'s hotel room had a balcony looking out over a church. The peacefulness of the mountains, no responsibility, and medical care made her creative life possible. She had what she called her 'simple luxuries – cold water, coffee and cigarettes'. She could work again. Bryher gave her notebooks, reference books, anything she wanted. H.D. was fulsome in her

thanks: 'I can never begin to thank you, dear Fido, for showing me the "path" here & for all the Greek and Italian journeys this recalls.'

In the summer of 1948, she moved to the Minerva Hotel in Lugano; she said Lugano was more beautiful than the Nile Valley or the Gulf of Corinth. Her schedule was work, gentle outings and no demands. On 17 July, at the hotel, she and Bryher celebrated the anniversary of their meeting, thirty years earlier.

For Bryher, the problem became who would care for the carer. She had spent her life thinking of others, but no one seemed to look out for her. She found the upkeep of Kenwin hard to sustain. The boiler needed repairs, the gardener left, maids were hard to find. Designed as a modernist centre for the arts, not much went on there once Macpherson and H.D. were gone. Bryher welcomed Schmideberg's company but his drinking got out of hand.

After an abdominal operation in 1953, H.D. moved back to Dr Brunner's Nervenklinik. Bryher called the clinic a 'microcosm of the world'. It was an asylum in the best sense of the word, five houses in beautiful grounds with lakeside views. The inhabitants were drug addicts, alcoholics, the mentally ill. H.D. liked the strange people gathered there; she was perhaps happier than at any point in her life. Her book-filled balcony room looked out over a lake with white swans. There was a little room where Bryher could stay and all around were pine and cedar trees. The food was good, she would breakfast at eight then go back to bed for an hour, she ran a reading group, went out to the cinema and to concerts. She once said that had she been Catholic, she would have become a nun. This was close to the sequestered life.

In December that year, Walter Schmideberg was admitted to the clinic too, ill with alcoholism and a gastric infection. He died there the following year.

From her safe haven, H.D. published a book of poems a year. In her poetry she channelled creative disorders of thinking, her crisis of identity, the myths of ancient Greece, her fascination with things occult, her unconscious mind. She thought there was a fourth dimension to past, present and future. 'The room has four walls, there are four seasons.' She allied her creativity to the universal experience of the dream. She worked on her *Tribute to Freud*. In it, she wrote:

He had dared to say that the dream came from an unexplored depth in man's consciousness and that this unexplored depth ran like a great stream or ocean underground... He had dared to say that it was the same ocean of universal consciousness... he had dared to imply that this consciousness proclaimed all men one; all nations and races met in the universal world of the dream...

In 1956, she slipped on a rug on the polished floor and broke

her hip, but was unperturbed when confined to bed and alone with her imagination. The clinic was a mix of hotel, rest home and hospital. Never good at making decisions, or even capable of making them, H.D. felt safeguarded and liberated by institutional life. She corresponded with Pound and with Aldington, whose second wife left him. Bryher visited, brought her whatever she wanted, answered her every request and kept the flame of her literary distinction alive.

Honours for H.D. accrued: the Harriet Monroe prize, a citation for distinguished service from Bryn Mawr, the Gold Medal Award from the American Academy of Arts and Letters. The International Communication Association in Washington wanted her to lecture, the Poetry Center in New York wanted her to read. There was a flurry of reissue of her books. 'For beauty of phrase and psychological insight there is no poet more interesting than HD', Bryher wrote. 'Flower leaf and salt water and a mind like a diving bird.'

In March 1959, Bryher went to the Paris exposition 'Les Années Vingt – American writers and their friends in Paris, 1920–30' curated by Sylvia Beach, with memorabilia from Shakespeare and Company. 'It's most beautifully done with everyone we knew and many we did not,' Bryher wrote to H.D. Contact Editions featured large, and all the little magazines Bryher's patronage had kept alive. Twenty thousand people visited, and the same number when the exposition moved to London the following year. When Bryher walked in Paris with Sylvia, passers-by said, 'C'est Mademoiselle Beach.' That winter, Sylvia stayed for a week at Kenwin and Bryher showed her part of her memoirs, which she was writing. Romaine Brooks and Natalie Barney visited too. 'Nothing seems to daunt these old ladies,' Bryher said.

death of H.D.

In May 1961, the freeholder of the Nervenklinik sold the estate. Everyone had to move at short notice.

> Most occupants had a very difficult time with relocating: Most of them were old ladies of eighty and over and we had one attempted suicide because they were so distressed at having to move from their rooms where they had been, some of them almost twenty years.

H.D. was wrenched from what had become her home. Bryher moved her to the Hotel Sonnenberg, Zurich, with a view of the mountains, but it did not compare. H.D. only had a single room with a bath and a bit of flat balcony. The following month she suffered a stroke, which paralysed her right side and affected her speech. She died in the Klinik Hirslanden in Zurich on Wednesday 27 September 1961. Bryher felt it was merciful. 'She minded the frustrations so dreadfully,' she wrote to Silvia Dobson.

'It is impossible to believe in Bryher without HD,' Alice B. Toklas wrote to Perdita's husband, John Schaffner. She had heard of H.D.'s death from Sylvia Beach.

the cabin boy in the sailor suit

Bryher lived from then on more or less alone at Kenwin, travelled as she would, stayed in the shadows and kept from the limelight. She had always been solitary, her relationships defined by what she gave, with no vain wish for adoration or affirmation from another person. She had always expected others to take centre stage and win the accolades, for her to be the producer whose name was not remembered, the enabler not the star.

Without another cause to fight, or poet to sponsor, and with the world now a different place, year on year she wrote historical novels, set in Ancient Carthage at the time of Hannibal, or in sixth-century Cornwall, or third-century Switzerland, in Rome 400 BC, post-Arthurian Britain, or at the time of the Norman Conquest. In these stories, the hero was variously a nine- or twelve-year-old boy, the elder brother watchful of his little sister, the putative soldier, the defiant Prince:

> he was thankful that he had run away from Exeter and home. He had taken nothing with him but a bag of dried meat and a sharp knife.*

> I will run away I had promised myself every morning, but then my mother had looked at me sorrowfully and begged me to be patient and so I had lost my courage. 'One day you will be second to the King' she had said…†

> He wondered how much he dared tell his sister. Brave as she was all women were afraid of raiders.‡

It was as if Bryher, in her stories, careful in their research, ponderous in a prose style that broke no new ground and stirred no literary interest, found the inner liberation she sought. She was matter-of-fact about her writing, apt to repeat the bad reviews: 'her language is jerky and unmelodious; her characterisation too thin'. But in these stories, written with no particular reader in mind, she found the key to freeing the small boy trapped in the wrong body, a salve to the gender quandary that so dismayed her when every expectation was for her to be a girl with curls.

Free at last from responsibility for others, and safe in her Bauhaus eyrie, Bryher could march over the Alps in the dead

* *This January Tale*, 1966.
† *Ruan*, 1961.
‡ *Roman Wall*, 1955.

of winter accompanied by a troop of elephants, be the cabin boy in the sailor suit, side with the Saxons against the Normans, travel with Columbus to America to find a brave new world. As a child, 'I loved antiquity. It was more real, it is more real to me than this present world...', Bryher said. 'I was nine when my parents gave me *The Young Carthaginian* by G.A. Henty:

> It fired my imagination because I was just the same age as Hannibal when he had sworn his famous oath to fight Rome... I wanted to be a cabin boy and found that I could reply to tiresome arguments 'if Hannibal was old enough to go on a campaign when he was nine, I am old enough to go to sea.'

In her first autobiographical novel, *Development*, written in her early twenties, she voiced her own desire to be a writer:

> Work was difficult in an unbroken isolation which fettered thought and plundered her of dream, yet, sharp as it was to wait for life, there were days she was glad of her solitude, the solitude which had taught her the loneliness, the transience and the loveliness of words.

Solitude was Bryher's natural state. She lived behind a wall of money and was not open to being loved. Her demeanour was sober and controlled, strangely mannish and she seemed in a sense closed. Years of psychoanalysis reconciled her to who

she was. Behind the stern facade was a fierce and courageous heart. It was not easy for her to love H.D. with stalwart loyalty, rescue her from devilish mess, protect her from endless storms. Without Bryher's unstinting patronage, many new voices would have stayed unheard. She always and discreetly helped. Her demeanour belied her passion to learn by heart all H.D.'s poems, travel the world, dare to fence and fly, flout convention, free the oppressed and probe the human psyche. Bryher flouted expectations of gender and rules of marriage, embraced the new, left the closed incoherence of her Victorian home and sought an inclusive world.

Bryher's death

Bryher died at Kenwin on 28 January 1983, when she was eighty-eight. She left £462,000 in her will. The amount was residual, for while she lived she had given away much to her unorthodox family and to deserving and undeserving friends. By the terms of her father's trust fund, her brother's widow was the formal beneficiary of her estate, even though they had had no contact. Perdita benefited too.

On 1 February 1983, *The New York Times* printed an obituary:

Mrs Bryher was a minor member of the literary circle that included Ernest Hemingway, Gertrude Stein and André Gide...

Mrs Bryher lived with Hilda Doolittle, the Imagist poet and a distant cousin... Mrs Bryher helped to raise Miss Doolittle's daughter Perdita, now Mrs John Schaffner of New York, who became Mrs Bryher's adopted daughter and heir... Mrs. Bryher is survived by Mrs. Schaffner and four grandchildren.

It was as if a kindly grandmother had died. Deference to patriarchy was intact. Readers need not consider another Bryher, defined by a Scillonian island of granite hills, waves and sunsets,

separated from the mainland by an ocean and a sea, or hear of that Bryher's quest for liberation from the cage of gender, her disregard of conformity, passion for freedom, and unstinting generosity to those with minds like a diving bird.

NATALIE BARNEY

'I am a lesbian. One need not hide it nor boast of it, though being other than normal is a perilous advantage.'

'Love has always been the main business of my life,' Natalie Barney said when old. This main business involved lots of sex. Natalie went where desire led her. She shared her bed, the train couchette, her polar bear rug, the riverbank or wooded glade with many women, and not always one at a time. Modernism in art upended nineteenth-century rules of narrative and form. Modernism in Natalie's life upended codes of conduct for sexual exchange. For Natalie, modernism meant lovers galore.

Desire and Conquest were her twin themes. She was remarkable for her exuberant commitment to lesbian life. 'Living is the first of all the arts' was one of her epigrams. 'My queerness is not a vice, is not deliberate, and harms no one' was another. Throughout her long life, she managed concurrent affairs. She met her last amour on a bench by the sea in Nice when she was eighty.

Natalie liked drama and extravagant display. Jealousy and the florid feelings provoked by infidelity enhanced her desire. 'One is unfaithful to those one loves so that their charm will not become mere habit.' Many women fell in love with her, even more had sex with her. Of herself she said: 'I have loved many women, at least I suppose I have.' Her sexual enthusiasm was unwavering. She was rich – very – and felt entitled. Disinhibited, she did not stall at taking off all her clothes in or out of doors. There are photographs of her from the 1890s, naked in Acadia National Park in Maine. No pleasure was more intense for her than orgasm. In an autobiographical piece, she wrote of how, as a child at bath time, 'the water that I made shoot between my legs from the beak of a swan gave me the most intense sensation'. Thereafter, she pursued this sensation with scores of women.

Her mother, whom she adored, was a diva, startling and theatrical. Her father was violent and alcoholic. Defying him was an essential component of Natalie's freedom. 'I neither like nor dislike men,' she wrote. 'I resent them for having done so

much evil to women. They are our political adversaries.' She said she became a feminist when travelling in Europe in her teens with her mother and seeing women treated as badly as mules and slaves. She scorned the view that a woman's lot was to be wife to a husband for life and to give birth to his children. 'The finest life is spent creating oneself, not procreating' was Natalie's view. 'What makes marriage a double defeat is that it works on the lowest common denominator; neither of the ill-assorted pair gets what they want.' Natalie was not going to battle with the male establishment to change man-made laws, or march for women's right to vote or be deans of colleges, or lawyers, doctors, politicians. Nor, like Sylvia Beach, did she set herself a mission to accomplish, a goal to achieve. She took her own freedom as a birthright. Her defining characteristics were independence of thought and doing as she pleased.

Her inspired contribution was to be transparent about same-sex desire in a repressed and repressive age. Too impatient, privileged and self-occupied to give much time to a task or a cause, she led by candid example. Many women followed and were liberated by her courage. She bleached of stigma the language of same-sex love, was proud of her love affairs and cocked a snook at her detractors. 'Why should I bother to explain myself to you who do not understand – or to you who do?'

She had a sort of moral compass, though of her own calibration. She valued and sustained friendship, dispensed with euphemism and guilt and tried to

live the truth of what she felt. She bore no grudges, was patient with difficult partners and emotional frailty, and her lovers felt understood by her. 'You are capable – and it's your only fidelity – of loving a person for that which she is. For that I esteem you,' the poet Lucie Delarue-Mardrus wrote to her. 'I often reflect that nothing has come to me from you, great or small, that has not been good' was Colette's view.

On the downside, her multiple and overlapping involvements hurt many vulnerable women. Dolly Wilde, Renée Vivien, Romaine Brooks, Eva Palmer were among those who suffered being adored by Natalie one night but left alone because she was with someone else the next. And after a time, with the litany of so many women, and Natalie's reluctance to draw a line as her list of lovers accrued, more really did come to seem like less.

mother. the first relationship

The first woman for whom Natalie said she felt 'an absolute emotion' was Alice Pike Barney, her mother:

> When she bent over my bed before she went out to a
> party, she seemed more beautiful than anything in my
> dreams. I would stay awake anxiously waiting her return,
> for whenever she was away I was afraid something terrible
> might happen to her...
>
> When she came home with my father, often very late at
> night, I would hear the rustling of her dress as she passed my
> bedroom. I would tiptoe barefoot toward the strip of light
> which shone under her door. I could not leave until she put
> out her lamp...

Mother – beautiful, beyond any dream, a strip of light under the door – induced sleeplessness and anxiety, was out of reach and set the bar for unattainable love.

Alice Barney, a woman of formidable energy, enthusiasms and self-regard, was thwarted and denied expression, in her own and Natalie's view, by her husband, Albert. On honeymoon in 1876, Alice realized that her marriage was a mistake. To her diaries she confided her contempt for Albert: his eyes were set too near together, his ideas were prejudiced and narrow, he had no soul.

Albert Barney, mortified and frustrated by her rejection, sought consolation in whisky and other women. He viewed the artistic aspirations of his wife and Natalie, his elder daughter, as affectations and an undermining of his authority as head of the household. His dissatisfaction was at its worst when he was drunk. He became alcoholic and abusive. Natalie thought he wanted to love his family, but his love was thwarted. 'His affection for me was demonstrated with gifts and bruises: he would pull me back from the traffic with such vigor that I would have preferred the accident.'

She thought her mother responded to his behaviour with saintly restraint:

'Live and let live' was her motto. She had great patience with difficult characters, ungenial though they might be. The desire to control other people was foreign to her. When anyone failed her she was more sorry for them than for herself.

For herself, Natalie resisted her father's authority, shunned his presence and would not do as he instructed. She would not

allow him to thwart her lesbian identity, curtail her freedom or interfere with her intention to live her life as a work of art. Scornful of his drinking, she disdained alcohol. Liquor, she said, brutalized the mind and body. Drinking someone's health in it was a contradiction in terms. 'I loathe the enthusiasm, the writing, friendships and love affairs that come from being drunk.' Her self-expression took root in opposition to him. 'I can't and won't submit to his whims as you do', she told her mother. 'It doesn't pay. I think I shall be very polite and never answer him back, but have my own way when it's reasonable just the same.'

Having her own way became Natalie's creed for life. Her sexuality was her business, not her father's or any man's. She said she once had eighteen assignations in one night. But though her compulsion was to explore and gratify the range of her desires, she stayed true to the ideal of love. There was a questing nature to the transference chain, a search for purity of feeling, a desire freely to evolve, defy, be true to herself and to live life to the full.

Natalie matched her mother in theatricality. She saw her parents' marriage as a disaster, a trap to curtail her mother's freedom and artistic aspiration. To conform was to deny and repress. She was glad to be 'naturally unnatural' and spared desire for any man. She would not comply with society's expectation of a woman's place. Were she to wed, it would be solely to gain her inheritance.

cultural forces

In her writing, as in her life, Natalie scoffed orthodoxies, heterosexuality and male traditions of style and narrative. She was dismissive of the literary elite:

mind pickers and culture snobs... I do not understand those

who spend hours at the theater watching scenes between people whom they would not listen to for five minutes in real life.

She wrote mainly in French, in which she became fluent. As a child in Washington she had a French governess; America looked to Europe for its culture. In her teens she went to a girls' boarding school, 'Les Ruches' ('The Beehives') in Fontainebleau. The school's headmistress, Marie Souvestre, was lesbian and founded the school with her partner, Caroline Dussaut. They separated in 1883; Marie Souvestre went to England with another teacher, Paolina Samaïa, and together they started Allenswood, a school for girls in Wimbledon. Among their pupils were Dorothy Strachey* and Eleanor Roosevelt, who married her distant cousin Franklin Delano Roosevelt. When first lady of America, Eleanor took as her lover Lorena Hickok, known as Hick, a reporter with Associated Press. Hick moved in to the White House and stayed with Eleanor for most of the twelve years of Roosevelt's presidency. Eleanor kept a photo of Marie Souvestre on her desk.

When she was eighty-three, Dorothy Strachey wrote the novel *Olivia* about being a pupil at Allenswood, and her passion for Marie Souvestre (Miss Julie). Published by the Hogarth Press in 1949, the year the censorship of Radclyffe Hall's *The Well of Loneliness* was finally lifted, and dedicated 'To the beloved memory of V.W.' (Virginia Woolf), Dorothy Strachey said she wrote *Olivia* to please herself 'without considering whether I shock or hurt the living, without scrupling to speak of the dead'. She wanted to recapture the emotions she felt when she was sixteen. To do so, she said she needed to overthrow the theories and dictates of 'the psychologists, the psychoanalysts, the Prousts and the Freuds', whom she accused of 'poisoning

* Lytton Strachey was her brother.

the sources of emotion', of applying 'poisonous antidotes' to the romantic realities of life.

'Love has always been the chief business of my life,' Dorothy Strachey, like Natalie Barney, wrote. Her childhood passion was succeeded by other loves. Nonetheless, at the grand age of eighty-three she 'felt the urgency of confession', the need to assail and stand up to the cultural forces that had compelled her to conceal her deepest feelings, kept her 'from any form of unveiling', forbidden her 'many of the purest physical pleasures' and denied her literary expression of who she quintessentially was.

It was a heartfelt cry from an old woman. Dorothy Strachey died in 1960 at the age of ninety-four.

So as a girl Natalie learned something of how to be lesbian and a lot of how to speak French. 'Being bilingual is like having a wife and a mistress, one can never be sure of either,' she said. Writing in French freed her from Washington constraints of expression but restricted her readership. In her lifetime she published, mostly privately, five volumes of poetry, three of epigrams, two of essays and three memoirs. She did not write stories with a linear narrative, paragraphs and chapters. For punctuation, she favoured ellipses and dashes. She liked fragmented ideas – 'scatterings', she called them, *pensées*, maxims, aphorisms – the stuff of short attention span. She wrote some poetry in English. Her only novel in English was semi-autobiographical: *The One Who Is Legion*. Her writing was personal, her topics same-sex love, feminism, Hellenism, pacifism, paganism… Unambitious for professional success, the life she lived was the work of art that mattered.

Eva Palmer and Sappho

Natalie met Eva Palmer on vacation in Bar Harbor in Maine in 1893. She called her 'the mother of her desires'. Natalie was eighteen, Eva was twenty. They began a relationship that lasted

a decade and set the paths of both their lives. Over that period they exchanged about a thousand letters. Bar Harbor was a summer resort for the wealthy and the Barney 'summer house', castellated in the style of an English castle, had twenty-six rooms. Eva's family too was hugely wealthy. Her father, Courtlandt Palmer, was heir to a million-dollar fortune made in real estate, though he died when she was fourteen, several years before she first met Natalie.

Eva had studied classics at Bryn Mawr college. Both she and Natalie dignified same-sex desire by reference to the mores of classical Greece. Eva wanted to live the ideals of Sappho. Both she and Natalie dreamed of a utopia, modelled on Sappho's community on the island of Lesbos, where creative women supported and loved each other.

Eva's plan had an intellectual underpinning but she was in thrall to Natalie's verve, courage and braggadocio. She fell in love with her and idealized this love with reference to Sappho's writing:

> Your letter folds me as closely as your arms and touches
> me as marvelously as your lips, I am bound by it as though
> all your body were over me, held by it as by your eyes when
> they glitter like jewels in the sun. My poet, my mistress, my
> lover! I love you all ways tonight, but most of all for the
> grace of your lines.

Sappho

Though mere fragments of Sappho's poems and thoughts survive, these were inspiration to the lovers and poets in Natalie's circle. They learned Greek to understand Sappho and wrote verse in homage to her.

Sappho was born in about 612 BC at Eressos, a seaside village in south-west Lesbos. She came from an aristocratic family, married, had a daughter and was widowed young. In a political dispute, she was exiled from Lesbos to Sicily. When she returned, she set up a school for music and dance for girls in Mytilene, the capital of Lesbos.

This school became her life. The themes of her poetry were the pleasures and pains of her all-female community. These poems, written to be recited, used the vernacular of Lesbos. They revealed her love for a favourite, pain at separation, grief when girls left to marry, nostalgia at remembering pleasures shared, jealousy about rivals. In one fragment, she wrote of a lover who outshone all the women of Sardis as the moon outshone the stars. In another, she invoked Aphrodite to help her, not break her heart with pain and sorrow. In a third, she described her feelings on seeing and hearing the woman she loved.

In classical Greece, no other woman poet achieved Sappho's recognition. Fifth-century vases testified to her fame, her portrait was in the Acropolis at Athens, the Syracusans erected a statue of her in their town hall, the Alexandrians collected her work into nine books, she was read in schools up to the fourth century AD.

Natalie, Evalina Palmer and others in their circle allied Sappho to their modernist view in much the same way as James Joyce reclaimed Odysseus. Role models for lesbians were few. Sappho was evidence that such desires were time-honoured, that there had always been women who felt as they did, whose emotions

were pure and lifestyles self-willed, not prescribed or dictated by men.

Natalie's openness was contagious and gave courage to lesbians less bold than she. Those less confident to be true to themselves gravitated towards her and were emboldened by her candour. The pursuit of desire, love triangles, the pain of jealousy, infidelity and broken affairs became their interpretation of Sappho and a link to a classical culture.

This swell of lesbian visibility was from the ground up, a heartfelt movement, an opposition to exclusion, denial and insult. Natalie aspired to make Paris the sapphic centre of the Western world. Unflinching, outspoken, unembarrassable, she did not hide behind euphemism, say what society might want to hear, or curry acceptance. Around her there formed a community of lesbians who could be who they were. Paris allowed such freedom.

Liane de Pougy

In spring 1899, Natalie was in Paris with her mother. She was twenty-three and glad to be rid of the 'rigid protocol' of Washington society. They shared a house in avenue Victor Hugo. Alice Barney enrolled for James Whistler's course in portrait painting for women at the Académie Carmen in the Passage Stanislas, owned by Whistler's principal life model Carmen Rossi, with whom Natalie had a fling. Natalie studied French classical poesy and Greek with a scholar and poet, Charles Brun, and wrote poems in French about love and her lovers.

She began another 'living as the first of the arts' relationship. It caused a dramatic rift between her and her father. Liane de Pougy was a famous Paris courtesan, who numbered Albert, Prince of Wales and Maurice de Rothschild among her clients. Courtesan was a more respectable word than prostitute for

women who had sex with rich clients for a lot of money. Born Anne-Marie Chassaigne in 1870 in the Breton city of Rennes, she fled to Paris to escape her humble roots, miserable marriage and young son, and joined the salon of the Comtesse Valtesse de la Bigne. She took her professional name from a favoured client, the Comte de Pougy. Society columns of the 1890s wrote of her beauty, her

jewels, and the company she kept. In payment for a stint, she might receive 'a necklace of the white pearls I love worth one hundred thousand francs'. The scrimping days of Anne-Marie Chassaigne ended.

To deflect unwanted attention from her father and protect her inheritance prospects, Natalie declared her engagement to an ersatz fiancé, Robert Cassatt, whose family had made their money in railroads. He agreed in writing to a 'chaste and intellectual marriage'. Natalie made clear their arrangement was a societal and financial cover; she desired women, not men, and that would always be so. Cassatt said he desired women too, so they had that in common. Out with him one afternoon in an open landau in the Bois de Boulogne, they passed Liane de Pougy's carriage in the Passage des Acacias. Natalie and Liane 'exchanged long looks and half glances'.

Next morning, Natalie called with roses and cornflowers. Liane was in a blue silk bed. They soaked together in a perfumed

bath and had sex on Liane's polar bear rug.* Liane praised Natalie's white blonde hair, 'like a moonbeam', her blue eyes and 'vicious white teeth'. In the evening they went to see Sarah Bernhardt as Hamlet at her own theatre. Passers-by applauded Liane as she stepped from her carriage. Natalie compared Hamlet's passivity to the subjugation of women. Men, she said, made laws for their own benefit. Her resolve was to revise these laws to favour women who love women. Her rejection of male orthodoxies was unequivocal: There was no God, the Bible was man's fiction, an overprinted fable: '"God will punish you even to the third and fourth generation." Let's raise a glass of cool water to the health of the fifth generation.'

Natalie pursued Liane out of desire, but also declared a half-hearted feminist intention to save her from prostitution. She suggested to Cassatt that, when married, they adopt Liane to provide income for her too, so she could retire as a sex worker. Cassatt was not keen. Marrying for money and agreeing not to have sex with his wife was one thing. His wife having sex with his daughter who was seven years older than he was and a famous courtesan was a stretch too far.

Liane gave Natalie a silver and moonstone ring embossed with a bat, symbolizing rebirth, and inscribed with a message of love. It complemented Natalie's anklet, commissioned from the jeweller René Lalique, of bats flying among diamond stars. They began a one-act play about Sappho, had fantasies about finding a 'blessed little nook' together, but until that happened, Liane explained,

> I still need 800,000 francs before I can stop. Then I shall cable you: 'Come take me' We'll really live. We'll dream, think, love, write books.

* Natalie inherited this rug and kept it in her bedroom for most of her life.

They travelled to London together, booked a suite at the Hotel Cecil, hired a boat on the Thames. The papers praised Liane's beauty, her ermine coat, her hat wreathed with roses.

Mr Barney travelled to Paris, irate at what he was hearing about his daughter. His tolerance of alcohol had diminished; one whisky and he was drunk. He forbade Natalie to have anything more to do with Liane, and took her to Dinard in Brittany with her mother and sister, Laura. Natalie went for long horse rides, read the poetry of Verlaine, Baudelaire and Mallarmé, wrote poems in French about her lovers and sent letters to Liane about her beauty and skin like rose-tinted snow.

Liane began a memoir, *Idylle Saphique*, a confession from the demi-monde, about their affair. 'It's going well', she wrote to Natalie after twelve pages. 'I think you'll like it.' She tried to join her in Brittany but was snubbed by the Barneys. Robert Cassatt wrote from Pittsburgh ending his engagement and la Valtesse wrote to Liane asking, where was she? A charming young man of good family was offering 500,000 francs for her. It was not possible to run a business this way.

Back in Paris, Natalie and Liane resumed their affair. Mr Barney had his spies. He wrote to Natalie that he was informed of 'things so repugnant that one has to pity the minds that have conceived them' and demanded she end all contact with Liane or return to Washington. Natalie replied with scorn:

Ever since I remember you your one ambition for us was petty and worldly. Even religion was made a sort of social duty. One should go to church because it looked well, or because people would think it strange if we didn't. You must understand how petty, how ugly our whole upbringing was. You showed me at the age of twelve all that marriage means – the jealousness, the scum, the tyrannies – nothing was hidden from me. I was even made a witness when still a mere child of the atrocious and lamentable consequences an uncontrollable

temper can have on a good and kindly woman… Seeing all this made me lose faith in you – respect for you. I no longer felt myself your daughter.

To keep him from coming to Paris, she gave false assurance she would 'give up seeing this woman'. Liane wrote to her of her intention to end the relationship. '*Everyone* tells me to let you go, that we can have no future together.'

Natalie worked on a collection, in French, of thirty-five of her love poems to and about her lovers, *Quelques Portraits-Sonnets de Femmes*. In them, she experimented with rhyme and verse. She wrote of breasts like lotus flowers on a tranquil pond, hearts pounding like the sea, the scent of her lover's hair, her lovers' orgasmic cries… In a personal preface, 'for those who never read prefaces', she apologized for daring to offer 'French verses to France'. 'Nothing about me must surprise you. I am American,' she wrote.

In another room of their house, Alice Barney did pastel portraits to illustrate the book. Her French was poor, she did not read the poems, but thought these friends of Natalie made beautiful models.

Renée Vivien

Natalie's response to her father's ultimatum about Liane de Pougy was to court additional scandal. Riding in the Bois one afternoon, she met a childhood friend from Cincinnati, Violet Shillito, and her sister Mary. Violet told her of her close friend Renée Vivien, and how she, like Natalie, wrote poetry in French. The four arranged to go to a matinée:

The butler announced the arrival of the landau and at the same time handed me an envelope on which I recognised Liane de Pougy's handwriting. She was travelling in Portugal.

Natalie took little notice of the play or of Renée, whom she thought looked ordinary. She sat in the back of their box and read and reread Liane's letter. Liane was with a client, a prince from somewhere, but her thoughts were of Natalie.

> The moon sulked and I thought of you moonbeam, of
> your fine, fine hair... my little blue flower whose perfume
> intoxicated me oh so sweetly, you, my fair one, my Flossie...

Next evening, Natalie took Renée skating at the Palais de Glace in the Champs Elysées. Afterwards, they went back to Renée's vast apartment in rue Crevaux. It was candlelit, perfumed with incense and the windows were heavily curtained. The place was adorned with gigantic Buddhas draped in black, masks, ancient instruments and snakes behind glass, and in every corner were vases of white lilies. Natalie left at dawn. It was, she said, 'a disquieting beginning in which two young women try to find themselves in a mismatched love affair'.

Renée had blonde hair, a smooth complexion, heavy eyelids, a retroussé nose, a hand tremor and an engaging lisp. Though tall, she stooped to make herself appear less so. She wore unsteady hats and long purple or black dresses. She was clumsy, always losing her gloves, a scarf, or giving things away, her bracelets, a necklace. She would open her bag, spill out banknotes then scoop up most,

though not all of them. She translated the poetry of Sappho from Greek to French and in refined French wrote her own poetry about her love for and scorn of women and her longing to be dead.

She was born Pauline Tarn in England in June 1877; her mother was from Michigan and her father from Teesdale. Her paternal grandfather made a fortune by expanding a single grocery shop into chain stores. Her parents fought and her father, like Natalie's, became an alcoholic.

The family moved to Paris when Pauline was two. She had an English governess, went to a French school and by the age of nine was writing love poems in French to a girl called Blanche. Also when she was nine, her father died. Weakened by alcoholism, he developed pneumonia after bathing in the sea near Étretat in Normandy. His father accused his daughter-in-law of ruining his son's life and in revenge excluded her from his will. He made Pauline and her sister, Antoinette, sole joint beneficiaries when they married or reached the age of twenty-one, whichever was first. Pauline's mother was resentful to the point of cruelty. Her relationship with Pauline, at no time good, became terrible.

She arranged their return to England four years later. Pauline knew no one in England; Paris was her city of choice.

Back in London, Pauline shut herself in her room, wrote poems, read Victor Hugo, Byron and Keats, played Chopin piano sonatas, felt daunted by 'continual vexations, continual suffering and sorrow' and tried to drown herself, tried to kill herself with chloroform. She confided her unhappiness to Amédée Moullé, a fifty-year-old Parisian poet who critiqued her work and sent her books. He offered to marry her so she could gain her inheritance and return to Paris.

To prevent this, her mother locked her in the house 'as in a jail… all the doors were locked'. Pauline escaped through a window, pawned a brooch and stayed for five days in a lodging

house until a maid found her and took her home. Her mother then tried to have her certified insane. Pauline thought she wanted her consigned to an asylum as a ruse to steal her inheritance. The case went to court, Pauline was made a ward of court and assigned a legal guardian. Her mother was foiled. As soon as she was twenty-one, Pauline left for Paris.

There she discarded the name Pauline Tarn, the tyranny of her mother and the repressions of English society. She recreated herself as Renée Vivien, 'born again to life', to be a lesbian poet and lover. She wrote only in French. With publication of her first poems in 1901 she hid her gender behind R. Vivien, then used the masculine form René, before settling for Renée Vivien. She was passionate about Natalie's childhood friend, Violet Shillito from Cincinnati, who was studying French in Paris. She wrote poems to her and the violet became her lifelong symbol of love.*

Renée's life was short, her output impressive: eleven volumes of poetry, two of them translations from Greek, collections of short stories, an autobiographical novel. Natalie became the inspiration for many of her poems, and for the novel. And it was Natalie who encouraged her to study Greek with her own tutor, Charles Brun, so as to read Sappho in the original. After two years Renée was fluent and known as 'Sappho 1900' for her openly lesbian poems and translations of Sapphic fragments.

Though Liane de Pougy was more fun and Eva Palmer 'the mother of her desires', Natalie, always energetically polyamorous, simultaneously pursued a relationship with Renée.

> she had brown eyes which often sparkled with gaiety but
> when her beautiful swarthy eyelids were lowered they revealed
> more than her eyes – the soul and the poetic melancholy that
> I sought in her…
>
> She had a sense of humor which was easy to restore and a

* Violet died of typhoid fever in 1901.

childlike drollness which suddenly removed half of her twenty years. The weakness of her chin could be particularly noted in profile, but when seen from the front no one could resist the laugh on her full lips and her little teeth of which even the canines were not pointed. Her complexion uniformly smooth and enhanced by a beautiful texture, was virginally pink when she became animated. Her nose was fine and slightly turned up.

Colette, a fleeting lover of Renée's some years later, confirmed the bursts of mischief that belied her melancholy:

Impossible to find anywhere in that face any sign of the hidden tragic melancholy that throbs in the poetry of Renée Vivien. I never saw Renée sad.

But, whatever the facade, Renée was self-destructive. She had read Byron, Huysmans, Keats and Baudelaire and melancholy was her territory. And addiction. From the start, her love for Natalie was tortured:

In you I find the incarnation of my deepest desire. You are more strange than my dream. I love you and I am already certain you will never love me. You are the suffering that makes happiness contemptible.

And suffer she did. She bombarded Natalie with flowers, jewels and poems. Her love, she wrote, was 'like snow pure passion, like the attraction of deep water, like standing at the edge of an abyss, like wedding day chastity…' She did not have Natalie's self-belief or capacity for a good time. She could only bathe vicariously in Natalie's Amazonian power. It was as if their destinies were in full view – Renée would have to die young, Natalie would sail on to grand old age.

Natalie was concerned by the quality of Renée's devotion. She would have preferred something simpler. And sexually, Renée could not help but withhold. For Natalie, her lovers' orgasms were a badge of honour. Renée was too anxious about her body,

too troubled in her mind and, as time went by, too full of alcohol and drugs to be freely responsive.

Natalie regretted 'throwing her soul into disarray' and exacerbating her despair. 'I did not want it to be like that, rather that she should love me just enough to bring sunshine into her life.' For Renée, Natalie was a much-needed challenge to her despair. Death, sex and doomed love were recurring themes in her poetry. 'Let the Dead Bury Their Dead' was the title of one of her poems. 'But not the Living', Natalie wrote in the margin.

back to Bar Harbor

Quelques Portraits-Sonnets de Femmes, Natalie's book of love poems, was published in spring 1900 in Paris by Paul Ollendorff. A review 'Yankee Girl, French Poet', with the subtitle 'Sappho Sings in Washington', was printed in the *Washington Post* and read by Albert Barney. He instructed his staff to prepare Bar Harbor for the arrival of his family, then went to Paris, bought up and destroyed the printers' plates and all unsold copies of Natalie's book and insisted she return to America with him and her mother.

They sailed on the SS *St Louis* on 7 July 1900. Later that month he had a heart attack while playing golf, which spared him news of the publication of Liane de Pougy's raunchy roman à clef, *Idylle Saphique*. In Paris it was common knowledge that the Flossie Temple Bradford of this romance, who fervently kissed the ankles and thighs of its narrator, was Natalie Barney, the wild girl from Cincinnati, the ash-blonde heiress, who most mornings could be seen galloping bareback in the Bois de Boulogne.

Albert Barney's intervention was not successful. Confined to bed, he was too ill to surveil his daughter or his wife. Natalie persuaded Renée Vivien to come and stay. To Eva Palmer, who was in Bar Harbor on holiday with her sister May, Natalie sent

a copy of *Sonnets de Femmes* with a note comparing Eva's heart to the last days of autumn.

Eva, provoked to learn that Natalie and Renée were lovers, and by a dedication that she saw as a denial of her own vitality and youthfulness, invited them to join her at Duck Brook, 'you know the one I mean where the boys sometimes swim'. They read Swinburne and with a Kodak Brownie box camera took photographs of each other posing naked.

In August, to raise money for the new Bar Harbor hospital, Natalie's mother staged an all-women theatre piece, scripted by Natalie and her sister, Laura. There were four 'charming tableaux': Renée played a spoof Alice in Wonderland, May Palmer was Helen of Troy, Laura was Cleopatra, and Eva, with props of Doric columns and a harp, wearing Grecian robes, strap sandals and with a wreath in her red hair, was Bar Harbor's Sappho.

Albert Barney stayed in bed.

Eva, Renée, Olive, Oscar, Bosie

Natalie, Eva and Renée moved back to Paris together. For them all, Oscar Wilde was a revered figure from the recent past, a genius and champion of same-sex relationship and free expression, martyred by society. Sylvia Beach hung framed photographs of him on the wall in Shakespeare and Company. Natalie had met him when she was six in the Long Beach Hotel, New York. Boys had pelted her with preserved cherries, which stuck in her hair, and she had run across the hotel lobby crying. Oscar Wilde picked her up and calmed her with his story of *The Happy Prince* who was in love with a little swallow. Natalie wrote to Wilde when he was in Reading Gaol, saying she wanted to comfort him against his persecutors, as he had comforted her.

Wilde, after persecution and humiliation, died in poverty in a Paris pension, the Hôtel d'Alsace, in November 1900. His lover,

Bosie, Lord Alfred Douglas, then turned against him, his own past, and any public support for homosexuality. Bosie determined to present himself as a heterosexual married man. He looked for a wife among Natalie's circle – for a wealthy lesbian willing to share her inherited money with his title.

Olive Custance, born in England in 1874, had affairs with both Natalie and Renée Vivien. Her grandfather was the High Sheriff of Norfolk, her father was a Colonel, home was Weston Hall, a sixteenth-century estate in twenty acres of land, and as the elder of two daughters she stood to inherit. Her first volume of poems, *Opals*, was published in 1897. She prefaced the initial poem, 'Love's Firstfruits', with a quote from Sappho.

> 'Opals', she wrote, 'are the stones of love and sorrow and they have suggested many of my songs to me.'

Natalie wrote an admiring letter. Olive told the publisher, John Lane of Bodley Head:

> I had an adorable letter this morning from a beautiful American girl the author of a new volume of poems which she sent me… She had read *Opals* and fallen in love with my soul!

Natalie met her. She was taken with Olive's brilliant eyes, her breathless voice, as well as her soul. 'Come my poet my priestess', she wrote to her,

> Come it is Tuesday night! Come to me and we will be quiet. I only know that I so love your lips that I will do whatever they tell me.

Olive, for her part, wrote to Bosie praising *his* sonnets. They exchanged letters, then arranged to meet at London's South Kensington Museum.* Bosie was thirty. He said he fell in love

* Now the Victoria & Albert Museum (the V&A).

at first sight but 'did not think he had the slightest chance of marrying her'. 'You are a darling baby', he wrote to her,

> and you are exactly like a boy and you know perfectly well that I love you better than anyone else, *boy or girl*... You have everything. I used to wish you were a boy, now I am glad you are not.

Separated from him on holiday in France in 1901, Olive wrote,

> Oh how I miss you... your sweet golden head, your small red mouth always it seems a little shy of my kisses, and above all your great blue eyes... the most beautiful eyes a boy ever had.

Natalie, she told him,

> is rather fascinating and clever but her life is ugly... and I cannot forgive that. She says she loves me, but some who have loved her tell me she does not know what love means... and from what I know of her I can well believe it... but because I am indifferent to her she has a passion for me that is almost beautiful at times. I have prayed all my life that I might meet a man I could love with all my soul.

not all roses

Renée, a part of the amorous circle, wrote to Olive in October 1901:

> Sweetest, how maddeningly exquisite it was to hold your fresh frail body in my arms – to clasp you and kiss you in a bewilderment of delight... I wrote to Bosie that you were like a wild rose, all faint perfumes and delicacy of colour, fresh and frail. I love you, who are the one entirely beautiful, entirely joy-giving thing in my life. You have brought me nothing but roses... the roses of Sappho.

Olive, who wanted a husband, got engaged to George Montagu, MP for South Huntingdon, a friend of Bosie's from

their time at Winchester College and, like him, 'gender fluid'. King Edward VII sent congratulations on this engagement. Fearing jeopardy of his political career by the Wilde scandal, Montagu broke from Bosie. Douglas wrote a sonnet – 'Traitor' – then, over dinner in Kettner's in Soho with Olive, persuaded her to elope with him. They married by special licence at St George's Church, Hanover Square on Tuesday 4 March 1902. They informed Olive's parents by telegram, then took the ferry to Paris. Colonel Custance contacted the police but the deed was done. Olive and Bosie's only child, Raymond, was born eight months later. Natalie was his godmother.

Bosie and Olive's marriage was complex, stormy and destructive. The main casualty of it was their son. Caught in a web of hostile relationships, then diagnosed as schizophrenic, Raymond Wilfred Sholto Douglas spent most of his life in St Andrew's Hospital in Northampton, the same hospital where Lucia Joyce was incarcerated.

Albert Barney's death

In October 1902, Natalie's father, ill with pleurisy, asked her to go with him to Monte Carlo for the sea air. Natalie was 'too tormented' over Renée to agree. Renée had met someone new and she wished to break free from Natalie. Their relationship had become one of separations and short-lived reconciliations. Natalie called it 'defeated love'. But though she praised infidelity as a lifestyle, she was provoked by the jealousy it caused. Because Renée had a new lover, Natalie wanted her back.

Renée had met Baroness Hélène van Zuylen, poet, racing driver, socialite, daughter of Salomon James de Rothschild, known as La Brioche for the way she coiled her hair. In *Souvenirs indiscrets*, Natalie described her as a fat, rich, domineering Valkyrie. Renée was in La Brioche's thrall and after 1902 she dedicated her

books to her. They collaborated on works of poetry and prose. Their relationship lasted five years.

Albert Barney went alone to Monte Carlo with a nurse. Natalie's concern was to meet with Renée. She heard she was going to Bayreuth with Eva Palmer for Wagner's *Ring Cycle* and persuaded Eva to give her her ticket. 'First our eyes met then our hands in the shadows.' She implored Renée to agree to another meeting. Renée agreed, but did not show up. 'One can't play one's life over again,' she wrote. Natalie persisted.

On 5 December, Natalie was again summoned to Monte Carlo. Her father was dying. She arrived too late. His nurse met her at the station and told her the previous night he had dreamed of Natalie's wedding and spoken of intending to divorce his wife and cut her out of his will. Natalie observed his dead body but felt no grief. She went alone to his cremation at Père-Lachaise cemetery, then sailed with his ashes to New York to meet up with her mother for funeral ceremonies and estate formalities.

life without father

Natalie returned to Paris richer than ever. Her share of her father's estate was $2,500,000, the money hers to use as she would.* She was richer than Bryher. She acquired a house in Neuilly and, in homage to Sappho, staged *tableaux vivants* in the garden. In *Cinq petits dialogues grecs* ('Five short Greek dialogues'), she sketched her rules for sapphic love: women were to relinquish ties to family, – husbands, children and country – and instead write, dance, compose and act on their love and desire for each other.

She and Eva Palmer wrote and produced *Equivoque*, which extolled Sappho's life and incorporated her writing. Raymond Duncan, Isadora's brother, was choreographer, Penelope

* Equivalent to about $75 million in 2020.

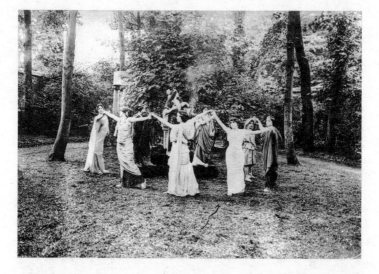

Sikelianos, his wife, played the harp, Eva, Renée, Colette – who was light-hearted about her lesbian affairs – and others danced in gauze togas around an incense-burning altar. In one tableau, the dancer Mata Hari rode, naked except for a crown, into the garden on a white horse with a bejewelled harness. (She joined the German secret service in 1907 and was executed as a spy by the French in 1917.)

Neighbours complained. 'What do I care if they vilify me or judge me according to their prejudices' was Natalie's view of any upset to others caused by her homage to Sappho.

Eva Palmer's biographer, Artemis Leontis, described Natalie's allegiance to and emulation of Sappho and the goings-on in her Neuilly garden:

> Barney's pavilion with its expansive garden became a gathering place. Women came and went, sometimes crossing paths and sharing in acts of love. Eva watched as Barney made love to others; or she made love while Barney or another woman watched her; or she read what Barney wrote about her other lovers; or she pursued lovers and wrote about them to Barney.

Eva Palmer aspired to reconstruct the Hellenic ideal and to that end seriously studied the language and culture of ancient Greece. Natalie favoured 'inspiration independent of technique'. She wrote to Eva:

> I am so glad that I have never carved a statue or painted a picture or produced anything as beautiful as yourself. Life has been your art – you have set yourself to music, your days are your sonnets.

Natalie's plans were for the here and now.

For Colette, Natalie's tableaux and Sapphic dances were French fun and games rather than Hellenic renaissance. Natalie went to tea with her after the publication of Liane de Pougy's *Idylle Saphique*. 'My husband kisses your hands', Colette told her after this meeting, 'and me all the rest.' With similar light-heartedness, Colette began an affair with Renée, attracted to her superficial charm and style. She revised her view when she saw the dark side of Renée's soul. They smoked Chinese tobacco together in miniature silver pipes and wrote numerous letters, most of them now gone. 'Our intimacy did not seem to make any real progress,' Colette said.

to Lesbos with Renée

Natalie's past lovers were ever present with new ones in the wings. She did not accept being ousted from Renée by La Brioche, the forceful Baroness, née Hélène de Rothschild, the Valkyrie. She wrote Renée a prose poem, *Je me souviens*:

> Let us forget the days of anger and all that separates your hand from my loving hand… Close your eyes. Let me love you. Go mad with me…

She implored Renée to accompany her to Lesbos where, as poets, they would live like Sappho. Renée finally acceded and

in August 1904 they met in Vienna, took the Orient Express to Constantinople, then an Egyptian steamer, the *Khedire*, to Lesbos. Natalie, elated, said she was travelling to discover not a place but a person. Renée, as they arrived, stood at dawn at the ship's prow to behold the island as it emerged from the sea.

Disaffection was swift. This was not the classical Lesbos of their imaginations: no myrtle groves, hyacinth gardens, lesbians, or Sappho, only rough-looking fishermen and shepherds. They had each other and no one else. They rented two villas joined by an orchard, wrote and translated poems and talked of building a lesbian community on the island where women 'vibrant with poetry, youth and love would come from all parts of the world'. An elderly woman cooked their food. Renée gave hers to the dogs and subsisted on wine and a few figs. Natalie viewed the island as an Aegean bed in the sun and hinted that for the first time in their affair, Renée reached orgasm. She saw this as a triumph, 'smothered a cry of victory', and spoke of their souls and bodies being deeply united.

Deep unity ended after a month with a letter from La Brioche stipulating a date for meeting Renée in Constantinople. Renée telegrammed confirmation. Were she to refuse, she told Natalie, the Baroness might hire detectives, alert the embassies, abduct her, do anything to get her back. 'Her power like her fortune has no limit,' Renée said.

Colette's sane eye

Colette was alone in discerning that Renée's theatricality was a cover for sickness. Her house in rue Villejust, adjacent to the avenue du Bois where Renée lived, was a walk away across two courtyards. She visited often. Renée, in her lisping English accent, would say, 'Oh my dear little Colette, how disgusting this life is!' then burst into laughter. Colette said Renée's

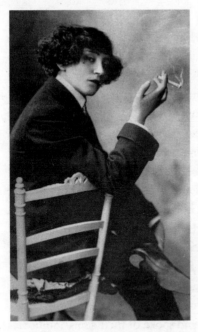

apartment smelled like a rich man's funeral. When she brought a lamp to brighten the darkness, Renée wept. She tried to open one of the leaded windows, but they were all nailed shut. La Brioche summoned Renée at whim and sent messengers with presents: a collection of ancient Persian coins, a glass cabinet of exotic butterflies, 'a miniature garden of bushes having leaves of crystal and fruit of precious stones'. Renée referred to her as 'the master'.

Renée, alarmingly thin herself, served to Colette and friends lavish buffets with raw fish rolled on glass wands, foie gras, expensive champagne and lethal cocktails of toxic content:

> Among the beverages that she raised to her lips was a cloudy elixir in which floated a cherry harpooned on a toothpick.
> I laid a hand on her arm and cautioned her.
>
> 'Don't drink it… I've tasted it. It's deadly… it tastes like some kind of vitriol.'
>
> … She laughed, flashing her white teeth.
>
> 'But these are my own cocktails, ma pethith Coletthe. They are excellent.'

Colette observed Renée's disturbed relationship to food, her addiction to drink and drugs and the way she tried to conceal her addiction. In her memoir, *The Pure and the Impure*, she wrote how 'the wiliest madwoman' loses command if 'through a narrow

crack in her sealed universe, she lets a sane eye peer in and profane it'. She observed Renée's ruse of how to drink to excess. The maid, Justine, was complicit. She sat, ostensibly sewing, in a room by the bathroom. Renée constantly went to her for help with her clothes, the food, some seemingly trivial domestic need. Each time, Justine gave her from under a chair a glass filled with alcohol and drugs, Renée then went to the bathroom, gargled with an ever-renewed glass of perfumed water, and rejoined her guests. Some supposed her to be drinking rosewater.

Renée's thinness was from anorexia, her hand tremor from alcoholism, her mood swings from drug addiction. She passed out in mid-conversation, then came to and behaved as if nothing had happened. She talked of physical lovemaking in crude language: how many times and in what way. She was secretive about her work, guarded about her feelings, concealing about her habits. In the middle of dinner she told friends she was summoned, she must go, then burst into tears. There was a carriage waiting. She wrote poetry of melancholy, originality and erudition. After Colette, with her sane eye, had peered into the tragedy of illness and addiction, her relationship to Renée turned to concern.

Renée's involvement with the Baroness lasted until 1907. La Brioche then left her for another woman. When Renée died in November 1909 of anorexia and drug and alcohol addiction, she weighed under six stone. She was thirty-one. Natalie heard she was dying and hurried to her house, but arrived too late.

Eva Palmer leaves for Greece

Most of Natalie's lovers left after a time. It was hard for them to feel safe or special enough, given her terms. Her appetite for love was impressive, her transparency refreshing, but the jealousy and insecurity she provoked were as old as the Aegean hills.

244 | NO MODERNISM WITHOUT LESBIANS

Eva Palmer was the next to go: 'I have walked after you for years, like a high-heeled woman whose feet hurt but who is too proud to say so,' she told Natalie by way of valediction. 'If you care for me let our misery be between ourselves.'

Eva's commitment to the culture of ancient Greece was life-long. As a model for living, she saw Hellenism as superior to the dystopia of the industrial age. Though in thrall to Natalie as a life force, she did not trust her, could not stay in her orbit and was too serious-minded to accept Natalie's hedonistic interpretation of Sappho and her lack of interest in social and political affairs.

In the summer of 1906, Eva left for Greece with Raymond Duncan and his wife, Penelope Sikelianos. They planned to live by the unmechanized ways of the ancient Greeks; to adopt their techniques of spinning, skills in weaving, principles of theatre, ways of making music, poetry and art. Eva Palmer saw in these things a model to emulate, a higher plane of living. Most of all, she wanted to break with Natalie, who was scathing: 'What you are doing is both sterile and valueless… as a continuous performance of defiance to the passer by I think you worthy of better things.'

The trio lived in a restored villa outside Athens. Raymond made the furniture. They all wore ancient Greek togas made from yarn spun on their own loom and discouraged people in modern clothes from visiting.

Eva began a relationship with Penelope's brother, the poet Angelos Sikelianos. He was twenty-two, ten years her junior. They viewed their relationship as predetermined by fate. He was her Adonis, she was Aphrodite; together they would recreate an ideal time. When Eva told Natalie she was going to marry Angelos, live permanently in Greece and fulfil the Delphic ideal, Natalie tried to dissuade her.

Eva's abiding desire for Natalie was clear in her letters – 'Oh hands that I have loved, eyes that I have followed, hair that I have sobbed to touch' – but she was tired of her 'intrigues and

passions'. In the summer of 1907 she travelled back to Paris with the Duncans and Angelos to see if they and Natalie might all be friends. She put on 'proper clothes' before the meeting. Natalie showed Angelos a letter in which Eva had declared undying and passionate love for her. Angelos thought Eva to be still in love with Natalie.

He and Eva sailed on to America for their wedding. Her arrival in September 1907, wearing a toga and Greek sandals, no hat, arms and ankles bare, made the front page of *The New York Times* and *Washington Post*. Her appearance was thought beyond eccentric. The papers wrote of the one-time debutante, 'rich enough to do as she liked', who had abolished lingerie and startled passengers on an ocean liner. 'Her father who was president of the Gramercy club died fifteen years ago. Her mother is now Mrs Robert Abbe.'

Eva married Angelos in Bar Harbor on 9 September 1907. She returned to Greece as Kyria Sikelianou, Angelos Sikelianos's wealthy American wife, in love 'with his country, his people, his language and his dreams'. She did not revisit America for twenty years and only on one occasion did she again wear Western clothes – when she met up with her ailing mother at a spa in Aix-les-Bains. She bought fashionable clothes so as not to upset her, but threw them out of the train window when they parted.

In Greece, her money financed Angelos and their revival of Greek culture. She built a villa at Sykia and a stone house in Delphi. She grew crops, made wine, emulated how ancient Greeks wove and wore their clothes, concocted her own dyes from beets and flowers and shells and made connection with Greek women through spinning and weaving. Her dresses, beautiful and embroidered, copied the traditional folds depicted on ancient reliefs. She was attentive to Angelos. They replicated ancient ways of making music, of dancing, reciting poetry and staging plays. She held exhibitions of Greek folk art and

handicraft and directed performances of traditional songs and dances by the villagers of Parnassos. She immersed herself in Byzantine music and planned to open a school for the preservation and teaching of ancient Greek music. She told Natalie she was happy,

After two years of marriage, she had a son. She then asked Natalie to stop writing to her.

By 1912 she no longer wanted sex with Angelos and voiced no objection to his relationship with his cousin Katina, a servant in their house. She continued to collaborate with him and to finance him.

Eva made Delphi the cultural centre of her revival of the Greek ideal. She directed two major international festivals of Greek drama in the sacred space of the ancient amphitheatre there, presenting pioneering productions of Aeschylus – *Prometheus Bound* and *The Suppliant Women*. She invited local people to a performance and asked their views of the play. An actor who worked under her direction said of her:

> She was the only ancient Greek I ever knew. She had a strange power of entering the minds of the ancients and bringing them to life again. She knew everything about them – how they walked and talked in the market place, how they latched their shoes, how they arranged the folds of their gowns when they arose from the table, and what songs they sang, and how they danced, and how they went to bed. I don't know how she knew these things, but she did.

Eva Palmer as a modern woman reached out to the classical past. For her, progress was to emulate a past Utopia. And yet ultimately hers was an isolated experiment. The marriage did not last, she overspent on the Delphic festival of 1927, lost her fortune, mortgaged her houses and ran up a debt of a million drachmas. She moved back to America in 1933 to try to raise

money. Her autobiography *Upward Panic* made no mention of any lesbian involvement.

Alice Barney marries again

Alice Pike Barney did not mourn the death of her husband Albert. Merrily widowed, she aspired to make Washington the cultural centre of the Western world. As a showcase for contemporary American art, she founded Studio House in Massachusetts Avenue. Her oil paintings of women, many of them Natalie's lovers, hung alongside those of Joshua Reynolds and James Whistler. She produced and directed plays and operettas for which she wrote the libretti, staged tableaux in which, scantily clad, she danced as a dervish, she set up a centre for decorative arts where she taught tie-dyeing, she became vice-president of the Society of Washington Artists. Mention of her in the society columns was frequent, with photographs of her at first nights and comment on what she wore – black tulle patterned with peacock eyes and with ostrich plumes in her hair.

In 1909, aged fifty-two, seven years after Albert's death, she married Christian Hemmick, her 'pink pet' she called him, the male lead in many of her productions. He was twenty-two, bleached his hair and fancied young male dancers. Natalie asked her mother why, after a ghastly first marriage, she wanted to tie herself to another man, particularly a pederast. Perhaps it was not Natalie's place to question unorthodox behaviour, given her display with Liane de Pougy and half the lesbians of Paris. Her sister, Laura, thought that Hemmick was after their mother's money. As a precaution, before the ceremony, Alice assigned her properties to her daughters.

Christian Hemmick was not an ideal husband. Alice was always busy, while he fooled around. She wrote cheques to him and financed his enthusiasm for dubious business ventures. For

one project – the making and marketing of scented household cleaning products – he took stuff from the scullery, mixed it with Alice's perfumes and designed labels for the jars. She set him up in an office but instead of working, he wrote letters on scented notepaper to young men.

Natalie castigated her mother for her lavishness to this 'worthless boy pederast husband and the thousands of dollars wasted on him'. By 1918 Alice wanted a divorce. Hemmick objected that he was Catholic and marriage a divine contract. When she learned he was having an affair with the dancer and artist Paul Swan, dubbed 'the most beautiful man in the world', she told him the marriage was over and she would be writing no more cheques. She reverted to being Mrs Barney.

the temple of friendship

For her part, Natalie, freed from her father's pressure to conceal her lesbian identity and rich in her own right, consolidated her Paris life.

In 1909, aged thirty-three, she rented 20 rue Jacob. The house became her home for sixty years. In its garden was a small eighteenth-century pavilion with, carved above its entrance, the dedication À L'AMITIÉ, and in this pavilion, which Natalie called her Temple of Friendship, her famous or infamous salons began, held between the hours of four and eight on Friday afternoons.

These afternoons evolved into a showcase for artistic innovation. 'I didn't create a salon', Natalie wrote, 'a salon was created around me.' Her initial hope was for French, American and English writers to meet and disseminate new writing and ideas beyond national boundaries, but over time these meetings took on their own life. Paul Valéry called the gatherings 'the hazardous Fridays', they became so unpredictable.

'The universe came here', wrote the French writer Edmond Jaloux, 'from San Francisco to Japan, from Lima to Moscow, from London to Rome.' Natalie's visitors were drawn to the cutting edge of art, the conversation, the strawberry tarts and the prospect of finding lovers and friends.

The word got round, and among a roll call of lesbians were Gertrude Stein with Alice B. Toklas; Sylvia Beach and Adrienne Monnier; Janet Flanner and Solita Solano, who was drama editor of the *New York Tribune*; Bryher and H.D.; Colette, Djuna Barnes, Romaine Brooks, Nancy Cunard, Liane de Pougy, Olive Custance, Lily de Gramont, Lucie Delarue-Mardrus, Mimi Franchetti, Radclyffe Hall....

Visitors spilled from the Temple into the garden and then the ground-floor dining room, its walls covered in red damask, the domed ceiling painted with nymphs, its furniture haphazardly acquired: an Empire couch, Spanish chairs, portraits on the walls of Natalie's lovers painted by her mother, Lalique lamps sculpted as bouquets of roses, photographs of friends framed in gold and tortoiseshell: Apollinaire, Proust, Gide, Picasso, Cocteau, Sarah Bernhardt, Stravinsky, the Queens of Spain and Belgium, Nadia Boulanger, Greta Garbo with Mercedes de Acosta... On an oval table at the room's centre were a tea urn, glass pitchers of fruit juice, triangular sandwiches and little cakes from Rumpelmayer's.* On a side table were port and whisky. Natalie's famous housekeeper, Berthe Cleyrergue, did not arrive until June 1927.† Before her, domestic helpers came and went. Natalie said she preferred them 'a little blind and deaf'. Berthe did not speak English.

* A patisserie on the rue de Rivoli with gilded mouldings, marble tables and frescoed walls.
† Berthe came from Bourgogne and for 40 years was Natalie's librarian, manager, receptionist, nurse and cook.

As a frontispiece to her publication *Aventures de L'Esprit*, Natalie doodled a calligram in the style of the poet Apollinaire. It showed the pavilion with L'AMITIÉ scrawled across its doors leading to the garden and dining room, and crowded into and spilling out of every space were the handwritten names of the visitors to her Fridays. It was a roll call of modernists – French, American, English – who all contributed to new ways of expression in the decades before the Second World War. Making threads of connection, drawing these disparate names together, weaving in and out among them was their host, Natalie Barney. The Amazon.

Remy de Gourmont, symbolist poet, novelist and critic, gave her the Amazon soubriquet. De Gourmont was in his fifties when they met. His face was ravaged by lupus and Natalie described his clear blue eyes as like 'two children living in a ruin'. Fortnightly from January 1912 until October 1913 he published a letter, written ostensibly to Natalie, in the *Mercure de France* – 'Lettres à l'Amazone', he called these essays. In them, he extolled her and the thoughts and feelings she inspired in him. He said whenever he saw her, he felt a quickening of his heart. 'If I dared I would have you read everything I write,' he told her. For him, she encapsulated the exuberance of the new.

Natalie, however daunting her sex life, was true to her dedication to l'Amitié. In 1966, aged ninety-one, still straight-backed and strong-faced, she described friendship as the most lasting virtue, 'the most free of passing emotions', sustained by loyalty and choice. 'I've never given up my friends,' she said. 'They've given me up but I've never given them up.'

ladies with high collars and monocles

In the early decades of the twentieth century, literary lesbians from America and England left their home towns for Paris. News

spread that it was the city of like minds and hearts. On arrival, they headed to Natalie's Friday salon in the same way as aspiring novelists headed to Sylvia Beach's Shakespeare and Company. Many had a distinctive dress code, as Sylvia pointed out.

High collars and monocles, though not de rigueur, were clues. So was brilliantined short hair, a white carnation or sprig of violets pinned to a jacket lapel, a ring on the pinkie finger. Beyond such badges of allegiance, an appraising glance of recognition was universally understood.

At Le Monocle, a club in Montmartre, the clientele divided into butch and femme, the bemonocled and besuited who pro-positioned the befrocked. At 20 rue Jacob of a Friday, dress code was not prescriptive. Natalie liked her blonde hair long or up and wore jewels, furs and fripperies, high collars and high boots, fancy dress or nothing at all, according to the occasion and her mood.

fidèle/infidèle and idleness

Natalie described her nature as fidèle/infidèle and divided her amours into relationships, affairs and adventures. By fidèle/infidèle, she meant she would be steadfast to lovers in her way but would not, could not, be sexually faithful. She thought heightened desire in relationship did not last, and because heightened desire was imperative to her, she kept moving on. In her three categories, relationships were deep and long-lasting; affairs were serious but less compelling, and adventures too numerous to tally. Alice B. Toklas said she picked up her adventures in the toilets of Paris department stores.

Natalie had no need to earn a wage, publish for money or, like James Joyce and Sylvia Beach, make worried appeals for funding. She could be lofty about her unconcern for possessions. There was hauteur in her epigrams: 'Why grab possessions like

thieves, or divide them like socialists when you can ignore them like wise men?' Or, 'I dread possessions because they possess you.' Or, 'I can live without fear of robbers. You can't rob an atmosphere.' Such thoughts floated above an astonishingly large bank account.

From a bubble of privilege, she extolled idleness. 'I think one must be idle in order to become oneself,' she wrote. 'If you have a profession you become part of that profession. With work you become a function. With idleness you become who you are.' She had no need to submit to an occupation to pay the bills.

Paris was a grand place to be idle, to become who you are, to have relationships, affairs and adventures. Paris allowed such indulgence.

thoughts of an Amazon

Radical in her lesbian separatism for her own or any time, ironic and scathing of patriarchal power, in her writing Natalie voiced her thoughts on the folly of war, the nonsense of religious dogma and, most of all, her preoccupation with love between women and with the women whom she loved. Between 1910 and 1940 she collected her epigrams, aphorisms and quips, written on scraps of paper as and when they came to her, and published them in books – with gaps of a decade – with the titles *Éparpillements* ('Scatterings'), *Pensées d'une Amazone* ('Thoughts of an Amazon'), and *Nouvelles pensées de l'Amazone* ('New Thoughts of the Amazon').

The first novel, Adam and Eve's, has been overprinted.

Marriage: neither alone nor together.

Fame: To be known by those one does not care to know.

Youth is not a question of years: one is young or old from birth.

There are more evil ears than bad mouths.

Eternity – a waste of time.

At worst, her insistent pithiness made her sound like a scribe of mottoes for Christmas crackers: 'My only books, Were women's looks' was one unworthy quip. Another was that her favourite book was her cheque book. She was not a self-censoring writer. The prose of her fiction was short on narrative outline, though not as bewildering or prolix as Gertrude Stein's. 'Gertrude chose the language of the stammerers', she said. 'I like to find a thought as in a nut or seashell.' 'While I make for a point Gertrude seems to proceed by avoiding it.' Gertrude took no offence. They were lasting friends.

Natalie's defining autobiographical epigram was 'living is the first of all the arts'. How she lived her life was her gift and creation, and in her lifestyle she captured the essence of modernism: the shedding of past certainties and exuberance for the new.

Natalie meets Lily

Scornful of her mother's marriage in 1909 to Christian Hemmick, the 'worthless pederast', Natalie, that year, embarked on a profound relationship for herself. It was with Lily de Gramont, duchesse de Clermont-Tonnerre. Natalie was thirty-two, Lily was thirty-four.

They met in late April. The poet Lucie Delarue-Mardrus – who years earlier had been one of Natalie's liaisons – introduced them. Lucie was described by the Belgian sculptor Yvonne Serruys as the 'queen of Lesbos-Paris'. 'Nature had fitted her perfectly for the role she played among the women of her time,' Yvonne said of Lucie. She made and gave her a small bronze statue of her 'superb androgynous body'.

Lucie talked with Lily of Natalie's Sapphic ways. In love poems to Natalie, written in 1902/3 and published posthumously as *Nos secrètes amours*, she expressed turmoil at being one among many of her lovers:

My joy and my pain, my death and my life,
My blonde bitch.

Lily confided to Lucie her disaffection with men, her desire
for women, her abusive childhood and marriage.

the duchesse de Clermont-Tonnerre

On 1 May 1909, Natalie and Lily dined alone together. They ate
plovers' eggs, drank a glass of Sauternes, then stayed together
for three nights and two days. By the end of that time, Lily was
in love. 'I kiss your hands, your caressing hands, fluid as the
water we love! See you tomorrow, my love,' she wrote to Natalie
when finally she got home. From then on, until her death forty-
five years later, they celebrated 1 May as their anniversary.

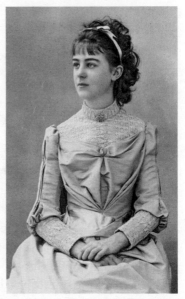

Lily, grey-eyed, tall, bilin-
gual, was born into the French
aristocracy. Her mother died
giving birth to her on 23 April
1875. Her father, Agénor, duc
de Gramont, handed her over
to be cared for by her Gramont
grandparents, then married
Margaretha von Rothschild
and a share of the Rothschild
millions. It was a pattern for
aristocrats whose wealth was
diminishing to marry 'trade',
a title in exchange for money.
Lily was not welcomed by
her stepmother. 'Everything
was forbidden,' she said. She studied – English, German, the
piano, dancing, drawing – and lived in a world of splendour, of

stately homes, footmen, sumptuous receptions and emotional neglect.

Aged eighteen, she was pushed into society and primed for marriage. Offers came from men she did not know. Father

> used wake me up with a start at dawn to offer me now a
> young *conseiller-général* with a big future, now a young sprig
> of nobility who would inherit wonderful tapestry with friezes.
> 'With friezes?' I would repeat in a dazed way.

When she was twenty-one, she married Philibert, duc de Clermont-Tonnerre. She had two daughters, and two miscarriages caused by her violent husband viciously kicking her. Her respite was in books – she published the first translation of Keats' poetry into French, wrote memoirs, poems, a novel – and in her friendships with Proust, Remy de Gourmont, Anatole France, and her close attachments to women – *la chaîne des dames* – the daisy-chain, the legion. Among her women friends were Anna de Noailles, Colette and her lover, Mathilde de Morny (known as 'Missy'), Lucie Delarue-Mardrus and then, and above all, Natalie.

Natalie was drawn to women who rose above the cruelty of abusive childhoods but at core were wounded and set apart. Of Lily, she wrote: 'If she has suffered much she has never told any one, it has stayed in her silences, in her voice, in her laugh and in the beauty of her face.'

Natalie wrote of her passion for her in 1911 in an unpublished autobiographical novel, 'L'adultère ingénue' ('The Adulterous Ingenue'). In it, she was explicit about sex in a way Radclyffe Hall, in her banned *Well of Loneliness* seventeen years later, was not. She described a train journey she and Lily made together through France. Lily had a fever:

> I undress her and take off all my clothes, sitting on the edge
> of her bed, lying under scant covers next to her. I let her feel
> my strength, my heat, she stops coughing. I try just to take

care of her but of a sudden my mouth is drawn to hers. Our desires repressed for too long follow the crescendo of shivers and cries before pleasure comes... I hold her close to me as she sleeps, warming her neck with my breath that must burn her through her nightdress, while my hands hold her breasts, their palms dry and hot.

Sylvia Beach said 'you can't censor human nature', but the censors would have consigned that to their bonfire. Lily was reticent about putting into print any mention of her relationship with Natalie. In her memoirs, without naming her, she wrote only of Natalie's laugh, her freedom, her ardent heart.

Lily's duc of a husband threatened to shoot her and Natalie. Lily had no option but to leave him and by doing so she was cut off from all rights to her children and all funds. Natalie helped her financially, loaned her money, paid towards the upkeep of her house in rue Raynouard, paid for holidays.

Separated from the duc and banished from French high society, Lily dressed in tailored suits and simple hats and had her hair shingled. In the 1914–18 war, she wrote articles for *Le Radical*, which earned her the nickname 'The Red Duchess'.

Natalie meets Romaine

By 1916, nine years on from when she and Lily first met, Natalie had formed another relationship. She had not tired of Lily, far from it, but she was smitten with the artist Romaine Brooks, American, good-looking, rich, emotionally damaged and with a perversity Natalie was drawn to and understood.

Romaine was forty-one. For her life-size monotone portraits, she was called 'the thief of souls'. She had had affairs with, among others, Renée Vivien, the dancer Ida Rubinstein, the poet, narcissist and fascist Gabriele d'Annunzio, the patron of music Winnaretta Singer. After mere months of marriage,

Romaine discarded her homosexual husband, John Ellingham Brooks.

Lily voiced no expectation of fidelity, gave no ultimatum; she wanted to keep the relationship between her and Natalie, who, she said, was her 'weakness' and nothing would change that, but she wanted to be clear about the terms of their involvement. 'The blonde and the brunette', she wrote of Natalie's new relationship, 'very becoming. I wonder if it is right to try to separate that which life has brought together.'

Natalie's reassurance was and was not convincing. She told Lily: 'I shall have my room in your house... my life in your life, my sleep on your heart...' But, she said, Romaine was too important, 'too good and too real and too everything to be merely in 2nd place'.

marriage contract

Lily asked for clarification. If neither she nor Romaine was second place, where were they? On 14 March 1918 she wrote frostily to Natalie about the relationship with Romaine, which had gone on for eighteen months. As intended reassurance, Natalie, on 20 June, drew up, in French, a handwritten contract between her and Lily.

This contract was to protect 'against whims, wanderings and changes' between them and to assert their unbreakable bond. It iterated how they had been together for nine years, shared joys and worries and admitted to other affairs. Though the prospect of new affairs was ever present, they intended to safeguard and continue their relationship. They were not enough for each other but no one else was more important. They pledged never to part and to 'bring the other back' if separation threatened.

> The years have tested our union: by the sixth, sexual fidelity failed. This was inevitable because our only commitment is

to feelings and desire. Our love passion… pure, exclusive, devouring, free as fire – had become love love – another sort of beauty, a different purity: mature, patient, pitiful, supple, cruel, logical, human and complex as is life.

Love had lost its freshness, not 'its dominating faith, its purity, or its wings'. They would have other affairs and impose no restrictions but nonetheless live and die for each other:

il ne sera pas d'union aussi forte que cette union, ni d'association aussi tendre – ni d'attachement aussi durable…

no other union will be as strong as this union, or as tender, or as lasting…

It sounded less specious in French. It seemed like a cover for all real and hypothetical events. I am true to you. I told you I could never be true.

As a symbol of this promise we put a shining, unbreakable green ring, as wide as the universe, around our futures and ourselves… And you shall not be called my wife, or my slave, or my spouse, which are sexual terms for fleeting spans of time, but my one my eternal mate.

They signed the contract. Lily wore the shiny green ring Natalie gave her. It was not as wide as the universe. From then on, they began their letters to each other to 'my mate éternel'.

Lily then started an affair with the playwright Germaine Lefrancq, who had also had an affair with Natalie. In 1922, Liane de Pougy, who had risen up the social ladder to become Princess Ghika, formed a sexual threesome with Natalie and Lily. 'We laugh all the time, understand each other, melt into the other, undergo a fusion.' When Lily met alone with Liane, Natalie was jealous, felt betrayed and told her to choose. Lily stopped seeing Liane, who noted that Natalie and Lily 'almost never leave each other'.

Was this a blueprint for lesbian marriage? It was not for the faint-hearted. Was it modernist? It did not fit the Judaeo-Christian orthodoxy. It was not what fathers prescribed for their daughters. It questioned the old order, required a thick skin, a good deal of spare time and an unusual capacity for adventure. As a lifestyle, it provoked anxiety, jealousy, insecurity and doubts about self-worth. But it surely allayed or avoided, at least for a while, feelings of boredom, entrapment or any sense of 'ending up'.

It was Natalie's rationale for her polyamorous life. She did not want, like Gertrude and Alice, a replica of conventional marriage with a gender twist. She wanted validation for her feelings and behaviour, if only to herself and her lovers. Such validation was not on offer from society. She contrived it for herself.

Romaine Brooks

One tiresome practical complication was that 1 May, the day declared an anniversary for Natalie and Lily de Gramont, the day for plovers' eggs, Sauternes and remembrance, was also Romaine Brooks's birthday. Natalie had to juggle her commitment to love and no second place.

Romaine, tall, slim, with dark hair and eyes, had no wish to live on Lesbos or emulate Sappho. Her ambition was to create works of art, not be one. She left an impressive oeuvre of portraits of the lesbians in her and Natalie's circle. After the Second World War, Natalie took the novelist Truman Capote to visit Romaine's Paris studio. She and Romaine were then in their seventies; Romaine was living in isolation in the South of France. Her portraits lined the walls. Capote compared the immense studio to 'a shrine museum' and called it 'the all-time ultimate gallery of famous dykes... an international daisy-chain'.

You know how you know when you're not going to forget something? I wasn't going to forget this moment, this room, this array of butch-babes.

There were about seventy portraits. On the walls and propped against the walls were self-portraits and portraits of Natalie, Lily, the Princesse de Polignac, Gertrude Stein, Una Troubridge, Renata Borgatti, Radclyffe Hall, Gluck. In contrast to the passivity of the female model for the male artist, the reclining nude, Romaine's butch babes stood tall, in high hats, with collars, coifs and jackets, monocles and riding whips.

no pleasant memories

Beatrice Romaine Goddard was born in a Rome hotel on 1 May 1874. Her father was an army major, her mother an heiress. Her parents divorced soon after her birth and her father did not figure in her life. Her severely mentally ill brother, St Mar, five years her elder, was the total focus of her mother's attention:

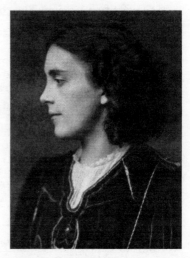

She never failed to remind me that I was not good-looking like St. Mar, and indeed, my pale face and dark hair could in no way compare with his angelic blondness.

Major mental illness shrouded Romaine's family history. Childhood, she said, was like living on an avalanche: 'no fixity, no foundation, only unfractional time, carrying with it the sensation of danger more mental than physical.'

As an adult, she spoke of herself to Natalie as a martyred child, her life blighted by her mother's 'mad egotism'. In the 1930s she drafted a memoir in which she described the chaos and anxiety her mother caused:

> my mother rarely slept during the night and never went to bed. Her meals were served at any hour of the day or night, and sometimes, by her orders, they were not served at all. Those in her immediate circle could but follow her example and accept the dictates of her eccentricities. Fortunately there were times when she was quite lost to the world, and these were our most pleasant moments. She would converse to herself, or rather to invisible friends. She was quite gracious with these phantoms, reserving for this world alone the incessant irritability of her other moods.
>
> Yet, in all this confusion, my mother always impressed everyone with the sense of her immense importance. Perhaps this could be accounted for by her arrogance, unusual culture, and personal elegance. The atmosphere she created was that of a court ruled over by a crazy queen; and before my brother showed definite and incurable signs of madness, she treated me either as one of royal blood – since I was descended from her – or else as a page-in-waiting rather than a little girl. There was even a time when she dressed me up in replicas of the clothes my brother had worn as a very small boy.

Romaine called this memoir *No Pleasant Memories*. From the age of six, her escape was to draw. As she, her mother and brother moved from one country and hotel to another, she would find a quiet corner, get out her pad and pencils and draw the view from the window and childhood images of home: houses, trees, cats, flowers.

From an early age, her interests defined as art, music and girls.

She was sent to a convent, then to Mademoiselle Bertin's finishing school in Geneva, to be taught how to manage the servants. She ran away to Paris, studied singing and French, and held hands with and kissed the English contralto Clara Butt.* 'My life was transformed', Romaine wrote of Clara. 'I now lived on a higher plane of love and adoration. My new friend radiated kindness and sympathy.'

In Rome, Romaine studied art then went to Capri to paint, and while there made an impulsive and extremely brief marriage to John Ellingham Brooks, who was homosexual and wanted her money. She moved to England, took a studio in Tite Street in London, worked with the Newlyn School of artists in Cornwall, then returned to Paris. In 1906, she too had an affair with Renée Vivien:

> I found myself drifting along with her… If ghosts were wont to visit and haunt me, she, pale life, visited and haunted death.

Renée told her La Brioche, the Baroness van Zuylen, was jealous.

> I willingly believed her and made it the pretext to end our friendship. But she had taken this indirect way hoping to attach me still further. Someone came to intercede for her. I would not go back… a few months afterwards I heard she was dead.

Winnaretta Singer

After her affair with Renée, Romaine's 'friendship' was with Winnaretta Singer, the Princesse de Polignac, ten years older than Romaine, cultured, rich, and an extraordinary patron of modernist music and art. Winnaretta's sexual appetite matched Natalie's. Her salon was a huge contrast to Natalie's 'hazardous

* Edward Elgar wrote the song cycle *Sea Pictures* for her.

Fridays'. Her gatherings were serious and focused, though not such fun.

Proust described her as 'icy as a cold draught and with Dante's profile'. Virginia Woolf said she was like 'a perfectly stuffed cold fowl'. She lived in a mansion on the corner of avenue Henri-Martin and rue des Sablons (now rue Cortambert). She commissioned her portrait from Romaine, who made notes of the sitting:

the head is bent forward with profile emerging from out of a profusion of dark hair. The lowered eye escapes detection. The nose is arched and noble, but the mouth with its protruding lower lip shows strong atavistic ruthlessness ever active in self-defence.

Strong atavistic ruthlessness ever active in self-defence sounds all right for portrait painting but hard work in an intimate relationship. Romaine's painting showed her in profile, wearing a white dress. Winnaretta was pleased. Other portrait commissions followed for Romaine, and a solo exhibition at the Galerie Durand-Ruel in rue Laffitte.

Winnaretta was the twentieth child of Isaac Singer, who made a fortune out of the sewing machine he invented and patented in 1851. In total, he fathered twenty-four children from two marriages and various affairs. Winnaretta was born in January 1865. Her mother, Isabella Eugénie Boyer, was twenty-four, half French, half English, socially ambitious and musical. Her face

was said to be the model used by the sculptor Frédéric Bartholdi for the New York Statue of Liberty. Isaac Singer was fifty-three when she married him and not officially separated from his previous partner.

They lived first in The Castle, a palatial estate in 300 acres of land in Yonkers, north of New York, then when Winnaretta was six they moved to England, to Paignton in Devon, to Oldway Mansion, with 115 rooms, on a 17-acre estate. Singer died in July 1875, leaving $14 million in a much-contested will. Winnaretta was ten; her share of the fortune was about $1 million, to be invested and managed and hers when she was twenty-one.

After Singer's death, Winnaretta's mother took her children to Paris and remarried: Victor Reubsaet, a Dutch violinist, the son of a cobbler, who falsely claimed an inherited title. She called herself Viscomtesse d'Estenburgh, bought a large townhouse at 27 avenue Kléber in the 16th arrondissement, and in the grand salon held weekly recitals played by the finest musicians. For her fourteenth birthday present, Winnaretta chose a performance of Beethoven's String Quartet No. 14, Opus 131. When she was seventeen, her mother took her to Bayreuth, to one of the first performances of Wagner's *Parsifal*. Bayreuth was an annual event from then on.

She studied piano with the composer Émile Bourgeois and art at the atelier in rue de Bruxelles of Félix Barrias, who included Edgar Degas among his pupils. Winnaretta said the works of Degas, Monet, Sisley, Boudin and Manet 'threw a fresh light and meaning on all that surrounded me in the visual world'. But home life was intolerable. Her mother criticized her appearance; her stepfather sexually abused her, spent much of her mother's fortune and tried to acquire Winnaretta's too. The papers wrote of a feud of 'gigantic proportions':

The quarrel has reached such a pitch that Miss Singer has

left her home and has gone to board at a convent. Lawyers have been engaged, members of the damsel's family have been summoned and while the cause of the dissension continues to be a mystery to the world at large, the noise of the conflict has become distinctly discernible.

The rumour was that her stepfather had raped her. She left Paris, stayed with friends and when she was twenty-one had her money transferred into a Rothschild bank, out of his reach. She bought the lavish property on the corner of avenue Henri-Martin and to deter suitors and deflect from being lesbian married Prince Louis-Vilfred de Scey-Montbéliard. He was twenty-nine. She was careful enough before this marriage to draw up a trust deed tying her wealth and property to her two brothers Mortimer and Washington Singer, for her benefit not her husband's.

Neither her mother nor stepfather attended her wedding on Thursday 28 July 1887 at the Église St Pierre de Chaillot. Washington Singer walked her down the aisle. A newspaper account described her as tall, lithe, with sweet blue eyes and wavy brown hair, then switched to the underlying scandal:

> The true reason for Miss Singer's leaving her mother's home was her utter inability to get along with her stepfather, the Duke, whom his best friends admit to be a man of extremely uncertain temper. The Duchess does not lead the happiest of lives.

On her wedding night, at Prince Louis' family chateau in the Franche-Comté region of eastern France, Winnaretta told her husband that if he touched her she would kill him. Weeks later, her stepfather died of a heart attack; his funeral was held in the Église St Pierre. One newspaper commented that she had married to protect herself from the importuning of her mother's husband but now might regret her haste.

Winnaretta paid the Vatican enough to have the marriage

annulled. Then in 1893, aged twenty-nine, she made a lavender cover-up marriage with Prince Edmond de Polignac, who was fifty-nine, homosexual, and a composer and musician. By the marriage, she acquired a title and social cover; he acquired money and opportunity to perform his music in public – which he did until his death in 1901.

the salon of the Princesse de Polignac

The Princesse de Polignac's yacht was moored at Nice; in Venice she acquired a palazzo and in Paris she became a Right Bank institution. Her musical evenings were a showpiece for the Parisian musical avant-garde. Her salon, decorated in Louis XVI style, with wood panelling, a vaulted ceiling and a balcony around the upper storey, seated a hundred. In it were two grand pianos and a Cavaillé-Coll organ. To perform their own and others' music, she commissioned the best organists in Paris. Debussy and Ravel came to hear new works in acoustically ideal surroundings. Proust, Cocteau and Colette all wrote of the musical soirées at the Polignac salon.

Inscribed on the scores of many works she commissioned from Ravel, Fauré, Poulenc and Stravinsky was the dedication 'À Madame la Princesse de Polignac'. Prokofiev wrote his piano sonata No.3 for her; Ravel dedicated his *Pavane for a Dead Princess* to her. She subsidized the Opéra de Paris, the Ballets Russes, the Paris Symphony Orchestra. A performance in her salon was a stepping stone to a wide audience, particularly when she interceded on the composer or performer's behalf. She was as influential to new music as were Sylvia Beach and Bryher to new writing and Gertrude Stein to new painting. Stravinsky received a commission from her in November 1912: her appreciation of him was immediate, she said. 'From the start it seemed

to me impossible not to recognize the importance of this new genius':

> You know my very great admiration for your talent. You
> will not be surprised then that I thought of you to write for
> me a work, which would belong to me and which I would
> have played in my music room which you are familiar with.
> It would obviously have to be a short work and for a small
> orchestra—maybe 30 to 36 musicians.

She told him the piece should last around fifteen minutes and have two pianos or four hands so she could perform with another pianist. She offered him 3,000 francs and suggested a deadline of 8 April so the piece could debut around the end of April or the beginning of May. Stravinsky proposed a concerto for piano and orchestra:

> I would need 2 flutes (the first changing to the piccolo),
> 2 oboes, 2 clarinets (the 2nd changing to the bass clarinet),
> 2 bassoons (and the contrabassoon if possible), 2 horns in F,
> 2 trumpets in C, 2 tympani, a grand piano, a harp, 2 first
> violins, 2 second violins, 2 violas, 2 cellos and a double bass.

Lily de Gramont described a salon evening at Winnaretta's mansion at avenue Henri Martin:

> a large room is reserved for music. The platform is at the far
> end, the Princess rustles her train of silver-grey satin going
> up and down the middle of the nave, the faithful gather to the
> right and left... the groups go to their places: the first three
> rows for the American billionaires, white hair and diamonds
> and the British duchesses; three other rows for the important
> French women with tinted hair; the youth gather at the back...

There was a sense of a bygone age. It was not like Natalie's hazardous Fridays. One visitor spoke of a stampede for the buffet between concertos. Moneyed, powerful, entitled, imperious,

the Princesse de Polignac shored up tradition even while she embraced the new. She viewed change as evolution rather than departure. Down the years, as well as Proust, Colette and Cocteau, Kurt Weill and Cole Porter attended her salons, and so did Isadora Duncan, Cecil Beaton, Benjamin Britten.

She was patron to Nadia Boulanger, Clara Haskil, Arthur Rubinstein, Vladimir Horowitz, Ethel Smyth, Le Corbusier. In a piece for *The New Yorker*, Janet Flanner described her as eccentric. She was parsimonious over small payments and careless about her appearance; she had panic attacks about thunderstorms or street demonstrations.

Isadora Duncan, who married Winnaretta's brother Paris Singer, said she looked like a Roman emperor (Ernest Heming-way thought the same of Gertrude Stein), and that 'when she spoke her voice had a hard metallic twang'. She thought her harsh demeanour was a mask to hide 'extreme and sensitive shyness'. Virginia Woolf, on first meeting her in 1936, wrote:

> I saw La Princesse de Polignac... whatever she was born she's grown into the image of a stately mellow old Tory; and to look at you'd never think she ravished half the virgins in Paris and used, so Ethel Smyth tells me, to spring upon them with such impetuosity that once a sofa broke.

The composer, conductor, pianist and teacher Nadia Boulanger called Winnaretta 'one of the last great patrons in history'.

> Her collection of paintings was fabulous... She'd arrive in London and an hour later you'd be playing music or reading poems. How many soirées we all went to where we played lots of Monteverdi, Schütz's *Resurrection*, Carissimi's *Jephte*, and then all the works she commissioned... There was the famous evening when her butler entered appalled, 'Madame la Princesse, four pianos have arrived'. Stravinsky's *Les Noces* was to be played for the first time.

Winnaretta's lovers

Winnaretta had lovers galore. She said that after confessing to a priest, he refused her a second hearing. She neither advertised her relationships nor concealed them. She practised and expected discretion and left instruction for her personal papers and letters to be burned after her death.

Colette, to whom Winnaretta gave extravagant gifts, wrote of 'a deep blue-eyed gaze, a conqueror's chin, an air of indestructibility'. Among the gifts Winnaretta sent her were a vase of flowers with a diamond necklace hidden among them, a red Renault car, an antique writing table. Maurice Goudeket, who in 1935 became Colette's third husband, thought Winnaretta always seemed like a guest in her own house.

Ethel Smyth

Winnaretta went to the first night of Ethel Smyth's second opera, *Der Wald* (The Forest), at Covent Garden in 1903. Ethel, smitten by her, gave her an inscribed copy of the opera and said she had met 'the most adorable human being in the world [...] grave, natural, don't-care-ish, the soul of independence – in short all the things I like.' She stayed at the Singer mansion in Paignton and at the Palazzo Polignac in Venice, and from England sent declarations of love:

> It is difficult to stand up against my feeling for you... your personality has the inevitableness, the rare finality of nature itself... Other people seem to me so fussy, so personal – so bereft of possibilities... You are the only human being I ever saw who combines limitless serenity and limitless passion... I am as certain of one thing as of death – I love you more in five minutes than anyone else ever did in five years.

Her love was not reciprocated. Winnaretta's involvement in 1903 was with Olga de Meyer, tall, red-headed, an artists' model to Whistler, John Singer Sargent and Walter Sickert, and said to be the daughter of Edward VII when he was Prince of Wales. Villa Olga in Dieppe, the house she grew up in, was bought by him for her mother. Her marriage in 1899 to the *Vogue* photographer Adolph de Meyer was, as with Winnaretta's, a cover to conceal same-sex relationships.

Spurned, Ethel Smyth then thought Winnaretta 'the worst' as a human being. And she 'detested and distrusted' the Meyers.

Romaine Brooks met Winnaretta at a salon evening of Olga de Meyer's in 1904. She had hesitated between a singing or painting career and she and the Princesse shared a passion for culture and an imperious manner. And for Romaine it was a relationship that furthered her career in Paris as a portrait painter.

Though Ethel Smyth's love was rebuffed, Winnaretta supported both her music and her fight for suffrage. Ethel wrote the suffragettes' rallying cry 'The March of the Women', worked with Emmeline Pankhurst and the Women's Social and Political Union and was imprisoned in Holloway in 1912 for throwing a rock through the window of the Secretary of State for the Colonies, Lewis Harcourt. Emmeline's daughter, Christabel, went to France to avoid arrest and stayed with Winnaretta, who helped her financially. Emmeline's deputy, Annie Kenney, a Lancashire mill worker, visited her there:

> I was shown into the largest room I had ever seen in a private house. There were beautiful books everywhere. I picked one up and found it to be a translation of Sappho's poetry. The colour of the leather binding was the shade of a ripe pink cherry.

Ethel thanked Winnaretta on the Pankhursts' behalf: 'You are a brick and I think Mrs P's greatest comfort is to know she has friends like you.'

philanthropy

Winnaretta was a brick for many good causes. In the First World War she paid for X-ray units needed by Marie Curie, bought an old hotel in Paris and had it converted into a hospital for the blind, and gave money for welfare and to supply ambulances for Belgian soldiers. She continued her music patronage during the war. In spring 1916 she gave Erik Satie a commission to set to music *The Death of Socrates* from Plato's *Phaedo*. Satie, who was short of money, described himself as 'swimming in happiness and free as water'.

After the war, Winnaretta withdrew from society for some years. The death in 1920 of a lover, Isaure de Miramon, aged forty-one, from a drug overdose sent her into deep depression. Madame de Miramon, unhappily married, beautiful and musical, had been introduced to opium by Jean Cocteau. 'We go on because we have to, but with a heart full of shadows and distress that time will not alter,' Winnaretta wrote to a friend.

In January 1923 Winnaretta offered Paul Valéry 12,000 francs to arrange monthly lectures in her home for a year. He could choose the topics. That year too, Violet Trefusis became her lover.

Violet Trefusis

Violet had been exiled to Paris from England after the intensely public scandal of her love affair with Vita Sackville-West. Her mother, Alice Keppel, socially acceptable as Edward VII's mistress, forced Violet into a sham marriage with Denys Trefusis and packed them both off to Paris. Violet, broken-hearted, wrote to Vita:

What a dreadful thing is marriage. I think it is the wickedest

thing in the universe. Think of the straight, clean lives it has ruined by forcing them to skulk and hide and intrigue and scheme, making of love a thing to be hidden and lied about. It is a wicked institution. It has ruined my life, it has ruined Denys's – he would give his soul never to have married. It has ruined – not *your* life but our happiness…

Ever since I was a child I have loved you. Lesser loves have had greater rewards – you don't know what you have been – what you are to me: just the force of life; just the raison d'être.'

In 1923, Winnaretta was fifty-eight and Violet twenty-eight. Proust's analogy for the Princesse was an icy draught, Virginia Woolf's was a stuffed fowl, Violet's was a rock face:

She hung over life like a cliff; her rocky profile seemed to call for spray and seagulls; small blue eyes – the eyes of an old salt – came and went; her face was more like a landscape than a face, cloudy of hair, blue of eye, rugged of contour… Like all fundamentally shy people she was infinitely intimidating. People quailed before her.

The Princesse and Violet were partners for ten years. Violet wrote polished, clever, subversive and underrated novels in French and English. Her themes were betrayal, marriage for gain, malicious matriarchs, love versus possessions. On the first page of the manuscript of her first novel, 'The Hook in the Heart', she wrote: 'Less voluntary than grief or death is the choice of desire.'

Violet wanted to escape from England, forget Vita and win back her mother's approval. Denys Trefusis wanted freedom and travel. Mrs Keppel wanted the restoration of social status. Winnaretta satisfied all of them. In December she arranged a cruise, in her yacht, up the Nile to Egypt and Algeria. In her party were Violet and Denys, Mr and Mrs Keppel, the pianist Jacques Février and Winnaretta's nephew Jean de Polignac and

his fiancée, the composer Germaine Tailleferre, from whom Winnaretta had commissioned a piano concerto earlier in the year. In January they disembarked in Algiers and stayed at Bordj Polignac with panoramic views of snow-capped mountains and desert plains.

The writer Harold Acton said:

Princess Winnie taught Violet discretion, it was rumoured with a whip – so her subsequent liaisons with ladies were less advertised.

His friend, the society celebrity Diana Cooper, 'told a marvellous story that was going the rounds':

a Mrs Blew-Jones, who was taking some furs to the Polignac house at eleven one morning, was asked by the servant at the door whether she was the lady who was expected. She said she was, and was immediately shown into a large room where she was greeted by the old Princess in a dressing gown and *top boots*. On a sofa in another part of the room she saw Violet Trefusis and another woman both stark naked locked in a peculiar embrace. She ran from the room in terror. It sounds incredible, may be exaggerated but can't be quite invented.

Perhaps Mrs Blew-Jones was both exaggerating and inventing. But as well as being a discerning patron, the old Princess was an audacious lesbian. And if Ethel Smyth, who was in love with her, said she once pounced so hard she broke the sofa, then who knows, perhaps she did.

St Loup

Don't Look Round was the title of Violet's memoir. In it she wrote of meeting Marcel Proust at a lunch party not long before he died in November 1922. He advised her to visit the hilltop town

of Saint-Loup de Naud on the road to Provins, 80 kilometres from Paris. She went there with Winnaretta and they found an ancient tower in a dilapidated state, which had once been part of an eleventh-century abbey. The Princesse bought and restored it for Violet and this 'romantic and mysterious' tower became the setting for their relationship. Violet projected a personality on to her tower:

> It is sensuous, greedy, ruthless, vindictive. If it takes a dislike to you, you are done. If on the other hand, you have the good fortune to please St Loup it is equally unscrupulous. No scène de séduction is too crude, no posture too audacious. It beckons, importunes, detains.

Crude seduction scenes and audacious postures might bear out the gossip of Diana Cooper, Ethel Smyth and Mrs Blew-Jones, the lady who was *not* expected.

Natalie and Romaine

Natalie's ease and warmth were a welcome gift to Romaine after the rocky profile and icy draught of the Princesse. Natalie told Romaine she was beautiful, a genius, her singing voice perfect, her paintings immortal, she had no disguise, no pose and was 'a real head and soul in an unreal world'. Romaine was, Natalie said, dearer to her than her own life. 'I love my Angel better than anything else in the world and prove it.' In return she asked only that Romaine should need her above all others. And Romaine said Natalie 'had an unusual mind of the best quality', but she decried her Friday salons as gatherings of drunkards and society women, which perhaps was not a fair description of Gertrude Stein, Sylvia Beach, Djuna Barnes, Colette, Janet Flanner and the rest.

After meeting Natalie, Romaine painted the portraits of lesbians that so riveted Truman Capote, the women who attended

the Friday gatherings: ladies with high collars and monocles. She painted Radclyffe Hall's partner, Una, Lady Troubridge, with two of their show-dog dachshunds, did a memorable self-portrait in high hat and gloves, made Lily de Gramont look plain and bushy-browed and Natalie serene and gentle with nothing wild about her, a small model of a prancing horse the only tribute to de Gourmont's Amazonian view. She and the English society painter Gluck did reciprocal portraits. Romaine called hers 'Peter a Young English Girl'. Gluck's portrait of Romaine stayed unfinished. They quarrelled over the sitting and Romaine stormed out.

no second best

Where to live was for Romaine an unresolvable problem. For Natalie, Paris was essential – her Friday salons and community of lesbians. If she and Romaine lived in the same house or near to one another, as she hoped, 'and walked out hand in hand at the end of the day', it would have to be in Paris, which Romaine called a desert, 'wanting all calm, beauty and dignity'. 'No Paris for me', she wrote.

> I suppose an artist must live alone and feel free otherwise all individuality goes. I can think of my painting only when I am alone, even less do any actual work.

But Romaine could no more find the perfect home than the perfect person. She excelled in making the places she acquired fit her laws of beauty, Natalie said of her. In 1918 in rue Raynouard – the road where Lily de Gramont lived – Romaine created a seemingly ideal studio designed entirely to her taste, but could not settle. She moved on to Capri, London, New York, then Florence, Venice, Nice.

After spending time with Natalie, then time apart, Romaine at

first missed her greatly, then 'regained that state of mind which constitutes my personal life'. When they were together for any length of time, Romaine lost her sense of self and needed to return to solitude. She also objected to Natalie's lack of exclusivity, even though she found proximity taxing.

Natalie struggled with Romaine's equivocation and what she called a 'relentless quality' that made Natalie behave like some 'dumb, devoted, pitiable animal'. With Lily, Natalie was at ease. With Romaine, each time they separated, she feared she would not come back.

Nonetheless, Natalie's relationship with Romaine was compelling. 'My angel is my only real companion and friend', she wrote, which was not quite what she had conveyed to Lily. They opened a joint Swiss bank account. Natalie talked of their being together for the rest of their lives and of sharing the same grave. In Paris they picnicked in the Bois de Boulogne. On Capri they stayed in the Villa Cercola, which Romaine acquired in 1918. At Honfleur they stayed with Lily de Gramont, but how to make both of them feel first best – or at least not to make either feel second best – was a difficult call.

Romaine did not care that the great Sappho had lived in harmony with a community of women. In summer 1922 she agreed to meet Natalie in Calvados for a holiday. Natalie wrote excitedly about plans: Lily would be there too, would Romaine find out about maps and roads, could they fit their trunks and Romaine's maid into Natalie's Buick, various friends would meet up with them at Chambourcy, they could all go to Capri.

Romaine's reply was brutal: Natalie should count her out. She intended to holiday alone on the Italian coast. 'Always remember, Nat, that I prefer Nat Nat to being alone, but alone to being with anyone else.' Natalie, she said, had many friends and she, Romaine, had one 'and therein lies the difference'.

Romaine's haughtiness grated on Lily de Gramont: 'Mrs

Brooks', she wrote in her memoir, 'puts bars on the windows of her various establishments to keep out the disappointing human race and now no longer knows who is the prisoner.'

Natalie tried to be reparative but was not going to change. Nor did Romaine spare Natalie provocation and jealousy from her own involvements. An affair with the pianist Renata Borgatti, one of the Princesse de Polignac's protegées, lasted some years. She painted her portrait and they holidayed together on Capri. 'So Renata Borgatti is "on to you" as we say,' Natalie wrote:

> I am alone and you are with her. I know you have not bathed
> without everyone on that island desiring you – that they would
> follow the glimmer of your perfect form to the ends of the
> earth – yet can any of them but me so grasp the inner goddess,
> the real sense of your greatness.

Among Renata Borgatti's other affairs on Capri was the writer and memoirist Faith Compton Mackenzie, whose husband, Compton Mackenzie, wrote a satirical and antipathetic roman à clef, *Extraordinary Women*, about lesbians on the island. And another of the 'inner goddess's' affairs on Capri was with Luisa Casati, dubbed the patron saint of exhibitionists, who bought diamond collars for her pet cheetahs, dyed her hair flame red, gave extravagant parties and accrued debts of $25 million. Romaine painted her portrait too, as did Giovanni Boldini and Augustus John. Jacob Epstein sculpted her and she was photographed by Man Ray, Cecil Beaton and Adolph de Meyer. In 1932 her possessions were seized and sold to appease her creditors. After Romaine, she linked up with the Princesse de Polignac.

Partners changed in a game of musical chairs – or beds. There was no rule book for lesbians, no guide except perhaps gleanings from Sappho. They were outsiders. There was no family help, guidance or approval and there was something spoiling and

irrelevant about the sexological notions and pathologizing of Freud, Krafft-Ebing, and Havelock Ellis.

the well of awfulness

After 1927, men rarely attended Natalie's hazardous Fridays. Natalie then termed the gatherings the *Académie des Femmes*, a snook at the all-male *Académie Française*, which barred women. She sponsored a prize for women writers, encouraged and helped finance individual projects and forged connections for writers with publishers.

Attendees read from their work. There was a packed audience on the afternoon Radclyffe Hall read from her gloomy sapphic *Well of Loneliness*. In London in 1928, ten years after the censoring of *Ulysses*, it was condemned as obscene by a kangaroo court in an outcome-driven trial where no defence was allowed, then 'burned in the King's furnace'. In Paris, Sylvia Beach sold pirated copies in Shakespeare and Company.

England's ruling class, the lawmakers and law enforcers, all aristocrats and members of the men-only Garrick Club, censored the book solely because of its lesbian theme. The Attorney General, Sir Thomas Inskip, held the book at arm's length as he gave the court's verdict. He had, he said, no idea whether the book had any literary qualities; it must be destroyed because its subject matter was obscene. It would corrupt the young and 'suggest thoughts of a most impure, immoral, unclean and libidinous character' to them. The practice in which its heroine indulged was referred to in the first chapter of the Epistle to the Romans and in the second satire of Juvenal. (He read Classics at Cambridge.) It glorified the vice of physical relations between women. It asked for toleration of the people who indulged this vice. It was:

propaganda for the practice which has long been known as

Lesbianism, a well-known vice, unnatural, destructive of the moral and physical fibre of the passive persons who indulge in it, who are the victims of others, this book is a plea for the active persons who practice this vice... it is corrupting and obscene and its publication is a misdemeanour.

The subject was off limits. Radclyffe Hall became a martyr and lesbian icon. Her *Well of Loneliness*, dubbed 'The Bible of Lesbianism', stood alone. Natalie was joyful about lesbian desire. Radclyffe Hall's tortured and quasi-religious references to sex were, as Colette said, 'terribly adolescent'. Janet Flanner, in her Paris letter for *The New Yorker*, called it an innocent and confused book that should have paved the way for better novels about lesbian love. Virginia Woolf said it was so dull any indecency might be lurking in it – she could not keep her eyes on the page. As a literary or psychological study, *The Well* received scant praise and much derision. 'The Sink of Solitude' was the title of one spoof. But the prurient scandal stirred by censorship meant millions of pirated copies were sold.

Radclyffe Hall's courage in speaking out was commendable, but her lack of wit, wisdom, irony, style, oomph and fun made her book a sorry candidate for lesbian literary accolade. Homosexual men had Oscar Wilde to cherish, grieve for and admire. Lesbians had Radclyffe Hall, who, in deference to Havelock Ellis, called herself a congenital sexual invert with 'terrible nerves'.

Her clothes were tailored, her demeanour patrician. She was everywhere accompanied by her partner, Una, Lady Troubridge, who called her John and revered her – until John fell for Eugenia Souline, 'Chinkie Pig', a Russian nurse, then all hell broke loose. At Radclyffe Hall's salon afternoon in 1929 at Natalie's, crowds of lesbians were eager to meet her. Janet Flanner was there. She described her as a strange but impressive looking woman, short of stature, with a disproportionately large head and perfect

haircut. 'Her hands and feet were also large as were the beautiful sapphires which she wore, one as a finger ring and one each as a cufflink.'

the sapphic centre of the western world

Natalie championed the way for lesbians who wanted more fun than down the gloomy Well. Many of her guests had been, were or would be her lovers. These lovers should have had a calligram to themselves: the Hellenist Evalina Palmer, the courtesan Liane de Pougy, the poets Lucie Delarue-Mardrus, Renée Vivien and Olive Custance, the writers Lily de Gramont, Colette and Djuna Barnes, the portrait painter Romaine Brooks, the patron and socialite Nancy Cunard, Elizabeth Eyre de Lanux, an American fresco painter, artist and writer, who lived next door in rue Jacob and became intrigued by the visitors to Natalie's temple. Year on year, the list grew longer.

Dolly Wilde

Oscar Wilde said to André Gide: 'Do you want to know the great drama of my life? It's that I've put my genius into my life; I've put only my talent into my work.'* Natalie echoed this sentiment. From childhood she had a passion for Oscar and the theatre of his life.

Oscar's niece, Dolly Wilde,

* 'Voulez-vous savoir le grand drame de ma vie? C'est que j'ai mis mon génie dans ma vie; je n'ai mis que mon talent dans mes œuvres.'

lived in the shadow of her uncle. Born in 1895, the year he was imprisoned, she looked like him 'except that she was handsome', Janet Flanner said. Oscar's homosexuality, glittering career and downfall informed Dolly's own sense of self. The difference was that his genius triumphed over his downfall. Dolly's personal connection to him was slight: from prison he sent her mother, his brother Willie's second wife, £50 to pay for her birth. That was the extent of his concern for her. Nonetheless, she described herself as 'more Oscar-like than he was like himself'.

Dolly arrived at Natalie's salon on 28 June 1927. She was thirty-one, Natalie fifty. The Oscar connection made seduction de rigueur. Natalie described Dolly as 'half androgyne and half goddess'. 'No one's presence could be as present as Dolly's.' They began a love affair that lasted, on and off, for fourteen years, until Dolly's death.

Like Natalie, Dolly wanted to live her life as a work of art, but she had nothing of Natalie's toughness or self-regard. Nor did she have a private income. She wanted to write. She earned occasional money translating work by Colette, Nancy Cunard and Lily de Gramont from French to English, but not enough to fund her lifestyle. She ran up bills at the Paris Ritz and hoped someone else would settle them, squatted in borrowed flats, left letters unanswered and Sylvia Beach's library books unreturned. She was always late. She drove too fast in borrowed cars and moved from alcohol to heroin addiction.

Joe Carstairs

In the First World War, she lived in Montparnasse with Marion 'Joe' Carstairs. They both then drove ambulances at the front for the American Red Cross. Joe Carstairs was tattooed with stars, smoked cigars, had affairs with Marlene Dietrich, Gwen Farrar, Tallulah Bankhead and others, and apparently could 'dance a

Charleston which few people can partner'. Via her American mother and the Standard Oil Company, she inherited a fortune. She was not sure who her father was.

After the war she started a London chauffeur service using all women drivers, bought a speedboat and became 'the fastest woman on water'. In 1933, with mere thousands of the millions of dollars of her inherited money, she bought the Caribbean island of Whale Cay. 'I am going to live surrounded only by coloured people,' she told the press. She built a Great House for herself and her lovers, cottages for her workers, a dock, a school, a church, a fish cannery and a general store. She made laws: adultery and alcohol were banned and miscreants punished by her private militia, who wore uniforms and wielded machetes. She was more than a little mad.

Janet Flanner

Janet Flanner was briefly one of Dolly's lovers. She arrived in Paris in 1922, aged thirty and in love with the actress and writer

Solita Solano. She had left the husband whom she had married to extricate herself from her family home in Indianapolis. For a year, she and Solita – born Sarah Wilkinson in Troy, in New York – absorbed the culture of Europe, travelling to Athens, the Greek islands, Constantinople, Rome, Florence, Vienna, Dresden, Berlin. In New York they were part of the literary and theatrical set, the Algonquin Round Table,

who met for lunch at the Algonquin Hotel on West 44th Street. Dorothy Parker was a member.

In Paris, they wanted to live together openly, 'begin anew'. Like-minded lesbians were already in the city: Sylvia Beach, Gertrude Stein, Natalie, Djuna Barnes. 'I wanted Beauty with a capital B,' Janet Flanner said. They rented rooms on the fourth floor of the Hôtel Saint-Germain-des-Prés at 36 rue Bonaparte in the 6th arrondissement for a dollar a day including heating. The charms of the place, Solita said, were not in its amenities. They rose at eight, had brioche and coffee for breakfast, ate lunch in a nearby bistro, La Quatrième République, wrote in the afternoons and early evenings, then met with Natalie Barney, Sylvia Beach and the 'accents we hoped to leave behind'. Twice a week they took French lessons. Janet wrote an autobiographical novel, *The Cubical City*, lesbian poetry in the style of Sappho and articles for newspapers and magazines. In 1925 she became Genêt of *The New Yorker* with her fortnightly 'Letter from Paris'.

She compared Dolly to someone from a novel:

> On the street, walking, or at a Paris restaurant talking…
> she seemed like someone one had become familiar with by
> reading, rather than by knowing.

Dolly had, she said, 'a floral quality which was the bloom of her charm'. This charm was enhanced by Dolly's drug habit. After shooting up heroin or snorting cocaine, she 'scintillated with epigrams' that no one could remember. She mixed with the Jean Cocteau set and scored her drugs from the *marchands de paradis* in the restaurants and bars off the Champs Élysées. Her father, like Natalie's, had been alcoholic.

the rat was Dolly

Within weeks of beginning a relationship with Natalie, Dolly

wrote of feeling tortured, of 'struggling to get her hand out of the trap'. Her letters were desperate:

> Do you love me? I wonder! Not that it matters at all. Perhaps I shan't even mind when you leave me – only then there could be no love making – *impossible* thought... Who will flee first? Just now I am too in love with you to dream of change... Did you know that it was nearly four o'clock when I left you last night? I ache with tiredness and darling I am *bruised*. Toujours. D

Once again, Natalie had started up a 'liaison' with a self-destructive young woman who was provoked by her infidelity and composure. Dolly beseeched Natalie not to leave her, not to stop loving her. 'You overshadowed me like a great mountain that at once uplifted me and awed me.'

Her love for Natalie, she wrote, 'shattered the fortress' of her self-sufficiency:

> You have held so many hands, so many waists, written so many love letters.

> Always wonderful Natalie, I miss you every night with fierce discomfort...

> Darling Natalie, don't shake me off. Don't stop loving me. You are the only serious thing in my life emotionally.

Natalie stored these letters in a wooden box. Dolly was not the only serious thing in *her* life emotionally. Always present were Romaine, Lily de Gramont, the marriage contract in a drawer, the liaisons and affairs.

In 1933 Romaine gave Natalie a warning. She said she had 'suffered it to pass' as merely unpleasant while Natalie had 'a not unfriendly tribe of second-rate young women', but Dolly Wilde was too much. Romaine called Natalie weak and governed by vanity. 'Your life at present is infested by rats, <u>& one of these rats is gnawing at the very foundation of our friendship</u>.'

That rat was Dolly. Unless Natalie got rid of her, she would leave. 'R might as well insist on your killing me as not to see you' was Dolly's response when Natalie told her of this.

Dolly was a liaison, and Natalie was not going to sacrifice a relationship for her. As with Renée Vivien, heroin and drug addiction dictated Dolly's demise. She tried cures, detoxifications, psychoanalysis, but always lapsed. She several times overdosed and slashed her wrists in suicide attempts. Natalie sent silk pyjamas and money. 'Romaine and Lily are the only people you give spiritually to... to the others you give material gifts,' Dolly told her.

In 1938, when she was forty-three, Dolly was diagnosed with breast cancer. She refused surgery. On 21 July 1939 the manager of the Hôtel Montalembert in Paris wrote to Natalie:

> I am told by friends of Miss Wilde that you are the person
> with the most influence over her. She is drinking so much that
> delirium tremens will follow and probably suicide. Also she
> emits piercing cries all night, alternating with groans which
> disturb her neighbours. I would be infinitely grateful if you
> could remove her to a sanatorium.

Dolly killed herself the following April with heroin and paraldehyde in a rented room in London. Ten years after her death, Natalie paid privately to publish *In Memory of Dorothy Ierne Wilde: Oscaria*. Printed by Darantiere Press, on the frontispiece was a photo of Dolly dressed as Oscar. It was an anthology of tributes: Janet Flanner called Dolly 'utterly singular and unique'. She had, she said, 'as many versions of herself, all as slightly different, as could have been seen in views of her supplied by a room lined with mirrors.' Gertrude Stein said, 'Well she certainly hadn't a fair run for her money.' Lily de Gramont wrote of her Irish beauty and social gift and 'extraordinary verbal gift inherited from her famous uncle'. She died, she said, '*encore jeune, encore*

belle, encore avide' – still young, still beautiful, still eager. Natalie threaded her way among these tributes, pulling them together, much as she did with the guests at her salon.

the wide literary lesbian web

Natalie helped make Paris the sapphic centre of the Western world. Beyond a carousel of changing partners was the need for self-expression, a yearning for love, and a determination to be free. Tolstoy's view in *Anna Karenina* that if there are as many minds as there are people, then there are as many kinds of love as there are hearts, resonated for lesbians who made their way to Paris. Expression of their love and interaction was disallowed in law. And so they wrote about themselves and each other, for themselves and each other. Their novels, poems and stories became a coded conversation.

Vita Sackville-West and Violet Trefusis together wrote a novel about their love affair. They variously gave it the title 'Rebellion', 'Endeavour' and 'Challenge'. Conformity won the day. Vita's mother, Lady Sackville, fearful of gossip, paid off the printer's costs and had the plates destroyed. 'If VT was a man I could understand,' she wrote in her diary. 'But for a woman, such a love beats me.' 'I hope Mama is pleased', was Vita's response, 'she has beaten me.'

'These Sapphists *love* women; friendship is never untinged with amorosity,' Virginia Woolf wrote in her diary in December 1925. She did not view herself as one of 'these Sapphists'. She described herself as 'sexually cowardly', and with 'a terror of real life'. Her novel *Orlando* was her gift to Vita, with whom she was, in her way, in love. No scandal attached to it. Virginia Woolf wrote with a literary eloquence that defied censorship, though her inspiration was androgyny, lesbian love and the elopement of Vita with Violet. The book was published to

critical acclaim in September 1928 and was in its third edition by December.

Retaliation came from Violet, banished to Paris and forced by her mother into a sham marriage. She was depicted in *Orlando* as the evil fox for whom English was 'too frank and candid a tongue'. Her reprisal, *Broderie anglaise*, was a roman à clef in French that was candid, frank and scathing. Broderie anglaise, a kind of English needlework that decorates holes, became her metaphor for the hypocrisy of her mother, Vita and Virginia. Virginia was portrayed as Alexa, 'an old maid', 'incomplete as a woman', her bed 'so small and shy' you can scarcely find it in the bedroom. Her hair was thin (Vita often talked of Violet's 'truly beautiful hair'). Everything about Alexa was cerebral: she had beautiful hands but was too thin, uninterested in food, wore dowdy clothes, was 'very Oxford'. A fifteenth-century Flemish painter would, Violet wrote, have 'portrayed her with a caged goldfinch and a carnation spotted with dew'.

Publication of *Orlando* coincided with the censorship for obscenity of Radclyffe Hall's *Well of Loneliness*. Virginia Woolf offered to testify in court in defence of *The Well*, though she thought it a 'meritorious dull book' and was relieved not to be called. Radclyffe Hall viewed her own sexual orientation as tragic. She called herself and Stephen Gordon, the hero of her book, 'congenital sexual inverts', using Havelock Ellis's terminology. His textbooks about such matters were also censored.

Natalie figured in *The Well* as Valérie Seymour, 'a kind of light-house in a storm-swept ocean' who in Paris gave courage to her dismal sisters in their tragedy of inversion.

Natalie as a real or fictional lesbian appeared in many of the poems, novels and memoirs of her friends and lovers: Liane de Pougy's *Idylle Saphique*, the poetry of Renée Vivien and Olive Custance, the landmark *Well of Loneliness*. Lucie Delarue-Mardrus,

in her novel *L'Ange et les Pervers* ('The Angel and the Perverts', portrayed her as a wealthy manipulative lesbian who lived for seduction:

> perverse, dissolute, self-centred, unfair, stubborn, sometimes miserly, often play-acting, irritating most of the time, a monster – but a true revolutionary who inspires others to rebel.

Djuna Barnes and *Ladies Almanack*

Djuna Barnes wrote *Ladies Almanack* at Natalie's suggestion in the year *Orlando* was published and *The Well* banned. Organized according to the months of the year and illustrated with twenty-two pen and ink drawings, it was a bawdy satire on lesbians in Natalie's circle.

In 1917, in 'The Mark on the Wall', Virginia Woolf wrote of how *Whitaker's Almanack* encapsulated patriarchal rule. Published annually in the United Kingdom from 1868, it was a trove of data, facts and figures about governments, rulers, kings and occasions.

Djuna Barnes's *Almanack* was designed as a manual for lesbians who 'discard Duster, Offspring and Spouse'. Constructed like a medieval calendar with monthly entries and zodiac signs that corresponded to some aspect of desire – the 'twining thigh', the 'seeking arm', the language was a mix of flowery Elizabethan and colloquial English with much use of capital letters, neologisms, cryptic allusions and filthy jokes. It was irreligious and subversive, a raucous lampoon, hilarious to those who knew the references.

Natalie, the central character, was Dame Evangeline Musset, a lesbian pope, whose desires were infinite and bed never empty. (Colette's lover, Missy, had termed Natalie 'the Pope of Lesbos'.) Dolly Wilde featured as Doll Furious or Doll on her Arm, or 'my great big beautiful bedridden Doll'.

> 'And' said Dame Musset, rising in Bed, 'that's all
> there is and there is no more.'
> 'But oh!' cried Doll.
> 'Down Woman,' said Dame Musset in her friendliest,
> 'there may be a mustard seed!'
> 'A grain, a grain!' lamented Doll.

Janet Flanner and Solita Solano were Nip and Tuck, journalists hampered by censorship restrictions. Nip cannot publish anything about Dame Musset and her minions. Una Troubridge was Lady Buck-and-Balk, who sported a monocle and communicated with spirits. Radclyffe Hall was Tilly Tweed-in-Blood who 'sported a Stetson and believed in Marriage' but only between women. 'One was to be a wife the other a bride.' Mimi Franchetti was Señorita Fly-About. Lily de Gramont was the Duchesse Clitoressa of Natescourt who often 'took tea' with the Dame. Romaine, Dame Musset's final choice in love, was Cynic Sal who wore a top hat, cracked a sharp whip and 'never once descended the Driver's seat to put her Head within'.

When Dame Musset died aged ninety-nine, forty women shaved their heads, carried her corpse through the streets of Paris and laid her on a funeral pyre. She burned to ash except for her tongue: 'it flamed and would not suffer Ash and it played about…'. Her acolytes sat on this tongue and 'from under their Skirts a slow Smoke issued'. They put the tongue in an urn on an altar in Dame Musset's temple of love, 'where it flickers to this day'.

Ladies Almanack, financed by Bryher, published by Contact Editions and printed in Dijon by Darantiere Press, had no

expectation of general release. One thousand and fifty copies were circulated among friends and acquaintances. Djuna hand-coloured the illustrations in forty copies. She feared confiscation by the postal service if she had page proofs delivered to her address, so she asked Sylvia Beach to take them at Shakespeare and Company. Sylvia refused. She foresaw trouble with the authorities even beyond the sort she got into when she published *Ulysses* in 1922.

Djuna managed to smuggle some copies into America:

> Sold all 50 Almanacks I brought in with me… and can sell 100 at $5 when they arrive if they get through the post. These problems are quite tame in comparison to the difficulties experienced by Hall in getting the *Well* published and distributed.

Natalie and her salon attendees knew each other, painted each other, wrote about each other, slept with each other. Theirs was a microcosm, a world within a world. They devised their own almanack, found their own way of being true to themselves.

For three decades, Natalie's salon was the sapphic centre of the Western world, beyond interference from the patriarchs of England and America, the fathers, dictators, legislators with their stately homes, swathes of land and titles and honours conferred: the Home Secretary, the Lord Chief Justice, the Secretary General, the Director of Public Prosecutions, the Attorney General, the Supreme Court, protectors of the status quo as laid down by their forefathers, with their sense of entitlement, for whom women had no rights beyond those they deigned to confer, for whom wives were servants and daughters possessions, and for whom the word 'lesbian' was on a par with 'pervert' because women's bodies belonged to men.

In 1940, one power branch of patriarchy – militaristic, fascistic – destroyed Natalie's particular kingdom of women, broke it

apart and made them run for cover. Nor, in Paris, did they reconvene.

death of Natalie

Natalie stayed true to the main business of her life. In February 1956, aged eighty, she travelled to Nice to visit Romaine, but took rooms at the Hôtel d'Angleterre so as not to disturb her. They lunched together each day, but for the rest of the time Romaine wanted to be alone. 'My angel's weary look made me very remorseful,' Natalie said. One afternoon in wintry sunshine, sitting on a bench in the Promenade des Anglais, she struck up a conversation with Janine Lahovary, who was Swiss, fifty-six, stylish and in a joyless marriage.

Madame Lahovary knew of Natalie's reputation. She described their ensuing relationship as a mental liberation and a resurrection. 'Natalie Barney has a new love affair. Isn't it wonderful?' Alice B. Toklas wrote to a friend. 'She's the one bright spot in a fairly cheerless world.' Romaine's response to Natalie's news was cool: 'A love affair can cause trouble at our age, so do be careful,' she wrote.

Natalie reassured Romaine she was 'as ever the nearest and dearest to my heart'. But Madame Lahovary wanted to be with her and Natalie was a pragmatist. She viewed an available lesser love as preferable to an empty bed. When Monsieur Lahovary asked Natalie to leave his wife alone, she asked him to leave his wife alone, too. After he died Janine moved from Switzerland to live with Natalie in Paris. She cooked for her and looked after her; when Natalie had a cold, Janine put cologne on cotton wool for her to sniff. To Romaine, Natalie described herself as quiet, well-fed and often bored. 'Even at night, each time I awake, you are my greatest preoccupation and greatest love', she wrote to her as late as May 1964.

Natalie outlived her other lovers. She was ninety-six when she died on Wednesday, 1 February 1972 in Janine Lahovary's arms. Two days later, she was buried near Renée Vivien in the cemetery at Passy. A photograph of Romaine was interred with her. Twenty people gathered for this, the last of her Fridays. One of them commented that Natalie would not have chosen to be among them. 'She never went to a funeral in her life.'

'We do not touch life except with our hearts,' was Natalie's view. Reaching out for love, was her life's work. 'It is not the love I receive, but the love I feel that matters,' she had written when young. Her life *was* her work of art: defiant, questing. Her concern was the open expression of lesbian identity. 'I am a lesbian. One need not hide it, nor boast of it, though being other than normal is a perilous advantage.' Natalie dared openly to break the rules of patriarchy. She gave courage to others to be true to themselves. And yet she knew how elusive her quest for intimacy was. Of Romaine she said, 'I belonged to everyone, she belonged to no one; we considered ourselves quite different, and yet in our loneliness we were alike.'

GERTRUDE STEIN

'Pigeons on the grass alas.
Pigeons on the grass alas…
If they were not pigeons on the grass alas
what were they.'

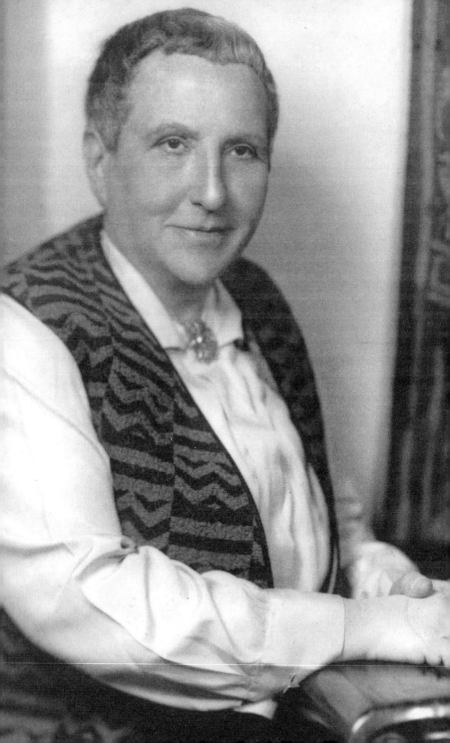

Gertrude Stein and her partner, Alice B. Toklas, were at the cultural heart of Paris for four decades. Intrinsic to the modernist movement, an indomitable duo, photographed by Man Ray, painted by Picasso, featured in memoirs, they were a sight to be seen.

'The two things you never asked Gertrude, ever', the composer Virgil Thomson said, 'were about her being a lesbian and what her writing meant.' Gertrude was terse on both subjects. About being lesbian she said: 'I like all the people who produce and Alice does too and what they do in bed is their own business and what we do is not theirs.' She was equally laconic about her writing. 'Twentieth-century literature is Gertrude Stein,' she said without irony. After a public reading of an unfathomable piece of her prose, an audience member asked her why she did not write the way she spoke, for she was direct and down-to-earth in conversation. 'Why don't you read the way I write?' was her reply.

She was large, though not in height. In portraits and photographs her eyes look thoughtful, her face strong. In bulk and stillness she was like a Buddha. Her handshake was warm, her laugh infectious and her hair brown. She liked loose comfortable clothes with deep pockets and she wore sandals over her socks in winter, made for her by Raymond Duncan, dancer, philhellene and brother to Isadora. Comfort dictated what she wore, but she cared about the quality of the silk of her shirts, the provenance of the brooch at her throat, the way her neck scarf was tied. Above all, she was comfortable with herself. People valued her friendship and opinion and had a good time in her company. As with Natalie, she thought living was the first of all the arts but whereas for Natalie that meant lots of lovers, for Gertrude living meant the uxorious company of her partner and home builder, Alice B. Toklas.

Alice was under five feet tall and her legs dangled when she sat. She had grey eyes, dark hair and a moustache, which the editor

of *House Beautiful* said made other faces look naked by comparison. Her senses of smell and taste were acute, though she was a heavy smoker. She took great care of her hands and nails, which she massaged and manicured daily, and she always carried both her own and 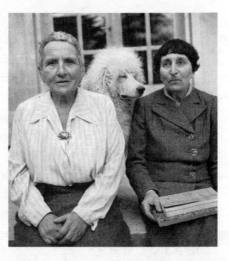 Gertrude's bags and umbrellas, or sat in the less comfortable chair, or walked behind Gertrude. But she fostered this image of the self-effacing handmaiden and it belied her forceful role in their relationship.

Gertrude achieved her status as notable lesbian and architect of modernism without seeming to expend effort. 'To try is to die,' she said. Though above all she championed her own work, she furthered a galaxy of careers. Before they were famous, and for not much money, she bought the work of and praised Matisse, Picasso, Cézanne and other artists whom the establishment decried as 'wild beasts'. She guided and encouraged Ernest Hemingway, F. Scott Fitzgerald and Paul Bowles early in their careers.

In Gertrude's view, she just happened to be a genius. 'Think of the Bible and Homer think of Shakespeare and think of me,' she advised. That was how things were, like oak trees were programmed to be oak trees and rivers ran down to the sea. She lived as she chose and thought others should do so too. The bones of her lesbian love life were that as a student at Johns Hopkins University in 1900 she had an unhappy triangular affair with May Bookstaver, a graduate student, and that in Paris in 1906

she met her partner for life, Alice B. Toklas. 'Little Alice B. is the wife for me,' she wrote. These were not topics for gossip, theory or censure. They were how it was and who she was. If others objected or took offence, that was their problem. Gertrude held libertarian views and was of a generous nature, but she was too comfort-loving and individualistic to struggle for a cause. Living happily with Alice, eating long lunches, talking with friends, walking the dog, driving the car, writing her modernist prose and being a genius took her time. She championed ordinary, homey living: 'I have it, this interest in ordinary middle class existence', she wrote in her autobiographical modernist magnum opus, *The Making of Americans*:

> in simple firm ordinary middle class traditions, in sordid material unaspiring visions, in a repeating, common, decent enough kind of living, with no kind of fancy ways inside us, no excitements to surprise us, no new ways of being bad or good to win us.

She was born in 1874 and died in 1946: in that span of time she lived through political upheaval and the slaughter of a billion people in two world wars. This turbulence and carnage was, she averred, a product of patriarchy:

> father Mussolini and father Hitler and father Roosevelt and father Stalin and father Lewis and father Blum and father France... There is too much fathering going on just now and there is no doubt about it, fathers are depressing.

Gertrude was not answerable to any father, from God down. She was true to herself, pursued her own ambition and kept to her own theory of obligation and personal value judgements. Freedom of thought and expression defined her. To be lesbian was to differ from the mainstream, slough off the directives of fathers and depart from nineteenth-century thinking, but in her lifestyle, apart from her and Alice both being women, she did not want

to change the recognized values of harmonious married life. It was in art and literature that she departed from patriarchal ideas, dogmas and past conventions of style and content, left behind old ways of seeing and saying, forged new ways of expression and took credit as the mother and father of modernism.

She resented the attention given to James Joyce's *Ulysses* and cancelled her subscription to the Shakespeare and Company lending library when Sylvia Beach published it. She viewed Joyce as her rival and said he smelled of museums and that was why he and not she was accepted. 'You see it is the people who generally smell of the museums who are accepted and it is the new who are not accepted.' They only met once, at a party given by the American sculptor Jo Davidson, who did a sculpture of Gertrude. Sylvia Beach introduced them. Gertrude said to Joyce, 'After all these years.' Joyce said, 'Yes, and our names always linked together.' Gertrude said, 'We live in the same arrondissement.' And with that their one and only exchange ended.

Gertrude's parents

In her writing, the bones of biography, what happened when and where, did not concern Gertrude. She was laconic about her early years:

> I guess you know my life history well enough – that I was in Vienna from six months of age to four years, that I was in Paris from four years of age to five, that I was in California from six years of age to seventeen and that I was born in Allegheny, Pennsylvania.

That was as empirically revealing as Gertrude felt she needed to be. Her concern was with philosophical and psychological concepts: existence, identity, descriptions of fundamental aspects of human nature: 'bottom nature', she called it.

The Steins were German-Jewish immigrants for whom English was a second language. For the first four years of her life Gertrude heard 'Austrian German and French French' then, when she was five, 'American English'. 'Our little Gertie is a little schnatterer,' her Hungarian governess wrote in 1895:

> She talks all day long and so plainly. She outdoes them all.
> She's such a round little pudding, toddles around the whole
> day and repeats everything that is said or done.

Repeating everything figured in Gertrude's adult writing too. Her detractors ridiculed the extent of it. 'The hymn of repetition,' she called it. It became her stylistic stamp:

> She had sound coming out of her. She was knowing that thing.
> She had had sound coming out of her she was knowing that thing.
> He had had sound coming out of him she was knowing that thing.
> He had sound coming out of him she was knowing this thing...

was immediately recognizable as Gertrude's inimitable or imitable innovative prose. But her father, Daniel Stein's, discursive letters, scornful of syntax, grammar or punctuation and eliding into a rambling outpouring, perhaps found echo in her own modernist, unbridled style. And her youngest brother, Simon, whom she described as simple minded, did seem to suffer from some sort of echolalia – a prolix rambling that Gertrude's critics thought infused her writing too.

Daniel Stein and his four brothers dealt in imported textiles. They prospered but quarrelled. Gertrude said her father 'liked to buy things and have big undertakings'. He was uncertain whether to live in Maryland, Pennsylvania, California or Europe. He had little brown eyes, 'sharp and piercing and sometimes dancing with laughing and often angry with irritation'. He had rapid mood swings and could be terrifying – he would pound the table, say he was the father, they were his children, they must

obey him or he would know how to make them. They were afraid
of and confused by him and never knew when playfulness would
change to an outburst and how far that would go. In the street he
muttered to himself, swept the air with his stick and held forth
about the weather or the fruit and made them feel embarrassed.
'Come on papa, all those people are looking,' they would say. He
took cake or fruit from street stalls and gave it to them, leaving
them uncertain whether he would pay the vendor. Sometimes
he forgot about Gertrude and her brother Leo if he was with
them. He dragooned his children into card games then, after a
few minutes, got impatient and told the governess to take over
because he hadn't time to go on playing. Then he left them with
a game none of them was interested in or would have thought of
beginning and nor could they abandon it because he would keep
coming in to see who was winning.

He was an ever-increasing problem as Gertrude and Leo
grew up. They were ashamed of him because he was so peculiar,
and frightened of his unpredictability. He was eccentric and even
a little mad:

> His children never could lose, until they grew up to be queer
> themselves, each one inside him, the uncomfortable feeling
> his queer ways gave them.

Leo in particular disliked and resented him. He described him
as stocky, dominant, aggressive and ill-educated and felt afflicted
by him with a deep neurosis. When adult, in an autobiographical
book *Journey Into the Self*, Leo tried to make sense of what he saw
as his father's malign influence.

Gertrude conceded her father encouraged a sense of freedom
in his children, but she had no love for him, though she looked
like him and felt there were similarities in their temperaments.
He was not appreciative of her. Like Sir John Ellerman and
Albert Barney, he let his daughter know she was not the kind

of daughter she ought to be. 'She was not very interesting ever to her father,' Gertrude wrote of herself. He criticized how she looked and said she was never thorough in anything. He wanted her to do housekeeping, dressmaking and cooking. Nothing Gertrude cooked turned out right.

> And then he would be full up with impatient feeling that she could not do that thing, that always she was not, as he put it, ever thorough in anything.

Mostly he took no notice of her and she did what she liked. But then capriciously he would say she must not go out that evening, she must stay in the house with her mother. Gertrude, he told Leo, was his responsibility:

> You have to take care of her sometime and you might as well begin, the sooner the better. You will have to do it sooner or later I tell you.

Gertrude, though uninteresting to her father, chose to become interesting to herself. And she was the centre of Alice B. Toklas's universe.

Daniel Stein married Amelia Keyser, 'a sweet gentle little woman', in 1864 soon after their first meeting. She was twenty-one, he was ten years older. One of his brothers arranged the marriage. Sometimes, said Gertrude, her father thought his wife was a flower; usually he forgot she existed. She called him Darling Dan or Dear Dan in her diaries and worried about his moods, his travels away from home and his health.

In her turn, Gertrude dedicated her books to DD, her Darling Darling, her Alice B. Toklas, her spouse in all ways but the law of any land.

Amelia was a good wife, an efficient housekeeper and the mother of nice children. She sewed, cooked and polished. Leo said she only read two books in her life: *Home Influence: A Tale*

for Mothers and Daughters and *The Mother's Recompense*, both by a Sephardic Jewish novelist, Grace Aguilar, who settled in Hackney in London. He never saw his father read a book of any sort.

Gertrude thought her mother oblivious to the individual characters of her children: she treated them fairly, bought presents for their birthdays, thanked God when Bertha's sore foot got better, Leo recovered from the measles or Gertrude from diarrhoea, but she did not relate to them as individuals:

> She was never important to her children excepting to begin them. She was a sweet contented little woman who lived in her husband and children, who could only know well to do middle class living, who never knew what it was her husband and her children were working out inside them and around them.

Gertrude in her own way championed her mother's bourgeois values and love of daily living, an orderly home, good food and comfort.

Gertrude and Leo's childhood

Amelia Stein became ill with bowel cancer in 1884 when Gertrude was ten. Daily, she wrote in her diary 'not quite well'. She chronicled doctors' appointments, salt baths and radiation treatments. Mothering became too much for her.

Unsupervised, Gertrude and Leo disappeared for days at a time, camping alone in the hills. They 'dragged a little wagon and slept closely huddled together'. They had a gun, and shot birds and rabbits. Nights were beautiful. 'In other lands the heavens appear as a surface; here every star shines down out of the blue behind it.' They spent their pocket money on books and read widely and unselectively – Wordsworth, Scott, Bunyan's *Pilgrim's Progress*, Shakespeare's plays, Congressional Records, science and

history books. Gertrude read the Bible to find out about eternity: 'There was nothing there. There was God of course and he spoke, but there was nothing about eternity.'

Her favourite things were books and food:

> Evolution was all over my childhood... with music as a background for emotion and books as a reality and a great deal of eating as an excitement and as an orgy... Most of all there were books and food, food and books, both excellent things.

Books and food were abiding passions for Gertrude. Most of the Steins were very large and keen on food. Simon, Gertrude said, would eat a family-sized rice pudding at one sitting. A problematic relationship to food affected many of her relatives. Grandma Stein was a mountain of a woman and one of her sons died from obesity. Leo, when adult, was anxious and fetishistic about his diet, had digestion problems, went on punishing fasts and regimes of raw vegetables and nuts and said he did not know when he was hungry. He blamed their father's weird control about what could or could not be eaten. Gertrude said of her father and food:

> He always liked to think about what was good for him in eating. He liked to think about what was good for everyone around him in their eating eating. He liked to buy all kinds of eating, he liked all kinds of thinking about eating, eating was living to him.

Alice more than attended to Gertrude's kinds of eating eating, as her recipes, published after Gertrude's death in *The Alice B. Toklas Cookbook*, testified.

Gertrude was the youngest of the five Stein children; Leo was two years older:

> It is better if you are the youngest in a family to have a brother two years older, because that makes everything a pleasure to

you, you go everywhere and do everything while he does it all for you and with you which is a pleasant way to have everything happen to you.

As a child, Gertrude was emotionally dependent on Leo. With little parental support or guidance, they turned to each other for comfort and safety. Neither felt close to their brothers and sister. They respected Michael but he was older, with the demeanour of the responsible eldest son. Bertha 'was not a pleasant person', Gertrude said. She shared a bedroom with her. 'It is natural not to care about a sister, certainly not when she is four years older and grinds her teeth at night.' She 'married a man who well they married'. Leo's only adult recollection of Bertha was a little girl on a chamber pot. In October 1941, aged nearly seventy, he dreamed he was married to her, which he found intolerable. In his dream she wanted to sleep with him but he insisted on going to another bed. Possibly when young and motherless there was some kind of sexual exchange between Leo and Gertrude. She was the sister he loved.

Her younger brother, Simon, had, she said, 'a very good nose and foolish but not silly eyes and he loved eating and fishing'. She tried, when she was eleven, to teach him that Columbus discovered America in 1492. She asked him each morning and evening, but he could never remember. He achieved little at school and when he left had difficulty in getting or keeping a job.

death of mother and father

In 1888, when Gertrude was fourteen, her mother, Amelia, died. 'We had already had the habit of doing without her,' Gertrude wrote, but after her death any semblance of family life disintegrated. Michael was a student at the Johns Hopkins University

in Baltimore, Bertha could not manage the housekeeping, the dining table was no longer laid and they all ate what and when they pleased. Gertrude and Leo sometimes talked and walked all night and slept all day.

And Father 'was more a bother than he had been'. He shut himself away for days at a time, was irritable and anxious, took out his frustrations on his children and his business affairs became erratic. He speculated with money and lost it. Leo and Gertrude bought books in the hope of them being an investment when financial ruin came: Shelley in green Moroccan leather binding, an illustrated set of Thackeray's novels.

This chaotic home life caused Gertrude what she called an 'agony of adolescence'. She had panic attacks and thought she was breaking down. She described her early childhood as a civilized time of evolution and order and her adolescence as medieval:

> Medieval means that life and place and the crops you plant and your wife and children are all uncertain. They can be driven away or taken away, or burned away, or left behind…
>
> Fifteen is really medieval and pioneer and nothing is clear and nothing is safe and nothing is come and nothing is gone. But all might be.

She dropped out of Oakland High School and did not know where to go or what to do. Leo did a year as a 'student at large' at the University of California at Berkeley, and father

> naturally was not satisfied with anything. That was natural enough… Then one morning we could not wake up our father. Leo climbed in by the window and called out to us that he was dead in his bed and he was… Then our life without a father began. A very pleasant one.

Natalie Barney had a similar response when her father died: she observed his corpse but felt no grief. Daniel Stein died in 1891, three years after his wife. He was fifty-seven. Michael,

who was twenty-six, said he died from overeating. He took over as head of the family. Gertrude was seventeen, Leo nineteen. Michael became their legal guardian. 'I remember', Gertrude wrote, 'going to court for the only time I was ever in one to say that we would have him.'

Michael took his responsibilities towards his brothers and sisters to heart. As Alice B. Toklas put it:

> He saw not any one of them would ever earn any money. None of them were made for a business career. And he didn't think of any profession in which they would succeed.

Daniel Stein's financial affairs were in a mess. 'There were so many debts it was frightening', Gertrude wrote, 'and then I found out that profit and loss is always loss... and it was discouraging...'

Despite debts, her father's will revealed his ownership of 480 acres of land, property in Baltimore and California, shares in cable, railroad and mining companies and, most lucrative of all, the franchise for an undeveloped project to consolidate the various street railroad systems in San Francisco. Michael Stein sold this franchise to the railroad magnate Collis P. Huntington and became supervisor of the newly formed Market Street Railway Company. His acumen in dealing with their father's affairs secured for Gertrude and her siblings an income for life. Gertrude described their inherited income as enough to keep them 'reasonably poor'. Others might think it was enough to keep them reasonably rich. It allowed them to travel, buy books and paintings and be free from the need to work for a living.

student days

For a year after their father's death, the four children lived together in San Francisco with Michael as head of the household. 'Then we all went somewhere,' Gertrude wrote. She and

Bertha spent time in Baltimore with their maternal aunt, Fannie Bachrach. Leo went to Harvard to study law, Michael stayed on in San Francisco for a few years with the Railway Company and married a strong-willed, assertive woman, Sarah Samuels, quite unlike his meek mother, Amelia. Simon was the only one to spend the rest of his life in California. Michael found him a job as a part-time gripman – a cable car operator. He died in the city in middle age, 'still fat and fishing'.

Gertrude chose to study medicine at the Johns Hopkins Medical School with a view to becoming a psychologist. She planned to specialize in nervous diseases in women and needed a degree in medicine for this. Her tutor, William James, 'the father of American psychology',* had published *The Principles of Psychology* in 1890 and was the first academic to offer a psychology course in the United States. Theodore Roosevelt and George Santayana were among his pupils. Gertrude was impressed by him and he with her, and they became friends.

Gertrude was taken with William James's idea that automatic writing was a pathway to reveal aspects of personality beyond consciousness. 'Automatic', not edited or honed, became the methodology of her prose style: the suspension of critical inter-vention, words allowed to spin out like a spider's web from what was hidden within her. She thought her automatic writing had an integrity beyond that of reasoned linear narrative.

For the first two years of studying medicine, Gertrude's grades were good: 1 for anatomy, 1.5 for normal histology, pathology and bacteriology, 2 for physiology, pharmacology and toxicology. She was a star pupil, though a fellow student, Arthur Lachman, who described her as big, floppy and besandalled and with a laugh

* William James was the first to recognise psychology as an independent discipline.

like a beefsteak, said she got into a muddle when told to make a model of a human embryo. She produced a fantastic construction with its spinal cord wrapped around its head.

But in her third year Gertrude both lost and found her way. She fell in love with a Bryn Mawr graduate, May Bookstaver, 'a tall American version of the handsome English girl – upright and a trifle brutal'.

passionate yearnings

Gertrude spoke of 'passionate yearnings', longings and desires. Her academic ambitions ended. 'Books, books, books', she wrote in one of her essays, 'is there no end to it. [...] Nothing given me but musty books.' May Bookstaver was already in a relationship with another graduate, Mabel Haynes, and from the start, Gertrude knew this might doom the love she felt. She explained to May that:

the middle class ideal which demands that people be affectionate, respectable, honest and content, that they avoid excitements and cultivate serenity is the ideal that appeals to me.

She believed physical passion, to be worth anything, must involve idealizing another. May told her, 'You are so afraid of losing your moral sense that you are not willing to take it through anything more dangerous than a mud puddle.'

Gertrude told her she 'feared passion in its many disguised forms', that she did not understand it, it had no reality for her. 'That is what makes it possible for a face as thoughtful and strongly built as yours to be almost annoyingly unlived,' May told her. Gertrude declared herself 'a hopeless coward. I hate to risk hurting myself or anybody else. All I want to do is meditate endlessly and think and talk.' But then May 'let her fingers flutter vaguely' near Gertrude's lips. Gertrude looked at the sky,

talked of honesty, then found herself 'intensely kissed on the eyes and lips'. She was unresponsive. 'I was just thinking...' she said. 'Haven't you ever stopped thinking long enough to feel?' May replied.

From then on, Gertrude could not extricate herself from what became a clichéd triangular affair, albeit between three women. Mabel Haynes had the stronger position, the prior claim and a financial hold over May Bookstaver. Gertrude, the usurper, the affair, the mistress, the infidelity, was expected to hide her involvement, be discreet and self-effacing. She and May met secretly in restaurants and museums, for walks in the park, at the apartments of friends who were away.

As the affair wore on, Gertrude felt herself trapped in 'unillumined immorality'. 'I never wanted to be a hero, but on the other hand I am not anxious to cultivate cowardice,' she wrote. She hoped some day to find a morality 'that can stand the wear and tear of real desire'. There were no helpful models in her family. Leo wrote to her in Baltimore, from Paris, of nights that 'cost me a hundred and fifty francs for champagne, eats, and the lady between midnight and six o'clock'. Michael's wife, Sarah, who had given birth to a son, wrote to her of the wonders of motherhood and of her doctor, whom Gertrude would 'adore meeting', who treated girls for 'self-abuse' by giving them 'very strong medicine to dissipate their sensations'. He said in cases of long practice the only recourse was to remove the ovaries. Sarah hoped Gertrude would marry this doctor, 'were you willing and if you have not formed any prior attachment'.

Gertrude grew to hate the 'turgid and complex world of divided emotions'. She longed for

> obvious, superficial, clean simplicity... no amount of reasoning
> will help in deciding what is right and possible for one to do.
> If you don't begin with some theory of obligation, anything is

possible and no rule of right and wrong holds. One must either accept some theory, or else believe one's instinct or follow the world's opinion.

She favoured a theory of obligation, of fidelity to commitment made. Natalie Barney believed in her own instinct, which led her to many a bedroom and grassy glade. Gertrude hated the jealousy and complexity of a triangular affair, found the feelings it provoked destructive and hurtful and wanted commitment and trust. It was not a question of rules of right or wrong. She did not like provocation and insecurity. She did not care about the 'world's opinion', which was antipathetic to same-sex relationship, but she did not want to be hurt, nor did she have Natalie's poly-amorous appetite. She wanted to replicate the safety she only fleetingly enjoyed before her mother became mortally ill.

In summer 1901, Mabel and May went on holiday together to Europe, leaving Gertrude waiting for infrequent letters. 'The pain of passionate longing was very hard to bear.' She wrote to May: 'I am now convinced my feeling for you is genuine and loyal. I dread you giving me up. I dread more being the cause of serious annoyance to you.'

May replied:

> Oh you stupid child, don't you realise that you are the
> only thing in the world that makes anything seem real or
> worthwhile to me. I have had a dreadful time this summer.

There were jealous scenes, painful separations and intermit-tent ecstasy. Mabel read a letter May was writing to Gertrude:

> She said she found it but I can hardly believe that. She asked
> me if you care for me and I told her that I didn't know and I
> really don't dearest… The thing upset her completely and she
> was jealous of my every thought and I could not find a moment
> even to feel alone with you. But don't, please don't, say any

more about giving you up. You are not any trouble to me if you will only not leave me.

May Bookstaver was not going to choose between her and Mabel. The affair dragged on. Gertrude did no academic work. Her teachers

would ask her questions although as she said to her friends it was foolish of them to ask her when there were so many eager and anxious to answer. However they did question her from time to time and as she said, what could she do she did not know the answer.

In her final year, Gertrude, once the star pupil, was the only one in her class of fifty-four to get a grade lower than 3. She got 4 in ophthalmology, otology and dermatology and 5 in laryngology, rhinology and obstetrics. She said she thanked her tutors for failing her:

You have no idea how grateful I am to you. I have so much inertia and so little initiative that very possibly if you had not kept me from taking my degree I would have, well, not taken to the practice of medicine, but at any rate to pathological psychology and you don't know how little I like pathological psychology and how all medicine bores me.

Other women students accused her of harming the struggle for equality and recognition. 'Remember the cause of women,' they said. Gertrude responded: 'You don't know what it is to be bored.'

Gertrude recounted this in the 1930s when she was sure of her influence and status, safe in her personal life, respected by her peers, confident of her judgement, opinions and views. At the time, academic failure coincided with emotional and intellectual confusion and unhappiness. Her unworkable love affair infected her with rootlessness and uncertainty.

London then Paris

In the summer of 1902, Gertrude joined Leo in Italy, then they travelled together to London and rented rooms in Bloomsbury. Leo bought his first oil painting – a seascape by Philip Wilson Steer, who was an influential art teacher at the Slade and a friend of Sickert. Leo said he felt like a desperado: oil paintings were for the rich. He and Gertrude visited the art historians Bernard and Mary Berenson in Surrey and met Bertrand Russell, 'a young mathematician of genius', Leo called him. Russell was married to Mary Berenson's sister Alys.

Discussions with the Berensons and Russell set Gertrude thinking about the novel she wanted to write: *The Making of Americans: Being a History of a Family's Progress*, her 900-page novel about herself, 'bottom nature' and 'every kind of men and women and all the kind of being in them'.

> I wanted to find out if you could make a history of the
> whole world, if you could know the whole life history of
> everyone in the world, their slight resemblances and lack
> of resemblances...

With the Berensons and the Russells, she and Leo discussed where and how to live: 'We have America versus England disputes all the time,' Leo wrote. 'The general theme is why in the name of all that's reasonable do you think of going back to America.' Gertrude planned to stay away for a year to free herself from May Bookstaver, but when Leo returned to Paris in December she was lonely.

She spent her days in the British Museum Reading Room. She planned to read all English literature, from the sixteenth century on, as background material for her novel about everybody in the world. She bought little grey notepads, made lists of books to read, arrived at the museum early in the morning, copied out

passages that resonated, took breaks only when hungry and read until closing time. When not in the museum, she wandered the streets of London and felt homesick for America and depressed:

> The time comes when nothing in the world is so important as a breath of one's own particular climate. If it were one's last penny it would be used for that return passage...
>
> An American in the winter fogs of London can realise this passionate need, this desperate longing in all its completeness. The dead weight of that fog and smoke-laden air, the sky that never suggests for a moment the clean blue distance that has been the accustomed daily comrade, the dreary sun, moon and stars that look like painted imitations on the ceiling of a smoke-filled room, the soggy, damp miserable streets and the women with bedraggled frayed-out skirts...

Gertrude endured this until February 1903, then headed back to Baltimore. She shared a flat with Johns Hopkins friends: Mabel Weeks, Harriet Clark and a sculptor, Estelle Rumbold Kohn. She wrote notes for possible stories, analysed herself and her friends but became ensnared again in the affair with May. She despaired, felt they were incompatible, that 'their pulses were differently timed' and that this incompatibility had been there from the start. In summer, in a renewed effort to get away from the emotional tangle of her affair, she sailed to join Leo in Paris, intending the visit to help separate her from May. From then on, Paris became her permanent home.

with Leo in Paris

'Paris was where the twentieth century was', Gertrude wrote, 'the place that suited those of us who were to create twentieth century art and literature.' She was twenty-nine and ambitious to be a writer. In Paris she flourished as who she was. 'Our roots

can be anywhere and we can survive because if you think about it we take our roots with us,' she said. It was not just what Paris gave, but all that it did not take away.

Leo had paved the way for her. Before she joined him, he had travelled to Japan, Ceylon, Cairo, collecting prints and art objects but uncertain which of his many interests to pursue. He went to Paris in 1902, intending to look at paintings. In his impulsive way he then decided to become an artist. He booked into a hotel, enrolled, like many Americans, at the Académie Julian at 28 Boulevard St-Jacques in the 6th arrondissement, did drawings of statues in the Louvre and life studies of his own body, and set out to learn the art market. He was a sociable man, intensely curious, and in Left Bank Paris writers and artists were valued. The art critic Bernard Berenson was his mentor, the cellist Pablo Casals a dining companion.

Leo's maternal uncle, Ephraim Keyser, a sculptor and teacher, told him of a studio for moderate rent at 27 rue de Fleurus, a short street off boulevard Raspail near the Luxembourg Gardens. It was a stone building, seven years old. A central archway led to a small paved courtyard; on the left was the concierge's office, to the right a two-storey apartment with kitchen, double-doored dining room and study, and on the floor above two bedrooms and the bathroom. There was an adjacent studio angled to catch the north light.

'I've got my house, my atelier and my fencing school all engaged for the summer as likewise a cook lady…' Leo wrote to Mabel Weeks, a student friend of Gertrude's. He asked Gertrude to come and live with him, hoping she would anchor him. She was hesitant, but agreed to join him for the summer. She stayed until her death in 1946.

They travelled to Rome, Florence and Fiesole to look at paintings. They met up with the wealthy Cone sisters, Claribel and Etta, Baltimore friends of Gertrude's, who were keen art

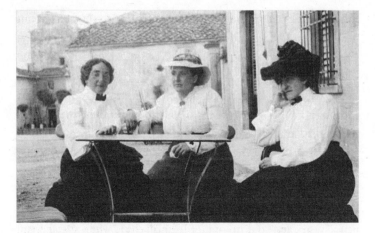

collectors. 'Gertrude and Sister C. came,' Etta wrote in her diary. 'Had a table d'hôte dinner at Fiesole and all got drunk... Gertrude and I lay there and smoked... Gertrude is great fun.'

Gertrude then went back with Leo to rue de Fleurus. Together they bought stuff for the apartment: high-backed Renaissance chairs, a fifteenth-century buffet decorated with carved eagles, seventeenth-century terracotta figurines, Italian pottery and, above all, paintings. Leo led the way but it became a joint enterprise, a shared enthusiasm. They bought prints – a picture of a woman in white with a white dog on a green lawn by Raoul du Gardier (a French painter and engraver with a studio in boulevard du Montparnasse), but the contemporary figurative work Leo saw did not particularly interest him and the older paintings were too expensive. 'I wanted an adventure,' he said.

her fit vocation

Paris worked its magic for Gertrude: the apartment was lovely, Hélène, Leo's cook, served an excellent roast chicken, Leo was protective, a fixed income went further than in the States.

To exorcise May Bookstaver, she wrote in fictional form about

the affair. She worked in the studio adjacent to the apartment: 'Leo never did paint there. I sat down in there and pretty soon I was writing and then he took a studio elsewhere, and we lived together there…'

She called her novel *Q.E.D.* May Bookstaver's letters were her reference material and they showed what she knew they would prove. Quod Erat Demonstrandum. The novel was a literal portrayal with only the names changed and her thesis was that the relationship had an inevitable trajectory, clear from the start. She wrote FINIS on the last page on 24 October and put the manuscript away in a cupboard. She said she forgot about it for thirty years and told no one of it until 1932, when she showed it to her agent, William Bradley – he and his wife, Jenny, were agents for most of the 'Paris exiles'. They discussed publication but he advised against, because it was about lesbians. Alice B. Toklas, by then Gertrude's partner for twenty-six years, read the manuscript and in a jealous rage destroyed all May Bookstaver's letters to Gertrude. *Q.E.D.* was not published until 1972, when all involved were dead.

After finishing *Q.E.D.*, and while making notes for her book about everybody in the world, Gertrude began writing *Three Lives*, fictional stories of three women, or as she put it 'a German woman, a German American woman and a negro woman, three serious stories and in each story one of them'.

In December 1903 Michael gave up managing the railroads and moved to Paris with Sarah and their young son, Allan. He realized that he, as well as Gertrude and Leo, could have enough money to live in Paris on the dividends from his various investments. He was known by some as Mr Sarah Stein. His wife was boss. They rented an apartment converted from a Protestant church, at 58 rue Madame, near rue de Fleurus. The living room, which had been a schoolroom, measured 40 × 45 feet.

'In our American life', Gertrude wrote in her second novel, *Fernhurst*:

> where there is no coercion in custom and it is our right to
> change our vocation so often as we have desire and opportunity,
> it is a common experience that our youth extends through
> the whole first twenty-nine years of our life and it is not till
> we reach thirty that we find at last that vocation for which
> we feel ourselves fit and to which we willingly devote
> continued labor.

By 1904, Gertrude was thirty and writing was her fit vocation to which she 'willingly devoted continued labor', albeit as the years went by only for half an hour after dinner. Her drifting days were done. She and Leo created a home together that quickly became famous. He went to art school in the mornings and a life-drawing class in the afternoons, but, unlike Gertrude, he could not settle to any profession.

collectors of modern art

Leo was at ease with Gertrude and wanted to spend the rest of his life with her. He rescued her when she was in turmoil and gave her a context to find herself. Their pleasure was to buy modern paintings together. Leo described this as a big adventure. They set themselves a limit of 300 francs a picture and purchased not with thoughts of investment, but because they liked the pictures and wanted to hang them on the apartment walls. They could only afford work by relatively unknown artists.

The adventure began in spring 1904. Bernard Berenson was in Paris. He asked Leo, 'Do you know Cézanne?' Leo said no. Berenson told him of Charles Loeser, an American art historian who lived in the Villa Torri Gattaia in the Florentine hills and had a collection of Cézanne's paintings. That summer, Gertrude

and Leo visited Loeser and saw an array of Cézanne's work. Leo said he went back to Paris 'a Columbus setting sail for a world beyond the world'. He and Gertrude went straight to the art dealer Ambroise Vollard's musty little shop, crammed with pictures, in rue Laffitte. Vollard had organized Cézanne's first one-man exhibition in Paris in 1895 and had a large stock of his paintings. A keen collector, he bought directly from artists, sometimes all the paintings in their studios en bloc, and he had a stash of work by Van Gogh, Gauguin, Bonnard, Vuillard, Derain, Rouault, Rousseau, Picasso and Matisse. He often commissioned portraits of himself from these artists.

Vollard got out paintings by Cézanne of an apple, a nude, a fragment of landscape, a small landscape of Aix-en-Provence, which both Gertrude and Leo liked.

Gertrude wrote to Mabel Weeks using the voice of one of her fictional characters, Melanctha in *Three Lives*:

> We is doin business. We are selling Jap prints to buy a
> Cézanne at least we are that is Leo is trying. He don't like
> it a bit and makes a awful fuss about asking enough money but
> I guess we'll get the Cézanne… That is Leo's connoisseurship.
> It's a bully picture all right.

Also in rue Laffitte was the confectioner Fouquet, where Gertrude and Leo treated themselves to strawberry conserve in a glass bowl or honey cakes and nut candies.

In October 1904 the second autumn salon opened at the Grand Palais in the Champs Élysées. The autumn salons began as a showcase for new artists, in contrast to the more staid spring salons. There was a whole room of Cézannes, fourteen paintings by Matisse, work by Toulouse-Lautrec, Bonnard and Vuillard. For Gertrude and Leo, the show was a turning point in their passion for modern art. That month, Michael said they had an unexpected windfall of 8,000 francs between them. They went

to Vollard's, looked through his stacks of canvases, chose two Gauguins – *Three Tahitians* for Leo and *Sunflowers* for Gertrude ('they were rather awful, but finally we liked them,' she said); two versions of Cézanne's *The Bathers* and two Renoirs. Gertrude said they bought in twos because they couldn't agree on which they preferred. They still had money left, and over honey cakes at Fouquet's discussed buying a big portrait by Cézanne of his wife, Hortense, sitting in a red armchair. They took it home in a taxi and hung it in the studio where Gertrude worked at night.

The little-known artists whose paintings they bought, happened to be Matisse, Picasso, Cézanne... For Gertrude, the ideas resonant in their work – new ways of seeing and departure from received forms of expression – echoed her own thinking. Within a short space of time, her and Leo's collection was worth more than a great deal of money.

Madame Cézanne

Gertrude thought the portrait of Madame Cézanne revolutionary. It influenced her writing of *Three Lives*. She said Cézanne built up his portrait with planes of colour and she built up her characters with repetitive sentences. She said there was no centre to the picture to give it an organizing principle: the composition was the picture and she saw in this what she herself wanted to do. She wanted the mental processes of her characters to shape her prose and for her writing to be at 'the front edge of time', smash assumptions of nineteenth-century order and structure, and let a new art emerge.

> Cézanne gave me a new feeling about composition. I was obsessed by this idea of composition. It was not solely the realism of characters but the realism of the composition which

was the important thing. This had not been conceived as a reality until I came along but I got it largely from Cézanne.

Years later she claimed that Melanctha was 'the first definite step away from the nineteenth century and into the twentieth century in literature', but at the time of writing she was unconfident. Leo saw no artistic merit in her stories and she was disheartened by his lack of praise or even minimal encouragement. She wrote again to Mabel Weeks:

> I went to bed very miserable… there ain't any Tschaikowsky Pathetique or Omar Kayam or Wagner or Whistler or White Man's Burden or green burlap in mine… Dey is very simple and very vulgar and I don't think they will interest the great American public. I am very sad Mamie.

Over time, Leo's refusal to validate Gertrude's work – and he never would give her a morsel of encouragement – caused an irreparable break in their relationship.

Gertrude wrote Melanctha at night with Madame Cézanne on the wall in front of her. There was no particular beginning, middle or end to her story. She wrote in what she called a 'continuous present' and thought this closer to people's true experience of reality: a multi-facetedness, 'Always and always. Must write the hymn of repetition,' she said.

Matisse

The following year, 1905, Gertrude, Leo, Michael and Sarah Stein and Claribel and Etta Cone all went again to the salon d'automne at the Grand Palais. Claribel Cone wrote of:

> a riot of colour – sharp and startling, drawing crude and uneven, distortions and exaggerations – composition primitive and simple as though done by a child…

The walls were covered with such canvases. The influential

art critic Louis Vauxcelles, seeing a Renaissance sculpture by Donatello displayed among these riotous paintings, wrote of 'Donatello parmi les fauves' – Donatello among the wild beasts.

So these groundbreaking artists became known as 'les Fauves'. Vauxcelles thought them dangerous and a new and horrible departure in art by a group of youngsters who proscribed classical drawing 'in the name of I-don't-know what pictorial abstraction'.

> This new religion hardly appeals to me. I don't believe in
> this Renaissance... M. Matisse, fauve-in-chief; M. Derain,
> fauve deputy; Monsieurs Othon Friesz and Dufy, fauves in
> attendance... and M. Delaunay..., infantile fauvelet...

The Cone sisters were among the mystified viewing the exhibition:

> We asked ourselves 'Are these things to be taken seriously'...
> Across the room we found our friends earnestly contemplating
> a canvas – of a woman with a hat tilted jauntily at an angle on
> the top of her head – the drawing crude, the color bizarre.

Their friends were the Steins – Gertrude, Leo, Michael and Sarah – and the painting they were earnestly contemplating was Henri Matisse's *Woman with a Hat*, a portrait of his wife, Amélie, who worked as a milliner to feed him and their children. Gertrude thought it 'perfectly natural', did not understand why it infuriated people and wanted to buy it. Leo said: 'It was what I was

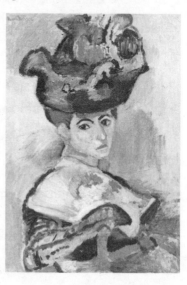

unknowingly waiting for… a thing brilliant and powerful but the nastiest smear of paint I had ever seen.' And Sarah Stein wanted to buy it because it looked like her mother.

Matisse quickly acquired a reputation as King of the Fauves. The exhibition's organizers asked him to withdraw the painting, but the artist Georges Desvallières, founder of the salon d'automne, was a friend and ally of Matisse. His support won through and the painting remained in the show.

Matisse wanted 500 francs for it. Gertrude and Leo offered 450. Madame Matisse told her husband to hold out for the extra 50 francs, which would mean winter clothes for their daughter. He did, and Gertrude and Leo telegrammed their acceptance. Matisse had no money and the patronage of the Steins came at a crucial time.

The walls of 27 rue de Fleurus began to crowd with his work. Within a short space, Gertrude and Leo bought *Joy of Life*, *Blue Nude*, a cast of his sculpture *The Serf*, *Portrait of Margot*, *Landscape at Collioure*. But Sarah Stein was his most loyal admirer. Her apartment became a shrine to Matisse. She bought a self-portrait, *Blue Still Life*, *Pink Onions*, *The Young Sailor*. 'She knows more about my painting than I do,' Matisse said of her. She went on buying his work long after Gertrude and Leo stopped.

saturday evening salons

Soon after buying Matisse's *Woman with a Hat*, Gertrude and Leo bought their first Picasso: *The Acrobat's Family with a Monkey*. They got it from Clovis Sagot, who had a gallery, which had previously been a pharmacy, at 46 rue Laffitte, close to Ambroise Vollard's. Picasso was only twenty-four and Sagot was the first dealer to show his work. He described Sagot as very difficult and a shark because of the deals he struck and the way he sold paintings for so much more than he paid artists for them.

After quarrelling over it, Gertrude and Leo bought another Picasso, of a nude girl holding a basket of red flowers. Then, within months, they bought *Two Women Sitting at a Bar*, *The Absinthe Drinker*, *Woman with a Fan*, *Woman with Bangs* and *Boy Leading a Horse*. Their whole apartment became crowded to the ceilings with works by Cézanne, Picasso, Matisse, Braque, Gauguin, Toulouse-Lautrec, Bonnard, Renoir – modernist paintings that now define an era. They did not insure the collection and for the most part did not frame them. Gertrude thought frames constrained pictures.

Curtailment to their collecting came when there was nowhere left to hang any more pictures. Gertrude said their Saturday evening salons began because so many people wanted to see these paintings at all hours of the day. 'Matisse brought people, everybody brought somebody and they came at any time and it began to be a nuisance.' She and Leo formalized the visiting to Saturday evenings. All kinds of people turned up: young painters, writers, collectors, dealers, tourists. They looked at the pictures while Leo held forth about them, and these visitors mingled with Monsieur and Madame Matisse, Picasso and his partner Fernande Olivier, Marie Laurencin and her lover, Guillaume Apollinaire.

Ambroise Vollard called the Steins 'the most hospitable people in the world'.

> People who came there out of snobbery soon felt a sort of
> discomfort at being allowed so much liberty in another man's
> house. Only those who really cared for painting continued
> to visit.

Unwittingly, Gertrude and Leo created a private museum of modern art. There was no systematic intention to their collecting beyond love of each work. What they looked for in each picture they bought was integrity of expression and a new way of seeing and saying.

William James visited: 'Another world of which I know nothing,' he said. Gertrude's American lesbian friends Ethel Mars and Maud Squire, both artists, were regulars at the salons. Their partnership was lifelong. They met at the Art Academy of Cincinnati, then went to Paris together in 1903. Both wore extravagant make-up and coloured their hair – Ethel's was orange. Maud Squire showed her work at the autumn salon. Gertrude wrote a poem about and for them, 'Miss Furr and Miss Skeene'.

Gertrude and Leo attracted as much interest as the pictures on their walls. Gertrude, in brown corduroy, sat in the studio in a high-backed Renaissance chair next to the large iron stove. Leo, in Japanese silk, sat with his feet high up on a bookcase because of his troublesome digestion and 'expounded and explained. People came and so I explained because it was my nature to explain,' he said. He talked of Renoir's feeling for colour 'as the stuff of art', Degas' intellect and control, Cézanne's treatment of mass. While he held forth, Gertrude studied people's characters so as to fit them into a 'characterological system' for *The Making of Americans*.

> I made enormous charts, and I tried to carry these charts out. You start in and you take everyone that you know, and then when you see anybody who has a certain expression or turn of the face that reminds you of some one, you find out where he agrees or disagrees with the character, until you build up the whole scheme.

Gertrude and Picasso

On their first visit to Picasso's studio, Gertrude and Leo spent 800 francs buying his paintings and Leo commissioned several drawings of himself, but it was Gertrude who became Picasso's intimate friend and championed him as a genius equal only to herself.

They became very close, and in the winter of 1906 he asked to paint her portrait. Thereafter, most afternoons for three months, Gertrude travelled, in the horse-drawn bus that connected the Left Bank with Montmartre, from her fine apartment in rue de Fleurus to Picasso's messy studio in the Bateau Lavoir, the 'laundry boat', the artists' workshops at 13 rue de Ravignan in the 18th arrondissement, carved out of what had once been a piano factory. There was no heating, a single water tap for all the studios, and on stormy days the building swayed. The poet Max Jacob coined its name. He also had a studio there, as did Apollinaire, Braque, Juan Gris, Modigliani…

Picasso lived there with Fernande Olivier, the model in many of his works. She had run away from an abusive husband when she was nineteen. Some winter days the studio was so cold she stayed in bed and for two months could not go out because she had no shoes. She thought intellectuals in France regarded women as incapable of serious thought and she complained she was referred to only as 'la belle Fernande', not as a person in her own right.

Marie Laurencin was the only woman artist in Picasso's 'group' at the Bateau Lavoir. When training as a porcelain painter in Sèvres, she had met Braque and through him Picasso and Apollinaire. She felt overshadowed by them all: 'If the genius of men intimidates me', she wrote, 'I feel perfectly at ease with everything that is feminine.' Each time she and Apollinaire quarrelled she went back to her mother, who was as antipathetic to men as she became. Only when Marie Laurencin broke from 'the genius of men' did she become successful in her own right as a painter, designer and illustrator.

Gertrude posed for Picasso sitting in an old broken armchair with one of its legs missing. She described him as like 'a good-looking bootblack… thin, dark, alive with big pools of eyes and a violent but not rough way', but she was critical of his selfishness

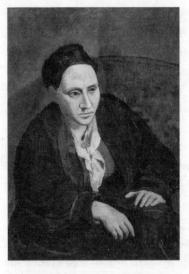

towards Fernande Olivier. He was, she said, a genius with a weak and indecisive character whose work transcended his personality.

Her portrait took eighty to ninety sittings because they talked so much. Gertrude thought their artistic intention similar – to change ways of expression in art – she in words and he in paint, to move on from strictures, structures, conventions, expectations and limitations; to take risks and break moulds.

In spring 1907, Picasso painted out Gertrude's head. 'I can't see you any longer when I look,' he said. They had become so absorbed in each other in conversation he had lost artistic detachment. He then went to Gósol in Spain for the summer with Fernande Olivier. Gertrude went to Fiesole with Leo. When Picasso returned in the autumn, he painted Gertrude's face from memory as if it were an imposed mask. People told him she did not look like that. In time she will, he said, and this was true. His portrait captured a constant of many photographs of her: a stillness of thought, a sense of her dwelling inside herself and looking out from somewhere deep behind her eyes. The portrait seemed to endorse May Bookstaver's criticism of Gertrude's face as being unlived in. It was as if she lived elsewhere. Gertrude liked the portrait throughout her life: 'For me it is I and it is the only reproduction of me which is always I for me,' she said.

Leo was scathing. In his view, Picasso created a stylistic incoherence by leaving the rest of the painting unmodified. His

criticism underscored his total disaffection with the work of Picasso and Gertrude, a rejection of them as individuals and artists. Before long he was calling both their efforts 'godalmighty rubbish', 'haemorrhoids' and 'cubico-futuristic tommy rotting'. Gertrude sided with Picasso. 'I was alone at this time in understanding him', she said. 'Perhaps because I was expressing the same thing in literature.' They both, she claimed, were chroniclers of the twentieth century, dismantling components of reality and reconstructing them in individual ways. She said they both sought 'to express things seen not as one knows them but as they are when one sees them without remembering having looked at them'.

Her portrait and their conversations formed a bond between them. Leo's disaffection marked a fissure in the deep romance of his and Gertrude's childhood, a romance that Leo had thought would last for ever. This fissure became open fracture when Alice B. Toklas arrived at 27 rue de Fleurus.

Alice B. Toklas arrives

At 5.12 on the morning of Wednesday 18 April 1906, movement along the San Andreas fault line caused a massive earthquake in San Francisco. The city's water mains were destroyed and uncontainable fires broke out, which spread until it rained; 28,000 buildings were destroyed, 3,000 people killed, and 250,000 made homeless. Tents were set up in Golden Gate Park; cooking in houses was prohibited.

No. 922 O'Farrell Street, where Alice B. Toklas lived, was spared, though the chimneys came down and the water pipes broke. The house, built of stone in the 1850s, was on a safe rocky hill in a suburb known as the Western Addition. Alice, who was twenty-nine, lived there with her widowed father and grandfather and young brother, Clarence. Her mother had died when

she was eighteen and she gave up studying music at Washington University to look after them all. She became 'the responsible daughter and granddaughter in a household of men', the only woman, the housewife. Much was demanded of her and she hated it. With an allowance for household expenses, she had to plan menus, order supplies, provide meals and do whatever was asked of her. There was, too, 'a procession of visiting male cousins many of them very old'.

At table, she kept quiet while the men talked about politics and economics. 'When I went to dine', wrote her friend Annette Rosenshine, an artist,

> I felt most keenly the pall that hung over the dining room;
> the stale smell from the chain of after-dinner cigars… Alice
> and I sat meekly swallowing our food never attempting to
> venture an opinion, nor were we encouraged to do so.
> Quickly we fled at the first opportunity to Alice's room to
> re-establish our lost identities.

Alice, Annette and a writer, Harriet Levy, who lived next door at 920 O'Farrell Street, were Jewish, lesbian, interested in artistic expression, uninterested in finding husbands and, after its devastation, keen to leave San Francisco. Annette had studied and exhibited at the Mark Hopkins Institute of Art in Mason Street. The building was destroyed the day after the earthquake by the fires that raged. Harriet was a close friend of Gertrude's sister-in-law Sarah Stein, who had also studied art at the Institute.

Sarah and Michael Stein owned rental houses in San Francisco and when safe to do so they came from Paris to assess the damage. To impress her American artistic friends, and share a taste of the salon d'automne, Sarah Stein took three Matisse paintings with her; one was the portrait of Madame Matisse with a green stripe down her nose. Harriet Levy invited Alice to see these pictures. 'Since the startling news that there was such stuff

in town has been communicated, I have been a very popular lady,' Sarah Stein wrote to Gertrude. Alice, intrigued by Matisse's portrait and tales of salon life, voiced her wish to go to Paris. Sarah Stein invited her and Harriet to travel back with her, but Alice had no money and felt responsible for her brother, Clarence.

The following year, Clarence was twenty-one and Alice thirty. San Francisco remained in a parlous state, without infrastructure or adequate hospital provision and with outbreaks of bubonic plague. Harriet agreed to lend Alice the money for her fare. They sailed together at the beginning of September 1907.

The day they arrived in Paris, 9 September, they visited Sarah and Michael Stein at their apartment in rue Madame. Alice was aware of vast rooms, tall windows, oak furniture, Persian rugs, paintings on every bit of wall, and Gertrude:

> She was a golden presence burned by the Tuscan sun and
> with a golden glint in her warm brown hair. She was dressed
> in a warm brown corduroy suit. She wore a large round
> coral brooch and when she talked, very little, or laughed,
> a good deal, I thought her voice came from this brooch.
> It was unlike anyone else's voice – deep, full, velvety, like a
> great contralto's, like two voices. She was large and heavy
> with delicate small hands and a beautifully modelled and
> unique head.

Alice wrote that promotional piece in her eighties, long after Gertrude was dead. It showed her skill as a publicist. From first meeting, she became the agent and servant of Gertrude Stein. She heard, she said, bells ringing in her head and so knew she was in the presence of genius. And Gertrude thought their meeting destined by some internal force of nature: 'It is inevitable that when we really need someone we find them. The person you need attracts you like a magnet.'

Alice the maidservant and more

Alice wasted no time. Gertrude, demoralized by Leo's scorn of her work, needed to be revered. Alice needed a home. She was

an experienced and capable manager, adept at subsuming her own ego. And she was a very good cook. Whatever Gertrude wanted, Alice would provide. The paradox was that Alice, while seeming to serve, dictated the agenda. She was the casting director: Gertrude would be the genius and Alice everything else. No outsider must get too near.

Next day they walked in the Luxembourg Gardens and had tea at Fouquet's. On the Saturday, Alice attended the salon evening at 27 rue de Fleurus. She looked at Picasso's *Melancholy Woman*, his preparatory works for the *Desmoiselles d'Avignon*, Matisse's *Woman with a Hat*, *Boy with a Butterfly Net*, *Self-Portrait* and *La Coiffure*, Pierre Bonnard's *The Siesta*, Picasso's *Boy Leading a Horse*, Lautrec's *Le Divan*, little paintings by Daumier and Delacroix, two Gauguins, dozens of Renoirs, Cézanne watercolours… She met Picasso, Fernande Olivier, Matisse, Miss Mars and Miss Squire. Every so often, Hélène came in and filled the iron stove with coal.

On 30 September Alice went, at Gertrude's invitation, to the preview of the autumn salon. Cézanne had died the previous year and there were over fifty of his paintings on show.

'Right here in front of you is the whole story', Gertrude told her. 'It was indeed the vie de Bohème, just as one had seen it in

the opera' was Alice's view. And at the heart of this grand opera was Gertrude:

> It was the enormous life she'd led that you could see... All the past experience gives a richness to every new vision. That's part of the genius... I wasn't so much younger in years. I was only two years and a few months younger. But I was so much younger in experience.

Alice's arrival was timely. In August 1906 May Bookstaver married a New York stockbroker and became Mrs Charles Knoblauch, and later that year Mabel Haynes married an Austrian army captain. Both Gertrude and Alice were uxorious, but not for a man. Alice would gladly have been known as Mrs Gertrude Stein. It was Gertrude who had the money, the house and sat in the captain's chair.

Gertrude arranged for Alice to have French lessons with Fernande Olivier and she gave her pages to read of *The Making of Americans*, about bottom nature and dependent independent and independent dependent characters and everyone who had ever lived.

The Making of Americans

By the time Alice arrived, Gertrude had filled up many exercise books in writing *The Making of Americans*: Alice read:

> The strongest thing in each one is the bottom nature of them. Other kinds of natures are in almost all men and in almost all women mixed up with the bottom nature in them. Some men have it in them to be attacking. Some men have it in them to be made more or less of the mixing inside them of another nature or of other kinds of nature with the bottom nature of them. There are two kinds of men and women, those who have dependent independent nature in them, those who have

independent dependent nature in them. The ones of the first kind of them always somehow own the ones they need to love them, the second kind have it in them to have power in them over others only when these others have begun already a little to love them, others loving them give to such of them strength in domination.

The book had no chapters and some sentences were twenty lines long. It marked, Gertrude told Alice, the difference between American and English literature. English literature made the nineteenth century, America made the twentieth and she, Gertrude, made twentieth-century American literature. Gertrude explained she was:

escaping from the inevitable narrative of anything of everything succeeding something of needing to be succeeding that is following anything of everything consisting that is the emotional and the actual value of anything counting in anything having beginning and middle and ending.

Alice thought Gertrude's writing more exciting than anything that had ever been written. She started typing it all up. Her routine was to go to rue de Fleurus early in the mornings and get to work while Gertrude was still in bed. She taught herself to type on a worn-out Blickensderfer typewriter:

The typewriter had a rhythm, made a music of its own... In those complicated sentences I rarely left anything out. And I got up a tremendous speed. Of course my love of Henry James was a good preparation for the long sentences.

She developed what she called a 'Gertrude Stein technique – like playing Bach'. She was one of the few able to decipher Gertrude's handwriting – Gertrude could not always do that. It was, Alice said, a very happy time in her life – 'like living history... I hoped it would go on for ever'.

Gertrude began *The Making of Americans* in 1903 and finished

it in 1908. It started as a chronicle of a family rather like her own, of German-Jewish immigrant stock. Any discernible narrative quickly became subsumed by Gertrude's musings on the 'fundamental natures' of the mother and father and their relationships with their three children and everyone else. She pondered human nature and the relation of all kinds of personality one to the other and lamented her authorial struggle with the task undertaken. She perhaps knew she might scare away readers and was not giving them a racy read:

> Bear it in your mind my reader, but truly I never feel it
> that there ever can be for me any such creature, no it is this
> scribbled and dirty and lined paper that is really to be to me
> always my receiver, but anyhow reader, bear it in your mind –
> will there be for me ever any such creature – what I have said
> always before to you, that this that I write down a little each
> day on my scraps of paper for you is not just a conversation
> to amuse you, but a record of a decent family's progress
> respectably lived by us and our fathers and our mothers and
> our grandfathers and grandmothers and this by me carefully
> a little each day to be written down here...

Her novel was certainly modern, then and whenever. Reading it required existential surrender and compassion for the author's struggle:

> I mean, I mean and that is not what I mean, I mean that not
> anyone is saying what they are meaning, I mean that I am
> feeling something, I mean that I mean something and I mean
> that not any one is thinking is feeling, is saying, is certain of
> that thing, I mean that not anyone can be saying, thinking,
> feeling, not any one can be certain of that thing, I am not ever
> saying, thinking, feeling, being certain of this thing, I mean,
> I mean, I know what I mean.

Alice typed away.

fried chicken and apple pie

Gertrude pined for American food so Alice cooked fried chicken and apple pie, roast turkey with stuffing of mushrooms, chestnuts and oysters. Often Alice did not leave the rue de Fleurus until midnight.

In the summer of 1908, Michael Stein rented the Villa Bardi in Florence for the summer months for his wife and son and Gertrude and Leo. Gertrude suggested Alice and Harriet Levy rent the Casa Ricci nearby. She introduced Alice to the Berensons, to Claribel and Etta Cone and to Mabel Dodge Luhan, adventurer, diarist, writer, who lived at the Villa Curonia. On that holiday, Gertrude formally declared her love to Alice and invited her to come and live with her and Leo at 27 rue de Fleurus. Alice wept with happiness. Harriet Levy said she counted thirty sodden handkerchiefs a day. 'Day after day she wept because of the new love that had come into her life,' Harriet wrote.

So Alice entrenched as Gertrude's lover, friend, housekeeper, amanuensis, cook, wife, everything. 'She is very necessary to me, my Baby...' Gertrude wrote. They started calling each other Lovey and Pussy. Alice was Pussy.

Leo, agreeable at first to Alice's arrival at rue de Fleurus, gave up his study so she could have a room of her own and was discreet about leaving the house so she and Gertrude could be alone together. 'It was very considerate of him,' Gertrude said. In 1909 he began a relationship of his own with Nina Auzias, a twenty-six-year-old artists' model. She was involved in affairs with three other men too. Leo was preoccupied with dietary matters, had gone deaf and stopped going to the Saturday salons: 'I would rather harbour three devils in my insides than talk about art,' he wrote to Mabel Weeks in February 1913. He genuinely hated Picasso's cubism and Gertrude's word portraits, but his greater

pain was that Gertrude turned from him, stopped being his disciple, and thought her own worth greater than his. The more she withdrew, the more he lost his self-esteem and lashed out. He felt he had no metier and had been broken by his childhood.

Alice affirmed Picasso's genius too. On meeting him, she again heard bells in her head, for only the second time in her life. And by her unqualified devotion to Gertrude, she contributed to splitting her from Leo.

Three Lives

Gertrude discussed her analyses of character with Alice and walked round Paris meditating and observing incidents, which she then used in her writing of the day. When she wrote, Alice said, 'there was no hesitation, she worked as quickly as her hand would move and there were no corrections in the manuscript'. Alice, as scribe, got to know all about Gertrude's bottom nature and the continuous present. Alice, as housekeeper, got to know all about the paintings by dusting them.

> I always say that you cannot tell what a picture really is or what an object really is until you dust it every day and you cannot tell what a book is until you type or proof read it. It then does something to you that only reading can never do.

No commercial publisher wanted *Three Lives*, Gertrude's stories of working-class women in Baltimore. They thought the writing too peculiar. May Bookstaver, as Mrs Knoblauch, arranged in 1908 for Grafton Press, an American vanity publisher, to bring out 500 copies at a cost to Gertrude of $660. The director, Mr F.H. Hitchcock, sent Gertrude the galleys in January 1909. 'My proofreaders report there are some pretty bad slips in grammar, probably caused in the typewriting,' he wrote. He thought Gertrude might have an imperfect

knowledge of English and he offered to correct these assumed slips for an additional fee. Alice checked that every repetition and grammatical peculiarity was there, as written by Gertrude. On publication, Hitchcock, worried in case Gertrude's stylistic oddities would be construed as his firm's incompetence, sent another letter:

> I want to say frankly that I think you have written a very peculiar book and it will be a hard thing to make people take it seriously.

Alice supervised distribution, sent out seventy-eight free copies, and pasted all reviews into an album. William James at the Johns Hopkins called it 'a fine new kind of realism', the *Boston Morning Herald* described it as extraordinary, the *Kansas City Star* called Gertrude 'a literary artist of such originality', Sarah Stein liked it a lot, H.G. Wells said at first he was repelled by her strange style but then read with 'deepening admiration and pleasure and would watch for her name curiously and eagerly', and Leo said it was not art it was rot.

Gertrude brooked the disappointment of only seventy-three copies sold a year after publication. With Alice there for her, her self-conviction grew. In style, subject matter and in her life, she pushed at the presumptions of the past. A heroine could be a black working-class woman, a marriage could be between two women, a book need not necessarily have consecutive chapters and a beginning, a middle and an end.

Boundaries between Gertrude and Alice blurred. They became a unit. For Gertrude, here was the partner with whom she could fulfil her 'theory of obligation' – who placed her centre stage, adored and desired her, would do everything for her, never be unfaithful, validate her in a manner denied her by her father and her brother. For Alice, here was deliverance from ruined San Francisco, financial hardship, the tedium of housewifery for unloved male relatives. She never visited any of them again.

Annette Rosenshine said Alice had 'found the brilliant personality worthy of her talents'. Alice's devotion and managerial talent shaped Gertrude's fame.

the ousting of Leo

At rue de Fleurus, the atmosphere became tense. An irritable note to Gertrude from Leo read:

> I told you one time since that I found it very disagreeable to come downstairs or into the house in the morning and find the light burning in the front hall. You said then that it was accidental. Now if you leave it on on purpose because you don't like to go upstairs in the dark or what not I'll try and get used to it, but if it's only carelessness I wish you'd jog your memory a little.

They bickered about gas and laundry bills, postage, a painting Leo took from Gertrude's bedroom, the division of money for the sale of prints. Their complete rift took time. Alice's adamantine support fed Gertrude's resolve. Leo would have liked rapprochement, but his insults continued. He called Gertrude a barbarian in her use of language, said she could not write plain English effectively, that her writing was all to do with her and nothing to do with literature. 'He said it was not it it was I. If I was not there… what I did would not be what it was.'

The more Leo criticized Gertrude, the more she turned away, and the more she turned away, the more critical he became. He said he could not understand her writing and she could not think consecutively for ten seconds.

> She doesn't know what words mean. She hasn't much intuition but thickly she has sensations and of course her mania, herself. Her idea of herself as a genius.

Being a genius was a point of contention. Gertrude said, 'It was

I who was the genius, there was no reason for it but I was, and he was not.' Leo said, 'Gertrude and I are just the contrary. She's basically stupid and I'm basically intelligent.' Gertrude said his discouragement of her writing was 'the beginning of the ending and we always had been together and now we were never at all together. Little by little we never met again.'

Gertrude's word portraits

In 1908, Gertrude began writing what she called 'word portraits', which she viewed as the verbal equivalent of cubist paintings. *Ada* was the first. It was of Alice. Gertrude came in waving a notebook one evening as Alice was about to serve supper. Her portrait, she said, must be read immediately. Alice liked her food hot, Gertrude liked hers tepid. Alice began reading.

> I thought she was making fun of me and I protested... Finally
> I read it all and was terribly pleased with it. And then we ate
> our supper.

The portrait began with an account of what a good daughter Alice had been, how she looked after her mother, then when her mother died she kept home for her father and took care of her brother. 'There were many relations who lived with them. The daughter did not like them to live with them and she did not like them to die with them.'

Ada went away. Her father wanted her to return. She wrote him 'tender letters' but she never went back because she met 'some one' who loved her.

> She came to be happier than anybody else who was living then.
> It is easy to believe this thing... Trembling was all living, living
> was all loving, some one was then the other one. Certainly this
> one was loving this Ada then. And certainly Ada all her living

then was happier in living than any one else who ever could, who was, who is, who ever will be living.

So there it was. Perfect love and perfect bliss. Just like in the songs 'There Never Was a Girl Like You' and 'There's No Moon Like the Honeymoon' – except the love was between two women and the prose style distinctly unfamiliar.

In her second word portrait, *Gertrude Stein and Her Brother*, Gertrude wrote of her disaffection with Leo and her fracture from him:

> She was thinking of being one who was a different one in being one than he was in being one. Sound was coming out of her and she was knowing this thing. Sound had been coming out of him and she had been knowing this thing. She was thinking in being a different one than he was in having sound come out of her than came out of him. She was thinking in being a different one. She was thinking about being a different one. She was thinking about that thing. She had sound coming out of her …
>
> Each one of the two was different from the other of them. Each one of them was knowing that thing. She was different from him in having sound coming out of her. She was thinking this thing. She was thinking in this thing. She had sound coming out of her. She was different in being one being one. She was knowing that thing.
>
> She was different in being one having sound coming out of her she was different in being that one from any other one. She was one having had sound come out of her she was different in being that one from any one. She had sound coming out of her. This was a thing she was being. Sound was coming out of her, sound had come out of her, perhaps sound would come out of her.

It continued for 147 pages.

rue de Fleurus to themselves

Gertrude and Alice looked for another apartment. They found one overlooking the Palais-Royal gardens, but Leo settled the matter by moving to the Villa di Doccia in Settignano near Florence. 'It will take days to have the floor fixed and the closets constructed,' he wrote to Nina Auzias. In a rough division of spoils, he took most of the Renoirs and Matisses, Gertrude kept the Cézannes and Picassos.

Leo said Alice's arrival was a 'godsend' that allowed separation between him and Gertrude to happen without 'an explosion'. 'I hope that we will all live happily ever after and continue to suck our respective oranges,' he wrote to Gertrude. But he went on calling her writing 'silly twaddle', 'sub-intelligent gabble' and 'utter bosh'. 'Like all children and madmen she adequately communicates only to herself.'

Gertrude and Alice decided never to see him again:

> Do you remember how we decided that indeed if he came we would have it said that there would be no admittance. Do you remember that we decided that we had entertained him as frequently as we would and that now when he came we would have him told that we would not receive him. Do you remember that?

For Gertrude, the split was as radical as that of Sylvia Beach from James Joyce. Most of the lesbians of the era, to flourish in their self-styled lives, needed to free themselves from domination by men, be they brothers, fathers, husbands, legislators. It was as if men could not accept being other than the dominant force. Or worse, they expected women to be in service to them in order to merit an identity.

Leo made reparative overtures, which Gertrude rebuffed. She did not reply to his peace offerings and letters. For her, the rift was absolute. Once, in Paris, they passed each other in the street

on opposite sides of the road. Leo raised his hat and that was all, a sad end to a sibling love affair, a childhood romance.

Mabel Dodge

Mabel Dodge, at her Villa Curonia near Florence, blamed Alice for the break between Gertrude and Leo:

Alice Toklas entered the Stein ménage and became a handmaiden. She was always serving someone, and especially Gertrude and Gertrude's friends. She was perfect for doing errands and was willing to run all over Paris to get one a special perfume or any little thing one wanted... But lo and behold she pushed Leo out quite soon. No one knew how exactly and he went off to Florence and from that time I date his extreme neuroticism... Before that he had a human contact through his sister.

When Leo moved to Florence, he often visited Mabel Dodge and spoke of his hurt and contempt. She said:

He had always had an especial disgust at seeing how the weaker can enslave the stronger... Alice did everything to save Gertrude a movement – all the housekeeping, the typing, seeing people who called and getting rid of the undesirables, answering letters – really providing all the motor force of the ménage and Gertrude was growing helpless and foolish from it and less inclined to do anything herself.

Leo told her he had seen trees strangled by vines in the same way.

Mabel's villa was a fifteenth-century Medici palace, which she restored to its Renaissance opulence. Surrounded by olive groves, it looked out towards Florence and the Apennine mountains. Her 'Gran Salone' (she pronounced it with an American drawl) was 90 feet long with high windows, a fourteenth-century stone fireplace with sun symbols, Florentine paintings, a Chinese terracotta statue of Guan Yin, the Goddess of Mercy... The salon opened to a loggia with views of a fifteenth-century Carthusian monastery.

'Please come down here soon,' Mabel wrote when Gertrude was in Italy with Alice in the summer of 1912, 'the house is full of pianists, painters, pederasts, prostitutes and peasants.' Mabel's unsatisfactory husband, Edwin Dodge, was in America. She said she most associated him with motoring around Italy and looking at churches. 'Eating alone with Edwin was sad,' she said. Over time Mabel had four husbands and became known as Mabel Evans Dodge Sterne Luhan.

During her stay, Gertrude wrote – between midnight and dawn, in a room next to Mabel's bedroom – another word portrait: *Portrait of Mabel Dodge at the Villa Curonia*. Mabel was having an affair with the twenty-two-year-old tutor of her son, and she described one night in her *Intimate Memories, volume 1*:

> white moonlight – white linen, and the blond white boy
> I found sweet like fresh hay and honey and milk... my
> natural desire for him was so strong, like light shaking out
> of clouds... and so we remained for heaven knows how long
> while Gertrude wrote on the other side of the wall, sitting in
> candlelight like a great Sybil, dim against the red and gold
> damask that hung loosely on the walls.

At dawn, Alice, in a small room next to Gertrude's, typed up

the work of the night. Each day, both she and Gertrude were equally delighted by what Gertrude had written, though Gertrude could not always recall what that was. Her portrait of Mabel Dodge began cheerily enough: 'The days are wonderful and the nights are wonderful and the life is pleasant', but quickly became cubist:

> Bargaining is something and there is not that success. The interior is what if application has that accident results are appearing. They did not darken. That was not an adulteration. So much breathing has not the same place when the end is lessening. So much breathing has the same place and there might not be so much suggestion. There can be the habit that there is if there is no need of resting.

Mabel called the portrait 'a masterpiece of success' and said even if she did not altogether understand it, 'sometimes I don't understand things in myself, past or about to come'. She thought that while Gertrude was writing the portrait, through her 'unconscious lines she seemed to grow warmer to me'.

At lunch, Gertrude, sitting in Edwin Dodge's chair, sent Mabel

> such a strong look over the table that it seemed to cut across the air to me in a band of electrified steel – a smile travelling across on it – powerful – Heavens! I remember it now so keenly!

Alice hurried from the room to the terrace. Gertrude gave 'a surprised noticing glance after her and when Alice did not return, followed her'. She came back alone and said 'She doesn't want to come to lunch. She feels the heat today... From that time on', Mabel wrote, 'Alice began to separate Gertrude and me poco poco.'

Alice sent Gertrude's portraits and manuscripts of *The Making of Americans* and of *Three Lives* to publishers. A cupboard at rue de Fleurus filled with their return. Some rejection letters

were caustic. Mr Arthur C. Fifield, Publisher, of Clifford's Inn, London, E.C., wrote:

19 April 1912

Dear Madam

I am only one, only one, only one. Only one being, one at the same time. Not two, not three, only one. Only one life to live, only sixty minutes in one hour. Only one pair of eyes. Only one brain. Only one being. Being only one, having only one pair of eyes, having only one time, having only one life, I cannot read your M.S. three or four times. Not even one time. Only one look, only one look is enough. Hardly one copy would sell here. Hardly one. Hardly one. Hardly one.

Many thanks. I am returning the M.S. by registered post. Only one M.S. by one post.

Sincerely yours.

Mabel Dodge loved her own portrait, personally paid for 300 copies to be printed and bound in Florentine floral wallpaper, and wrote a eulogistic article about Gertrude, which was published in March 1913 in the New York magazine *Arts & Decoration*:

Gertrude Stein is doing with words what Picasso is doing with paint. She is impelling language to induce new states of consciousness, and in doing so language becomes with her a creative art rather than a mirror of history.

In her impressionistic writing she uses familiar words to create perceptions, conditions and states of being never before quite consciously experienced. She does this by using words that appeal to her as having the meaning that they seem to have.

In Gertrude Stein's writing every word lives and apart from concept it is so exquisitely rhythmical and cadenced that if we read it aloud and receive it as pure sound, it is like a kind of sensuous music.

Just as one may stop for once, in a way, before a canvas of Picasso and letting one's reason sleep for an instant may

exclaim 'it is a fine pattern', so, listening to Gertrude Stein's words and forgetting to understand what they mean, one submits to their gradual charm.

Mabel praised 'Gertrude's Revolution', hypnotic effect and magical evocation and said 'out of the shattering and petrification of today, up from the cleavage and disintegration, we will see order emerging tomorrow'.

Gertrude was 'as proud as punch' with Mabel's generous praise. She confided how, with disappointing regularity, her work

came back quite promptly and with very polite handwriting and sometimes regretful refusals… You can understand how much I appreciate your letter.

But their friendship did not survive. The end was, Mabel felt sure, Alice's doing:

Alice's final and successful effort in turning Gertrude from me – her influencing and her wish and I missed my jolly fat friend very much.

monogamy

With 27 rue de Fleurus to themselves, Gertrude and Alice had a covered hallway built between the studio and living area, the cast-iron stove taken from the studio and a fireplace installed, gas lamps removed and the place wired for electricity, and rooms repapered and redecorated.

From their first meeting on, they were never apart for more than a few hours. They never travelled independently, or had separate friends. To escape Paris in the summer months, they rented a large house in the village of Bilignin, near Belley, east of Lyons. The poet Bravig Imbs, who visited them there, described a night when Gertrude took him to see the ancient landscape high up near Saint Germain les Paroisses. There were poplar trees

and a ruined tower and the valley was suffused with moonlight. 'We must be getting back to Alice,' Gertrude said. 'If I'm away from her for long I get low in my mind.'

Alice, on meeting Gertrude, had arrived at her destination. Gertrude liked to write, talk to people, walk Basket the dog, drive the car, look at paintings and meditate about life and art. Alice did the rest. She was secretary, cook, agent and housekeeper. When they went on holiday, which was often, Alice did the packing. And she supervised the cooking: 'In the menu there should be a climax and a culmination', she wrote. 'Come to it gently. One will suffice.' Throughout her life she collected recipes: Polish dumplings made with sour cream, cottage cheese, butter, eggs and flour; hardboiled eggs served with whipped cream truffles and Madeira wine; hare cooked in dry champagne, cognac, fat salt pork, truffles, cream and butter; omelettes with six eggs, chicken livers and cognac; bananas flamed in kirsch; chocolate whip made of eggs, bitter chocolate, icing sugar, cream and cognac.

'She is very necessary to me. My sweetie. She is all to me,' wrote

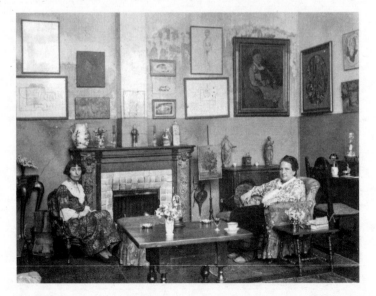

Gertrude, who was freed from all chores and could concentrate on being a genius. Gertrude said Alice was always 'forethoughtful, which is what is pleasant for me'. Others besides Leo and Mabel Dodge suffered the strength of Alice's claim. Mabel Weeks, Gertrude's friend from their student days, wrote to Gertrude of their correspondence: 'Don't read this to Alice. Unless I feel that sometimes I can write just to you it's no fun to write.'

Visitors commented on Gertrude's sense of repose. Alice had none. She got up at six in Bilignin to pick wild strawberries for Gertrude's breakfast, and in Paris to do cleaning because she did not trust hired staff. She said she could contemplate violence towards a maid who broke anything and her relationships were bad with a succession of cooks and maids.

Gertrude did not resist being infantilized. She lived in the cocoon of her own intelligence and meandering imagination. 'It's hard work being a genius', she said. 'You have to sit around so much doing nothing.' Alice nicknamed her Baby as well as Lovey.

love letters for Alice

They wrote notes to each other, inscribed DD and YD (Darling Darling and Your Darling). 'Our pleasure is to do every day the work of that day', Gertrude wrote, 'to cut our hair and not want blue eyes, to be reasonable and obedient. To obey and not split hairs.'

She penned her love for Alice in a piece called *Bonne Année*:

I marvel at my baby I marvel at her beauty I marvel at her
perfection I marvel at her purity I marvel at her tenderness.
I marvel at her charm I marvel at her vanity I marvel at her
industry I marvel at her humor I marvel at her intelligence
I marvel at her rapidity I marvel at her brilliance I marvel
at her sweetness I marvel at her delicacy, I marvel at her
generosity, I marvel at her cow.

Cows, Steinian scholars advise, are orgasms. Gertrude, in her bedroom pieces, made many a reference to them. She described her piece *A Book Concluding With As A Wife Has A Cow: A Love Story* as her *Tristan and Isolde*:

> Having it as having having it as happening, happening to have it as happening. Happening and have it as happening and having to have it happen as happening, and my wife has a cow as now, my wife having a cow as now, my wife having a cow as now, my wife having a cow as now and having a cow as now and having a cow and having a cow now, my wife has a cow and now. My wife has a cow.

They took holidays in Italy and Spain. Alice particularly liked Ávila. Her Spanish look was a long black dress, black gloves and a feather hat with flowers. Neither of them ever wore trousers. Gertrude's sartorial choice for summer was ecumenical and on one occasion she was mistaken for a bishop.

the history of anything

After writing the history of everyone in *The Making of Americans* and the history of anyone in her portraits, in *Tender Buttons* Gertrude wanted to write the history of anything. She gave as her objective the need 'to completely face the difficulty of how to include what is seen with hearing and listening'. *Tender Buttons* was her 'first conscious struggle with the problem of correlating sight, sound and sense and eliminating rhythm'. She was:

> trying to live in looking and not mix it up with remembering and to reduce to its minimum listening and talking and to include colour and movement:

ORANGE
A type oh oh new new not knealer knealer of old show beef-
steak, neither neither.

RHUBARB
Rhubarb is Susan not Susan not seat in bunch toys not wild and
laughable not in little places not in neglect and vegetable not in
fold coal age not please.

Gertrude said what excited her was:

that the words that made what she looked at be itself were
words that, to her, exactly related themselves to the thing at
which she was looking, but as often as not had nothing to do
with what any words would do that described that thing.

Her excitement did not help comprehension. Some thought
tender buttons were clitorises, others thought they were mari-
nated mushrooms. But while *Three Lives* and *The Portrait of Mabel
Dodge at the Villa Curonia* had been privately printed, *Tender
Buttons* found a publisher, although of an unorthodox sort.

Mabel Dodge again was the instigator. She gave a copy of
Gertrude's portrait of her to her friend Carl Van Vechten –
photographer and writer. He wrote more than twenty books –
among his novels were *The Tattooed Countess* and *Nigger Heaven*,
and he promoted all forms of African art. Many of his photo-
graphic portraits were of homosexual men and lesbian women:
Pierre Balmain, Christopher Isherwood and W.H. Auden,
Tallulah Bankhead, James Baldwin, Truman Capote, Elsa Max-
well, Virgil Thomson, Gore Vidal.

Mabel Dodge said he was 'really queer looking' and 'when he
laughed little shrieks flew out between the slits in his big teeth'.
They spoke on the phone each day and he called her Mike. He
had a large private income, was married but homosexual and
he supported new writers and modern art. Gertrude, Alice and

he became firm friends. and formed what they called the Woo-jums family. He was Papa Woojums. Alice was Mama Woojums, who did all the tedious work. Gertrude was Baby Woojums. Van Vechten championed Gertrude and did all he could to see her work published, publicized and performed. Donald Evans, the publisher he found for *Tender Buttons*, was an American friend who wrote strange imagist poetry and had started *Claire Marie*, which promised 'New Books for Exotic Tastes':

> Claire Marie believes there are in America seven hundred
> civilized people only. Claire Marie publishes books for civilized
> people only. Claire Marie's aim it follows from the premises is
> not even secondarily commercial.

Mabel Dodge said Donald Evans was pale and thin with dark brooding eyes that seemed dead but saw everything. Claire Marie Press, she told Gertrude, was absolutely third rate. She advised her against publishing with him and said to do so 'would signal to the world that there was something degenerate, effete and decadent about the whole Cubist movement which they all connect with you'.

But Gertrude went ahead, and in June 1914 a thousand copies of *Tender Buttons* were printed and bound in canary yellow covers. To promote the book, Evans wrote:

> The last shackle is struck from context and collocation, each
> unit of the sentence stands independent and has no commerce
> with its fellows. The effect produced on the first reading is
> something like terror.

Such publicity did little to entice readers. Reviewers voiced confusion. The *Chicago Tribune* pondered whether the 'Tender' of the title was a rowboat, a fuel car attached to a locomotive or a human emotion. The *Detroit News* wrote that after reading bits of it, 'a person feels like going out and pulling the Dime Bank building over on to himself'. The *New York Post* reviewer

wondered if Gertrude had been smoking hashish and the *Commercial Advertiser* wrote:

> The new Stein manner is founded on what the Germans call
> 'wort salad', a style particularly cultivated by crazy people...
> The way to make a wort salad is to sit in a dark room,
> preferably between the silent and mystic hours of midnight
> and dawn, and let the moving fingers write whatever comes...

No reviewer claimed to understand *Tender Buttons*, though all agreed it was a departure from the past and unlike anything else.

In the August edition of *Trend*, Carl Van Vechten described Gertrude as 'massive in physique, a Rabelaisian woman with a splendid thoughtful face, mind dominating her matter'. He said words 'surged through her brain and flowed out of her pen', and *Tender Buttons* was irresistible, sensuous, fresh and with majestic rhythm. And Janet Flanner in a 'Letter from Paris' wrote: 'No American writer is taken more seriously than Miss Stein by the Paris modernists.'

So, despite her unpublished, largely unread oeuvre, Gertrude Stein became famous, a woman staunchly married, but to a woman, a writer if not one to be read. And Alice, the shrewd publicist, holding bags and brollies in the shadows, wearing gypsy frocks and with dark Hebraic hair, dangling earrings and proud moustache, was half of the picture of a sight to be remembered.

Tender Buttons did not sell well, Claire Marie Press folded and Donald Evans killed himself. But the literary world, even while it mocked Gertrude Stein, reckoned with her and the questions she asked about life and art.

the First World War

The Archduke Franz Ferdinand of Austria, heir presumptive to the Austro-Hungarian throne, and his wife, Sophie, Duchess of

Hohenberg, were assassinated in Sarajevo on 28 June 1914, but that was the Balkans and distant from lesbians in Paris experimenting with the English language. John Lane, founder in London with Charles Elkin Mathews of The Bodley Head and publisher of Oscar Wilde and the literary periodical *The Yellow Book*, had told Gertrude his wife had enjoyed *Three Lives* and if she came to his office in July, a contract to publish would await her.

Gertrude and Alice duly went to London, met with John Lane, secured publication agreement and chose a three-piece suite to replace the chairs Leo had taken with him to Florence.* On 4 August, Britain declared war on Germany. Travel restrictions meant they could not get visas and permits to return to France. Their intended brief visit lasted eleven weeks. Gertrude's Baltimore cousins wired them money and John Lane put publication on hold. 'Do you remember it was the 5th of September we heard of asphyxiating gases?' Gertrude wrote. 'Do you remember that on the same day we heard that permission had been withheld? Do you remember that we couldn't know how many h's in withheld?'

It was 17 October when they got home. Paris was 'beautiful and unviolated', Gertrude said. But there were blackouts, fuel and food shortages, Zeppelin alarms and fears of invasion. Friends scattered. Derain and Braque had been conscripted. Picasso said, 'On August 2 1914 I took Braque and Derain to the Gare d'Avignon. I never saw them again.' Braque suffered a head injury in the Second Battle of Artois in June 1915, and had to be trepanned to save his eyesight. Matisse moved to Nice with his family. Apollinaire served as a brigadier with an artillery regiment; he died aged thirty-eight in the flu pandemic of 1918. Marie Laurencin had married a German and was living in Spain. Leo

* It arrived a year later.

went back to New York and had intensive psychoanalysis. Carl Van Vechten told Gertrude he met him occasionally, 'scowling in galleries at manifestations of modern artists and talking but never to me. He seems to be quite certain that he doesn't like me.' Michael and Sarah Stein moved to the French Riviera; they loaned nineteen paintings by Matisse to an art exhibition in Berlin and never got them back. Claribel Cone was stuck in the Regina Palace Hotel in Munich for the duration of the war.

Paris was too dangerous and deserted for Gertrude and Alice to stay. They rented a villa in Majorca and to finance the additional expenditure Gertrude sold Matisse's *Woman with a Hat* for $4,000 dollars to Sarah and Michael Stein.*

On Majorca, Gertrude and Alice kept to their roles of writer and acolyte, husband and wife, but were cut off from home and friends. Gertrude wrote plays and poems. One play, *Turkey and Bones and Eating and We Liked It*, was twelve pages long, had seventeen scenes and such lines as 'I do not like cotton drawers. I prefer wool or linen. I admit that linen is damp. Wool is warm. I think I prefer wool.' Scene VI was 'A water faucet'. She also wrote more poems about her love for Alice. One called 'Lifting Belly', which was fifty pages long, Virgil Thomson described as 'concerning the domestic affections':

> I say lifting belly and then I say lifting belly and Caesars. I say lifting belly gently and Caesars gently. I say lifting belly again and Caesars again. I say lifting belly and I say Caesars and I say lifting belly Caesars and cow come out. I say lifting belly and cow come out… Lifting belly high
>
> That is what I adore always more and more.
>
> Come out cow.

They stayed on the island until December 1916. After the death

* Equivalent to about $100,000 in 2020.

of about a million fighting men, French victory at the Battle of Verdun stopped Germany's advance towards Paris. Gertrude and Alice felt safe to return to rue de Fleurus.

war work

In Paris, out of a wish to contribute to the war effort, Gertrude and Alice, under the auspices of the American Fund for French Wounded, volunteered to distribute hospital supplies. Gertrude ordered a model-T Ford from America and had it converted into a supply truck. They called the Ford Auntie. It had wooden wheels and bicycle-thin tyres and required a great deal of cranking. For their first assignment, in March 1917, they drove to Perpignan to organize a distribution depot there.

Gertrude drove. Alice map-read. They set off armed with a Michelin Guide to hotels and restaurants. Alice planned the route according to the Guide's gastronomic promise. The car's maximum speed was thirty miles an hour. It kept breaking down and Gertrude dragooned passing men to help. She had 'a scary habit of talking and forgetting about driving' and was not good at following directions. When Alice told her they were on the wrong road, Gertrude responded, 'wrong or right, this is the road and we are on it'.

They distributed medicines, blankets and food parcels to hospitals in the South of France. It was like a continuous Christmas, Alice said. She did the stocktaking and paperwork and sent weekly reports to the Fund. They also used Auntie to ferry wounded soldiers to hospitals. Gertrude, with her own money, bought X-ray equipment, thermometers, bandages and cigarettes. If inspired, in the car or a field, she wrote poems:

The wind blows
And the automobile goes

Can you guess boards.
Wood.
Can you guess hoops.
Barrels.
Can you guess girls.
Servants.
Can you guess messages.
In deed.
Then there are meats to buy.
We like asparagus so.
This is an interview.
Soldiers like a fuss.
Give them their way.
Yes indeed we will.
We are not mighty
Nor merry.
We are happy.
Very.
In the morning.
We believe in the morning
Do we.

A second assignment was to distribute supplies from a depot at Nîmes to military hospitals in southern France in the Bouches-du-Rhône and the Vaucluse. Braque encountered them at Avignon. Gertrude was wearing a greatcoat and Cossack hat and Alice a pith helmet and officer's jacket with lots of pockets:

> Their funny get-up so excited the curiosity of the passers-by that a large crowd gathered around us and the comments were quite humorous. The police arrived and insisted on examining our papers. They were in order, but for myself, I felt very uncomfortable.

At Christmas 1917, Gertrude and Alice hosted a dinner and dance at their Nîmes hotel for convalescing British soldiers.

They danced with the wounded men. 'It was as gay as we could make it', Alice said. 'But the British army was not cheerful.'

On the day of the victory procession, the Armistice, the défilé, on 11 November 1918, they got up at sunrise to join the celebrations:

'It was a wonderful day', Gertrude wrote:

Everybody was on the streets, men, women, children, soldiers, priests, nuns, we saw two nuns being helped into a tree from which they would be able to see.

They all marched past through the Arc de Triomphe...

Everybody except the germans were passing through. All the nations marched differently, some slowly, some quickly, the french carrying their flags the best of all...

However it all finally came to an end. We wandered up and we wandered down the Champs Élysées and the war was over and the piles of captured cannon that had made two pyramids were being taken away and peace was upon us.

She and Alice were awarded Reconnaissance Française medals for their war service to the French.

Gertrude the oracle

Gertrude thought that painting, after its cubist high point, lapsed into a secondary form of expression. After the 1914–18 war ended, the focus of the Saturday salons shifted from painters to writers, mainly young and American, who sought her views on their work. Her approval furthered careers. Her prestige was enormous. She had been the person to promote and encourage Picasso and cubism and there was high respect for her opinions, even if few managed to read her work.

Leo wrote to her in December 1919, hoping yet again to repair the breach between them. He told her he had spent nearly all his time in New York trying to cure his neurosis.

But they're damned hard things to cure… and I was in almost utter despair. Then I got on a tack that has led to better states… and brought about a condition where it was possible to write to you.

The "family romance" as it is called is almost always central in the case of a neurosis, just as you used to get indigestion when we had a dispute. So I could tell pretty well how I was getting on by the degree of possibility I felt of writing as I am doing now.

Gertrude did not answer. She did not want to revisit neuroses, disputes, indigestion and the family romance. She had Alice.

Bravig Imbs

The American novelist and poet Bravig Imbs, author of *Confessions of Another Young Man*, said Gertrude had the secret of imparting enthusiasm, though she preferred to talk about baseball, or gardens, or the cuisine of the Ain rather than literary things. 'It was those things that made her laugh and radiate,' he said. He first met her when she was walking Basket by the Seine docks. He sought her guidance about his writing and showed her his short stories: 'You have the gift of true brilliancy,' she told him.

And less than anyone should you use crutch phrases. Either the phrase must come or it must not be written at all. I could never understand how people could labour over a manuscript, write and rewrite it many times, for to me, if you have something to say the words are always there. And they are the exact words and the words that should be used. If the story does not come whole, *tant pis*, it has been spoiled, and that is the most difficult thing in writing, to be true enough to yourself, and to know yourself enough so that there is no obstacle to the story's coming through complete. You see how you have faltered,

and halted and fallen down in your story, all because you have
not solved this problem of communication for yourself. It is
the fundamental problem in writing and has nothing to do with
metier, or with sentence building or with rhythm. In my own
writing as you know, I have destroyed sentences and rhythms
and literary overtones and all the rest of that nonsense to get
to the very core of this problem of the communication of the
intuition. If the communication is perfect, the words have life,
and that is all there is to good writing, putting down on the
paper words which dance and weep and make love and fight
and kiss and perform miracles.

In the art world, Gertrude 'could make or mar an exhibition
with little more than a movement of her thumb', Imbs said.
With writing, as with painting, she was emphatic about what and
who was good and what and who was not. With Alice managing
them, her callers became like a court seeking the sovereign's
favour. Virgil Thomson thought the line that applied was: 'Will
you come into my parlour said the spider to the fly.'

only the men

Annette Rosenshine revisited after the war and found how
impenetrable Alice's power had become. She went to tea wearing
a new Paris hat, hoping to show her small sculptures to Gertrude.
Alice looked at the pieces in silence then, when Gertrude came
over, turned off the lights. She answered questions Annette put
to Gertrude, and when they went for a drive she chose what
streets Annette should see. 'I was ostracised as far as Gertrude
was concerned,' Annette said.

Only the men got to Gertrude's sanctum. Alice directed
wives to the kitchen. They sat with her. She said she would one
day write her memoir and call it 'Wives of Geniuses I Have Sat
With'. When she did write her memoir, after Gertrude's death,

she called it *What is Remembered. Time*'s reviewer described it as the 'book of a woman who all her life has looked in a mirror and seen someone else'.

Even Bryher was downgraded in the salon evenings:

the atmosphere seemed full of gold. There was a table piled with books and beyond this a high chair where Gertrude sat, surrounded by a group of young men. At first there was a little general conversation, then she would pick up a phrase and develop it, ranging through a process of continuous association... She offered us the world, took it away again in the following sentence, only to demonstrate in a third that it was something that we could not want because it never existed...

Gertrude had no use for me but she did not dislike me. I had nothing to offer her in the way of intellectual stimulus and, unlike her young men, brought her no personal problems. I knew this and so, whenever I could, I slipped away to join Miss Toklas in her corner.

Djuna Barnes thought Gertrude chauvinistic and disliked the Stein Toklas ménage:

Do you know what she said of me? Said I had beautiful legs! Now what does that have to do with anything? Said I had beautiful legs! Now I mean what did she say that for? I mean if you're going to say something about a person... I couldn't stand her. She had to be the centre of everything. A monstrous ego.

It was Alice, not Gertrude, who chose to consign women to the kitchen. At college, Gertrude's company was essentially with lesbian or lesbian-friendly women: the Cone sisters Claribel and Etta, the artists Ethel Mars and Maud Hunt Squire, Mabel Weeks, May Bookstaver. But Alice let no other woman get near. And Gertrude's 'bottom nature' was essentially passive; with Leo

she was the complaisant sister, with Alice the compliant spouse. Why make decisions was Gertrude's view.

Natalie Barney was not seen by Alice as a threat. She and Gertrude used to take an evening walk with Basket. Natalie liked Gertrude's 'staunch presence, pleasant touch of hand, well-rounded voice always ready to chuckle'.

Sylvia Beach said she felt like a guide from a tourist agency because so many young American writers called at Shakespeare and Company and asked her to introduce them to Gertrude Stein.

Sherwood Anderson

Sherwood Anderson was one suppliant:

> *'Dear Miss Gertrude Stein'*
>
> *Would you let me bring around Mr Sherwood Anderson of White and Winesburg Ohio to see you this evening? He is so anxious to know you for he says you have influenced him ever so much & that you stand as such a great master of words. Unless I hear from you saying NO I will take him to you after dinner tonight*
>
> *Yours affectionately*
> *Sylvia Beach*

Anderson arrived at the rue de Fleurus in 1921 with Tennessee Mitchell, the second of his four wives. They were, Anderson wrote in his memoirs, 'persistently unhappy together'. They married with the understanding they would come and go as they pleased and she would retain her own name. He was forty-five, had given up his paint business in Ohio, had a breakdown, walked out on his first wife and three children and married Tennessee. Small towns in Ohio were the setting for the two works of fiction he gave to Gertrude. *Poor White* was set in a

farming town that becomes industrialized. *Winesburg, Ohio* was a book of interrelated short stories, about characters thwarted by small-town life.

Gertrude told him: 'You sometimes write what is the most important thing of all to be able to write, passionate and innocent sentences.' In his diary, Anderson described her as 'a strong woman with legs like stone pillars sitting in a room with Picassos'. Tennessee, a sculptor, music teacher and suffragist, wore big hats and floating scarves like Isadora Duncan and when she tried to join in the conversation, Alice took her across the room to show her something interesting. 'I couldn't see the necessity for the cruelty to wives that was practised in the rue de Fleurus,' Sylvia Beach wrote in her memoir. She was critical too of the way French people were isolated from the Gertrude Stein court. She never met any French people there and thought Gertrude looked at the French without seeing them.

Gertrude and Ernest

Ernest Hemingway was twenty-three when he arrived at Gertrude's in 1922 with a letter of introduction from Sherwood Anderson. Hadley, his first wife, eight years older than he, was consigned to the kitchen. Hemingway was besotted with Gertrude, who was about the same age as his mother, Grace. He wrote of Gertrude's thick hair, beautiful eyes, and 'strong German-Jewish face'. He described her as heavily built 'like a peasant woman' and was intrigued by the size of her breasts. He wondered how much each one weighed: 'I think about ten pounds, don't you Hadley?' he asked when they left.

Hemingway's mother, when he was a child, dressed him and his elder sister, Marcelline, in identical clothes. She had wanted twins. 'Summer girl', she captioned a photo of Ernest aged two

 in 1901, in a white frock and flowered hat. Sometimes she dressed him and Marcelline as girls, sometimes as boys. She gave them the same hairstyle, they slept in the same room in identical cots, had the same dolls and were expected to do everything together. She bought clothes in twos: lacy dresses, flowered hats, sailor suits, though Ernest was soon larger and taller than his sister, who was eighteen months older.

Ernest's father, in contrast, determined to make him a manly man. Dr Hemingway taught each of his six children to shoot and fish and not complain if hurt. He, like Gertrude's father, had volatile mood swings and violent outbursts of rage. Marcelline wrote:

> Sometimes the change from being gay to being stern was so abrupt that we were not prepared for the shock that came when one minute Daddy would have his arm around one of us, or we would be sitting on his lap laughing and talking and a minute or so later, because of something we had said or done, or some neglected duty of ours he suddenly thought about, we would be ordered to our rooms and perhaps made to go without supper. Sometimes we were spanked hard our bodies across his knee. Always after punishment we were told to kneel down and ask God to forgive us.

He hit them with a razor strop, made them wash their mouths out with soap, did not speak to them for days at a time. Their mother hit them too, though not as hard.

Grace Hemingway felt superior to her husband. She saw herself as an unfulfilled opera star and earned more as a singing teacher than he as a doctor. Ernest referred to her as 'that bitch' and said he hated her. She did not go to his wedding in 1921 and when he told her, in February 1927, of his impending divorce, she wrote:

> I'm sorry to hear that your marriage has gone on the rocks but
> most marriages ought to. I hold very modern and heretical
> views on marriage but keep them under my hat.

The following year, her husband shot himself in the head with his own father's Smith and Wesson revolver. He was fifty-seven. The theme of a father's suicide recurred in Ernest Hemingway's short stories and in *For Whom the Bell Tolls*.

That was the background to Hemingway's displays of manliness in his life and work. His upbringing stirred confusion in him about gender, identity and the boundaries between one person and another. His younger sister Ursula said that when he came back from the First World War, they shared a bed so she would not be lonely in the night. She was seventeen.

To Gertrude, as to Sylvia Beach, he recounted his injuries by trench mortar in Italy in July 1918 when serving as an ambulance driver. In his novels he wrote of Spanish bullfighting, aeroplane crashes, big game hunts, deep sea fishing, hard drinking, hard fighting. 'Killed my 2 buffalo with the 30-06 Springfield – also all lions. Got some beauties and some wonderful heads,' he recorded in January 1934 when hunting in Nairobi. Of Gertrude, he wrote:

> She used to talk to me about homosexuality and how it was
> fine in and for women and no good in men and I used to listen
> and learn and I always wanted to fuck her and she knew it and
> it was a good healthy feeling and made more sense than some
> of the talk.

Gertrude's view was:

We are surrounded by homosexuals. They do all the good
things in the arts and when I ran down the male ones to
Hemingway it was because I thought he was a secret one... I like
all the people who produce and Alice does too and what they
do in bed is their own business and what we do is not theirs...

Emerald Cunard, when she met Hemingway in 1944, said:

I was startled. Not a bit what I expected. You may think it
bizarre of me but he struck me as androgynous... It is not
the *mot juste* perhaps but that's how he struck me. Distinctly
emasculated.

'Gertrude Stein and me are just like brothers,' Hemingway
wrote to Sherwood Anderson in 1922. It is unusual to wonder
how much each of your brother's breasts weigh and to want to
fuck him, knowing he is lesbian.

Gertrude, too, pondered the ideas about gender in currency
from sexologists and psychologists. She was interested in the
theory of the Viennese psychologist Otto Weininger that:

all women who are truly famous and are of conspicuous mental
ability reveal some of the anatomical characters of the male,
some bodily resemblance to a man.

Weininger thought women who were attracted to and by other
women were themselves half male. Havelock Ellis had a similar
theory about the 'congenital sexual invert'. But Hemingway, the
macho man, wanted to fuck the city's most famous lesbian whom
he viewed as his brother, and Alice, who boasted the moustache,
was the wife who did the cooking and sewing. Sigmund Freud
might have tried to unravel the confusion felt by a son whose
mother had treated him as the twin of an older sister, or that of
a girl like Bryher who felt she should have been born a boy. It
seemed that male and female, brother and sister, homosexual

and lesbian meant different things to different people in the early twentieth century, as at all other times.

Gertrude, Hemingway felt, understood both him and his work. 'It was a vital day for me when I stumbled upon you,' he told her. He said he loved her and she was godmother to his son 'Bumby'. Alice was frosty about their closeness. 'Don't you come home with Hemingway on your arm,' she told her. Gertrude had 'a weakness for him', she said, and she did not like it. For months after first meeting her, Hemingway called Alice Miss Tocraz. He described her as dark, with a hooked nose, a Joan of Arc haircut and a lapful of needlepoint on which she worked non-stop. He particularly liked her fragrant colourless alcohols that tasted of raspberries and blackcurrants but packed a fiery punch.

Hemingway said Gertrude 'ruined him as a journalist' and helped create him as a novelist. She encouraged his early fiction, his short stories and debut novel, *The Sun Also Rises*. He read 'a lot of her new stuff' and took her advice. He said if you mentioned Joyce more than once in her presence, you would not be invited back.

She and Alice visited Hemingway and Hadley at their lodgings in rue du Cardinal Lemoine. Gertrude sat on their mahogany bed while he read aloud from his *Three Stories and Ten Poems*. She said the poems were 'direct and Kiplingesque' but she did not care for the prose. 'There is a great deal of description in this and not particularly good description. Begin over and concentrate,' she told him. Contact Editions published this first work of Hemingway's in 1923.

'I've thought a lot about the things you said about working', Hemingway wrote to her from Rapallo on 18 February 1923. When he got a block about writing, she told him to try free association and automatic writing, and let things flow and leap onto the page without critical censor. Hemingway came up with:

Hadley and I are happy sometimes. Her friends call her Hadley. We are happiest in bed. In bed we are well fed. There are no problems in bed. Now I lay me down to sleep in bed. There are no prayers in bed. Beds only need be wide enough.

That summer, before he and Hadley left for Canada, Gertrude wrote one of her special portraits for him:

Among and then young.
Not ninety-three.
Not Lucretia Borgia.
Not in or on a building.
Not a crime not in the time.
Not by this time.
Not in the way.
On their way and to head away. A head any way. What is a head. A head is what every one not in the north of Australia returns for that. In English we know. And is it to their credit that they have nearly finished and claimed, is there any memorial of the failure of civilization to cope with extreme and extremely well begun, to cope with extreme and extremely well begun, to cope with extreme savagedom.
There and we know.
Hemingway.
How do you do and good-bye. Good-bye and how do you do.
Well and how do you do.

Hemingway wanted to reciprocate her kindness. In 1924 he was guest editor for a month of Ford Madox Ford's literary magazine *Transatlantic Review*. He showed Ford pages of *The Making of Americans*, then wrote to Gertrude about serializing it:

Ford alleges he is delighted with the stuff and he is going to call on you. He is going to publish the 1st instalment in the April No. going to press the 1st part of March. He wondered if you would accept 30 francs a page and I said I thought I could get

you to (Be haughty but not too haughty) I made it clear it was a
remarkable scoop obtained only through my obtaining genius.
He is under the impression that you get big prices when you
consent to publish… Treat him high wide and handsome…

They are going to have Joyce in the same number.

After four instalments, Ford complained to Gertrude that
he had not known her book had 565,000 words – Hemingway
had inferred it was a 'long short story which might run for
about three numbers'. Ford and Hemingway fell out, Gertrude
blamed Hemingway, John Quinn, who financed *Transatlantic
Review*, died suddenly in July 1924 aged fifty-four, the magazine
foundered after a year of life and Gertrude did not get paid.

Hemingway marked the souring point in his and Gertrude's
relationship from when, in 1926, Alice cut Gertrude's hair very
short with the kitchen scissors. He thought this made her look
like a Roman emperor, whereas before she had seemed to him
like an earth mother, a northern Italian peasant woman with
'lovely, thick alive immigrant hair'. After he and Gertrude
quarrelled, their interaction became as bitter as if they had
been lovers.

Like his father, and in the same manner, in 1961 Hemingway
ended his own life. On Sunday 2 July, before seven in the
morning, three weeks short of his sixty-second birthday, at his
home in Ketchum, Idaho, near the Wood River, with a view
of the Sawtooth Mountains, he took a double-barrelled Boss
shotgun from his storeroom and blew his brains out. His wife
Mary – Kitten Pickle, he called her, she was his fourth wife, he
was her third husband – found him. They had been married since
1946. She claimed his death was an accident and that he shot
himself while cleaning his gun.

Gertrude and F. Scott Fitzgerald

F. Scott Fitzgerald first met Hemingway in a bar in Paris in May 1925. He, his wife, Zelda, and their daughter, Scottie, had moved to Paris the previous month and were living at 14 rue de Tilsitt near the Arc de Triomphe. He was twenty-eight, three years older than Hemingway, and had just published *The Great Gatsby*. His first novel, *This Side of Paradise*, sold 40,000 copies in 1920, the year it was published, and he followed this with *The Beautiful and Damned* in 1922. *Gatsby* did not sell particularly well but he was proud of the book: 'it is something really

NEW in form, idea structure – the model for the age that Joyce and Stien [*sic*] are searching for, that Conrad didn't find.'

T.S. Eliot read it three times and thought it the first step forward for American fiction since Henry James. Hemingway, full of admiration, took Fitzgerald to meet Gertrude. She told him *This Side of Paradise* 'really created for the public the new generation'. He wrote to her that she was very handsome, acutely sensitive, gallant and kind:

> I am a very second rate person compared to first rate people…
> and it honestly makes me shiver to know that such a writer as
> you attributes such a significance to my factitious, meritricious
> (metricious?) *This Side of Paradise*.

He called often at rue de Fleurus and they discussed his

drinking problem. Gertrude's way of dealing with drunk people was to treat them as if they were sober. 'It is funny,' she said,

> the two things most men are proudest of is the thing that any man can do and doing does in the same way, that is being drunk and being the father of their son... If anybody thinks about that they will see how interesting it is that it is that.

Hemingway said of Fitzgerald:

> If he was not an alcoholic I never saw one nor met one, nor knew one well in my life... Every time I would get him to stop drinking or drink only wine Zelda would get jealous and get him off of it.

Hemingway downed liquor without apparent mood change, Fitzgerald got drunk very quickly.

Gertrude praised and encouraged them both and they treated her like an oracle. There was passing paranoia when she said Fitzgerald had a 'stronger flame' than Hemingway. Fitzgerald thought she was somehow belittling one or other of them. Hemingway wrote a four-page letter to reassure him:

> I cross myself and swear to God that Gertrude Stein has never last night or any other time said anything to me about you but the highest praise. [...] As for comparison of our writings she was doing nothing of the kind – only saying that you had a hell of a roaring furnace of talent [...] If you had pressed her she would have told you to a direct question that she believes yours a better quality than mine. Naturally I do not agree with that – anymore than you would...

Thus they deferred to Gertrude's judgement and revealed to her their insecurity and need.

In June 1925, Fitzgerald told Gertrude he was anxious to read *The Making of Americans*, learn from it and imitate things out of it. Six months later he said he was in '"the geographical center"

of it, and fascinated by it'. He made no written reference to ever finishing or making sense of it.

Gertrude told him he would write an even greater novel than *Gatsby*. When *Tender is the Night* was published in April 1934, he sent her a copy inscribed 'Is this the book you asked for?'

Gertrude and T.S. Eliot

T.S. Eliot went to tea at the rue de Fleurus on 15 November 1924. He sat holding his umbrella, asked Gertrude why she so frequently used the split infinitive and said he would print a new piece by her in *The Criterion*, the London magazine he edited. Gertrude sent him 'the fifteenth of November' so he would know it was written uniquely for him and not plucked from the cupboard. It was all about wool is wool and silk is silk or wool is woollen or silk is silken. Eliot published it two years later. The literary editor of the *New York Evening Post*, Henry Seidel Canby, wrote of it:

> If this is literature or anything other than stupidity worse than madness then has all the criticism since the beginning of letters been mere idle theorizing.

publication of *The Making of Americans*

Lesbians saw Gertrude into print. Mabel Dodge privately published Gertrude's portrait of her at the Villa Curonia, and Margaret Anderson and Jane Heap included pieces by her in *The Little Review*. Then in 1925, seventeen years after Gertrude finished writing it and commercial publishers had rejected it, a short run of *The Making of Americans* was at last published by Contact Editions, which was financed by Bryher, with her husband of convenience Robert McAlmon as editor.

Bryher described her first meeting with Gertrude in her memoir, *The Heart to Artemis*. She was walking with McAlmon in Paris. Gertrude stopped her car and 'lumbered down'.

> Two penetrating eyes in a square impassive face seemed to be absorbing every detail of my appearance. 'Why McAlmon' a puzzled voice remarked, 'you did not tell me that you had married an ethical Jewess. It's rather a rare type.'

Bryher was not remotely Jewish, though she was ethical. But, she said, 'you did not argue with Gertrude Stein. You acquiesced.'

Gertrude signed a contract with Contact. There was to be an initial print run of 500 copies plus five deluxe versions printed on vellum. Gertrude said she would personally shift fifty copies. Darantiere, as ever, was the printer. Carl Van Vechten, who despite great efforts had failed to find an American publisher, was delighted; he viewed Gertrude's book as 'big as, perhaps bigger than James Joyce, Marcel Proust or Dorothy Richardson'. He compared it to the Book of Genesis: 'There is something Biblical about you Gertrude. Certainly there is something Biblical about you.'

Publication was tortuous. Alice accused McAlmon of being irresponsibly drunk throughout the whole process. Gertrude said McAlmon forgot from one letter to the next what he had or had not agreed. She wanted her book 'to go big and I want to get my royalties'. Spurred by Alice, and without consulting McAlmon, in the middle of production she asked Jane Heap, of *The Little Review*, to find a different American publisher. Jane Heap approached Benjamin Huebsch, publisher of D.H. Lawrence's *Sons and Lovers*, James Joyce's *Dubliners* and Sherwood Anderson's *Winesburg, Ohio*. She did not know he had turned down Gertrude's book thirteen years previously. Then Gertrude told McAlmon that Boni & Liveright were interested in bringing out all her work. She wrote to him on 16 September:

It is for me an important opportunity. Their proposal is to buy *The Making of Americans* from you that is the 500 copies minus the 40 copies already ordered, for a thousand dollars… They would pay for the unbound sheets and covers upon delivery… Will you wire me your answer within 24 hours. You will realise how much this opportunity means to me.

McAlmon sent his wire, 'Book bound offer too low and vague.' He followed up with an irritated letter: it was unbusinesslike for Boni & Liveright not to deal with him, the printing costs had been $3,000, he did not feel like making a gift of his work to any publisher. Nonetheless, Gertrude phoned Darantiere and asked him to send the plates to Boni & Liveright. Darantiere checked with McAlmon, who told him not to take any orders except from Contact. On 8 October McAlmon again wrote to Gertrude:

> Had you wished to give arbitrary orders on the book you could have years back had it printed yourself… the book is now complete, stitched, and will be bound. You will get your ten copies which will be sufficient for your friendly gifts and at least more than commercial publishers give authors. Whatever others you want you can have at the usual author's rate of 50% on the sale price of eight dollars. We will send out review copies to some special reviewers if you choose to send us a list of names and addresses. Further panic and insistence and 'helping us' will not delight me.

Three months after publication in December, only 103 copies had been sold. Reviews were thin and poor. Edmund Wilson in *The New Republic* said he could not read it through:

> with sentences so regularly rhythmical, so needlessly prolix, so many times repeated and ending so often with present participles, the reader is all too soon in a state not to follow the slow becoming of life, but simply to fall asleep.

The *Irish Statesman* said it must be among the seven longest books in the world. The *Saturday Review of Literature* wrote: 'Miss Stein has exhibited the most complete befuddlement of the human mind.' The reviewer expressed concern for the well-being of the compositors and said they deserved sixteen bucks a day for the rest of their natural lives.

Six months later, McAlmon wrote a scornful letter to Gertrude about the book's lack of sales:

> You knew it was a philanthropic exercise as the MS had been some twenty years on your hands. There is no evidence of any order having come through your offices except from your immediate family. If you wish the books retained you may bid for them. Otherwise, by Sept – one year after publication – I shall simply get rid myself of them en masse by the pulping proposition.

At the age of fifty-two, Gertrude was a well-known literary figure but with a dismal publishing record and viewed by many to be unreadable. She was a modernist, an innovator, though few seemed quite sure what she was on about. She did not buy the copies from McAlmon, nor did he pulp them. The book's reputation grew. But Gertrude and McAlmon were through with each other and theirs became another relationship beyond repair.

In 1931, Edmund Wilson published *Axel's Castle*, critical essays subtitled 'A Study in the Imaginative Literature of 1870–1930'. In it, he put Gertrude in the same company as acknowledged great modernists: Proust, Joyce, Yeats, Eliot, Paul Valéry – all men, of course. She was the only woman included. Wilson wrote that although Gertrude wrote nonsense,

> One should not talk about 'nonsense' until one has decided what sense consists of... Most of us balk at her soporific rigmaroles, her echolalic incantations, her half-witted sounding catalogues of numbers. Most of us read her less and less. Yet... we are still always aware of her presence in the background of contemporary

literature. And whenever we pick up her writings, however unintelligible we may find them, we are aware of a literary personality of unmistakeable originality and distinction.

The Autobiography of Alice. B. Toklas

In person, Gertrude was commonsensical and wise. She was respected, sought after, quoted, interviewed and lampooned, but except for contributions to the short-lived literary magazines she was seldom published. The world knew of Gertrude Stein but less than a few read her and appreciated her for the genius she considered herself to be. Alice did not swerve from doing all she could to promote her, but she let her know she would like her to be rich and successful in a popular way. The reputations of many of the young men whose careers Gertrude had helped forge were secured. Alice urged her to write a memoir. She felt sure it would be a financial success. Gertrude feared compromising her art. 'Remarks are not literature,' she said. She suggested Alice write her memoirs and call them My Life with the Great, or My Twenty Five Years with Gertrude Stein. Alice responded that she did everything else but could not be an author too.

So Gertrude, prompted by Alice, in the autumn of 1932 wrote *The Autobiography of Alice B. Toklas*. It took her six weeks. Familiarity with their merged personalities was all too real. Gertrude knew Alice through and through, and with the alter ego device Alice could be responsible for snide remarks and equivocal opinions about friends and contemporaries.

The *Autobiography* was a light-hearted mix of fact, fiction, opinion, insult and anecdote. The American publisher Harcourt Brace snapped it up. *Atlantic Monthly* serialized it. The opening section 'Before I came to Paris' established Alice's character: 'a gently bred' intelligent young Californian woman, a moderately contented housekeeper for her father and brother, for whom

life was reasonably full: 'I enjoyed it but I was not very ardent in it.'

Then came the San Francisco earthquake, an apocalyptic event equalled only by its sequel: Alice travelled to Paris and met Gertrude Stein. Gertrude was at the centre of 'the heroic age of cubism'. She familiarized Alice with the world of modern art, took her to the cutting-edge art shows, introduced her to everyone of consequence and allowed her to serve the person at the vanguard of modern taste, modern literature and American cultural identity.

The narrative moved quickly to the main subject of concern – Gertrude. 'In English literature in her time she is the only one. She has always known it and now she says it.' Gertrude was good-humoured, unpretentious, well-educated, widely travelled and there was only one language for her: English. She did not like the theatre, she could not draw and 'Gertrude Stein never had subconscious reactions'. She was an ordinary, middle-class American woman, educated in Massachusetts and Maryland, who just happened to be a genius.

The *Autobiography*, with Gertrude and Alice at its centre, chronicled a quarter of a century of Paris life. Picasso, Matisse, Apollinaire, Hemingway, Scott Fitzgerald were there, so was the cook Hélène, Mabel Weeks, Basket the dog and Auntie the car. It covered the revolutionary exhibitions of the Fauves and Cubists, the struggles of the little magazines in the twenties, the aspirations of the expatriate writers after the 1914–18 war. And because six years after its publication Europe was wrecked by a war that ended a civilization, it came to be seen as an exemplar, a model of its kind. Nowhere was the word lesbian used. Sylvia Beach, Adrienne Monnier, Janet Flanner, Jane Heap, Margaret Anderson, Natalie Barney made guest appearances but not as women who loved women. Nor were Gertrude and Alice lesbian partners. They were indivisible, a unique entity.

Reviews were good. Edmund Wilson in the *New Republic* praised the book's wisdom, distinction and charm and said it showed Gertrude's influence at the source of modern literature and art. Cyril Connolly in the *Sunday Times* called it a model of its kind that stood up to any amount of rereading. And Janet Flanner, Genêt, in her 'Letter from Paris' called it:

> a complete memoir of that exciting period when Cubism was being invented in paint and a new manner of writing being patented in words, an epoch when not everyone had too much to eat but everyone had lots to say, when everything we now breathe was already in the air and only a few had the nose for news to smell it – and with most of the odors of discovery right under the Toklas-Stein roof.

She said the book was simply written 'in Miss St- that is to say, Miss Toklas's first, or easiest literary manner'.

The book was reprinted four times in four years. Bernard Faÿ translated the French edition published by Gallimard, Cesare Pavese the Italian edition. Here for Gertrude, at the age of sixty, was popular success.

Many of those written about took offence. Hemingway seethed. Gertrude had said he learned the art of writing from proofreading her *Making of Americans*, that she and Sherwood Anderson created him and 'were both a little proud and a little ashamed of the work of their minds'. She said he was 'yellow', meaning cowardly, 'just like the flat-boat men on the Mississippi river as described by Mark Twain', that he 'looks like a modern and he smells of the museums', that 'whenever he does anything sporting something breaks, his arm, his leg, or his head'. Hemingway felt publicly humiliated by her and thought she had exacted revenge because of the fracas over the serializing of *The Making of Americans* in the *Transatlantic Review* a decade previously.

He publicly called her a bitch. Criticized by his editor, Maxwell Perkins, for this, Hemingway responded in a letter to him on 7 September 1935:

> Gertrude? What would you like me to put in place of bitch? Fat bitch? Lousy bitch? Old Bitch? Lesbian Bitch? What is the modifying adjective that would improve it? I don't know what word to replace bitch with. Certainly not whore. If anyone was ever a bitch that woman was a bitch. I'll see if I can change it. … For Christ's sake Max don't you see that they have to attack me to believe in themselves…. Would you prefer fat female? That is possible. I'll change it to fat female or just female. That's better. That will make her angrier than bitch, will please you by not calling a lady a bitch, will make it seem that I care less about her lying about me, and will please everyone but me who cares only about honesty.

Gertrude, he said, was menopausal and all her former talent had degenerated to 'malice and self-praise… Homme des lettres, woman of letters, salon woman. What a lousy stinking life.' He said she and her feathered friends had decided nobody was any good creatively unless they were queer, that she thought all queer people talented and that anyone who was any good must be queer. When he heard her voice on the radio in 1934, he described it as like a distant echo from the tomb of a dead friendship.

In cold revenge, he later retaliated in his own memoir, *A Moveable Feast*, published posthumously in 1964. In his account of how their friendship ended, he said he called one morning at 27 rue de Fleurus, the maid gave him a glass of Alice's eau de vie and told him Gertrude would soon be down; he then heard Alice speaking to Gertrude as he had never heard one person speak to another:

> never, anywhere, ever. Miss Stein's voice came pleading and begging, saying Don't pussy. Don't. Don't Please don't. I'll

do anything pussy but please don't do it. Please don't. Please
don't pussy.

Hemingway said he slipped away, unable to listen to more.

The *Autobiography of Alice B. Toklas* caused sufficient offence
for *transition* to publish a supplement in February 1935 with the
title 'Testimony Against Gertrude Stein'. Among those retaliat-
ing were the magazine's editor, Eugène Jolas, Georges Braque
and Henri Matisse. In a foreword, Jolas wrote that Gertrude
had no real understanding of what was happening with her
contemporaries and was never ideologically intimate with such
movements as Fauvism, Cubism, Dadaism, Surrealism and that:

> The *Autobiography of Alice B. Toklas* in its hollow tinsel
> bohemianism and egocentric deformations may very well
> become one day the symbol of the decadence that hovers
> over contemporary literature.

Braque, in his testimony, said Gertrude never knew French
well, entirely misunderstood cubism because she saw it simply
in terms of personalities and that he had felt most uncomfortable
when he met her and Alice at Avignon during the war and they
were wearing boy-scout uniforms and pith helmets.

Matisse was offended by Gertrude's description of his wife as 'a
very straight dark woman with a long face and a firm large loosely
hung mouth like a horse'. His wife, he said, was 'a very lovely
Toulousaine' with beautiful dark hair.

Leo's scorn matched Hemingway's: he called the *Autobiog-
raphy* a farrago of clever anecdote, stupid brag and general bosh.
'God what a liar she is', he wrote to Mabel Weeks.

> If I were not something of a psychopathologist I should
> be very much mystified. Some of her chronology is too
> wonderful... Practically everything that she says of our
> activities before 1911 is false both in fact and implication

but one of her radical complexes, of which I believe you
knew something, made it necessary practically to
eliminate me.

Most readers found Gertrude's *Autobiography* light-hearted,
humorous and refreshingly easy to read. But she had angered
many men. And for herself she was equivocal about the success
that followed publication. This popular, easy-to-read style was
not how she wanted to be represented:

> So many people knowing me I was I no longer and for the
> first time since I had begun to write I could not write and
> what was also worse I began to think about how my writing
> would sound to others…

She wanted to earn a lot of money but did not want to do
what she had to do to achieve that. 'There are some things a
girl cannot do,' she said. She reasoned, quite rightly, it was the
work of her true self that had made people interested in her in
the first place. But following the success of the *Autobiography*,
Bennett Cerf, founding editor of Random House, gave her
contracts for what she regarded as her real work and published
her much rejected *The Making of Americans* and *Three Lives*, and
a collection of her portraits and essays called *Portraits and Prayers*.

The success of the *Autobiography* brought money, fame and
invitations to lecture in the States. 'There is no doubt about
it there is no pleasure like it, the sudden splendid spending of
money and we spent it,' Gertrude wrote. They bought an eight-
cylinder Ford, had running water installed in the country house
in Bilignin and a telephone put in there. 'Now that I was going
to be an author whose agent could place something I had of
course to have a telephone,' she wrote. And Basket got two new
collars with studs and a new coat from Hermès, purveyor of
coats for racehorses.

Gertrude and Virgil Thomson

One popular success led to another. In the 1920s, Gertrude had begun a playful collaboration with the composer and pianist Virgil Thomson. He was part of the modernist music scene in Paris with Francis Poulenc and Nadia Boulanger. His partner was the painter and writer Maurice Grosser. Thomson set some of Gertrude's poems, such as 'Susie Asado', to music:

> What is a nail. A nail is unison.
> Sweet sweet sweet sweet sweet tea.

Or from 'Preciosilla':

> ...allmost, a best, willow, vest, a green guest, guest, go go go
> go go go, go. Go go. Not guessed. Go go.
> Toasted susie is my ice-cream

He played the piano and sang the words and found in doing so he revolutionized English musical declamation. He thought if a text was set judiciously, just for the sound of it, meaning would take care of itself.

> And the Stein texts, for prosodizing in this way, were manna. With meanings already abstracted, or absent, or so multiplied that choice among them was impossible, there was no temptation toward tonal illustration, say, of birdie babbling in the brook or heavy heavy hangs my heart. You could make a setting for sound and syntax only, then add, if needed, an accompaniment equally functional. I had no sooner put to music after this recipe one short Stein text than I knew I had opened a door.

Thomson saw that a true creative union for Gertrude's words was not with modern painting but with modern music. In 1927 he set to music a 3,000-word piece of Gertrude's 'Capital Capitals'. It evoked, he wrote:

> Provence, its landscape, food and people, as a conversation

among the cities Aix, Arles, Avignon and Les Baux which are called Capitals One, Two, Three and Four. It also reflects the poet's attachment to that sunny region which she had first known as an ambulance driver in World War One.

He took Gertrude's words

If in regard to climates if we regard the climates, if we are acclimated to the climate of the third capital...

The first capital is one in which there are many more earrings.

The third capital. They have read about the third capital. It has in it many distinguished inventors of electrical conveniences.

and set them to music for four male voices with him at the piano. This music went through many styles, none of which related to the words: Spanish rhythms, lyrical flights, church harmonies, fanfares, lines intoned on one note, chants... He described the piece as a cantata and it lasted eighteen minutes.

'Capital Capitals' had a one-off performance as a midnight entertainment at a costume ball given by Gertrude's friend and Natalie Barney's lover, Lily de Gramont, duchesse de Clermont-Tonnerre, at her eighteenth-century house in rue Raynouard. At the last minute, one of the singers got ill, so Virgil Thomson sang his part as well as playing the piano.

The partygoers read into it what they would. Lily de Gramont lined her garden paths with blue candles. Concealed in the bushes was a quartet with hunting horns. The Polish-born opera singer Ganna Walska arrived in a six-foot-wide white satin decolleté dress with a ten-foot train. Lily met her at the door, said 'you know the size of my rooms' and sent her into the garden, 'and there all evening she paraded like a petulant peacock'.

Gertrude adored the 'Capital Capitals' evening, as seemingly did everyone there. It was extravagant, stylized, theatrical, enter-

taining. Eighteen minutes of shared entertainment was different from 900 mystifying pages to read all on your own.

Four Saints in Three Acts

Gertrude and Virgil Thomson discussed producing a whole opera with her libretto and his music. Gertrude gave the ground plan:

> I think it should be late eighteenth-century or early
> nineteenth-century saints. Four saints in three acts. And
> others. Make it pastoral. In hills and gardens. All four and then
> additions. We must invent them. Next time you come I will
> show you a little bit and we will talk some scenes over.

She wanted the saints to be Spanish. St Teresa of Ávila and St Ignatius Loyola were the main ones. She did not stick at four; she included at least twenty others, including a St Answers and a St Martyr, a St Plan and a St Settlement. And there were two Saints Teresa – a contralto and a soprano.

There were one-line scenes and Gertrude's usual subversions: in one of the more than two scene twos of Act Three, 'Pigeons on the grass alas', became an aria for Saint Ignatius.

> Pigeons on the grass alas.
> Pigeons on the grass alas.
> Short longer grass short longer longer shorter yellow grass.
> Pigeons large pigeons on the shorter longer yellow grass alas
> pigeons on the grass.
> If they were not pigeons what were they.

Virgil Thomson made 'If they were not pigeons on the grass alas what were they...' break into a chorus with the next lines 'They might be very well, very well...', while offstage was a celestial harmony, 'Let Lucy Lily Lily Lucy Lucy let.'

As ever, Gertrude sent verbs, nouns and adjectives to the wind.

Stage directions were fleeting and not easy to follow: 'Saint Teresa half in and half out of doors.' 'Saint Teresa preparing in as you might say.' There were mundane asides: 'How do you do.' 'Very well thank you.' 'And when do you go.' 'I am staying on quite continuously.' There were Gertrudian incantations:

How many saints can be and land be and sand be and on a high plateau there is no sand there is snow and there is made to be so and very much can be what there is to see when there is a wind to have it dry.

Gertrude finished the libretto in 1927. She then tried to find money for Thomson to live on while he worked on the music. He performed for the Cone sisters 'to no great cash result'. Elsa Maxwell invited him to lunch at the Paris Ritz and seemed to promise a commission from the Princesse de Polignac, but that did not happen.

Thomson composed the opera sitting at his piano and chanting until something happened. 'Speech alone lacks music's forward thrust,' he said. He wanted to carry listeners along on a magic carpet. His music infused an emotional logic into the script and made sense of what was certainly not nonsense. It became a piece of moods rather than literary meaning, humorous in the sense of joyful, a kaleidoscope of an opera with allusion to time, place, narrative but nothing specific.

He wrote for a flute, a piccolo, an oboe, two saxophones, a clarinet, a bassoon, a trumpet, trombone, accordion, celesta, glockenspiel 'and lots of other battery', four violins, a viola, a cello and a double bass. He had been a church organist so there were church-style cadences and hymn-style tunes for Gertrude's words such as: 'There can be no peace on earth with calm.' While composition was in progress, Gertrude went with Jean Cocteau to Thomson's 'narrow room in the hotel Jacob' to hear him accompany himself on the piano and sing the opera

in different voices. Cocteau described the work as solid, 'like a table that stands on its legs, a door one can open and close'.

By 25 August 1933, Virgil Thomson had finished two acts of *Four Saints in Three Acts*. He wrote to the composer Aaron Copland that in three more weeks he would have it finished. The time for production seemed right because of the popularity of *The Autobiography of Alice B. Toklas*. He asked the English impresario C.B. Cochran to consider staging it. Cochran declined.

'Chick' Austin – Arthur Everett Austin, director of the Wadsworth Atheneum in Hartford, Connecticut – agreed to produce it under the auspices of the Friends and Enemies of Modern Music and to raise all necessary funds. He planned to stage it at the Atheneum to coincide with the opening there of Picasso's first solo exhibition in America. Art prices had rocketed. In 1929 a group of collectors opened the Museum of Modern Art. As the Depression set in, stocks and bonds declined and the buying of Picasso, Braque and Matisse became investments of rising profit.

Virgil Thomson chose a friend, Frederick Ashton, as the choreographer. Ashton was thirty and had worked with Marie Rambert and C.B. Cochran. John Houseman was the producer. Though a playwright, he had not then had a play staged. Later he ran the Mercury Theatre with Orson Welles. Abe Feder, just out of college, was lighting designer; Alexander Smallens, Leopold Stokowski's assistant, was the conductor. Thomson asked the artist Florine Stettheimer to design the sets and costumes. She wrote in her diary:

> He makes the words by Gertrude Stein come alive and flutter
> and in sound have a meaning. He wants me to do the visual
> part of the opera.

This commission was her sole stage endeavour. She oversaw the execution of her designs. She lived with her invalid mother and two sisters in an apartment in the Alwyn Court

Building on West 58th Street and 7th Avenue. Like the Steins, the Stettheimers were German-American Jews. Florine Stettheimer's work was admired by the photographer Alfred Stieglitz and the artists Marcel Duchamp and Pavel Tchelitchew, but she seldom showed her bright figurative paintings outside of her home. Thomson described her apartment as 'very high camp'. It was itself like a set design with gold and marble, red velvet curtains, plumes and lace.

She made detailed maquettes for *Four Saints*. She used cellophane, beads, gilt and drapes. There was a proscenium arch fashioned of lace, a cellophane backdrop and cyclorama, which created 'waves of light' and 'a great curtain of jewels', a sea wall of shells, palm trees with fronds of white tarlatan, an arch threaded with crystal beads, a stone lion, costumes of black chiffon with black ostrich plumes. St Teresa was to go on a picnic in the second act in a cart drawn by a live white donkey, taking with her a tent of white gauze with a gold fringe. It was Florine's idea to have a maypole dance in one of the Act Twos.

She did a painting, now in the Chicago Art Institute, of Thomson singing and playing Four Saints on a piano surrounded by birds, bright palms and banners of St Virgil, St Gertrude, St Teresa, St Ignatius. And she added a Florine St.

She designed 200 costumes. The opera ran for 100 minutes.

an African-American cast

Virgil Thomson decided on an all-black cast. He praised the dignity, poise, diction and articulation of black performers and thought they were less likely to be fazed by the apparent senselessness of Gertrude's script than white singers inured to traditional operatic form.

So his buoyant music was sung by an all African-American cast, brought together by Eva Jessye, the first African-American

woman to gain international recognition as a professional choral conductor. She described *Four Saints* as a musical breakthrough for African-American singers:

> quite a departure, because up to that time the only opportunities involved things like 'Swanee River,' or 'That's Why Darkies Are Born,' or 'Old Black Joe.' They called that 'our music,' and thought we could sing those things only by the gift of God... With this opera we had to step on fresh ground, something foreign to our nature completely.

The Harlem cast liked the opera. Rehearsals in the basement at St Philip's Church on Harlem's 137th Street were fun. Ashton was popular. He helped performers learn music and movement simultaneously. He found the whole process 'frightfully exhausting' because they were not professional dancers, so it was hard for any scene to be the same twice running. He had difficulty finding six black dancers with ballet training, so a swimmer and a basketball player made up the numbers. He described his choreography as a 'mix of snake hips and Gothic'.

Singers were each paid $15 a week. One chorister, Tony Anderson, said that was fine: 'I could get five pounds of apples, three pork chops, five big rolls, a stick of butter and some jam for a dollar.'

For weeks prior to the opening night, curiosity about the opera built up. A reporter from the *New York Herald Tribune* came to a rehearsal and wrote a preview:

> Arias and recitatives like no hymns that St Philip's Protestant
> Episcopal Sunday School children ever sang are echoing
> through the old church building.

There was panic and tears when the orchestra arrived close to the opening night and their understanding of the score was different from that of the singers.

The opera had its premiere at the Atheneum on 7 February 1934. The gala audience wore evening dress and tiaras. The reviewer for the *New York Herald Tribune* wrote:

> Since the Whiskey Rebellion* and the Harvard Butter Riots†
> there has never been anything like it. By Rolls Royce, by
> airplane, by Pullman compartment and for all we know
> by especially designed Cartier pogo stick, the smart set
> enthusiasts of the countryside converged on Hartford on
> Wednesday evening.

The New Haven Railroad ran special 'parlor cars' to ferry New York 'fashionables'. Gershwin went to the opening night, and so did Toscanini, Cecil Beaton and Dorothy Parker. Carl Van Vechten and Mabel Dodge were there. So were Florine Stettheimer's two sisters. So was Bryher. The engineer and designer Buckminster Fuller arrived in a three-wheeled Dymaxion car of his own design – an 'omni-medium' mode of transport he wanted

* A tax protest in 1791.
† A student protest of 1766.

to make fly – with the playwright and congresswoman Clare Boothe Luce and her friend the actress Dorothy Hale.

The show began with a roll of drums and the red velvet curtain opening on Saint Teresa The First in purple, played by Beatrice Robinson-Wayne backed by a chorus of angels and saints. The cellophane cyclorama dazzled and from the moment the chorus started with Gertrude's immortal words

> To know to know to love her so.
> Four saints prepare for saints.
> It makes it well fish.
> Four saints it makes it well fish,

The evening was a dazzling success of sights, sound and spectacle. There were tangos, military marches, a dirge. There was no plot, but life's modernist post-Christian narrative was, perhaps haphazardly, to begin, perform for a random time, then end. The seemingly nonsensical text offered not one narrative but many voices, different truths and liberated imaginations. It was an extravaganza that paralleled the first comprehensive American retrospective of Picasso.

Here was a truly innovative piece with all the ingredients of modernism, rules broken, meaning, content and symbolism revised. More than *Ulysses*, which was bound within the traditional covers of a book, more than Madame Matisse with a green stripe down her nose, here was the essence of the new. Music, theatre, language, all took on new meaning.

The audience was treated to a cast of African-American performers, a groundbreaking opera put on by influential gay cultural figures, a libretto by Gertrude Stein, composition by Virgil Thomson, experimental stage sets by a woman artist. Curtain calls went on and on. 'A knockout and a wow', Carl Van Vechten wrote to Gertrude, sad that she and Alice were not there.

The significance of the production was clear to Bryher:

It was the perfect moment for *Four Saints* to be performed…
the evening remains for me one of the most triumphant
nights that I have ever spent watching a stage. The Negro
singers stood stiffly as in an eighteenth century painting
of a courtly festival, there was a plaster lion though he had
less to do than I had hoped, but Gertrude's text soared
out magnificently and with her, and our, rebellion against
outworn art.

Reviewers used superlatives: 'an overwhelming and inescap-
able success', 'the most enlightening theatrical experiment'… 'A
spirit of inspired madness animates the whole piece', wrote the
The New York Times. Kirk Askew and Julien Levy, both directors
of modern art galleries, called it 'a glorious and redemptive
affirmation of a new national culture': 'We didn't know anything
so beautiful could be done in America.' The *New Republic* said
it was the most important theatrical event of the season and the
'first pure, free theatre'.

The run was extended for two extra weeks, but the next show
was pre-booked, so despite demand the run had to end. While
fascism was eating at the heart of European civilization, *Four
Saints in Three Acts* rang out – zany, inclusive, playful, joyful and
open. It was fitting that it was produced in America, which at the
time championed democracy and the unalienable right of every
person to life, liberty and the pursuit of happiness. America
was not America without African Americans, American Jews,
American homosexuals, American lesbians and American zeal
for new voices.

Without discernible narrative or plot, *Four Saints* spoke for
an inclusive, diverse world. It was camp and outrageous, the
coming together of unfettered imaginations in a spectacle that
sloughed off the past and let everyone have a good time. For
Gertrude, the production was a revolutionary breakthrough in
communication of her work, an interacting of the two mediums

of music and literature, a popularizing of literary modernism without compromising her style.

After its sold-out run at the Wadsworth Atheneum, the show transferred to Broadway, to the 44th Street Theater in New York, on 20 February 1934. Cast and crew had a week to adapt a production created for a 299-seat theatre to one of 1,400 seats. They worked all hours.

Two days before the sold-out opening night, a fire marshal, who had read enthusiastic accounts of Florine Stettheimer's use of cellophane, came to inspect. He:

> walked up to our highly publicized cellophane cyclorama, took out a penknife, cut off a strip, set a match to it and dropped it just in time to save his hand from being burned.

He condemned the whole set. Only when everything was coated with a non-inflammable paste, which affected colour and weight and dripped under the heat of the lights and made the cellophane sag, could the show proceed. Florine Stettheimer ironed the cellophane after the inspector left so that it again reflected light. And the donkey had to be dropped because she too contravened safety regulations and was unpredictable.

Never again was cellophane sanctioned for a Broadway stage.

Four Saints had another run in November 1934 with the same cast in a downtown Chicago auditorium. Gertrude and Alice combined attending this with a six-month lecture tour in different states. They sailed on 17 October 1934 on the SS *Champlain* and there were flowers in their first-class cabin from Lily de Gramont. They stayed first in New York, at the Algonquin Hotel on 44th Street. There were pictures of them on the front pages of most of the papers and headlines like 'Gerty Gerty Stein Stein Is Back Home Home Back'. In Times Square, in revolving lights, were the words 'Gertrude Stein has arrived in New York'. 'As if we did not know,' said Alice. Gertrude met up with Natalie Barney, who

was in America to see her lionized, and they went for a walk in Central Park. Natalie asked her why she crossed the road without waiting for traffic signals. 'All these people, including the nice taxi-drivers, recognize and are careful of me,' Gertrude replied.

Curtis Air gave her and Alice complimentary first-class tickets to fly from New York to Chicago for the third run of *Four Saints*. Gertrude had to move from the VIP box of honour to an orchestra seat because she was deaf from the plane. At the after-theatre party she met George Gershwin, who was so taken with the Harlem choir he hired them the next year when his opera *Porgy and Bess* opened in Boston. John Houseman noticed Gertrude had dark spots on her lips and wondered if they were cancerous.

At home with success, Gertrude gave lectures at the Colony Club New York and at the universities of Columbia, Princeton and Washington. In December 1934, she and Alice had tea at the White House with Eleanor Roosevelt and her lover, Hick – Lorena Hickok, who lived there for the twelve years of Roosevelt's presidency. Gertrude then continued her tour to Toledo, Indianapolis, Houston, San Francisco, Pittsburgh… The years of negation were swept away.

> I cannot say that we don't like it we do like it wonderfully every minute and everything has worked out so beautifully… I am delighted really delighted with the way all the audiences take the lectures and it makes me happier than I can say.

She wanted more life for the opera but the people involved moved on and Virgil Thomson believed it was too soon for a new production; the original was too much in people's minds. He thought *Four Saints* would take its place in classical repertory.

Reading of Gertrude's success, James Joyce asked Virgil Thomson to compose a ballet based on a chapter about children's games in *Finnegans Wake*. He hoped it would be produced at the Paris Opéra with choreography by Léonide Massine. Thomson

declined on the grounds that ballets don't have words, but his real reason was the rivalry between Gertrude and Joyce. He did not wish to play one against the other and his first loyalty was to Gertrude.

She and he then had a falling out over money. Gertrude, or perhaps Alice, queried their fifty/fifty division of profits. Gertrude posited that the project only had life because of the commercial value of her name. Thomson was miffed:

> If you knew the resistance I have encountered in connection
> with that text and overcome, the amount of reading it and
> singing it and praising it and commending it I have done, the
> articles, the lectures, the private propaganda that has been
> necessary in Hartford and New York to silence the opposition
> that thought it wasn't having any Gertrude Stein, you wouldn't
> talk to me about the commercial advantage of your name.

There was anyway not much money to be had for anyone, given the huge cast, lavish production costs and a run of only six months. They patched up their quarrel enough to embark on a second opera, *The Mother of Us All*, about the women's suffrage movement in America, with the women's rights activist Susan B. Anthony as the central figure, but it was not put on until after the Second World War and Gertrude died without seeing it brought to life. It became one of the most widely performed American operas.

the end of an era

In January 1938, Gertrude and Alice moved from their Paris home of twenty-five years in rue de Fleurus. The landlord wanted their apartment for his son. They found a new apartment at 5 rue Christine in the Latin quarter. It had once been the home of Christina, Queen of Sweden and had the original seventeenth-

century wall boiseries. Janet Flanner arrived on moving day with a pot of white flowers. Gertrude gave her a pencil and piece of paper and said, 'Put the pot anywhere and make me an inventory of my art.' She had never bothered to do this before. Janet Flanner's inventory was a rather vague jotting, but she recorded 131 paintings including five Picassos 'still in the china closet'. She listed Picasso's portrait of Gertrude, his *Young Girl with a Flower Basket*, a 'Full Length Nude' from his Rose period, and nineteen small works 'including four perfectly matched heads of the 1913 Cubist period, rare in their unity'. She listed various Cézannes and two still lifes by Braque. None of the pictures was insured because that would cost too much.

this preposterous masculine fiction

In Gertrude's view, the only ones really grateful for the 1939–45 war were the wild ducks that lived in the marshes of the Rhône. Hunting guns were requisitioned so no one could shoot at them.

> They act as if they had never been shot at, never, it is so easy to form old habits again, so very easy.

Right up until the summer of 1939, she would not believe there could be another European war. That 'this preposterous masculine fiction', as Virginia Woolf termed it, would again engulf the world. Gertrude regarded war as a plunge back into medievalism, a sign of arrested development. 'It is queer', she wrote, 'the world is so small and so knocked about.' She voiced the hope that war might go out of fashion, like duelling, and thought the quickest way to stop it might be to ban the salute: 'That is what goes to everybody's head. No saluting, no war.'

She and Alice closed their Paris flat, loaded winter clothes, Picasso's portrait of Gertrude and Cézanne's portrait of Madame Cézanne into the car and headed for their country place in

Bilignin. They could not find their passports when they packed. In a half-hearted attempt to leave for America, they drove to the consulate in Lyons to get new ones but there were queues so they did not wait. Then a neighbour advised them to stay, said they were known and liked and everybody would look after them. So even though they were Jewish and American and by 1940 Bilignin was in Vichy-occupied France, they stayed. 'We always pass our wars in France,' Gertrude said.

As the war progressed they became short of funds, so they drove to Switzerland and sold the portrait of Madame Cézanne in order to buy food on the black market. 'We ate the Cézanne,' Alice said. Bernard Faÿ, translator of *The Autobiography of Alice B. Toklas* into French, negotiated with Marshal Pétain, head of the Vichy regime that collaborated with the Axis powers, to ensure their safety. He also secured extra rations for them of bread and petrol. He had been appointed head of the French collaborationist government at Vichy and was responsible for hundreds of Jews being sent to concentration camps. At the war's end, both Pétain and Faÿ were imprisoned for life as Nazi collaborators. Faÿ escaped to Switzerland. Pétain was exiled to the Île d'Yeu off the Atlantic coast. He died there in 1951.

Gertrude's death

At the war's end, Gertrude complained of tiredness and stomach pains. By December 1945 she had colitis and had lost weight. Her doctor told her to wear her corset differently. In April 1946, in great pain, she was taken to the American Hospital at Neuilly and was told she had cancer too advanced for surgery. She would not accept this stark news and insisted on an operation. She found a surgeon, Louis-Pasteur Vallery-Radot, grandson of Louis Pasteur, who agreed to operate on 27 July 1946, a Saturday. Alice wrote:

I sat next to her and she said to me early in the afternoon, What is the answer? I was silent. In that case, she said, what is the question? Then the whole afternoon was troubled, confused and very uncertain, and later in the afternoon they took her away on a wheeled stretcher to the operating room and I never saw her again.

Alice lived frugally for her remaining twenty-one years in a vain effort to keep Gertrude's art collection intact, rather than selling even one painting to raise capital. In her will, she stipulated that she be buried in the same grave with Gertrude in Père-Lachaise cemetery but that her own name be engraved on the back of the tombstone, behind Gertrude to the end.

do you still love life?

A decade after the war, in a changed and diminished world, Janet Flanner, in Cannes with a friend, visited Picasso's studio at his Villa La Californie for a viewing of his work. She said his salon was crowded with art works 'like an auction room'. In the halcyon days in Paris, she and Picasso had seen each other often in the Café de Flore at the corner of place Saint-Germain, but had never spoken. Picasso met her with his arms outstretched and said:

'You! Why didn't you ever speak to me in the old days at the Flore? For years we saw each other and never spoke, until now. Are you just the same as you are? You look fine. Not a day older.'

'Nor do you,' Flanner said.

'That's true,' Picasso said. 'That's the way you and I are. We don't get older, we just get riper. Do you still love life the way you used to, and love people the way you did? I watched you and always wanted to know what you were thinking... Tell me, do you still love the human race, especially your best friends? Do you still love love?'

'I do,' Flanner replied, astonished by what he was asking.

'And so do I,' Picasso said, and laughed. 'Oh we're the great ones for that, you and I. Isn't love the greatest refreshment in life?'

Then he hugged her.

'No one alive today can know which side's dead men will win the war,' Janet Flanner had written in 1939. When she met Picasso in Cannes, that particular 'preposterous masculine fiction' of war was finished with 60 million dead on the winning and losing sides, 22 million of them soldiers. The old days at the Café de Flore were gone, Sylvia Beach's Shakespeare and Company was closed, Natalie's Temple of Friendship empty, the graveyards fuller, the puffins on the Isle of Bryher fewer, the zany poems, experimental films and little magazines finished. But love of life and love continued to find its way. All over the world there were still lovers of love of

every sort. There was no cut down on kissing between those with the impulse to kiss. Lesbians continued to find each other one way or another. There were people who were riper not older, wiser not meaner, kinder not more cruel. Lovers of the human race and friendship still loved life and lovers and love. And the lovers of love and refreshment in life still loved, and loved lovers and loved love.

IMAGE CREDITS

181 Villa Kenwin © Wikimedia Commons
204 Bryher and Hilda Doolittle, from the H.D. Papers, American Literature Collection, Beinecke Rare Book and Manuscript Library, Yale University. Photographer unknown.
209 Bryher, photograph by Islay Lyons, 1966, Bryher Papers General Collection, Beinecke Rare Book and Manuscript Library, Yale University. Permission to reproduce granted courtesy of the Schaffner family and Manop Cheroensuk
214 Natalie Barney © Alpha Stock / Alamy
216 Natalie Barney © Eyevine
218 Alice Pike Barney © Everett Collection Historical / Alamy
222 Eva Palmer-Sikelianos © Wikimedia Commons
225 Liane de Pougy in 1902 © Bridgeman Images
229 Renée Vivien © PDVE / Bridgeman Images
239 Natalie Clifford Barney with dancers dressed in togas © Archives Charmet / Bridgeman Images
242 Colette © Roger Viollet Collection / Getty Images
254 Elisabeth (Lily) de Gramont © Art Collection 4 / Alamy
260 Romaine Brooks © Mondadori Portfolio / Getty Images
263 Winnaretta Singer © Heritage Images / Getty Images
280 Dolly Wilde © Joan Schenkar
282 Janet Flanner © Bridgeman Art Library
288 Djuna Barnes © Oscar White / Getty Images
294 Gertrude Stein © Hulton Archive / Stringer / Getty Images
296 Gertrude Stein with Alice B. Toklas and their dog Basket © Bettmann / Getty Images
315 Gertrude Stein with the Cone sisters © Wikimedia Commons
321 *Woman with a Hat* (1905) by Henri Matisse © Art Library / Alamy
326 Picasso's portrait of Gertrude Stein (1905–6) © Peter Barritt / Alamy
330 Alice B. Toklas © Culture Club / Getty Images
341 Mabel Dodge Luhan © Donaldson Collection / Getty Images
362 Ernest Hemingway as a child © Everett Collection Inc / Alamy
368 F. Scott Fitzgerald © Hulton Archive / Stringer / Getty Images
386 A performance of Virgil Thomson's opera, *Four Saints in Three Acts* © Lebrecht Music & Arts / Alamy
396 Janet Flanner © Library of Congress / Getty Images
346 Gertrude Stein and Alice B. Toklas at home in the rue de Fleurus © Fotosearch / Stringer / Getty Images

CITATIONS AND BOOKS

From the late 1980s on I researched in the archives for my biographies *Gluck, Gertrude and Alice, Greta and Cecil, Mrs Keppel and Her Daughter, The Trials of Radclyffe Hall* and *Wild Girls*. 'Di's Dykes', I dub this oeuvre of my books about lesbians. In *No Modernism Without Lesbians* I aim for a wider picture – of what lesbians achieved and can achieve when, collectively, they dictate their own agenda.

I have drawn on and added to past research. Access to material has now been revolutionised with online availability.

Sources of quoted material are cited by page number and opening phrase.

| ii | I think… if it is true | Leo Tolstoy, *Anna Karenina* |
| | As women we derive | Adrienne Rich 'It is the Lesbian in Us' *Sinister Wisdom* |

Throw over your man

1	The world has always	Janet Flanner, *The Cubicle City*, 1926
2	the all-time ultimate	Truman Capote, *Answered Prayers*, 1986
2	I am a lesbian	Natalie Barney, *Éparpillements*, 1910

3	When is a woman not	H.D., 'Borderline: A Pool Film with Paul Robeson', 1930
4	You are going to tell	Hansard, 15 Aug 1921, vol. 43
4	I am bold enough to say	Ibid.
5	England was consciously	Gertrude Stein, *Paris France*, 1940 and following
8	'You can't censor	Sylvia Beach, *Shakespeare and Company*, 1956
8	It is true that I only	Virginia Woolf to Ethel Smyth, 19 August 1930, *Letters of Virginia Woolf*, ed. Nigel Nicolson, vol. 4, 1978
8	the habit of freedom	Virginia Woolf, *A Room of One's Own*, 1929
9	Look here Vita	Virginia Woolf to Vita Sackville-West, undated 1927, *Letters of Virginia Woolf*, vol, 3, 1977

Sylvia Beach

Most of Sylvia Beach's papers are housed in the Manuscripts Division of Princeton University Library. The library at the State University of New York at Buffalo has many of her James Joyce letters, postcards and telegrams; letters from John Quinn; and correspondence with the printer Darantiere and with Paul Léon about legal issues.

Her papers collected by the Monnier estate are at the Harry Ransom Humanities Research Center, University of Texas.

Janet Flanner's papers are in the Flanner / Solano archive at the Library of Congress. The *New Yorker* magazine files are in the New York Public Library.

Harriet Weaver's papers and correspondence are in the British Library manuscripts collections. Her letters to James Joyce are at Cornell University.

11	They couldn't get *Ulysses*	*Shakespeare and Company*
13	My loves were	Ibid.
13	Sylvia had inherited	*Sylvia Beach 1887–1962*, Mercure de France
14	At Miss Barney's one met	*Shakespeare and Company*
15	I was not interested	Quoted in Noel Riley Fitch, *Sylvia Beach and the Lost Generation*

17	Granny taught us to knit	Ibid.
18	his open attentions to a fair	*Town Topics: The Journal of Society*, New York, 1915
19	the new black cook	Sylvia to Marion Peter, 29 November, 1916, Princeton
20	I'm treated like	Sylvia to Cyprian, 16 September 1916, Princeton
20	My Khaki suit	Sylvia to Cyprian, 20 August 1917, Princeton
21	In the unaccustomed	Quoted in Nigel Nicolson, *Portrait of a Marriage*
22	She seemed gray and white	*Shakespeare and Company*
22	That was the beginning	Ibid.
22	American by her nature	*The Very Rich Hours of Adrienne Monnier*
22	*Je te salue*	*La Figure*, 1923
24	Americans have democracy	*The Very Rich Hours of Adrienne Monnier*
25	Mlle Monnier, buxom as	Janet Flanner, *Paris was Yesterday*, 1972
26	distributed pyjamas	*Shakespeare and Company*
26	20 to 30 patients died every	Sylvia to Cyprian, 11 March 1919, Princeton
27	I really don't know where	Sylvia to Cyprian, 11 July 1919, Princeton
28	It was great fun getting	*Shakespeare and Company*
28	O mother dear, you never	Sylvia to Eleanor Orbison Beach, 27 August 1919, Princeton
30	If a manuscript was sold	Bryher, *The Heart to Artemis*
30	sitting in a sort	*Shakespeare and Company*
33	From that moment on	*The Very Rich Hours of Adrienne Monnier*, Introduction
35	As a young student under	*Shakespeare and Company*
37	The awful face of a mad	Quoted in Diana Souhami, *Mrs Keppel and Her Daughter*
37	Not long after	*Shakespeare and Company*
38	the philistines, the exhibition	Ed. Whelan, *Stieglitz on Photography*
39	But she did write a poem	*Shakespeare and Company*
39	You French have no Alps	Ibid.
40	I have found a wonderful	Hemingway to Hadley, 28 December 1921

41	crawled some hellish	Scott Fitzgerald to Hemingway, 8 November 1940
41	No one that I ever knew was	Hemingway, *A Moveable Feast*
42	'Here, read Hemingway	*Shakespeare and Company*
42	I found the acknowledged leader	Ibid.
43	thirteen generations of clergymen	Quoted in *Sylvia Beach and the Lost Generation*
43	The drinks were always on him	*Shakespeare and Company*
46	I had a narrow upbringing	6 January 1960. Quoted in *Dear Miss Weaver*
46	a remarkable person, a genius	*Dear Miss Weaver*
47	to probe to the depths of human	Ibid.
47	I can but apologise to you	Weaver to Joyce, 28 July 1915
48	I did my best to make her	Virginia Woolf, Diary, 14 April 1918
49	With us, love is just as	Margaret Anderson, *My Thirty Years War*
50	Why shouldn't women	Ibid.
50	We formed a consolidation	Ibid.
50	I don't remember ever having	Ibid.
51	The sweet corners of thine tired	Ibid.
51	Hanging from her bust were two	Ibid.
52	We'll print it	Ibid.
55	You're damn fools trying to get	Quoted in Ellmann, *James Joyce*
56	engaged in such a passionate exchange	*My Thirty Years' War*
56	I am sure she didn't know the significance	Quoted in Ellmann, *James Joyce*
57	You can no more limit his expression	*My Thirty Years' War*
58	I have never been too hungry	Ibid.
59	What a good thing for Joyce	*Shakespeare and Company*
59	overcome though I was	Ibid.
62	Undeterred by lack of capital	Ibid.
62	You cannot legislate against	Ibid.
64	invented, or, if she has not	*Essays of Virginia Woolf*, vol. 3
64	It was a tremendous relief	*Shakespeare and Company*
65	It wasn't long before	Ibid.
67	I am about to publish *Ulysses*	Sylvia to Holly Beach, 23 April 1921
68	Joyce was delighted to hear	*Shakespeare and Company*

68	fellow with bangs	Ibid.
69	My carpentry bill will be	Sylvia to Holly, 22 September 1921
70	I shan't forget you	Sylvia to Holly, 24 October 1921
70	the great amateur woman	Janet Flanner, *Sylvia Beach, Hommages*
72	a remarkable book	Quoted in *Sylvia Beach and the Lost Generation*
72	I am an elderly Irish gentleman	Ibid.
73	My darling, my love, my	n.d. April 1922, *Letters of James Joyce*, vol. iii
74	As might be supposed	Bodkin, 29 December, 1922, Public Record Office, London, *Ulysses* files, quoted in 'Sifting through Censorship'
75	Fortunately the book is too	Public Record Office, London, *Ulysses* files
76	It was hardly credited	Ibid.
77	He is such a terribly nervous	Sylvia to Harriet Weaver, 8 June 1922
77	to do everything I could for Joyce	*Shakespeare and Company*
78	As she well knew	Ibid.
79	she never allowed logic to	Marianne Moore, *Sylvia Beach, Hommages*, Mercure de France, 1963
79	We sent copies	*Shakespeare and Company*
81	The driver dumped his books	Ibid.
81	You couldn't persuade anyone	Ibid.
82	His clay-coloured head was bald	Ibid.
82	Henry Miller and that lovely	Ibid.
82	Dr Ellis said he would like	Ibid.
83	To Adrienne Monnier with *Navire*	T.S. Eliot, *Sylvia Beach, Hommages*
86	George is a fine big fellow	8 June 1922, Harriet Shaw Weaver Papers
86	Whatever spark or gift I	Quoted in *Lucia Joyce: To dance in the wake*
86	two people going to the bottom	Ibid.
87	She behaves like a fool	1 May 1935, Ellmann, *Selected Letters*
87	My love was Samuel Beckett	Quoted in *Lucia Joyce: To dance in the wake*

88	that poor proud soul	Ibid.
88	this was not a commercial	*Shakespeare and Company*
90	has written a preface to	Quoted in *Sylvia Beach and the Lost Generation*
92	tragic but very powerful	*Joyce in Court*
92	As for my personal feelings	*Shakespeare and Company*
94	she looks like a little old maid	Sylvia to her father, 17 October 1936, Princeton
96	When you do not like human	Gisèle Freund, *Photography and Society*, 1980
96	Adrienne used to call me	Quoted in *Sylvia Beach and the Lost Generation*
97	I tried always to do what I could	Bryher, *The Heart to Artemis*
98	wage war against a monstrous tyranny	Churchill, 13 May, 1940
98	cattle drawn carts	12 June 1940, quoted in *Sylvia Beach and the Lost Generation*
100	My nationality added to my Jewish	*Shakespeare and Company*
101	dressed as though for a vernissage	*Inturned*
101	the monkey house as we called	Ibid.
103	what if my dear dear friends	Ibid.
103	There is not a single Jew here	Katzenelson, *Vittel Diary*
107	I am putting an end to my	Quoted in *The Very Rich Hours of Adrienne Monnier*
107	Can see no remedy at all	Handwritten note, quoted in *Sylvia Beach and the Lost Generation*
107	with her firmness and calmness	6 February 1956, Mercure de France, *Sylvia Beach*
108	no citizen has ever done	*The Heart to Artemis* and *Hommages*

Works by Sylvia Beach

The Letters of Sylvia Beach, ed. Keri Walsh, 2010
Shakespeare and Company, 1956
Inturned, essay in *Sylvia Beach, 1887–1962, Mercure de France memorial volume*, Matthews, J. and Saillet, M., 1963

Books referencing Sylvia Beach

Anderson, Margaret, *The Fiery Fountains*, 1953
——*My Thirty Years' War*, 1930
Baker, Carlos, *Ernest Hemingway, a life story*, 1969
Beckett Remembering – Remembering Beckett, ed. James and Elizabeth
 Knowlson, 2006
Benstock, Shari, *Women of the Left Bank: Paris, 1900–1940*, 1986
Bryher, *The Heart to Artemis: a writer's memoir*, 1963
Budgen, Frank, *James Joyce and the Making of* Ulysses, 1972
Casado, Carmelo Medina, 'Sifting through Censorship': The British
 Home Office *Ulysses* Files, James Joyce Quarterly, vol. 37, 2000
Ellmann, R., *James Joyce Selected Letters*, 1976
——*James Joyce*, 1959
Fitch, Noel Riley, *Sylvia Beach and the Lost Generation: A history of literary
 Paris in the twenties and thirties*, 1983
——"Sylvia Beach: Commerce, Sanctification, and Art on the Left
 Bank," in *A Living of Words: American Women in Print Culture*, ed.
 Susan Albertine, 1994
The Letters of F. Scott Fitzgerald, ed. Andrew Turnbull, 1964
Flanner, Janet, *Paris Was Yesterday: 1925–1939*, ed. Irving Drutman, 1972
——*Paris Journal: 1944–1965*, 1965
——*Paris Journal: 1965–71*, 1971
——*Men and Monuments*, 1957
——*An American in Paris*, 1940
Ford, Hugh, *Published in Paris: American and British Writers, Printers, and
 Publishers in Paris 1920–1930*, 1975
Glass, Charles, *Americans in Paris: Life and Death Under Nazi Occupation*,
 2009
Hardiman, Adrian, *Joyce in Court*, 2017
Hemingway, Ernest, *A Moveable Feast*, 1964
——*Letters*, Cambridge edition, ed., Sandra Spanier, 2011
Joyce, James, *Ulysses*, 1922
——*Letters*, ed. Gilbert Stuart, 1957, 1966
——*Letters to Sylvia Beach 1921–1940*, ed. Melissa Banta and Oscar A.
 Silverman, 1987
Katzenelson, Itzhak, *Vittel Diary (22.5.43–16.9.43)* trs. Myer Coben,
 1964
Lappin, Linda, 'Jane Heap and Her Circle', *Prairie Schooner*, vol. 78, 2004
Lawrence, D.H., *Selected Letters*, 1950
Lee, Hermione, *Virginia Woolf*, 1996
Lidderdale, Jane and Nicholson, Mary, *Dear Miss Weaver*, 1970
Maddox, Brenda, *Nora: A Biography of Nora Joyce*, 1988

Matthews, J. and Saillet, M., *Sylvia Beach 1887–1962*, Mercure de
 France, 1963
Monnier, Adrienne, *The Very Rich Hours of Adrienne Monnier*, ed. and trs.
 Richard McDougall, 1976
Nicolson, Nigel, *Portrait of a Marriage*, 1992
*Prudes on the Prowl: Fiction and Obscenity in England, 1850 to the Present
 Day*, eds David Bradshaw and Rachel Potter, 2013
Pound, Ezra, *ABC of Reading*, 1951
——*Selected Letters 1907–41*, 1950
——*Selected Poems*, ed. T.S. Eliot, 1928
Rauve, Rebecca, 'An Intersection of Interests: Gurdjieff's Rope Group
 as a Site of Literary Production', *Twentieth Century Literature*, vol. 49,
 2001
Shloss, Carol Loeb, *Lucia Joyce: To dance in the wake*, 2004
Souhami, Diana, *Mrs Keppel and Her Daughter*, 1996
Stein, Gertrude, *Paris France*, 1940
Stieglitz on Photography: his selected essays and notes, ed. R. Whelan, 2000
Woolf, Virginia, *Letters*, vol. 2, 1912–1922; *The Question of Things
 Happening*, ed. Nigel Nicolson, 1976; vol. 3, *A Change of Perspective*,
 1977; vol. 5, *The Sickle Side of the Moon*, 1979
——*Essays*, ed. Andrew McNeillie, vol 3, 1986
——*The Diary of Virginia Woolf*, 5 vols, ed. Anne Olivier Bell assisted by
 Andrew McNeillie, 1976–84

Bryher

Bryher's papers are in 191 boxes at the Beinecke Library, Yale. These boxes
include correspondence, manuscripts, financial papers, papers about film
and papers about boys' books by authors like R.M. Ballantyne and G.A.
Henty:https://orbis.library.yale.edu/vwebv/holdingsInfo?bIbid.=3476386

Louis Silverstein's online H.D. Chronology is an invaluable and detailed
research guide covering every event in her life. http://www.imagists.org/
hd/hdchron1.html

H.D.'s papers are also at the Beinecke – in 69 boxes. The H.D. Inter-
national Society has an official website: https://hdis.chass.ncsu.edu. It has
also compiled a Bryher Chronology: https://hdis.chass.ncsu.edu/hdcircle/
bryher/

111 When is a woman not	H.D., *Borderline*
113 it is distinguished by	'Our Friend Bryher' in *The Very Rich Hours of Adrienne Monnier*

113	Gluck no prefix, no suffix	Diana Souhami, *Gluck: Her Biography*
113	I have rushed to the penniless	Bryher, *The Heart to Artemis*
114	I was completely a child of	Ibid.
115	There was only one street in Paris	Ibid.
117	his beard so neat it could have been	Robert McAlmon, *Being Geniuses Together*
117	'He keeps me in a glass case'	Ibid.
117	I found the French fleuret	*The Heart to Artemis*
118	In the early nineteen hundreds	'Recognition not farewell' *Life and Letters Today*, Autumn 1937
119	I watched the seamen	*The Heart to Artemis*
119	What do you expect	Ibid.
120	I was flung into a crowded	Ibid.
120	I had the emotional development	Ibid.
121	It was an instantaneous falling	Ibid.
121	even to see a puffin	Ibid.
121	There was something about	Ibid.
121	Women will never be accepted	Ibid.
122	Complete frustration leads to	Bryher, *Development*
122	I have always been a feminist	Ibid.
123	paint not the object	Stéphane Mallarmé to Henri Cazalis, 30 October 1864, *Oeuvres complètes*, 1945
123	The rhythms were new	*The Heart to Artemis*
123	to blot out this garden	H.D., *Sheltered Garden, Poems* 21
124	Was something going to happen	*The Heart to Artemis*
125	The door opened and I started	Ibid.
125	so madly it is terrible	H.D. to John Cournos, quoted in *Herself Defined*
126	I don't want to be (as they say	H.D., *HERmione*
127	We are legitimate children	H.D., *Asphodel*
127	She was a disappointment	*HERmione*
128	tall, thin, pale, rather handsome	To Dora Marsden, 1 July 1914, quoted in *Dear Miss Weaver*
128	best of the imagists	May Sinclair to Charlotte Mew, June 1915, Berg Collection
128	to deny love entrance	Quoted in *Herself Defined*
129	Hilda gets very low	Frieda Lawrence to Amy Lowell, February 1918

130	I feel my work is beautiful	H.D. to John Cournos, *Iowa Review*, vol. 16, no. 3
131	You seem to be in a rather	Aldington to H.D., 3 August 1918, Silverstein H.D. chronology
131	this preposterous masculine	Virginia Woolf to Margaret Llewelyn Davies, *Letters of Virginia Woolf*, vol. 2
132	No more than Cain	Aldington to H.D., December 1918, Silverstein
132	Her nerves are very shaken	D.H. Lawrence to Amy Lowell, 28 December, 1918
134	You must think me the greatest	Patmore to Bryher, 25 February 1922, Silverstein
134	The world is full of my daughters	Patmore to Bryher, 10 June 1924, Silverstein
134	sense of being in a bell jar	H.D., *Tribute to Freud*
134	stars turn in purple	H.D., 'Stars Wheel in Purple'
135	bluer than blue, bluer than gentian	H.D., *Asphodel*
136	When I met Bryher first	Ibid.
137	that seemed to be the only	H.D. to Ezra Pound, 1928
137	Hilda's circle did not like me at all	*The Heart to Artemis*
138	back and forth from Audley Street	Ibid.
139	her tall form languidly	Havelock Ellis, *The Fountain of Life*, 1930
140	When a creative scientist	H.D., *Notes on Thought and Vision*
140	super feelers of the super mind	Ibid.
140	We had made a pact	Ibid.
142	They are not important	H.D., *Tribute to Freud*
142	this writing on the wall before me	Ibid.
143	Hilda went right out of her mind	Quoted in *Herself Defined*
146	the energy of a yearling	*Robert McAlmon and The Lost Generation*
146	to sing with my own	'Some Have Their Moments'
147	I thought America	Bryher, *West*, 1925
148	I put my problem	*The Heart to Artemis*
149	I was desperately	Ibid.
150	We are in a terrible	H.D. to Viola Jordan, 17 February 1921, Silverstein
152	moneymakers on the grand	*Being Geniuses Together*
155	Mary was one of the few	'Recognition not Farewell', *Life and Letters Today*, Autumn 1937

156 'Just to prove my darling	15 May 1922 and 15 June 1927
158 I personally don't trust	Unpublished letter, Silverstein
159 We strove for a name	H.D., *Heliodora*, 1924
161 Please if you can	Macpherson to H.D. circa 1926. Quoted in *Herself Defined*
163 Hoping to be a man	Kenneth Macpherson, 'One'
164 She looked a fright	Ibid.
165 not to get caught up	Macpherson to H.D., 1927. Quoted in *Herself Defined*
166 as the stone will cause	Macpherson, *Pool Reflection*, 1927
166 one of Pabst	Macpherson to H.D., 27 October 1927
167 never to be forgotten	*Close Up*, vol. 4, no. 4, April 1929
168 We were invited	*The Heart to Artemis*
170 a chill passed over me	Donald, *Close Up*
171 a dame from the city	Ibid.
171 This is a four-reel film	Ibid.
172 Inside every person	'Secrets of a Soul', Bernard Chodorkoff and Seymour Baxter. American Imago, vol. 31, no. 4, 1974
173 I do not believe	Ibid.
173 The object of my search	*The Heart to Artemis*
175 Brave, handsome	Macpherson to H.D., 1928. Quoted in *Herself Defined*
177 Not black films	Donald, *Close Up*, vol. 5, no. 2
177 made her entry	Janet Flanner, *Paris was Yesterday*
179 ruined our make-up	Quoted in Martin Bauml Duberman, *Paul Robeson*
179 When is an African	H.D., 'Borderline – A Pool Film with Paul Robeson', 1930
179 It's a dreadful highbrow	Quoted in *Paul Robeson*
180 It was the time of	*Heart to Artemis*
183 that seldom if ever	*Analyzing Freud: The Letters of H.D., Bryher and their Circle*
184 usually a child decides	Ibid.
184 F says mine	H.D. to Bryher, 23 March 1933 quoted in Friedman, *Psyche Reborn* and *Analyzing Freud*

184 I feel so very very — H.D. to Bryher, 10 March 1933, *Analyzing Freud*

184 These Jews, I think — H.D. to Bryher, 28 May 1933, *Analyzing Freud*

185 I cannot understand — Bryher, 'What shall you do in the war?' *Close Up*, 1933

186 Freud in himself — *The Heart to Artemis*

186 He says 'many — H.D. to Bryher, 22 March 1933, *Analyzing Freud*

187 such a scene with Elizabeth — Bryher papers, Beinecke, quoted in *Analyzing Freud*

188 if you saw Hepburn — Quoted in *Herself Defined*

188 I had the great satisfaction — Ibid.

188 a Hilton on wheels — Macpherson, 'One'

189 I believe that my father — *The Heart to Artemis*

190 I read the news — Freud to Bryher, 19 July 1933, *Analyzing Freud*

191 Please Fido if you love me — H.D. to Bryher, 24 November 1934

192 I don't want to change you — Bryher to Macpherson, 25 August 1934

193 five buds and flowers — H.D. to Silvia Dobson, 1933, quoted in *Herself Defined*

195 I came to Vienna — Freud, 16 November 1938, letter to *Time and Tide*

195 I blame the English government — *Heart to Artemis*

196 Ask me to die — Ibid.

196 when people are fighting — Ibid.

196 I plundered the black — Ibid.

197 Here I was — Ibid.

197 that blue smoky — *The Days of Mars*

198 we were firm friends — Ibid.

199 I could visualise — H.D., *The Gift*

200 I had a sort of 'shock treatment — H.D. to Bryher, 21 September 1946, Silverstein

201 When you were so very ill — Bryher to H.D., 29 September 1946

207 Most occupants — Bryher to Silvia Dobson, 1 May 1961, Silverstein

207 she minded the frustrations — Bryher to Silvia Dobson, 1 October 1961, Silverstein

209 I was nine when my parents — Bryher, foreword to *The Coin of Carthage*

Works by Bryher

Amy Lowell: A Critical Appreciation, 1918
The Days of Mars: A Memoir, 1972
Development, 1920
Film Problems in Soviet Russia, 1929
H.D. fragment, typescript (at Beinecke)
The Heart to Artemis: A Writer's Memoirs, 1962
Two Selves, 1923
West, 1925
'What Shall You Do in the War?', *Close Up*, June 1933

Novels:
Beowulf, 1956
The Coin of Carthage, 1964
The Fourteenth of October, 1954
This January Tale, 1968
Roman Wall, 1955
Ruan, 1961

Works by H.D.

Asphodel, 1961
Collected Poems, 1912–44, 1983
The Gift, 1998
Helen in Egypt, 1961
HERmione, 1981
Hymen, 1921
Notes on Thought and Vision, 1982
Palimpsest, 1926
Tribute to Freud, 1956

Works referencing Bryher

Aldington, Richard, *Death of a Hero*, 1929
——Richard Aldington & H.D., *The Early Years in Letters*, ed. Caroline Zilboorg, 1992
Collecott, Diana, *H.D. and Sapphic Modernism*, 1999
Donald, James, A. Friedberg and L. Marcus, eds, *Close Up 1927–1933: Cinema and Modernism*, 1998
Dobson, Silvia,'Mirror for a Star', letters and autobiographical notes. Unpublished typescript at Beinecke
Duberman, Martin Bauml, *Paul Robeson*, 1989

Ellis, Havelock, *Fountain of Life*, 1930
——*Studies in the Psychology of Sex*, vol. 1: *Sexual Inversion*, 1897
Flanner, Janet, *Paris Was Yesterday: 1925–1939*, ed. Irving Drutman, 1972
Freud, Sigmund, *The Interpretation of Dreams*, 1900
——Letters to H.D. and Bryher (at Beinecke)
——*Totem and Taboo*, 1913
——*Why War?*, 1933
Friedberg, Anne, 'Writing About Cinema: *Close Up* 1927–1933', 1983
Friedman, Susan Stanford, ed., *Analyzing Freud: Letters of H.D., Bryher and their Circle*, 2002
——*Psyche Reborn: the emergence of H.D.*, 1981
Gregg, Frances, *The Mystic Leeway*, 1995
Grosskurth, Phyllis, *Havelock Ellis*, 1980
Guest, Barbara, *Herself Defined; the poet H.*, 1984
Hanscombe, Gillian and Smyers, Virginia, *Writing for Their Lives*, 1987
Knoll, Robert E., ed., *McAlmon and the Lost Generation*, 1962
Lawrence, D.H., *The Letters of D.H. Lawrence*, ed., Aldous Huxley, 1932
——*Selected Letters*, ed. James T. Boulton, 1996
Lawrence, Frieda, *Not I But the Wind*, 1934
Luhan, Mabel Dodge, *Lorenzo in Taos*, 1933
Macpherson, Kenneth, fragment of a novel on H.D., at Beinecke
——'One', notes for a memoir, at Beinecke
McAlmon, Robert, *Being Geniuses Together*, 1938
——*Some Have Their Moments*, typescript at Beinecke
——Letters to H.D. at Beinecke
Monnier, Adrienne, *The Very Rich Hours of Adrienne Monnier*, ed. and trs. Richard McDougall, 1976
Patmore, Brigit, *My Friends When Young*, 1968
Pearson, Norman Holmes, notes for a biography of H.D., at Beinecke
Pound, Ezra, *Selected Poems 1908–1959*, 1975
——*The Cantos*, 1956
——*Literary Essays*, ed. T.S. Eliot, 1956
——Letters to H.D. and Bryher, at Beinecke
Rosenberg, John, *Dorothy Richardson*, 1973
Sachs, Hanns, *Freud: Master and Friend*, 1944
Smyth, Ethel, *Impressions That Remain – Memoirs of Ethel Smyth*
Souhami, Diana, *Gluck: Her Biography*, 1988

Natalie Barney

Natalie Barney's and Romaine Brooks' papers are in the Archives of American Art and the National Museum of American Art at the Smithsonian Institution, Washington DC; the McFarlin Library at the University of Tulsa; and the Bibliothèque Littéraire Jacques Doucet in Paris. Six hundred letters between Natalie and Romaine Brooks, dating from 1924 to 1969, are in the McFarlin Library. The publication by Francesco Rapazzini of the marriage agreement between Natalie and Elisabeth de Gramont, shows Natalie's relationships in a new light.

The papers of Djuna Barnes are in the McKeldin Library, University of Maryland. The recent biography of Eva Palmer by Artemis Leontis is scholarly and impressive.

The Janet Flanner and Solita Solano papers are in the Library of Congress Manuscript Division, Washington, D.C.

213	I am a lesbian	*Éparpillements*
215	Love has always	*Selected Writings*
215	Living is the first	Ibid.
215	My queerness	*Lettres à une inconnue*, unpublished 1899
215	I have loved	*The Woman Who Lives With Me*, privately printed, no date; see *A Perilous Advantage*
215	the water I made	*Souvenirs indiscrets*
215	I neither like nor	*Pensées d'une amazone*
216	The finest life	Ibid.
216	What makes marriage	*Souvenirs indiscrets*
216	Why should I bother	*A Perilous Advantage*
217	I often reflect	Ibid.
217	When she bent over	'Tribute to my Mother', Archives of American Art
218	Live and let live	Ibid.
219	I loathe the enthusiasm	*Pensées d'une amazone*
219	mind pickers	Ibid.
221	Love has always been	Dorothy Strachey, *Olivia*
222	Your letter folds me	Eva Palmer to Natalie, 1901, Bibliothèque Jacques Doucet
226	God will punish you	*Pensées d'une amazone*
226	I still need	*My Blue Notebooks*
227	Ever since I remember	Undated, c.1900, Pike Barney letters, Archives of American Art, Smithsonian
228	The butler announced	*Souvenirs indiscrets*

229 'The moon sulked — *My Blue Notebooks*

229 a disquieting beginning — *Souvenirs indiscrets*

231 she had brown eyes — Ibid.

232 Impossible to find — Colette, *The Pure and the Impure*

232 In you I find — Chalon, *Portrait of a Seductress*

233 I did not want it — *Souvenirs indiscrets*

235 I had an adorable — To John Lane, 30 December 1900, Mark Samuels Lasner Collection, on loan to University of Delaware

235 Come my poet — No date, Henry W. Berg collection, New York Public Library

236 You are a darling — Quoted in Murray, *Bosie*

236 Oh how I miss you — Undated, *c.*1901, Berg

239 What do I care — *Éparpillements*

239 Barney's pavilion — Artemis Leontis, *Eva Palmer Sikelianos: A Life in Ruins*

240 I am so glad — 1 March 1901, Berg

240 Let us forget — *Je me souviens*

241 Her power like her fortune — *Portrait of a Seductress*

241 'Oh my dear little — *The Pure and the Impure*

242 Among the beverages — Ibid.

244 I have walked after you — *c.*1906, Jacques Doucet

244 What you are doing — Artemis Leontis, *Eva Palmer Sikelianos: A Life in Ruins*

246 She was the only ancient Greek — Robert Payne, *The Splendor of Greece*, 1960

248 I didn't create a salon — *Portrait of a Seductress*

249 The universe came here — Edmond Jaloux, *Les saisons littéraires*

250 If I dared — Remy de Gourmont, *Letters to the Amazon*, translated by Richard Aldington

251 I've never given up my — https://www.youtube.com/watch?v=ihzoLrUkNoc

252 I dread possessions — *Pensées d'une amazone*

253 queen of Lesbos — Yvonne Serruys, *Pensées* (notebook, undated).

255 used wake me up — Elisabeth de Gramont, *Years of Plenty*, translated by Florence and Victor Llona

255 If she has suffered much Quoted in Rapazzini, *'Eternal Mate'*

255 I undress her *L'adultère ingénue*, quoted in Rapazzini, *'Eternal Mate'*, Bibliothèque Doucet

257 The blonde and the Ibid.

257 I shall have my room Ibid.

257 too good and too real Ibid.

258 We laugh all the time *My Blue Notebooks*

260 You know how you know Truman Capote, *Answered Prayers*

260 She never failed to Romaine Brooks, *No Pleasant Memories.* And following

263 icy as a cold draught Michael de Cossart, *Food of Love: Princesse Edmond de Polignac and her salon*

263 perfectly stuffed 30 November 1937, Virginia Woolf, *Diary*, vol. 5, 1936–41

263 the head is bent Quoted in Secrest, *Between Me and Life*

264 The quarrel has reached Quoted in Sylvia Kahan, *Music's Modern Muse*

265 The true reason 'Americans in Europe', *New York World*, 1887

267 You know my very great 20 November 1912. Paul Sacher Stiftung, Basel

267 I would need Stravinsky to Winnaretta, 11 December 1912. Eric van Lauwe, Paris

267 A large room Élisabeth de Gramont, 'Une Passion malheureuse', *La Revue de Paris*, October 1931

268 I saw La Princesse To Dorothy Bussy, 15 December 1936

268 Her collection of paintings Bruno Monsaingeon, *Mademoiselle: Conversations with Nadia Boulanger*

269 the most adorable 1904, private collection. Quoted in *Music's Modern Muse*

270 I was shown into Annie Kenney, *Memories of a Militant*

270 You are a brick Ethel Smyth to Winnaretta, 13 April 1912, Bibliothèque Nationale, France

271 swimming in happiness — To Valentine Gross, 18 January 1917, Satie, *Correspondence*, Paris, 2000

271 We go on because — Winnaretta to Jean de Polignac, 18 Jan 1924. Quoted in *Music's Modern Muse*

271 What a dreadful thing — Violet to Vita, 11 May 1920, *Violet to Vita*

272 She hung over life — Violet Trefusis, *Don't Look Round*

273 Princess Winnie taught — Harold Acton, *More Memoirs of an Aesthete*

273 told a marvellous story — Duff to Diana Cooper, 6 February, 1927, *A Durable Fire*

274 It is sensuous, greedy — *Don't Look Round*

275 wanting all calm — Romaine to Natalie, 16 May 1925, McFarlin

276 Always remember Nat, — Romaine to Natalie, 25 July 1925, McFarlin

276 Mrs Brooks puts bars — Élisabeth de Gramont, *Pomp and Circumstance*

277 So Renata Borgatti is — Natalie to Romaine, 21 July 1920, McFarlin

278 suggest thoughts of — Transcript of *The Director of Public Prosecutions v. Rubinstein and Leopold Hill*, Bow Street Police Court, 16 November 1928, National Archives of Canada

280 Her hands and feet — Janet Flanner, *Paris Was Yesterday*

281 more Oscar like — Natalie Barney, *In Memory of Dorothy Ierne Wilde: Oscaria*

281 half androgyne — Ibid.

283 On the street — *In Memory of Dorothy Ierne Wilde*

284 Do you love me — Dolly to Natalie, undated, Jacques Doucet. And see *Truly Wilde*, 2000

284 You overshadowed me — July 1927, Jacques Doucet

284 Your life at present — Romaine to Natalie, 18 February 1931, McFarlin

285 Romaine and Lily are — Dolly to Natalie, 18 March 1932, Jacques Doucet

285	I am told by friends	R. Toulouse to Natalie, 20 July 1939, Jacques Doucet
285	utterly singular	*In Memory of Dorothy Ierne Wilde*
285	Well she certainly hadn't	Ibid.
285	extraordinary verbal gift	Ibid.
286	If VT was a man	Victoria Sackville, unpublished diary, February 1920, Lilly Library
287	a kind of lighthouse	Radclyffe Hall, *The Well of Loneliness*
288	perverse, dissolute, self	Lucie Delarue-Mardrus, *The Angel and the Perverts*
289	'And' said Dame Musset	*Ladies Almanack*
290	Sold all 50 Almanacks	Djuna to Natalie, 8 January 1929, Jacques Doucet
291	My angel's weary	Natalie to Romaine, 23 August 1955, McFarlin
291	A love affair can cause	Romaine to Natalie, 28 September 1963, McFarlin
291	Even at night	Natalie to Romaine, 8 May 1964, McFarlin

Works by Natalie Barney

Adventures of the Mind, translated by John Spalding Gatton, 1992
A Perilous Advantage: The best of Natalie Clifford Barney, translated by
 Anna Livia, 1992
Aventures de l'esprit, 1982
Éparpillements, 1910
In Memory of Dorothy Ierne Wilde: Oscaria, 1951
Natalie Clifford Barney: Selected Writings, ed. Miron Grindea, 1963
Pensées d'une amazone, 1920
Quelques portraits – Sonnets de femmes, 1900
Souvenirs indiscrets, 1960
Traits et portraits, 1963

Works referencing Natalie Barney

Adams, Jad, 'Olive Custance: A Poet Crossing Boundaries English
 Literature in Transition', 1880–1920, vol. 61, no. 1, 2018
Allan, Tony, *Americans in Paris*, 1977
Barnes, Djuna, *Ladies Almanack*, 1928 and 1972

Beach, Sylvia, *Shakespeare and Company*, 1956

Benstock, Shari, *Women of the Left Bank*, 1986

Breeskin, Adelyn, *Romaine Brooks: Thief of Souls*, 1971

Bristow, Joseph, 'There you will see your Page': Olive Custance, Alfred Douglas and Lyrics of Sapphic Boyhood

Brooks, Romaine, *No Pleasant Memories*, unpublished manuscript, c.1938. Smithsonian

Carpenter, Humphrey, *Geniuses Together: American Writers in Paris in the 1920s*, 1987

Chalon, Jean, *Portrait of a seductress: the world of Natalie Barney*, translated by Carol Barko, 1979

Colette, *The Pure and the Impure*, 1941

Cooper, Duff and Diana, *A Durable Fire: letters*, edited by Artemis Cooper, 1983

Cossart, Michael de, *Food of Love, Princesse Edmond de Polignac and her salon*, 1978

Custance, Olive, *Opals*, 1987

Delarue-Mardrus, Lucie, *The Angel and the Perverts*, 1995

Douglas, Alfred, *Autobiography*, 1929

Field, Andrew, *The Life and Times of Djuna Barnes*, 1983

Fitch, Noel Riley, *Walks in Hemingway's Paris*

Ford, Hugh, *Published in Paris: American and British Writers, Printers and Publishers in Paris, 1920–39*, 1980

Goujon, Jean-Paul, *Renée Vivien*, 1986

Gourmont, Remy de, *Lettres intimes à l'Amazone*, 1927

Gramont, Elisabeth de, *Pomp and Circumstance*, 1929

——*Years of Plenty*, 1931

Herring, Philip, *Djuna, The Life and Work of Djuna Barnes*, 1995

Jay, Karla, *The Amazon and the Page: Natalie Clifford Barney and Renée Vivien*, 1988

Kahan, Sylvia, *Music's Modern Muse: A Life of Winnaretta Singer, Princesse de Polignac*, 2003

Kenney, Annie, *Memories of a Militant*, 1924

King, Jean L., *Alice Pike Barney*, 1994

Klüver, Billy and Martin, Julie, *Kiki's Paris: Artists and Lovers 1900–1930*, 1994

Leaska, Mitchell A. and John Phillips, eds. *Violet to Vita. The Letters of Violet Trefusis to Vita Sackville-West*, 1989

Leontis, Artemis, *Eva Palmer Sikelianos: A Life in Ruins*, 2019

Lorenz, Paul, *Sappho 1900: Renée Vivien*, 1977

Monsaingeon, Bruno, *Mademoiselle: Conversations with Nadia Boulanger*, 1988

Murray, Douglas, *Bosie: A biography of Lord Alfred Douglas*, 2000

Orenstein, Gloria Feman, 'The Salon of Natalie Clifford Barney: An interview with Berthe Cleyrergue', *Signs*, 1 April 1979, vol. 4

Palmer Sikelianos, Eva, *Upward Panic*, 1993

Plumpton, George, *Truman Capote*, 1997

Pougy, Liane de, *My Blue Notebooks*, trs. Diana Athill, 1979

Rapazzini, Francesco, 'Elisabeth de Gramont, Natalie Barney's "eternal mate"', *South Central Review*, vol. 22, 2005

Rodriguez, Suzanne, *Wild Heart: Natalie Clifford Barney's Journey from Victorian America to the Literary Salons of Paris*, 2002

Sackville-West, Vita, *Challenge*, 1974

Schenkar, Joan, *Truly Wilde: The Unsettling Story of Dolly Wilde*, 2000

Secrest, Meryle, *Between Me and Life*, 1976

Souhami, Diana, *Mrs Keppel and Her Daughter*, 1997

——*Wild Girls: Paris, Sappho and art: the lives and loves of Natalie Barney and Romaine Brooks*, 2004

Strachey, Dorothy, *Olivia*, 1949

Summerscale, Kate, *The Queen of Whale Cay*, 1998

Thurman, Judith, *Colette: Secrets of the Flesh*, 1999

Toklas, Alice B., ed. Edward Burns, *Staying on Alone: Letters of Alice B. Toklas*, 1974

Trefusis, Violet, *Don't Look Round*, 1952

——*Broderie anglaise*, trs. Barbara Bray, 1986

Vivien, Renée, *The Muse of the Violets*, 1977

——*A Woman Appeared to Me*, 1982

Weeks, Jeffrey, *Sex, Politics and Society*, 1981

Weiss, Andrea, *Paris Was a Woman*, 1995

Wickes, George, *The Amazon of Letters*, 1977

Wineapple, Brenda, *Genêt: A Biography of Janet Flanner*, 1989

Gertrude Stein

The Gertrude Stein and Alice B. Toklas papers are in 173 boxes in the Beinecke Rare Book and Manuscript Library, Yale Collection of American Literature (YCAL). The Carl Van Vechten, Mabel Dodge Luhan and Florine Stettheimer papers are there too. The personal papers of Virgil Thomson are in the University of Colorado Boulder Libraries. Annette Rosenshine's papers are at the Bancroft Library.

293 Pigeons on the grass alas | *Four Saints in Three Acts*
295 The two things you never asked | *Virgil Thomson*
295 I like all the people who | Gertrude to Samuel Steward.
See *Dear Sammy*

295	Why don't you read	cited in Rogers, *When This You See Remember Me*
296	To try is to die	*Everybody's Autobiography*
297	I have it, this interest in	*The Making of Americans*
297	father Mussolini and father	*Everybody's Autobiography*
298	You see it is the people	Haas, 'Gertrude Stein Talking'
298	I guess you know	Gertrude to Harriet Levy, undated, Yale
299	Our little Gertie is a	Brinnin, J.M., *The Third Rose*
299	She had sound coming out of	*Two: Gertrude Stein and Her Brother*
299	liked to buy things	*The Making of Americans*
299	sharp and piercing	Ibid.
300	Come on papa	Ibid.
300	His children never could lose	Ibid.
301	And then he would be full up	Ibid.
301	You have to take care of her	Ibid.
301	a sweet gentle little woman	Ibid.
302	She was never important to	Ibid.
302	dragged a little wagon	Quoted in Rosalind Miller, *Gertrude Stein: Form and Intelligibility*
302	In other lands	*The Making of Americans*
303	Evolution was all over	Ibid.
303	He always liked to think about	Ibid.
303	It is better if you are	*Everybody's Autobiography*
304	was not a pleasant person	Ibid.
304	a very good nose	Ibid.
304	We had already had	Ibid.
305	was more a bother than	Ibid.
305	Medieval means that life	*Wars I Have Seen*
305	naturally was not satisfied	*Everybody's Autobiography*
306	I remember going to court	Ibid.
306	He saw not any one	R.E. Duncan, 'Interview'
306	There were so many debts	*Everybody's Autobiography*
308	a tall American version of	*Q.E.D.*
308	passionate yearnings	*Gertrude Stein: Form and Intelligibility*
308	Books, books, books	Ibid.
308	the middle class ideal	*Q.E.D.*
308	You are so afraid of losing	Ibid.
308	feared passion in its	Ibid.
308	That is what makes it	Ibid.

308	a hopeless coward	Ibid.
309	unillumined immorality	Ibid
309	very strong medicine to	Sarah Stein to Gertrude, undated, 1893, YCAL
309	turgid and complex world	*Q.E.D.*
310	The pain of passionate longing	Ibid.
310	Oh you stupid child	Ibid.
310	She said she found it	Ibid.
311	would ask her questions	*Everybody's Autobiography*
311	You have no idea how	Ibid.
311	Remember the cause of women	Ibid.
312	a young mathematician	Ibid.
312	every kind of men	*The Making of Americans*
313	The time comes when nothing	*Q.E.D.*
313	their pulses were differently	Ibid.
313	Paris was where the twentieth	*Paris France*
313	Our roots can be	*Lectures in America*
314	I've got my house	Leo to Mabel Weeks, 8 April 1903, YCAL
315	Gertrude and Sister C.	Cone Archives, Baltimore Museum of Art
316	Leo never did paint there	EA
316	a German woman, a German	*Three Lives*
317	'Do you know Cézanne?'	Leo Stein, *Appreciation*
318	a Columbus setting sail	Ibid.
318	We is doin business	To Mabel Weeks, undated, YCAL
319	Cézanne gave me a new feeling	Haas, 'Gertrude Stein Talking'
320	the first definite step	*Lectures in America*
320	I went to bed very miserable	To Mabel Weeks, undated, YCAL
320	a riot of colour	Claribel Cone, lecture notes. Papers owned by Ellen B. Hirschland
321	Donatello parmi les fauves	Louis Vauxcelles, *Gil Blas*, 20 March 1907
321	in the name of I-don't-know	Ibid.
321	This new religion	Ibid.
321	We asked ourselves 'Are these	Claribel Cone, lecture notes
321	it was what I was unknowingly	Leo Stein, *Appreciation*
323	Matisse brought people	*Selected Writings of Gertrude Stein*
323	The most hospitable	Vollard, *Souvenirs d'un marchand*

324	expounded and explained	Leo Stein, *Journey into the Self*
324	I made enormous charts	*How Writing is Written*, 1974
325	If the genius of men	Renée Sandall, 'Marie Laurencin: Cubist Muse or More?' *Women's Art Journal*, vol 1, no. 1, Spring 1980
325	a good-looking bootblack	Gertrude Stein, *Picasso*, 1938
326	I can't see you any	Ibid.
326	For me it is I and	Ibid.
327	I was alone at this time	Ibid.
327	to express things seen	Ibid.
328	the responsible daughter	Duncan, 'Interview'
328	I felt most keenly	Rosenshine, 'Life's Not A Paragraph'
329	Since the startling news	Donald Gallup, ed., *The Flowers of Friendship*
329	She was a golden presence	Alice B. Toklas, *What is Remembered*
329	It is inevitable	Gertrude Stein, preface to Francisco Riba-Rovira exhibition at Galerie Roquépine, May 1945
330	Right here in front of	*What is Remembered*
331	It was the enormous life	Duncan, 'Interview'
332	escaping from the inevitable	*Narration*
332	The typewriter had a rhythm	*What is Remembered*
332	like living history	Ibid.
333	Bear it in your mind my reader	*The Making of Americans*
333	I mean, I mean and that is	Ibid.
334	Day after day she wept	Levy, 'Recollections'
334	I would rather harbour	Leo Stein to Mabel Weeks, February 1913, YCAL
335	there was no hesitation	Duncan, 'Interview'
335	I always say that you	*Autobiography of Alice B. Toklas*
335	My proofreaders report	Gallup, *Flowers*
336	I want to say frankly	Ibid.
337	found the brilliant	Rosenshine, 'Life's Not A Paragraph'
337	I told you one time	Leo to Gertrude, undated, YCAL
337	He said it was not it it	*Two*
337	She doesn't know what	*Journey into the Self*
337	It was I who was	*Everybody's Autobiography*

338	Gertrude and I are	*Journey into the Self*
338	the beginning of the ending	*Everybody's Autobiography*
338	I thought she was making fun	*What is Remembered*
338	There were many relations	*Portraits and Prayers*
338	She came to be happier	Ibid.
339	She was thinking	*Two*
340	Like all children and madmen	Leo to Mabel Weeks, undated, YCAL
340	Do you remember	*As Fine As Melanctha*
341	Alice Toklas entered the Stein	Luhan, *Intimate Memories*
341	He had always had	Ibid.
342	Please come down here soon	Ibid.
342	Eating alone with Edwin	Ibid.
342	white moonlight – white linen	Ibid.
343	The days are wonderful	*Portraits and Prayers*
343	such a strong look	*Intimate Memories*
343	a surprised noticing glance	Ibid.
344	Gertrude Stein is doing with	Mabel Dodge, *Arts and Decoration*, March 1913
345	Alice's final and successful	*Intimate Memories*
346	We must be getting back to	Bravig Imbs, *Confessions of Another Young Man*
346	In the menu there should be	*The Alice B. Toklas Cookbook*
346	She is very necessary to me	*Painted Lace*
347	Our pleasure is to do every	'Bonne Année' in *Geography and Plays*
347	I marvel at my baby	'Coal and Wood' in *Painted Lace*
348	Having it as having having	*As a Wife Has a Cow: A Love Story*
348	to completely face	*Tender Buttons*
349	when he laughed	*Intimate Memories*
353	I say lifting belly	*Lifting Belly: Bee Time Vine*
354	a scary habit of talking	*Autobiography of Alice B. Toklas*
354	wrong or right, this is the	Ibid.
354	The wind blows	*Geography and Plays*
355	Their funny get-up	Georges Braque, 'Testimony against Gertrude Stein', *transition*, February 1935
356	It was as gay	*The Alice B. Toklas Cookbook*
356	It was a wonderful day	*Autobiography of Alice B. Toklas*
357	But they're damned hard	*Journey into the Self*
357	It was those things	*Confessions of Another Young Man*
357	You have the gift of true	Ibid.

358 could make or mar — Ibid.

358 I was ostracised — Annette Rosenshine, 'Life's not a paragraph'

359 book of a woman — Cited in Linda Simon, *The Biography of Alice B. Toklas*

359 the atmosphere seemed — *The Heart to Artemis*

359 Do you know what she said — Quoted in *The Formidable Miss Barnes*

360 staunch presence — Quoted in Wickes, *The Amazon of Letters*

360 Dear Miss Gertrude — Sylvia Beach to Gertrude, June 1921, YCAL

360 persistently unhappy — Sherwood Anderson, *Memoirs*

361 You sometimes write — Sherwood Anderson, *Gertrude Stein correspondence*

361 a strong woman with legs — Sherwood Anderson, *Memoirs*

361 I couldn't see the necessity — Sylvia Beach, *Shakespeare and Company*

361 strong German-Jewish — Ernest Hemingway, *A Moveable Feast*

363 I'm sorry to hear — Grace Hemingway to Ernest, February 1927

363 Killed my 2 buffalo — Hemingway to Arnold Gingrich, 18 January 1934

363 She used to talk to me — *A Moveable Feast*

364 We are surrounded by — Steward, *Dear Sammy*

364 I was startled. Not a bit — Emerald Cunard to Cyril Connolly, 1944

364 Gertrude Stein and me — Hemingway to Sherwood Anderson, 1922

364 all women who are truly — Otto Weininger, *Sex and Character*

365 I've thought a lot about — Hemingway, *Selected Letters*

366 Among and then young — *Portraits and Prayers*

366 Ford alleges he is delighted — February 1924, Hemingway, *Selected Letters*

368 it is something really — Scott Fitzgerald to Maxwell Perkins, 1 May 1925

368 I am a very second rate — Scott Fitzgerald to Gertrude, June 1925

369 It is funny, the two — *Everybody's Autobiography*

369 If he was not an — Hemingway to Cowley, 16 September 1951 Neville Collection

369	I cross myself and swear	Hemingway, Friday morning, autumn 1929
369	in the geographical	*Letters of Scott Fitzgerald*
370	Is this the book you asked	Ibid.
370	If this is literature	Quoted in Brinnin
371	two penetrating eyes	*The Heart to Artemis*
371	big as, perhaps bigger	Ibid.
371	There is something	Van Vechten to Gertrude, 16 April 1923, Burns, ed., *Letters of Stein and Van Vechten*
372	Had you wished to give	Robert McAlmon to Gertrude, 8 October 1925
372	with sentences so regularly	*Fernhurst*
373	One should not talk about	Edmund Wilson, *Axel's Castle*, 1931
374	Before I came to Paris	*The Autobiography of Alice B. Toklas*
376	a complete memoir of that	*Paris was Yesterday*
377	Gertrude? What would you	Hemingway to Maxwell Perkins, 7 September, 1935
377	never, anywhere, ever	Hemingway, *A Moveable Feast*
378	in its hollow tinsel	'Testimony Against Gertrude Stein', foreword, *transition*, February 1935
378	God what a liar she is	*Journey into the Self*
379	So many people knowing me	Haas, 'Gertrude Stein Talking'
380	And the Stein texts,	Virgil Thomson, *Virgil Thomson*
381	If in regard to climates	*Capital Capitals*
382	I think it should be late	James Mellow, *Charmed Circle: Gertrude Stein and Company*, 1974
382	Pigeons on the grass alas	*Four Saints in Three Acts*
383	Speech alone lacks	*Virgil Thomson*
384	He makes the words by	Parker Tyler, *Florine Stettheimer, A Life in Art*, 1963
386	quite a departure	cited in Steven Watson, *Prepare for Saints*
389	It was the perfect moment	*The Heart to Artemis*
390	walked up to our	David Harris, 'The Original Four Saints in Three Acts', *Drama Review*, vol. 26, no. 1, 1982
391	I cannot say that we don't	Rogers, *When This You See, Remember Me*

392 If you knew the resistance Thomson to Gertrude, 9 June
 1933, *The Letters of Gertrude
 Stein and Virgil Thomson*
393 They act as if they had never *Wars I Have Seen*
395 I sat next to her *What is Remembered*
395 You! Why didn't you *Paris was Yesterday,*
 Introduction

Works by Gertrude Stein

As Fine As Melanctha, Foreword by Natalie Clifford Barney, 1954
The Autobiography of Alice B. Toklas, 1933
Bee Time Vine and Other Pieces, Preface by Virgil Thomson, 1953
Everybody's Autobiography, 1938
Fernhurst, Q.E.D. and Other Early Writings, edited and with introduction
 by Leon Katz, 1972
Geography and Plays, 1922
Gertrude Stein on Picasso, edited by Edward Burns, 1970
How To Write, 1931
Lectures in America, 1935
The Making of Americans, 1966
Narration: Four Lectures, Introduction by Thornton Wilder, 1935
Painted Lace and Other Pieces, Introduction by Daniel-Henry Kahnweiler,
 1955
Paris France, 1940
Portraits and Prayers, 1934
Selected Writings of Gertrude Stein, edited by Carl Van Vechten, 1946.
 Includes:
 The Autobiography of Alice B. Toklas
 Tender Buttons
 Composition As Explanation
 Portrait of Mabel Dodge at the Villa Curonia
 As A Wife Has A Cow: A Love Story
 Four Saints in Three Acts
Tender Buttons, 1914
Three Lives, 1915
Two: Gertrude Stein and Her Brother and other Early Portraits, Foreword
 by Janet Flanner, 1951
Wars I Have Seen, 1945
Writings 1903–1932, 1998

Works referencing Gertrude Stein

Allmer P. and Sears J., *4 Saints in 3 Acts, a snapshot of the American Avant-Garde in the 1930s*, 2017

Anderson, Sherwood, *Gertrude Stein: Correspondence and Personal Essays*, 1972

——*Memoirs*, 1942

——*Notebooks*, 1926

Brinnin, John Malcolm, *The Third Rose, Gertrude Stein and Her World*, 1959

Bryher, *The Heart to Artemis*, 1962

Burns, E. ed., *The letters of Gertrude Stein and Carl van Vechten, 1913–46*, 1986

Duncan, Roland E., Interview for the Oral History Dept, Bancroft Library, Berkeley, 1952

Field, Andrew, *The Formidable Miss Barnes*, 1983

Fitzgerald, F. Scott, *The Letters of Scott Fitzgerald*, ed. Andrew Turnbull, 1964

Flanner, Janet (Genêt), *An American in Paris*, 1940

——*Men and Monuments*, 1957

——*Paris was Yesterday: 1925–1939*, ed. Irving Drutman, 1972

Gallup, Donald, *Pigeons on the Granite: Memories of a Yale Librarian*, 1988

——ed., *The Flowers of Friendship: Letters Written to Gertrude Stein*, 1953

Haas, Robert Bartlett and Gallup, Donald, *A Catalogue of the Published and Unpublished Writings of Gertrude Stein*, 1941

Haas, Robert Bartlett, 'Gertrude Stein Talking' – A Transatlantic Interview, 1945

Hanscombe, Gillian and Smyers, V.L., *Writing for their Lives*, 1987

Harris, David, 'The original Four Saints in Three Acts', *Drama Review*, vol. 26, 1982

Hemingway, Ernest, *A Moveable Feast*, 1969

——*Selected Letters, 1917–61*, 1981

——*Letters*, vol. 1 (1907–1922) ed., Sandra Spanier, 2011

Hobhouse, Janet, *Everybody Who Was Anybody*, 1975

Holbrook, Susan and Dilworth, Thomas, *The Letters of Gertrude Stein and Virgil Thomson*, 2010

Imbs, Bravig, *Confessions of Another Young Man*, 1936

James, William, *Writings 1878–1899*, 1992

Levy, Harriet Lane, *920 O'Farrell Street*, 1947

——'Recollections', typescript, Bancroft Library, Berkeley

Luhan, Mabel Dodge, *Intimate Memories*, 4 vols., 1933–7

McAlmon, Robert, *Being Geniuses Together*, 1968

Miller, Rosalind, *Gertrude Stein: Form and Intelligibility*, 1949

Mellow, James R., *Charmed Circle: Gertrude Stein and Company*, 1974

Page, T. and V.W., eds., *Selected Letters of Virgil Thomson*, 1988

Rogers, W.C., *When This You See Remember Me: Gertrude Stein in Person*, 1948

Rosenshine, Annette, 'Life's Not A Paragraph', typescript, Bancroft Library, University of Berkeley

Simon, Linda, *The Biography of Alice B. Toklas*, 1978

Sprigge, Elizabeth, *Gertrude Stein: Her Life and Work*, 1957

Stein, Leo, *Appreciation: Painting, Poetry and Prose*, 1947

——*Journey into the Self: Letters, Papers and Journals of Leo Stein*, edited by Edmund Fuller, 1950

Steward, Samuel, *Dear Sammy: Letters from Gertrude Stein and Alice B. Toklas*, 1977

Testimony Against Gertrude Stein.

Thomson, Virgil, *Virgil Thomson*, 1966

Toklas, Alice B., *The Alice B. Toklas Cookbook*, 1960

——*What Is Remembered*, 1963

Watson, Steven, *Prepare for Saints: Gertrude Stein, Virgil Thomson, and the Mainstreaming of American Modernism*, 1995

Weininger, Otto, *Sex and Character: An Investigation of Fundamental Principles*, 2005

Wickes, George, *The Amazon of Letters*, 1977

Wilson, Edmund, *Axel's Castle*, 1952

TEXT CREDITS

ACKNOWLEDGEMENTS

The vision and expertise of others transformed a meagre pdf attachment from me into this book. Thank you to Georgina Capel, my agent for 25 years. Thank you to Maggie McKernan Editor-at-Large at Head of Zeus, to Clare Gordon, Assistant Editor there and to Clémence Jacquinet, Production Director. I fear that one way or another I drove them all up the wall. Thank you to Jenni Davis for her scrupulous copy editing, to Adrian McLaughlin for his impressive typesetting, to Cliff Murphy for his indexing, and to Anna Morrison who designed the jacket.

I wrote much of this book at the London Library in St James's Square. It is a special place – a million books to be borrowed or browsed, online access to articles and archives, friendly and hugely knowledgeable librarians. I was spurred on there by a WhatsApp posse of writers. We wait for the library doors to open at 9.30, save each other places and share cake and coffee and occasionally champagne. When I work from home I dead head the geraniums and raid the fridge.

I hurry to the Tyrone Guthrie Centre at Annaghmakerrig whenever there is an available space. It is a paradisal artists' retreat, there's an enchanted house, a lake to swim in, woodland to walk

in and Lavina's cooking deserves a Michelin star. Thank you to Mary, Ingrid, Martina and all who make this place so special.

And thank you, as ever and always, to Naomi Narod, my best friend for 56 years. Her kindness to me has no limit. She even enthused when I read the entire manuscript out loud to her – twice.

INDEX